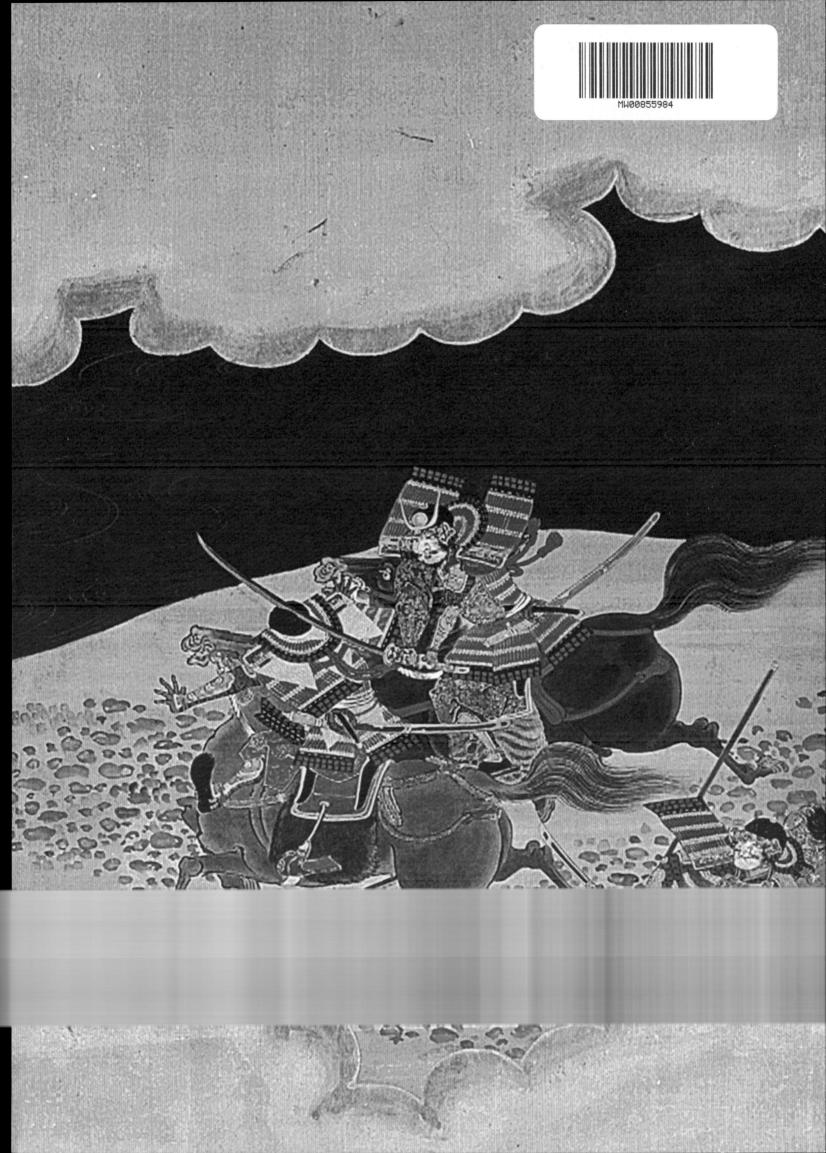
MW00855984

The Art of the Japanese
SWORD

THE CRAFT OF SWORDMAKING
AND ITS APPRECIATION

Leon and Hiroko Kapp
Yoshindo Yoshihara

photos by
Yoshikazu Yoshihara
and
Aram Compeau

TUTTLE Publishing
Tokyo | Rutland, Vermont | Singapore

Published by Tuttle Publishing, an imprint of Periplus Editions (HK) Ltd.

www.tuttlepublishing.com

Copyright © 2012 Paolo Saviolo

Produced by Paolo Saviolo

All rights reserved. No part of this publication may be reproduced or utilized in any form or by any means, electronic or mechanical, including photocopying, recording, or by any information storage and retrieval system, without prior written permission from the publisher.

Layout design and creative direction: Hiroko Kapp, Paolo Saviolo
Graphic design: Paolo Saviolo
Computer graphic: Mariella Sampietro - Saviolo Edizioni
Digital image processing: Fotomec, Torino, Italy
Text: Leon Kapp
Text and history supervisor: Paolo Cammelli
Japanese editor: Shigeyoshi Suzuki
English editor: Katherine Heins
Photographs: The tatara photos on pages 104–19 are by Takeshi Fujimori, courtesy of the Wako Museum. All other photographs are by Aram Compeau and Yoshikazu Yoshihara
Drawings: The oshigata of the tanto on page 91 is by Naoji Karita; all other oshigata are by Michihiro Tanobe. Black-and-white and color drawings are by Ryoichi Mizuki and Yoshindo Yoshihara

ISBN 978-4-8053-1240-7

Distributed by

North America, Latin America & Europe
Tuttle Publishing
364 Innovation Drive
North Clarendon, VT 05759-9436 U.S.A.
Tel: 1 (802) 773-8930
Fax: 1 (802) 773-6993
info@tuttlepublishing.com
www.tuttlepublishing.com

Japan
Tuttle Publishing
Yaekari Building, 3rd Floor
5-4-12 Osaki Shinagawa-ku
Tokyo 141 0032
Tel: (81) 3 5437-0171
Fax: (81) 3 5437-0755
sales@tuttle.co.jp
www.tuttle.co.jp

Asia Pacific
Berkeley Books Pte. Ltd.
3 Kallang Sector #04-01,
Singapore 349278
Tel: (65) 6741 2178
Fax: (65) 6741 2179
inquiries@periplus.com.sg
www.tuttlepublishing.com

23 22 21 20 19
10 9 8 7 6 5

Printed in Hong Kong 1905EP

TUTTLE PUBLISHING® is a registered trademark of Tuttle Publishing, a division of Periplus Editions (HK) Ltd.

ABOUT TUTTLE:
"Books to Span the East and West"

Our core mission at Tuttle Publishing is to create books which bring people together one page at a time. Tuttle was founded in 1832 in the small New England town of Rutland, Vermont (USA). Our fundamental values remain as strong today as they were then—to publish best-in-class books informing the English-speaking world about the countries and peoples of Asia. The world has become a smaller place today and Asia's economic, cultural and political influence has expanded, yet the need for meaningful dialogue and information about this diverse region has never been greater. Since 1948, Tuttle has been a leader in publishing books on the cultures, arts, cuisines, languages and literatures of Asia. Our authors and photographers have won numerous awards and Tuttle has published thousands of books on subjects ranging from martial arts to paper crafts. We welcome you to explore the wealth of information available on Asia at www.tuttlepublishing.com.

Table of Contents

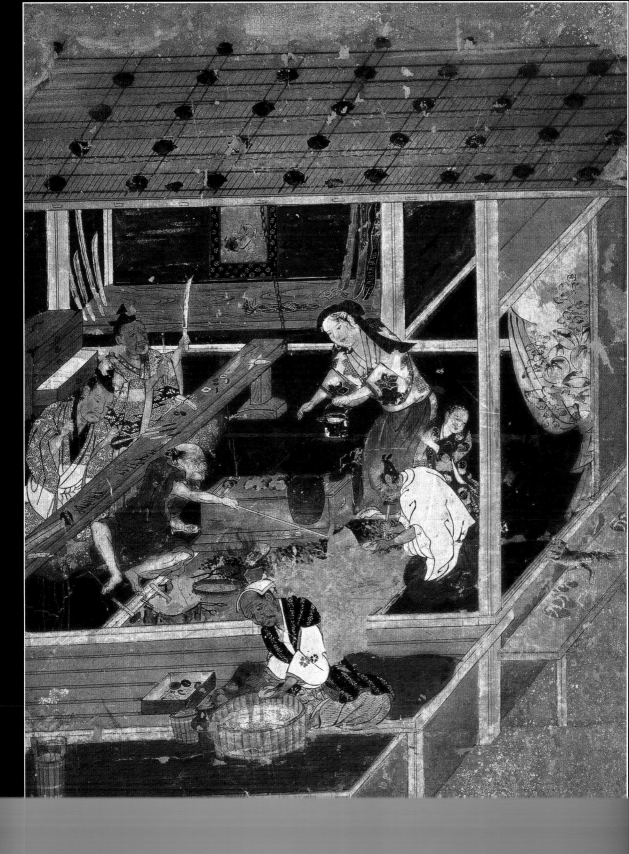

Zukishi-e (paintings of craftsmen). The paintings, classified as Juyo Bunkazai (Important Cultural Properties), are preserved at the Kita-in Temple in Kawagoe, Saitama Prefecture. Reprinted with permission.

Introduction

by Leon Kapp

The Japanese sword, a singular work of art in steel, can be appreciated from a number of viewpoints. Its functionality as a weapon is remarkable, as are the sophisticated metallurgy and scientific thinking utilized by the swordsmith. Beyond the shape of the sword itself, among the most critical aesthetic elements are the different crystalline structures and forms in the steel.

Its use as a weapon over the ages means that the Japanese sword serves as a living example of the evolving technology used in its construction. There is also an intimate connection between the sword and Japanese history, as its features were shaped in response to historical events. Furthermore, it is fascinating to meet and learn from the modern-day craftsmen who still produce these blades.

The purpose of this book is to convey to the reader a basic background regarding the Japanese sword, as well as to explain how to view and appreciate a blade and to show the details of how a sword is made and finished today. Modern craftsmen use completely traditional methods from the past to prepare their steel, forge the sword, and create the distinctive hardened edge. Japan, it seems, is unique in the way it has maintained its traditional sword-making technology from ages past. Our hope is that by gaining a good understanding of how a sword is actually made, the reader will be able to appreciate the Japanese sword more fully.

Japan's distinctive and sophisticated sword-making methods were perfected over hundreds of years, beginning sometime between the fourth and sixth centuries when swords and the technology to make them were first imported from China via Korea. Even today blades are still made using these time-tested techniques, which were preserved intact throughout the transition from the feudal past into the modern world. Beyond its superb functionality, part of the fascination of the Japanese sword is the fact that it is made from iron ore smelted in a charcoal-fueled furnace, using a bellows design that dates back approximately 2200 years. The steel is worked completely by hand with hammers and human labor, making each sword one-of-a-kind. Even with today's modern knowledge of metallurgy, it is unlikely that a better steel sword can be made.

The Japanese sword is remarkable both as a weapon and as an object of art. Its design evolved over centuries to cut well and efficiently. The properties that make it so effective as a weapon also lend it compelling aesthetic qualities. It is not easy to observe all of the essential details, however. To be fully appreciated, a sword must be in good condition, with no rust on its surface. It must not be "tired"; that is, it must not be over-polished or have been poorly restored or repaired in the past, as such factors can ruin the shape and obscure details on the surface. Once these conditions are met, it is necessary to have proper lighting and to hold the sword at a proper angle relative to the light. Some knowledge of traditional viewing methods is a further necessity to proper appreciation of a blade's qualities. As the Japanese swords one may see today are frequently in very poor condition, and proper lighting may not be available, simply examining and appreciating them can often be difficult.

The aim of this book is to provide a comprehensive introduction to the Japanese sword in order to help readers to examine and appreciate these inimitable works of art. It explains in detail the work of the swordsmith, along with that of other craftsmen who finish and mount the sword. The making of a Japanese sword is a long process: after the swordsmith makes the sword, it goes to a polisher for the final shaping and a polish that will bring out all of the details of the steel surface; it then goes to a craftsman who makes the habaki, a metal fitting that supports the hilt and secures the blade in the scabbard. Finally, the sword goes to a scabbard maker for a shirasaya (a simple wood scabbard designed to protect and preserve the sword), or for a traditional koshirae, the complete functional mounting.

Other topics covered in this text include an explanation of how to appreciate and handle a sword; descriptions of the smelting of the steel, the forging of the blade, and the finishing of the sword; a brief explanation of the metallurgy involved; and illustrations of the vocabulary used to describe the parts of the sword. Historical events, both ancient and modern, are also recounted in order to explain how traditional Japanese sword-making techniques from the past were preserved.

Most of the modern works shown in this book were made by Yoshindo Yoshihara and his family. The Yoshihara family has been active in making and promoting Japanese swords both in Japan and internationally. Yoshindo's grandfather, the first

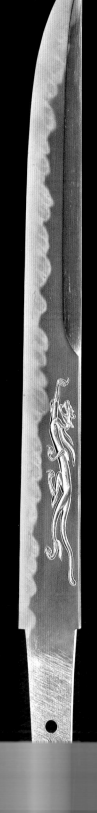

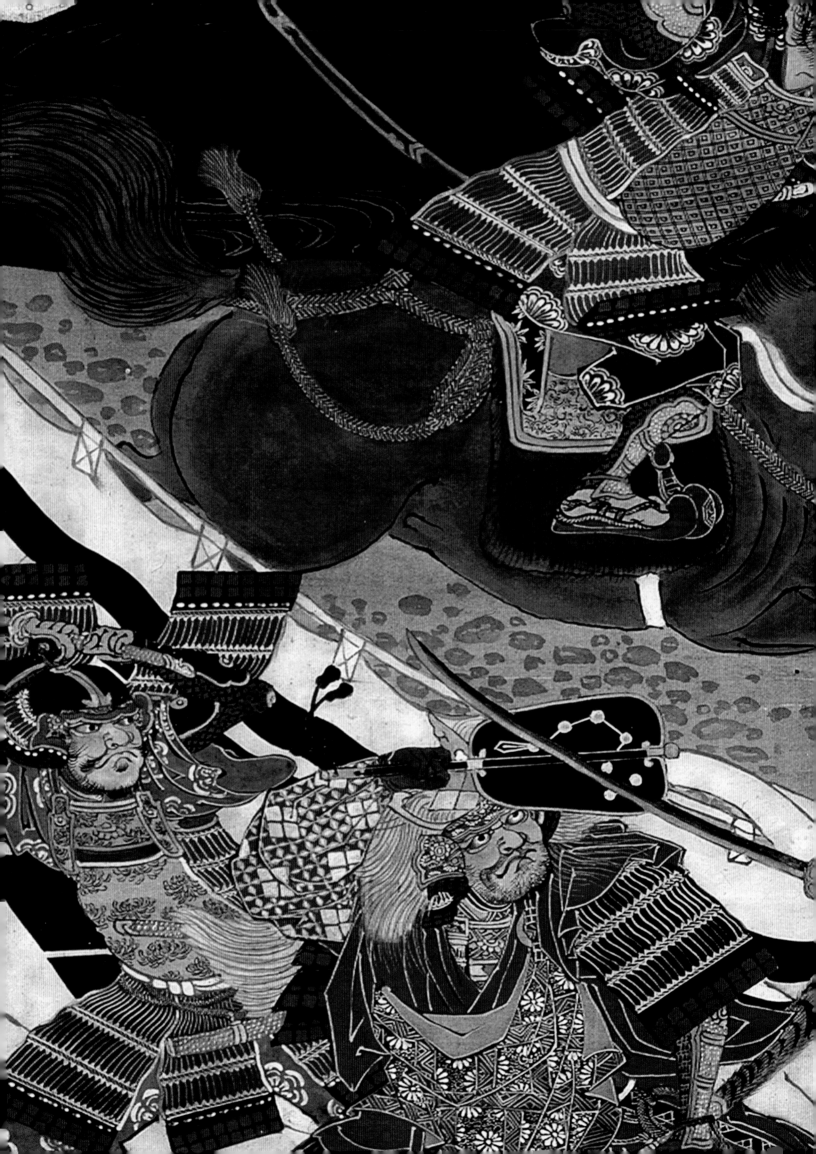

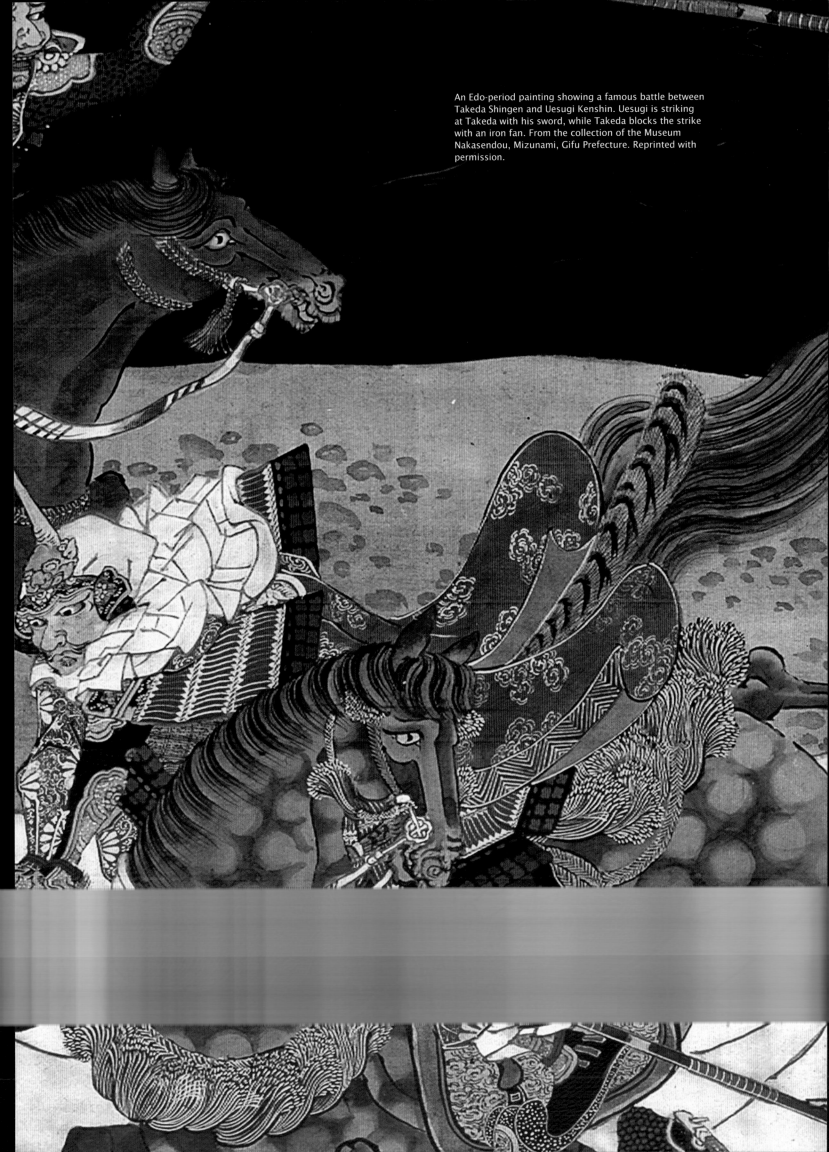

An Edo-period painting showing a famous battle between Takeda Shingen and Uesugi Kenshin. Uesugi is striking at Takeda with his sword, while Takeda blocks the strike with an iron fan. From the collection of the Museum Nakasendou, Mizunami, Gifu Prefecture. Reprinted with permission.

APPRECIATING THE JAPANESE SWORD

CHAPTER I

KANSHO
APPRECIATING THE JAPANESE SWORD

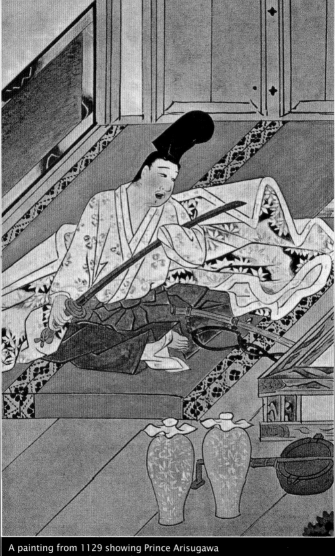

A painting from 1129 showing Prince Arisugawa
examining a sword. Notice that the sword rests on

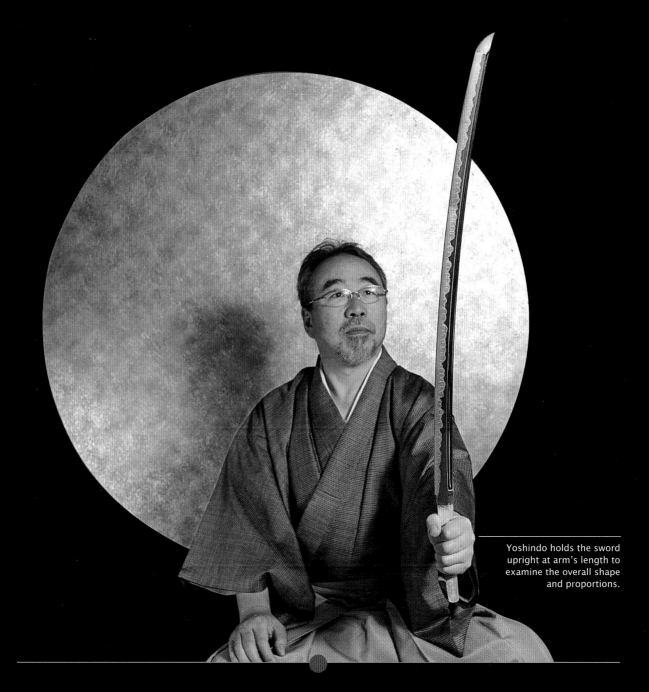

Yoshindo holds the sword upright at arm's length to examine the overall shape and proportions.

Examining a Japanese Sword

Examining all of the critical but subtle details in a Japanese sword is a demanding task that requires good lighting and a properly polished sword in good condition at the outset. There are three major

the base of the blade to the point, the degree of curvature, and the shape and size of the point. The

thickness of the blade, along with its weight and balance, should also be noted.

To examine the surface of the steel, a good light

a smith folds and forges the steel, one of several different patterns may be visible. A series of fairly

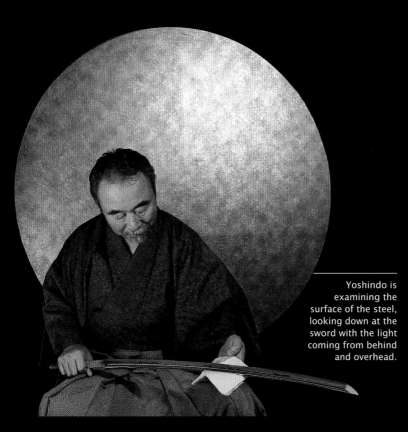

Yoshindo is examining the surface of the steel, looking down at the sword with the light coming from behind and overhead.

To view the hamon, hold the sword slightly below a focused light source such as a bare incandescent or halogen bulb. Around the light reflected on the blade, it is usually possible to see the distinct white line that defines the boundary between the hard martensite edge and the softer upper body of the sword. Many intricate details can usually be seen along this boundary line and within the hamon.

Examining a Japanese sword is an active process: not only must the blade be held in the proper position to examine each part of the sword, but it must be moved continuously so that the light reflected from the focused source moves along the surface of the steel, revealing its features (the jigane and jihada), as well as the details of the hamon. Learning to perceive all of the important aspects of the sword is a task that requires some practice.

straight lines running along the blade's length is called "masame hada"; a pattern resembling wood grain is "itame hada"; and a very fine and complex pattern resembling the grain of a wood burl is called "mokume hada." There are many variations on these patterns, depending on how the steel was made and the sword forged.

One of the most prominent aspects of a Japanese sword is its hamon, the area of hardened steel along the cutting edge. After forging, Japanese swords undergo a process that results in the formation of a very hard steel called martensite along the edge. Because the crystalline structure of the martensite that makes up the hamon is different from that of the softer steel in the upper body of the sword, the hamon stands out. A good hamon is clearly visible, with a continuous boundary along the body of the sword; it should be present along the entire length of the sword as well as on its point.

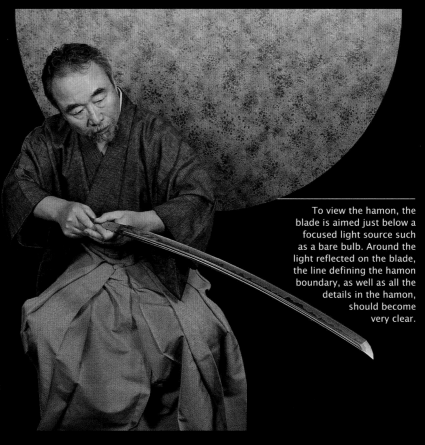

To view the hamon, the blade is aimed just below a focused light source such as a bare bulb. Around the light reflected on the blade, the line defining the hamon boundary, as well as all the details in the hamon, should become very clear.

Sword Care and Maintenance

Japanese swords require regular maintenance to remain in good condition. It can take a professional polisher a significant amount of time to polish a new sword or restore an old one, and the resulting finish on the sword must be carefully preserved. Many customs or rules have been developed in Japan to take care of these swords. These rules should be carefully observed to preserve a sword in good condition.

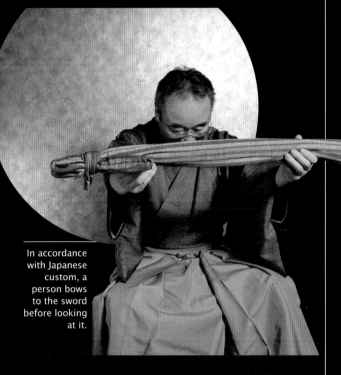

In accordance with Japanese custom, a person bows to the sword before looking at it.

The sword bag is untied and the sword is removed.

A Japanese sword is stored in a specially designed cloth bag. When first picking up a sword, it is customary to bow to the sword before removing it from the bag.

The cloth ribbon securing the mouth of the bag is untied, and the sword and scabbard are removed from the bag. The hilt is then gripped securely with the fingers of one hand, while the thumb of the same hand pushes the scabbard to separate it from the hilt gently and securely. Using this technique ensures that the sword comes out of the scabbard slowly, rather than in a sudden movement that could damage the scabbard or injure the person holding the sword.

If the scabbard is very tight, use both hands and both thumbs to ease the sword slowly out of the scabbard, with the thumbs acting as a brake. Once the blade can move freely, remove it completely from the scabbard. To minimize damage to the highly polished surface, the sword should be drawn from the scabbard slowly, with the cutting edge turned upward toward the ceiling. The blade should slide only along its back surface as it is pulled out. If the blade were removed with the cutting edge down, it would cut through the scabbard; sliding it out on its side would eventually produce visible scratches along the polished surface.

Once the sword is out of the scabbard, the blade is flush with the surface of the hilt; the rivet is then removed from the other side.

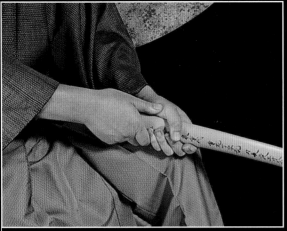

A Japanese sword is designed to fit snugly into the mouth of the scabbard, so the hilt must be loosened before the blade is pulled out. To begin to remove the sword, Yoshindo grasps the hilt with his right hand and pushes on the scabbard with his right thumb to ease it away from the hilt. This precaution will prevent a tightly fitting sword from suddenly jumping out of the scabbard. The right thumb and right hand on the hilt and scabbard act as a brake, so that initially the sword can move only a short distance out of the scabbard.

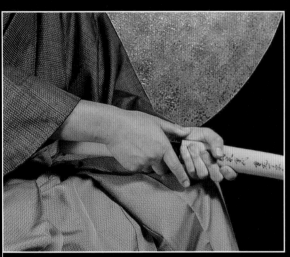

The loosened sword is now partly out of the scabbard. Notice that the right hand and right thumb are in contact with both the hilt and the scabbard.

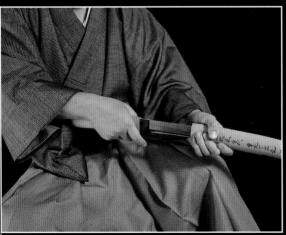

The sword should slide out of the scabbard only on its unsharpened back surface (the mune). Care should be taken to slide the blade along the mune when it is replaced in the scabbard as well.

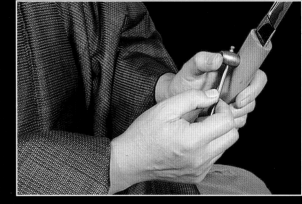

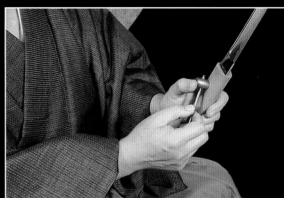

Yoshindo uses the flat face of a traditional tool called a mekugi-nuki to begin pushing the bamboo mekugi out of the hilt. The end of the mekugi protrudes slightly above the surface of the hilt, so this action loosens it.

Once the mekugi is loosened, Yoshindo can use the pointed end of the mekugi-nuki handle to push the rivet completely out of the hilt.

When the mekugi is out, the hilt can be removed. To accomplish this, hold the blade nearly upright, with one hand gripping the hilt tightly. Form a fist with the other hand and use it to strike the wrist of the hand gripping the sword. This should make the tang of the sword jump slightly out of the hilt. Once the tang is loose, it will be possible to grip the upper part of the tang and remove the blade from the hilt entirely. The habaki (blade collar) can then be removed: it will usually simply slide down and off the end of the tang.

When the sword is out of the scabbard and the mekugi has been removed, the blade is removed from the hilt. The blade is held almost vertically upright in the left hand. While the left hand holds the hilt, the right hand forms a fist and strikes the left wrist at the base of the left hand. This should loosen the sword from the hilt.

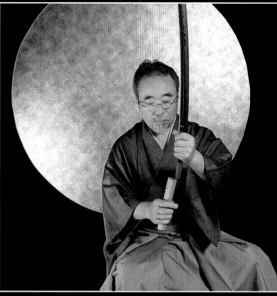

Once the sword is far enough out of the hilt, the bare tang of the sword can be grasped, and the sword can be completely removed from the hilt.

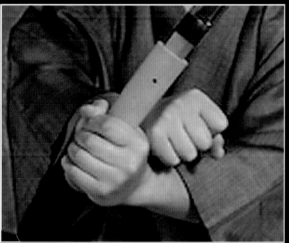

After a few gentle strikes with the right fist, the sword should begin to move. The blade is now a couple of inches (5 cm) out of the hilt.

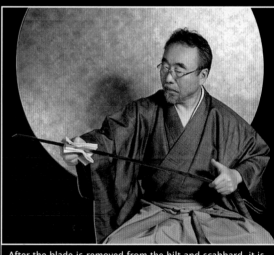

After the blade is removed from the hilt and scabbard, it is wiped with tissue or soft Japanese paper to remove any oil or dust from the blade. Notice that Yoshindo has wrapped the paper around the blade from the unsharpened back surface, and is wiping the blade from the tang toward the point. The blade should always be wiped or cleaned in this direction. Wiping the blade in the opposite direction, from the point toward the tang, is not a good idea. The curvature of the blade increases the likelihood of being cut.

After the scabbard, hilt, and habaki are removed, the blade must be cleaned to allow a clear view of the surface. This cleaning will remove any dust

area, remove the paper, replace it near the base of the blade, and move it forward again. Avoid moving the paper and wiping the blade in the

ened surface, move it along the blade from the base toward the point. After reaching the point

abrasive and absorbent powder that will remove any dust or moisture from the blade's surface.

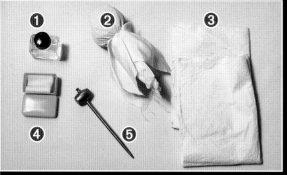

Items used to maintain and clean a sword. 1. Clove or camellia oil. 2. Uchiko wrapped in two layers of fabric. 3. Handmade Japanese washi paper used to wipe swords (plain facial tissue may also be used). 4. A small square of cotton cloth used to hold the oil. 5. The mekugi-nuki hammer used to remove the bamboo pin that secures the sword in the hilt.

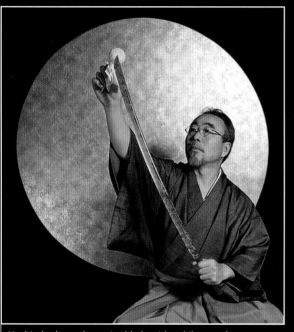

Yoshindo dusts the entire blade with uchiko powder.

The uchiko is wrapped, first in a layer of cotton and then in a layer of fabric, and tied at its base to form a ball. The fabric trailing from the end of the ball gives it a lollipop-like shape. Holding the trailing fabric, gently tap the uchiko ball along the surface of the blade, leaving a fine layer of white powder behind on the blade surface. Both sides of the blade must be dusted.

Next, use a clean sheet of paper to wipe off the uchiko powder. Move the paper from the base of the blade towards the point in exactly the same manner as was used to initially wipe off the blade. Again, it is best to only move the tissue from the base of the blade to the point. After the uchiko powder is wiped off, the surface of the blade should be very clean, with all traces of dust and moisture removed. At this

When the blade has been wiped off, Yoshindo dusts it with a very fine powder called "uchiko." This is used to clean the blade thoroughly so that the surface details are easily visible. The uchiko powder is wrapped first with cotton, then with fine fabric, giving it a lollipop shape.

After being dusted with uchiko, the blade is wiped with soft paper to remove the powder. The uchiko is a very fine absorbent, and after it is wiped off the blade, all dust and traces of oil and moisture will be removed. As before, the blade is wiped from the unsharpened back surface, and in one direction only, from the tang toward the point.

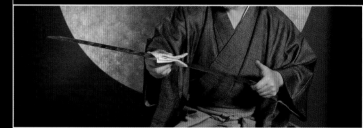

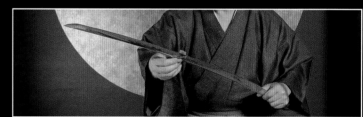

After viewing, the blade is coated with a fine layer of oil to protect it. A small piece of oil-soaked cloth is wiped over the blade from the back surface only, and in one direction only, from the tang toward the point, leaving the surface coated with a very thin layer of oil.

point, the blade surface can be examined in detail, while noting distinguishing features of the hamon and jigane as described earlier.

After the blade is viewed, it should be cleaned again before being replaced in the scabbard. This is because dirt, dust, fingerprints, saliva droplets, or other moisture left on the surface will damage the blade while it is sheathed. Any foreign substance left on the blade, or any contact between bare skin and the blade, will produce a rust spot in just a few hours. The blade should therefore be wiped again, dusted with uchiko, wiped off, and coated with a thin layer of oil (usually Japanese clove oil or camellia oil).

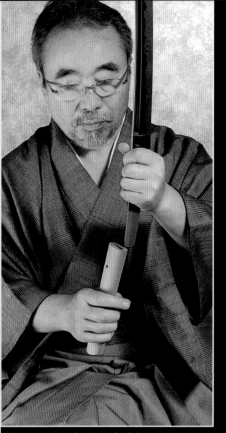

The tang is replaced in the hilt.

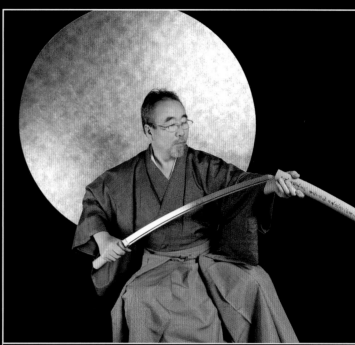

Once the hilt is replaced and the bamboo rivet secured, the sword is returned to the scabbard. The point is carefully put into the mouth of the scabbard along its back surface, with the cutting edge facing up.

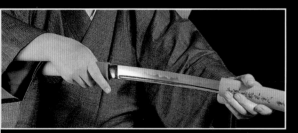

The sword is about halfway into the scabbard.

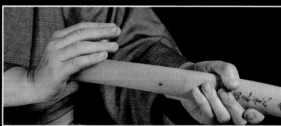

Once the sword is fully in the scabbard, Yoshindo pushes on the hilt to ensure that it meets the scabbard completely and the sword is securely seated.

To oil the blade, put a few drops of oil on a piece of cotton cloth, and then run the cloth over the surface of the blade to leave a thin protective layer of oil. In oiling the blade, use the same method as before: wrap the cloth around the blade from the back unsharpened surface, and wipe from the base of the blade toward the point.

(Note that if the blade is not set properly in the hilt, the mekugi will not fit all the way through the hole in the tang and into the corresponding hole in the wooden hilt.) After the blade is in the hilt, and the mekugi is in place, return the blade to its scabbard.

Holding the blade in the right hand with the edge facing upward, carefully insert the point of the sword into the mouth of the scabbard. Slowly push in the hilt. Then insert the bamboo mekugi into the hole in the tang and push it firmly into place.

hilt and secure the bag by winding the attached tie around the sword hilt.

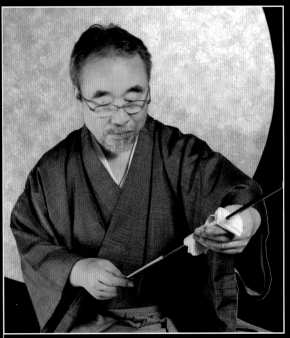

Yoshindo examines the tang of a sword. The signature, if any, and other information will be inscribed on the tang. The color of the tang, along with the rust and the file marks on the surface, can all provide information about the sword.

Once the blade has been removed from the hilt, additional details can be examined. For example, the condition and shape of the tang are important. The color, surface, rust, shape, decorative file marks, and any written inscription on the tang should be examined. If a sword is signed, the signature or other information will be inscribed on the tang.

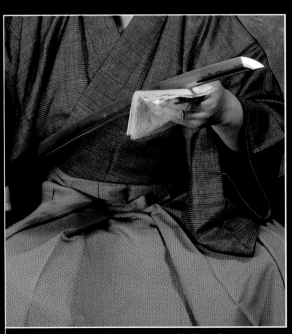

The polished blade of the sword should always be protected from direct contact with bare skin. Here, Yoshindo rests the blade on a clean sheet of paper. The tang of the sword may be held in the bare hand.

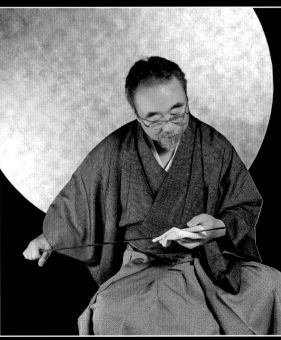

Examining the point of the sword. The shape and condition of the point, as well as the size and condition of the hardened cutting edge on the point (the boshi), are important in evaluating a sword.

The point of the sword is also an important area to examine. Pay particular attention to the shape and condition of the boshi—the hamon on the point — as well as that of the point itself.

The tang can be handled with no precautions, but any contact between bare skin and the polished blade should be avoided. A piece of paper or fabric is always placed between the hand and the blade to avoid direct contact with the polished surface. It is important to avoid touching the polished portion of the sword with bare skin because moisture or salt from the skin can easily and rapidly cause visible corrosion on the blade's surface. Anyone looking at a sword should always use clean paper or tissue to prevent direct contact between the polished surface and bare skin.

When it is necessary for one person to hand a bare blade to someone else, the blade is held point-up, with the edge aimed at the person holding it. The tang should be grasped near its top and bottom, leaving room for the other person to grip the central portion of the tang and receive it safely.

Common Problems

Although it is usually a simple process to remove the blade from its scabbard and hilt, some problems do arise. For instance, it can be difficult to remove the the hilt or the habaki (blade collar). However, there are routine methods of dealing with these problems.

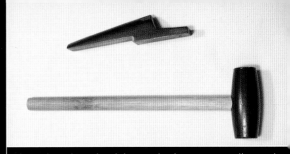

The tsuka-nuki tool and the wooden hammer or mallet used to loosen a tight hilt or tight habaki.

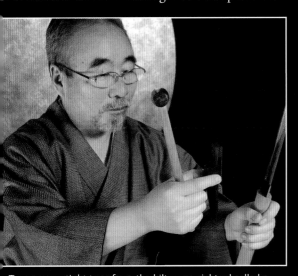

To remove a tight tang from the hilt, a special tool called a "tsuka-nuki" is used. Here, Yoshindo is holding a tsuka-nuki and a wooden mallet in his right hand.

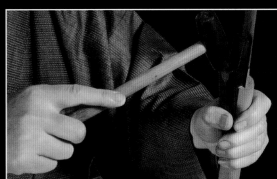

The wooden mallet is used to tap on the tsuka-nuki, which extends up along the polished blade to protect it. Several gentle blows will loosen the tang enough to remove it from the hilt.

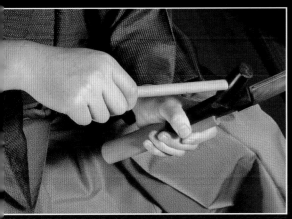

Yoshindo has tapped the tsuka-nuki with the hammer, moving the tang partly out of the hilt. It can now be grasped and removed from the hilt completely.

If the tang is set in the wooden hilt very tightly, it will be hard to remove. In this case, a Japanese tool called

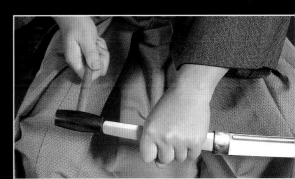

Sometimes a habaki is wedged very tightly on the tang of the sword and cannot be removed. In this situation, the bare tang is held in one hand while its base is tapped with a wooden hammer or mallet (using a steel hammer could bend or damage the tang). Several strikes with the mallet will usually loosen the habaki.

Once it has begun to move, it is easy to grasp the top of the tang and remove it from the hilt.

Another common problem is that the habaki fits too tightly on the tang and will not slide off read-

wooden mallet. The impact from the mallet will loosen the tang, driving it a short distance out of the hilt

and begin to move down the tang. At this point, it can be removed by sliding it off the sword.

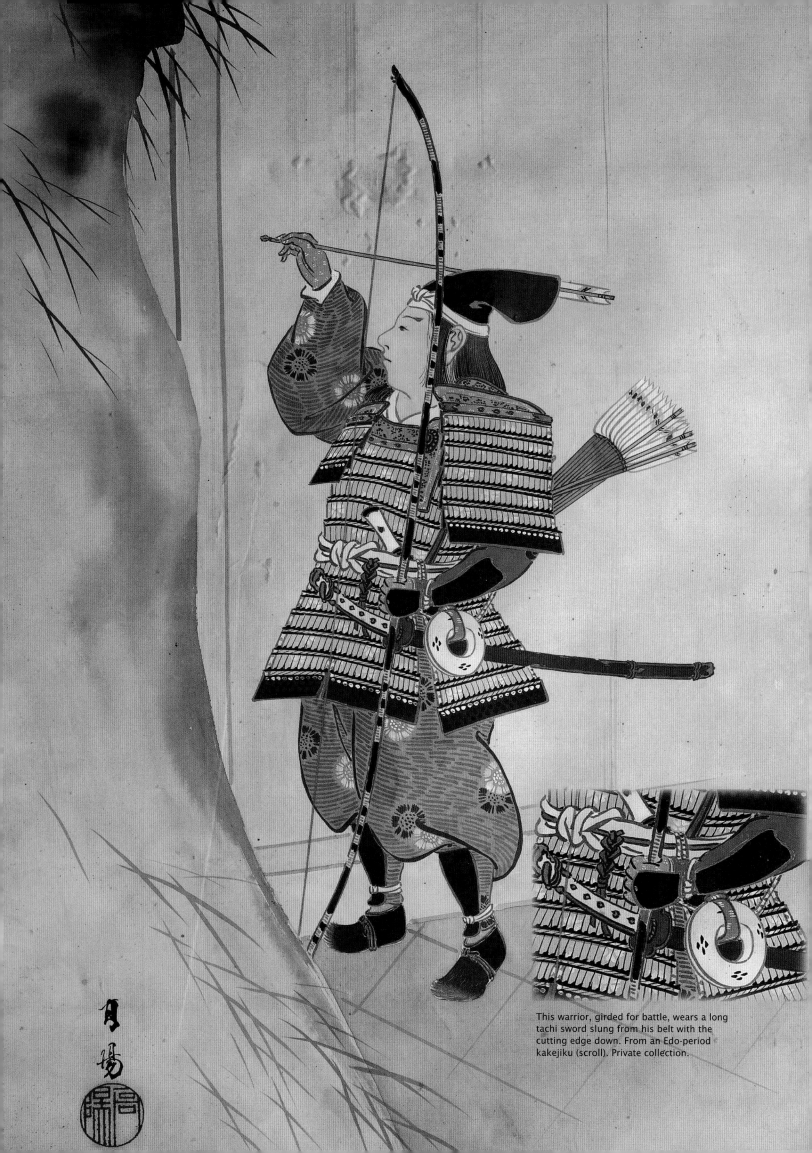

This warrior, girded for battle, wears a long tachi sword slung from his belt with the cutting edge down. From an Edo-period kakejiku (scroll). Private collection.

SWORD TERMINOLOGY

The Japanese people have long appreciated the Japanese sword both as a functional essential weapon and as an object of art. Along with methods of handling and maintaining swords, a wealth of specific Japanese-language terms used to describe a sword's features has developed over the course of history. There are no exact equivalents for many of these terms in English. The terms that follow are unique to Japanese.

1. The hamon is a visible, patterned band of hardened steel along the edge of the sword. It is this feature that gives the Japanese sword its superior cutting ability.

2. The term "sugata" refers to the shape of a blade. Generally speaking, the Japanese sword is single-edged, curved, and relatively thin, with a clearly defined point. However, Japanese swords come in a variety of shapes.

3. The words "jigane" and "jitetsu" refer to the appearance of the surface steel, its texture and color, and the pattern thereon. Traditionally forged Japanese steel is not bright or reflective: the steel usually appears dark, with a clear pattern visible on its surface.

For definitions of numerous other sword-related Japanese terms, please refer to page 27.

wielding a very long sword.
Private collection.

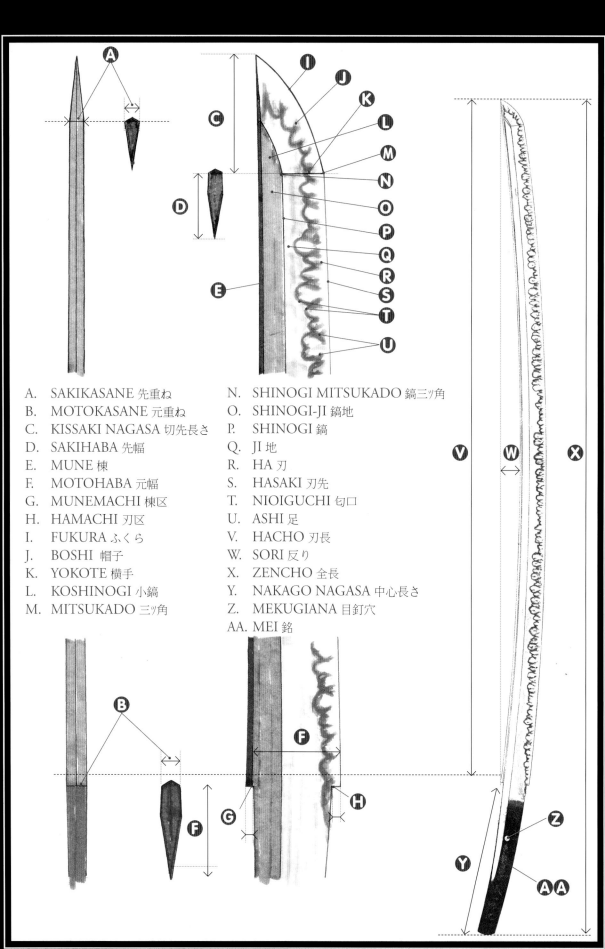

A. SAKIKASANE 先重ね
B. MOTOKASANE 元重ね
C. KISSAKI NAGASA 切先長さ
D. SAKIHABA 先幅
E. MUNE 棟
F. MOTOHABA 元幅
G. MUNEMACHI 棟区
H. HAMACHI 刃区
I. FUKURA ふくら
J. BOSHI 帽子
K. YOKOTE 横手
L. KOSHINOGI 小鎬
M. MITSUKADO 三ツ角

N. SHINOGI MITSUKADO 鎬三ツ角
O. SHINOGI-JI 鎬地
P. SHINOGI 鎬
Q. JI 地
R. HA 刃
S. HASAKI 刃先
T. NIOIGUCHI 匂口
U. ASHI 足
V. HACHO 刃長
W. SORI 反り
X. ZENCHO 全長
Y. NAKAGO NAGASA 中心長さ
Z. MEKUGIANA 目釘穴
AA. MEI 銘

A. SAKIKASANE 先重ね Thickness of the blade at the point

B. MOTOKASANE 元重ね Thickness of the blade at its base

C. KISSAKI NAGASA 切先長さ Length of the point

D. SAKIHABA 先幅 Width of the blade at the point

E. MUNE 棟 Unsharpened back surface of the blade

F. MOTOHABA 元幅 Width of the blade at its base

G. MUNEMACHI 棟区 Notch at the top of the tang where the mune surface begins

H. HAMACHI 刃区 Notch at the top of the tang where the cutting edge begins

I. FUKURA ふくら Curvature of the cutting edge within the point

J. BOSHI 帽子 Hamon on the point area

K. YOKOTE 横手 Line defining and setting off the point from the body of the sword

L. KOSHINOGI 小鎬 Portion of the shinogi in the point area (above the yokote line)

M. MITSUKADO 三ッ角 Spot where the yokote line, the edge of the blade, and the edge of the point meet

N. SHINOGI MITSUKADO 鎬三ッ角 Spot where the shinogi, koshinogi, and yokote lines meet

O. SHINOGI-JI 鎬地 Surface of the blade between the shinogi and the mune

P. SHINOGI 鎬 The well-defined line running along the length of the blade at the thickest part of the sword (present on shinogi-zukuri–style blades)

Q. JI 地 Steel surface of the sword

R. HA 刃先 Hardened steel along the edge area

S. HASAKI 刃先 Sharpened cutting edge of the sword

T. NIOIGUCHI 匂口 Clearly defined visible line separating the hardened cutting edge from the softer body of the sword

U. ASHI 足 Projections of the nioiguchi line that extend toward the edge of the blade

V. HACHO 刃長 Straight line used to define the length of the blade

W. SORI 反り Measure of the curvature of the sword

X. ZENCHO 全長 Measure of the full length of the sword including the tang (hacho

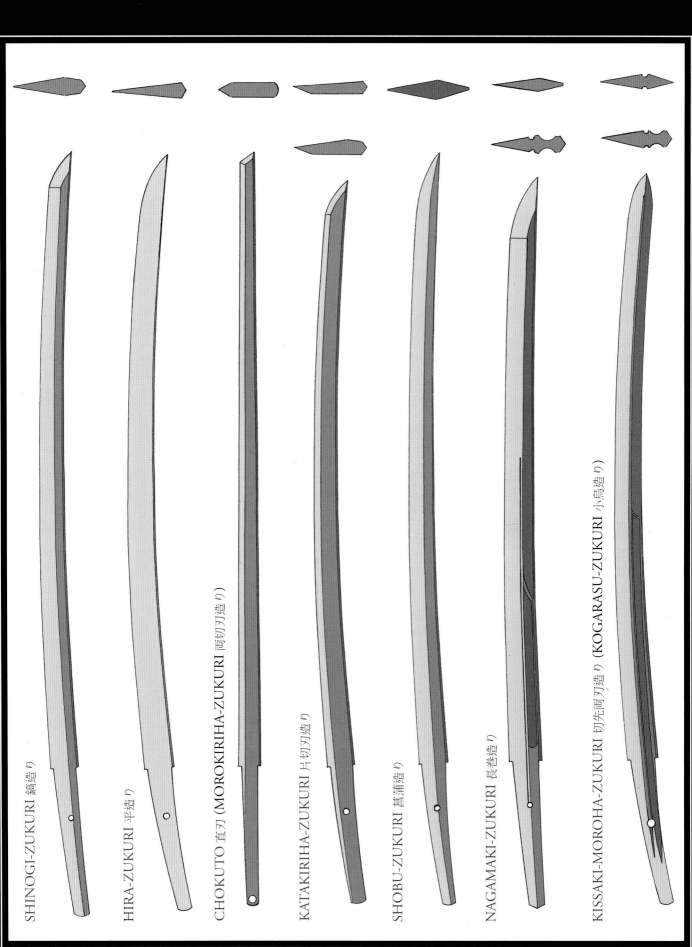

SHINOGI-ZUKURI 鎬造り

HIRA-ZUKURI 平造り

CHOKUTO 直刃 (MOROKIRIHA-ZUKURI 両切刃造り)

KATAKIRIHA-ZUKURI 片切刃造り

SHOBU-ZUKURI 菖蒲造り

NAGAMAKI-ZUKURI 長巻造り

KISSAKI-MOROHA-ZUKURI 切先両刃造り (KOGARASU-ZUKURI 小烏造り)

SHINOGI-ZUKURI 鎬造り
A sword with a shinogi (ridge line) running along its entire length where the blade is thickest. Has a yokote line and a well-defined point.

HIRA-ZUKURI 平造り
A flat-sided blade with no shinogi and no yokote line or defined point area.

JOKOTO or CHOKUTO 直刃
(MOROKIRIHA-ZUKURI 両切刃造り)
This is the oldest style of Japanese sword. It is straight, with a shinogi running close to the cutting edge and a very narrow point area. The shinogi and koshinogi are straight.

KATAKIRIHA-ZUKURI 片切刃造り
One side of this blade is flat (hira-zukuri), while the other side has a shinogi very close to the cutting edge. There is no yokote line on the flat side.

SHOBU-ZUKURI 菖蒲造り
This blade has a shinogi extending to the tip of the point, but lacks a distinctive, defined point area (i.e., it has no yokote line).

NAGAMAKI-ZUKURI 長巻造り
This style is basically a shinogi-zukuri sword; however, it has a characteristic large groove starting above the tang. The shinogi-ji is beveled strongly toward the mune edge in front of this groove. A small companion groove (soe-bi) runs below the main groove and below the shinogi line.

KISSAKI-MOROHA-ZUKURI 切先両刃造り
(KOGARASU-ZUKURI 小鳥造り)

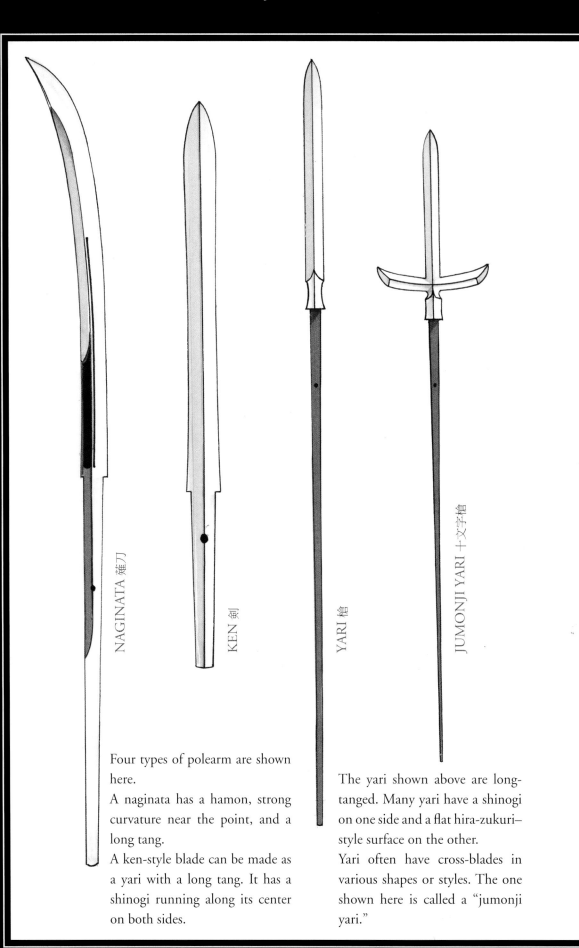

NAGINATA 薙刀

KEN 剣

YARI 槍

JUMONJI YARI 十文字槍

Four types of polearm are shown here.

A naginata has a hamon, strong curvature near the point, and a long tang.

A ken-style blade can be made as a yari with a long tang. It has a shinogi running along its center on both sides.

The yari shown above are long-tanged. Many yari have a shinogi on one side and a flat hira-zukuri–style surface on the other.

Yari often have cross-blades in various shapes or styles. The one shown here is called a "jumonji yari."

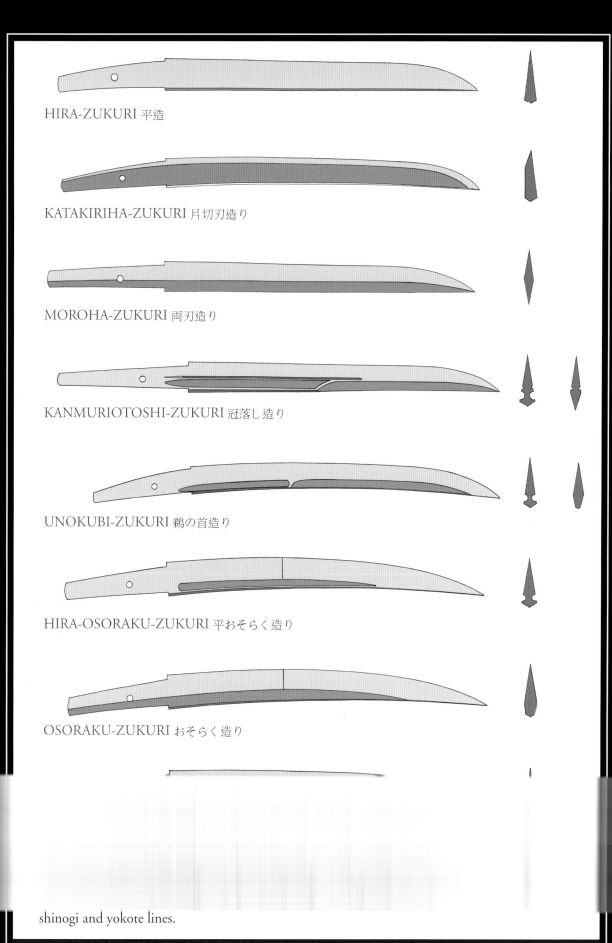

HIRA-ZUKURI 平造

KATAKIRIHA-ZUKURI 片切刃造り

MOROHA-ZUKURI 両刃造り

KANMURIOTOSHI-ZUKURI 冠落し造り

UNOKUBI-ZUKURI 鵜の首造り

HIRA-OSORAKU-ZUKURI 平おそらく造り

OSORAKU-ZUKURI おそらく造り

shinogi and yokote lines.

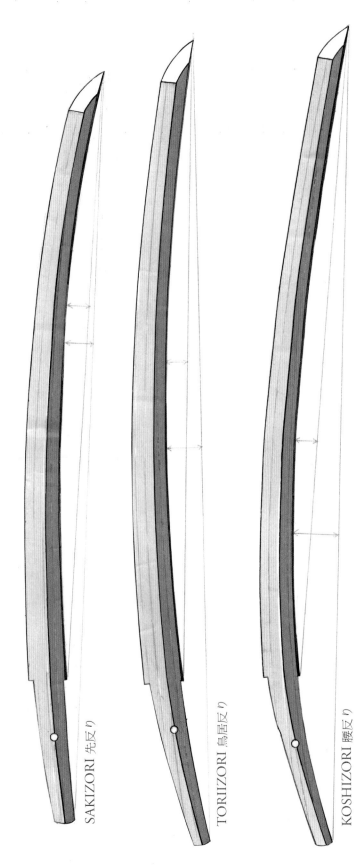

SAKIZORI 先反り

TORIIZORI 鳥居反り

KOSHIZORI 腰反り

The sori is a measure of the blade's curvature. Usually, a straight line is drawn from the very tip of the point to the munemachi (the notch at the base of the unsharpened back of the sword) at the top of the tang. The distance between the top of the mune and this straight line at its greatest point is called the "sori."

The curvature of the sword is also described in terms of the location of the sori. If the longest part of the sori line occurs in the center of the sword, the blade is said to have a "toriizori" or to be "wazori." If the sori is forward of the center of the blade (that is, the sori line is above the center of the blade and biased toward the tip of the sword), the sword is said to have a "sakizori." If the sori line occurs below the center of the sword and is biased toward the tang, the sword is said to have a "koshizori."

In this figure, all three swords actually have the same amount of curvature in the blade, but the location of the sori varies and they have differently shaped nakago. If a straight line were drawn from the tip of the point to the bottom of the nakago, and the sori was then measured from this line, the three blades would have different types and amounts of sori. Therefore, when swords are shown in photographs, the type of sori and amount of curvature will appear different depending on the vertical orientation of the sword in the photos.

KISSAKI: THE POINT

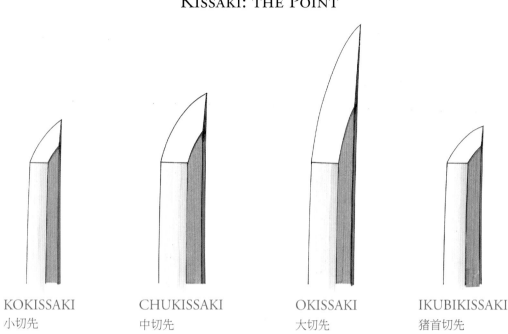

| KOKISSAKI | CHUKISSAKI | OKISSAKI | IKUBIKISSAKI |
| 小切先 | 中切先 | 大切先 | 猪首切先 |

The size and shape of the sword's point (kissaki) can vary. A kokissaki is a small point, a chukissaki is a medium-sized point, and an okissaki is a large point. The ikubikissaki is one whose length is the same as the length of the yokote line defining the point.

FUKURA: CURVATURE OF THE POINT

MUNE: THE SHAPE OF THE UNSHARPENED EDGE

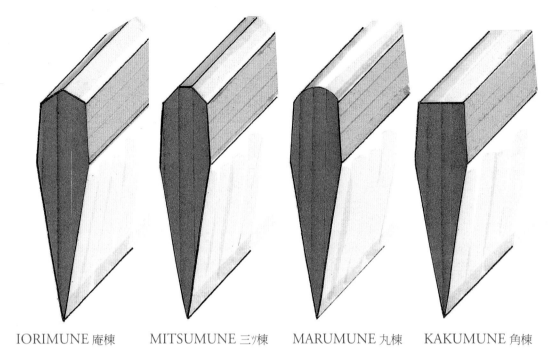

IORIMUNE 庵棟 MITSUMUNE 三ッ棟 MARUMUNE 丸棟 KAKUMUNE 角棟

The mune is the unsharpened back surface of the sword. The most common style is an iorimune, in which the mune has two sides that come to a peak at the top. A mitsumune has three surfaces: two sides that meet a flat top. A marumune has a rounded surface, and a kakumune is squared-off and flat.

NAKAGO SUGATA: TANG SHAPES

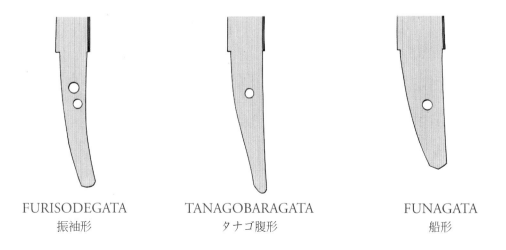

FURISODEGATA
振袖形

TANAGOBARAGATA
タナゴ腹形

FUNAGATA
船形

A few of the shapes that the nakago (tang) of a Japanese sword may take.

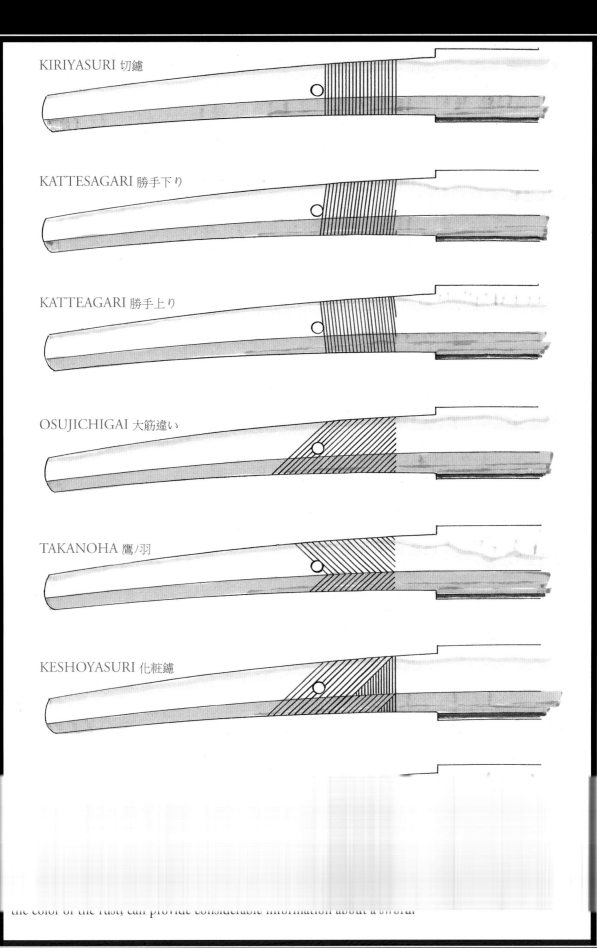

KIRIYASURI 切鑢

KATTESAGARI 勝手下り

KATTEAGARI 勝手上り

OSUJICHIGAI 大筋違い

TAKANOHA 鷹ノ羽

KESHOYASURI 化粧鑢

the color of the rust, can provide considerable information about a blade.

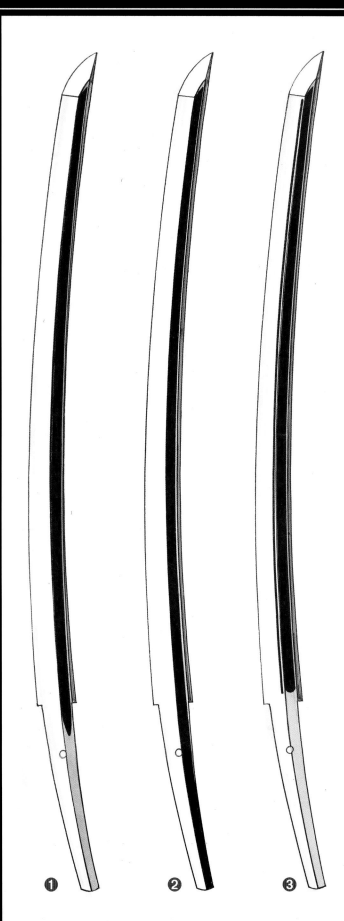

Hi (grooves cut into the sword's surface) usually extend the full length of the sword and run parallel to the back surface. They may have shaped ends, or they may simply be cut into the unpolished part of the nakago without a finished end. They can be wide (bo-bi) or very narrow (soe-bi and tsure-bi). Grooves are usually added for decoration, but they can also lighten a sword or strengthen it by making the blade stiffer.

The name of the hi is followed by the style in which the end nearest to the tang is finished (e.g., "bo-bi/marudome" refers to a straight groove that is finished with a round end just above the tang).

1. BO-BI/KAKINAGASHI
棒樋・掻き流し
A bo-bi is a straight groove. "Kakinagashi" means that the end closest to the nakago is not carefully finished, but simply tapers out below the polished area of the blade on the tang.

2. BO-BI/KAKITOSHI
棒樋・掻き通し
A bo-bi is a straight groove. "Kakitoshi" means that the end closest to the nakago is not carefully finished, but is cut all the way through the full length of the tang.

3. BO-BI WITH SOE-BI/
MARUDOME 棒樋に添樋・丸止め
This is a straight groove with a smaller parallel companion groove (soe-bi) below the shinogi line. "Marudome" means that both grooves stop above the nakago on the polished portion of the blade and are finished with rounded ends. The soe-bi runs the length of the blade, but stops before the yokote line and the point.

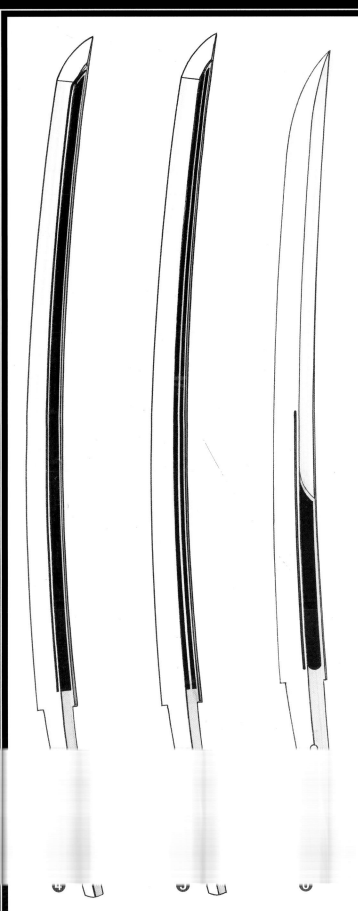

4. BO-BI with TSURE-BI/ KAKUDOME 棒樋に連樋・角止め

This is a straight groove with a smaller parallel companion groove. However, in this case, the second groove (tsure-bi) runs beyond the bo-bi near the point of the sword and extends into the shinogi-ji surface ahead of the larger bo-bi. Both grooves are finished with kakudome, a square end that stops the hi in the polished area of the sword above the nakago.

5. FUTASUJI-BI/KAKUDOME 二筋樋・角止め

Futasuji-bi are twin parallel bo-bi. "Kakudome" means that the grooves are finished with square ends, stopping just above the nakago.

6. NAGINATA-BI with SOE-BI/ MARUDOME 薙刀樋に添樋・丸止め

Naginata-bi, the grooves seen on pole-arms (naginata) and sometimes on tanto and katana (as shown here), have a characteristic design. A large bo-bi is finished with a marudome (rounded) end above the tang. The forward end of the bo-bi has a distinctive shape: the side of the hi closest to the cutting edge extends beyond the upper part, so the leading edge of the hi forms an arc. Matching this curve in the forward end of the hi, the upper surface of the blade (shinogi-ji) is beveled sharply toward the

BOSHI: THE SHAPE OF THE HAMON ON THE POINT

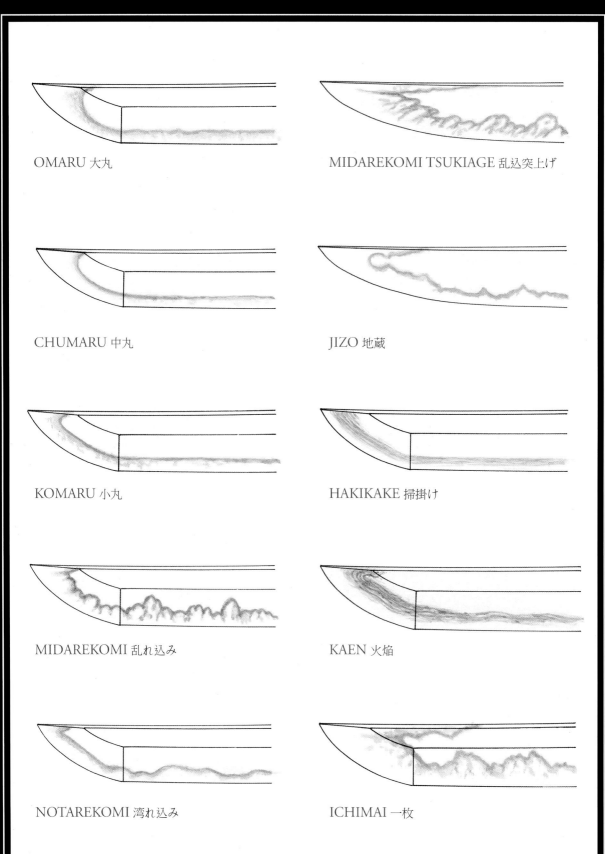

OMARU 大丸

MIDAREKOMI TSUKIAGE 乱込突上げ

CHUMARU 中丸

JIZO 地蔵

KOMARU 小丸

HAKIKAKE 掃掛け

MIDAREKOMI 乱れ込み

KAEN 火焔

NOTAREKOMI 湾れ込み

ICHIMAI 一枚

The boshi is the hamon in the point area. There are a number of styles; individual smiths and schools used characteristic boshi. Schools also changed their boshi styles in different eras.

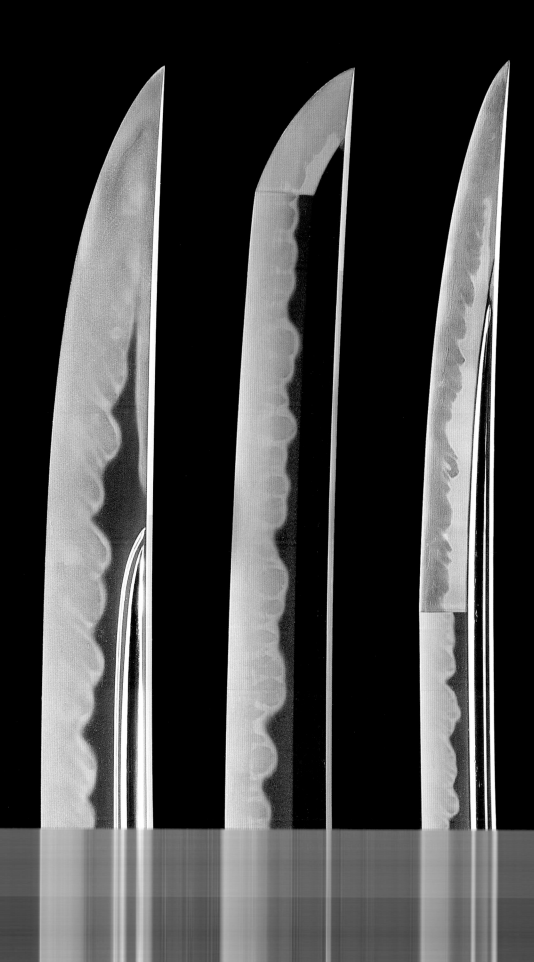

At right is an osoraku-zukuri tanto. It has a very large point that covers about half of the blade's length. The point area is defined by a yokote line, and is polished to contrast with the body of the blade.

Examining the Hamon

One of the most singular features of the Japanese sword is its hamon, the visible pattern of the hardened edge. After forging, the swordsmith coats the sword with clay, heats it, and then quenches it in water to produce the uniquely patterned edge. The hamon, which is composed of a form of steel called martensite, is far harder than the body of the sword. A properly made, functional Japanese sword must always have a hamon.

The hamon depends on the condition of the sword. If a sword is in poor condition, or has an old polish, or has been polished many times over the centuries, the hamon may be nearly or completely invisible. It may even be absent altogether.

Even if the hamon is in good condition and the sword has a good polish, the hamon might be difficult to see and appreciate. As mentioned earlier, the sword must be clean, examined under the proper light, and held at the correct angle relative to the light, with the sword pointed just below the focused light source. Under these conditions, the line defining the hamon will be visible near the reflected light source on the blade.

To examine a hamon in detail, the sword is aimed near or below a point light source, so that the details of the hamon can be seen by looking near the light reflected on the blade. As this only allows inspection of a small area, the sword must be moved continuously to examine the entire hamon.

Due to the significance of this feature, a person who is interested in Japanese swords should be aware of certain characteristics that the hamon possesses. It will usually have a well-defined boundary (nioiguchi or habuchi) that sets it off and makes it clearly visible against the body of the sword. There should be no gaps or breaks in the boundary line that defines the hamon, and this line should be present throughout the length of the blade, with no faded or weak areas. In addition, a good hamon does not usually have a simple shape or boundary, but contains a complex pattern and numerous details.

A hard, sharp cutting edge is required for a sword to be functional, and the complex structure of the hamon developed in response to this need for functionality. The oldest Japanese swords, which date back to approximately the fifth or sixth centuries, are straight, with narrow hamon. The older hamon were basically a straight band of brittle martensite steel running along the cutting edge of the blade. Although a sword made completely of brittle martensite would cut well, it would suffer a large amount of damage in use. Therefore early smiths made the body of the sword from much softer forms of steel called pearlite and ferrite. These gave the sword flexibility and toughness, so that it could bend to some extent without breaking. The design of the Japanese sword uses the particular properties of several forms of steel in different parts of the sword to make a functional, effective, and enduring weapon.

As swords evolved over the centuries, they became larger and acquired curvature; the hamon also become wider and more complex. This change in the hamon developed for a very good reason. As noted above, the simple straight hamon of the earlier swords consisted of a band of hard martensite steel bonded together with a softer steel

body in a straight line along the entire length of the sword. Because of the differences in the properties of these two types of steel, sometimes a single blow or strike could cause most of the narrow martensite cutting edge to separate from the body of the sword.

In response to this, swordsmiths learned to make more complex and wider hamon consisting of a series of semicircles or waves, often varying in width and height along the length of the blade. The visible boundary defining a complex hamon can range over the width of the blade from the upper part to the center, and down almost to the cutting edge. The hamon can be described as resembling a series of teeth. These "teeth" make the physical boundary between the martensite edge and softer sword body effectively much longer, and interlace the different types of steel present in the edge and body of the sword. Thus the cutting edge is bonded firmly to the body of the sword with an almost zipper-like structure. Complex hamon also limit the size of chips in the cutting edge and damage that can occur during use.

These hamon were first seen in Japanese swords from around the eleventh and twelfth centuries, and were further developed through the twelfth and thirteenth centuries during the Kamakura period (1185–1333). The modern swords we appreciate today are direct descendants of such Kamakura-period swords.

Many details can be seen when examining the hamon. The nioiguchi—the boundary defining the hamon, also called the "habuchi"—should be clear and unbroken along its length. Hamon often have extensions or projections called "ashi" going

steel is well interlaced with, and bonded to, the steel in the body of the sword.

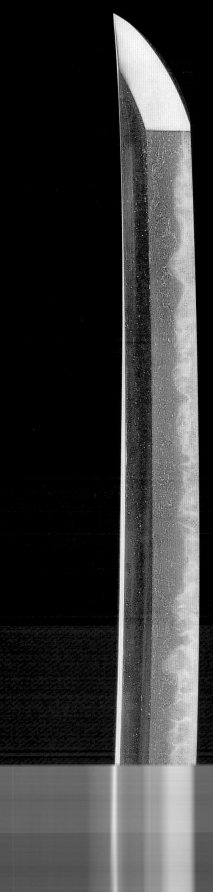

This sword from the Kamakura period has a well-developed choji hamon.

Hamon Patterns

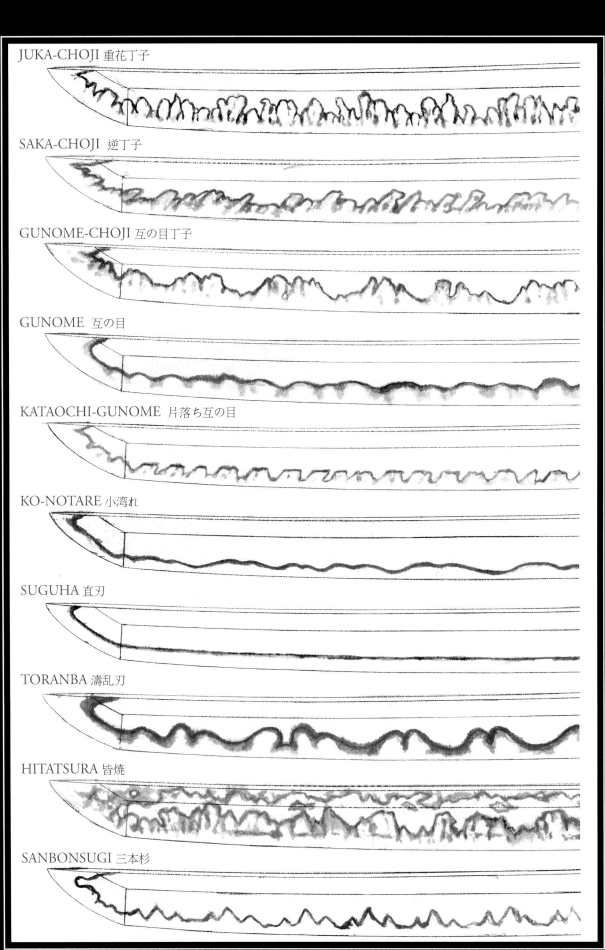

JUKA-CHOJI 重花丁子

SAKA-CHOJI 逆丁子

GUNOME-CHOJI 互の目丁子

GUNOME 互の目

KATAOCHI-GUNOME 片落ち互の目

KO-NOTARE 小湾れ

SUGUHA 直刃

TORANBA 濤乱刃

HITATSURA 皆焼

SANBONSUGI 三本杉

A swordsmith needs years of training to be able to master the extremely difficult process of making a hamon, and no two smiths carry it out in exactly the same way. In fact, a properly made complex hamon can function as a smith's "fingerprint." There are many smiths, or groups of smiths, whose work can be identified from their hamon alone.

Photographs of swords usually show only the outline of the hamon against the body of the sword; fine details are generally not visible. Traditional texts on Japanese swords are illustrated with oshigata, tracings of the shape of the sword with the hamon drawn in by hand in fine detail. Since the hamon is such an important aspect of a Japanese sword, the best way to present it in a text is to have a photograph of the sword alongside an oshigata of the same blade showing the hamon in detail.

In the illustration at right, a full-length photo of a tanto (dagger) is presented alongside its oshigata. The photo shows the overall shape and form of the blade, as well as the color and some details of the steel surface. However, few details of the hamon are visible beyond its general outline. The oshigata shows a thick, complex hamon boundary with an intricate shape, along with details such as ashi (lines of softer steel extending into the hamon to the cutting edge). When hamon are described or discussed, the details shown in the oshigata are used to describe the hamon and compare it to others.

visible in outline. The accompanying oshigata of the tanto shows the hamon in detail. Presenting a photo and an oshigata together is the best way to show a sword in a publication.

THE STEEL AND STRUCTURE
OF THE JAPANESE SWORD

Because the properties of the Japanese sword depend on the steel it is made from, it is helpful to learn something about the unique qualities of traditional Japanese steel. Broadly speaking, steel is a combination of iron and carbon. Japanese steel is made in a traditional Japanese-style smelter called a "tatara," using satetsu, an iron ore that is found in sand form. The steel that comes from the tatara as a result of this process is called "tamahagane."

When the satetsu is smelted in the tatara, the resulting steel has a high carbon content—up to 2 or 3 percent. However, to make a functional and practical sword, steel with a final carbon content of 0.6 to 0.7 percent is ideal. Thus, the swordsmith's first task upon receiving tamahagane from the tatara is to refine the steel and reduce the carbon content to this level.

The goals of the smith are to make the steel more homogeneous, to produce a uniform carbon content, and to remove impurities in the steel. This is accomplished by hammering out the tamahagane into a thin plate, then breaking up the plate into small pieces about an inch (2–4 cm) in size. These pieces are then stacked, heated, and hammered out into a billet. The billet is then repeatedly refolded over onto itself.

Throughout the process of hammering and folding the steel, the smith reduces the carbon content by about 0.2 percent with each fold. The steel is repeatedly folded until it reaches the appropriate carbon content of 0.6 to 0.7 percent. The smith can judge the carbon content of the steel by its behavior during the folding and forging process. Once the steel reaches the proper carbon level, it is forged out into the shape of a sword, and some filing and grinding work is done to further refine the shape.

The steel has to be worked in this manner for several reasons. First, the process optimizes the carbon content. Second, it removes slag and impurities; furthermore, the steel is more homogeneous after the forging process. The original tamahagane is very inhomogeneous, and would not make a good sword. In addition, the forged steel is tougher; that is, it is far more ductile than the original tamahagane and less likely to bend or break under use. Once the steel has been sufficiently worked and the sword has been shaped, the process of making the hamon, which requires a high level of carbon in the steel, can be carried out.

The basic principle involved in making a hamon is fairly straightforward, and utilizes an important property of steel: when steel is heated to a high temperature and then rapidly cooled, its crystalline structure will change, making it much harder than it was before. In practice, however, the details are critical; it took the Japanese perhaps five hundred years to progress from making the earliest basic hamon to being able to create the characteristic sophisticated hamon we see today.

Making a hamon requires some important conditions: the steel must be very pure and have almost no elements in it except iron and carbon. The carbon content must be fairly high: as stated earlier, 0.6 to 0.7 percent is ideal. The area of the steel where the hamon is to be produced must be heated to a critical point—typically close to 1470°F (800°C), the temperature at which steel loses its magnetism. Once it has reached the proper temperature, the steel must be cooled rapidly, usually by immersing it into a tank of water. The process of forming a hamon by heating and quenching the blade is called "yaki-ire."

There is another very important element in making a hamon. The hardened steel that composes the hamon must be restricted to the edge of the sword. If the entire sword is hardened, it will be very brittle and likely to break in use. Only the area along the edge of the sword is to be heated and rapidly cooled. To solve this problem, Japanese swordsmiths developed a method of hardening only the edge of the sword by coating the blade with clay in a complex pattern before beginning the heating and cooling process. Because the entire blade must be heated during this process, the clay coating is added in such a way as to allow the edge to cool very rapidly while at the same time slowing down the rate of cooling on other parts of the sword. The slower cooling rate on the body of the blade will prevent it from hardening during this process. Ideally, the result will be a hard edge with an intricate hamon pattern and a relatively soft body that will remain ductile and tough. If the hamon is properly designed and made, it will be unlikely to suffer much damage in use. In addition, a properly designed hamon will limit the size of nicks and damage that the edge will suffer during use.

The diagram on page 47 shows why it is possible to make a hamon in high-carbon steel. The horizontal axis of the iron-carbon diagram shows the percentage of carbon in a pure iron-carbon mixture, while the vertical axis shows the temperature. When iron and carbon are combined, the percentage of carbon and the temperature of the compound determine the form that the steel will take. Each form has different properties, the most important one for a sword being how hard the metal will be.

cal temperature that goes from 1340°F to over 1650°F (727°C to over 900°C), depending on the carbon content of the steel. If the steel is heated to this critical temperature or higher, it will lose its magnetism and take the form of austenite. However, a sword cannot remain at these high temperatures in normal life or use. If the blade is heated to above the critical temperature and cooled very rapidly, the austenite structure will break down and transform into another structural form called martensite. Unlike austenite, martensite can exist at room temperature; it is also very hard. Martensitic steel along the edge of a sword creates an optimal cutting edge.

To create a hard martensite edge while simultaneously leaving softer ferrite and pearlite in the sword body, the blade must undergo the yaki-ire process. The major problem is to insure that the edge area cools much more rapidly than the body of the sword, so that the edge becomes martensitic steel while that in the body of the sword remains in the form of ferrite and pearlite. As mentioned above, this is accomplished by coating the blade with a layer of clay that is very thin over the edge area and relatively thick over the body of the sword. The areas covered with the thicker layers of clay require only a few thousandths of a second longer to cool than the edge, but this is sufficient to leave the steel in a softer state after yaki-ire.

If the sophisticated clay coating functions as it is supposed to, this heating and quenching process will result in different hardnesses in the different parts of the blade. While the pattern of the clay affects the shape of the hamon, it does not exactly

In addition to the process already described, the construction of a Japanese sword usually requires an additional step: the forging of a softer steel core into the center of the sword. This core serves as a kind of shock absorber to protect the blade from extreme stresses and fracturing. Thus, the process of constructing a properly made Japanese sword results in a composite structure containing three types of steel:

• The soft steel core (the shingane);
• The hard, high-carbon outer steel jacket that forms the surface of the sword (the kawagane);
• The hardened edge formed of martensitic steel (the hamon).

The structure, composition, and metallurgy of the Japanese sword are unique. First, the quality of the steel makes possible its slender and graceful shape. The cutting edge has a visible pattern along the edge, unseen among other swords in the world, indicating that the edge has been hardened to a far greater degree than the rest of the sword. The steel itself shows signs of the forging necessary to make such a high-quality steel, and a pattern (jihada) can usually be seen on its surface. These features are all essential to the appreciation and evaluation of a Japanese sword.

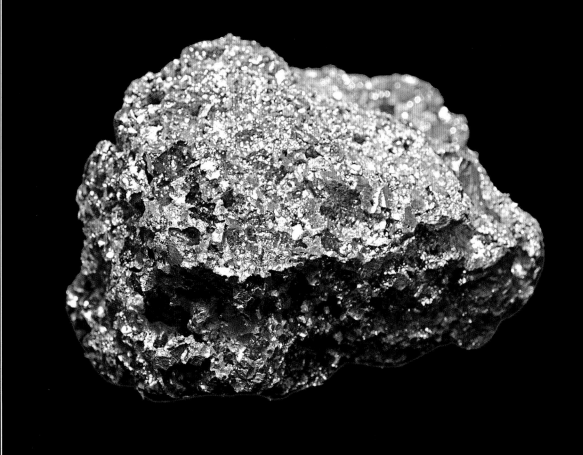

A piece of tamahagane, the high-carbon steel used to make a Japanese sword. Tamahagane is smelted from iron ore found in sand form.

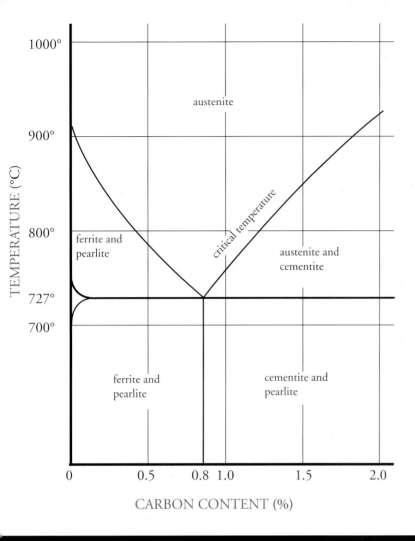

TEMPERATURE (°C)

1000°

900°

800°

727°

700°

austenite

critical temperature

ferrite and
pearlite

austenite and
cementite

ferrite and
pearlite

cementite and
pearlite

0 0.5 0.8 1.0 1.5 2.0

CARBON CONTENT (%)

This iron-carbon diagram shows the names of the different crystalline or structural forms taken by steel depending on the conditions. The two variables here are the temperature (shown on the vertical axis) and the carbon content (shown on the horizontal axis). To form the hamon, the blade must be heated above the critical temperature contour, where it loses its magnetism. A typical Japanese sword, with a carbon content of 0.6 to 0.7 percent, must be heated to around 1380˚F (750˚C) or higher to form a good hamon on cooling.

Cross-section of a typical Japanese sword. The blade has a core of soft steel (shingane) at its center, and is wrapped in a hard high-carbon steel jacket called the "kawagane." The yaki-ire process results in a cutting edge made of martensitic steel, which is far harder than the steel in the body of the sword. Thus, a properly made Japanese sword is composed of three different types of steel.

can be very detailed; it is the experience and skill of the swordsmith that will determine what the resulting hamon will look like.

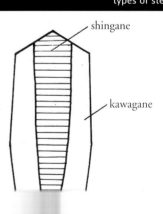

shingane

kawagane

edge
(martensite)

JIHADA AND JIGANE

There are customary ways of viewing and appreciating the Japanese sword, as previously described. The sword's singular appeal as an art form derives from the fact that innumerable features to be appreciated and evaluated lie in the blade and the steel itself. Although steel is used in other art works, generally speaking the shape is the feature of prime importance in such pieces. In appreciating the Japanese sword, there are many other elements to observe as well. Of course, the shape itself is a consideration: a good sword has a graceful shape and a very functional appearance. Its purpose is to cut well, and it is well designed for that. It is usually single edged, and is very slender and graceful, with some curvature. In addition, a well-made Japanese sword also feels well-balanced and very comfortable in the hands.

The steel on the surface of a Japanese sword (the jigane) has a definite color and texture. As the steel has a rather dark appearance, a good polish is required to bring out the details. In examining a well-made and well-polished sword, a clear color and fine texture can usually be seen. In addition, there is usually a distinct surface pattern that results from the repeated folding of the steel during forging. This pattern, which is called the "jihada," will vary from sword to sword depending on exactly how the smith made the steel for a particular sword, and on what kind of steel he used. The surface texture, color, and jihada are all features that should be carefully observed when evaluating a sword.

The appreciation of a Japanese sword also encompasses the properties inherent to the steel itself; that is, the different forms of steel and crystalline structures in the steel. When looking at Western swords, in contrast, the hilt, engraving, and other embellishments can be an integral part of the sword, and are considered alongside the blade itself when evaluating the sword. In this respect, appreciating and evaluating a Japanese sword is different from appraising other swords or edged weapons. Japanese swords are examined and appraised by looking only at the bare, unmounted blade.

JIHADA PATTERNS

The process of repeatedly hammering out and folding the steel over onto itself produces a pattern, or jihada, in the steel surface. Jihada can vary extensively due to differences in the forging techniques of different swordsmiths. A sword must also have a very good polish for these patterns to become easily discernible. The patterns shown here can be seen on swords from different smiths of various historical periods.

MASAME HADA 柾目肌
This is a straight pattern.

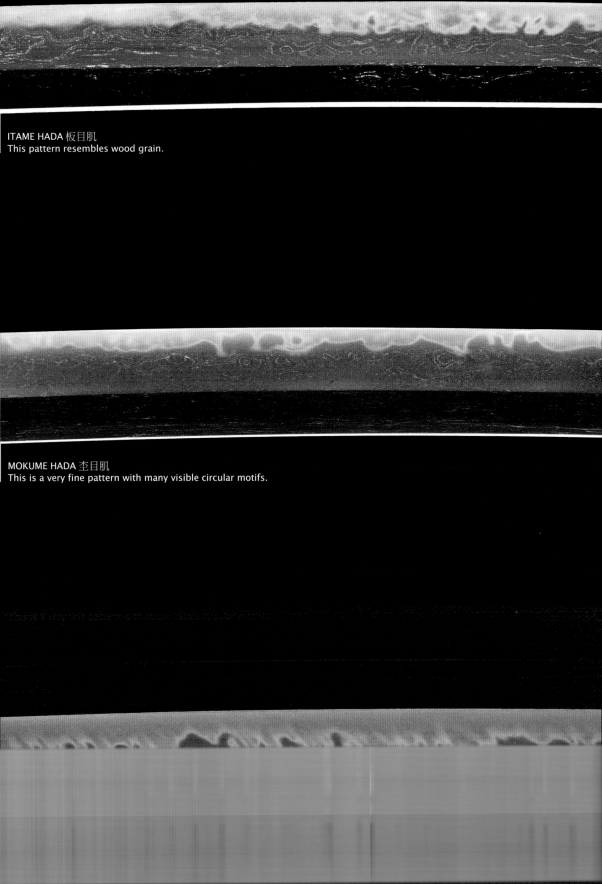

ITAME HADA 板目肌
This pattern resembles wood grain.

MOKUME HADA 杢目肌
This is a very fine pattern with many visible circular motifs.

The hamon of the Japanese sword is formed when the cutting edge is selectively hardened and the body of the sword remains relatively soft. This means that there are two types of steel in a typical Japanese sword: the harder steel in the edge area (the ha), and the softer steel in the body of the sword (the ji). Where these two types of steel come together and mix, a clear visible boundary is formed between them. This boundary usually appears as a line composed of very tiny crystalline particles called "nioi." The individual particles forming the line are too small to be resolved by the eye, and the resulting line appears continuous and unbroken. The nioi line is usually white, and clearly separates the hamon from the ji. Sometimes the boundary is composed of larger particles called "nie." This is the same as nioi, but the individual nie particles are large enough to be clearly seen by eye. Many hamon are composed of nioi, but also contain some nie particles. If the nie particles are visible in the ji above the hamon, they are called "ji nie." The exact appearance and composition of the nioi and nie lines and particles depend on what the swordsmith does, the steel he uses, and the details of how he performs yaki-ire.

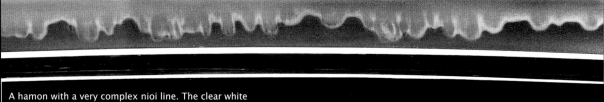

A hamon with a very complex nioi line. The clear white line defining the hamon boundary is composed of microscopic nioi particles.

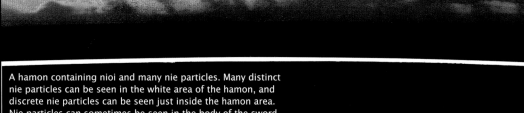

A hamon containing nioi and many nie particles. Many distinct nie particles can be seen in the white area of the hamon, and discrete nie particles can be seen just inside the hamon area. Nie particles can sometimes be seen in the body of the sword as well; here, large clear nie particles (ji nie) are visible above the hamon, up to and above the shinogi.

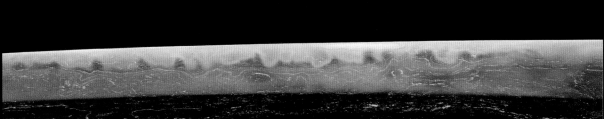

Above the hamon, the steel shows a white appearance. This effect is called "utsuri."

Sword Mountings:
Koshirae and Shirasaya

Japanese swords are mounted in one of two ways: they can be preserved or protected in a simple unfinished wooden scabbard called a "shirasaya," or in a koshirae, a functional traditional mounting that includes a lacquered scabbard, sword guard, other metal components, and a braided hilt wrapping.

When new swords are made today, the smith usually has them put into a custom-made shirasaya. If the owner wants a traditional practical koshirae, it must be commissioned from another group of sword craftsmen after the smith has finished his work. Most old Japanese swords seen in the West today are mounted in shirasaya because their koshirae have deteriorated over the years. Older swords must be re-polished periodically; when this is done they can then be mounted in new shirasaya to protect the newly polished blade. Thus, most of the Japanese swords one sees today will be in shirasaya.

Shown at left is a complete practical and functional mounting, or koshirae. This includes a lacquered scabbard, a braided hilt wrapping, and a sword guard (tsuba), as well as other metal components. From the collection of the NBTHK.

At right is a simple shirasaya. This unadorned, unfinished wood scabbard is not suitable for practical use of the sword. The writing on the shirasaya, called "saya-gaki," is an inscription added by the owner or maker of the sword. The saya-gaki contains information such as the sword's maker, its length, the date it was made, and the owner's name.

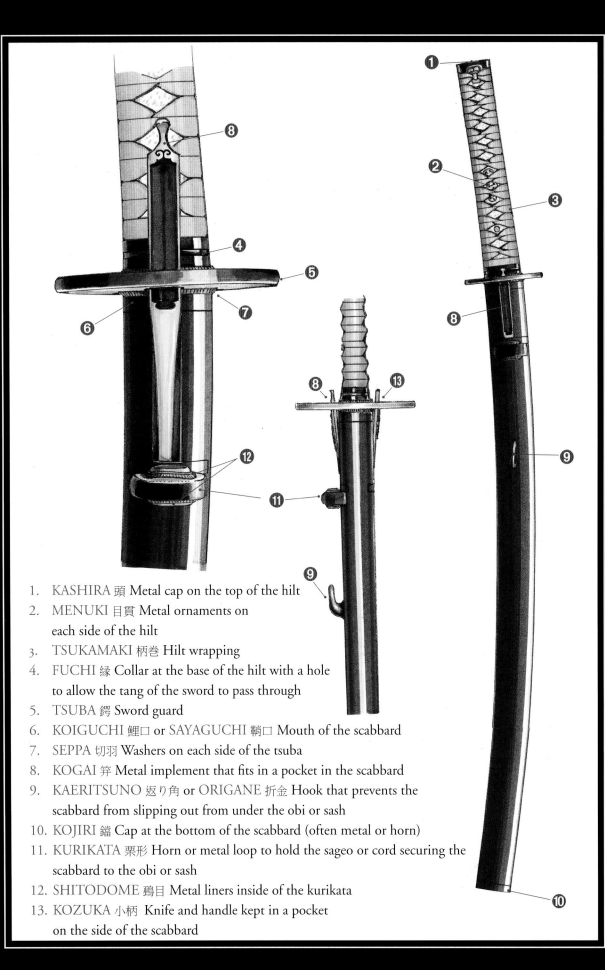

1. KASHIRA 頭 Metal cap on the top of the hilt
2. MENUKI 目貫 Metal ornaments on
 each side of the hilt
3. TSUKAMAKI 柄巻 Hilt wrapping
4. FUCHI 縁 Collar at the base of the hilt with a hole
 to allow the tang of the sword to pass through
5. TSUBA 鍔 Sword guard
6. KOIGUCHI 鯉口 or SAYAGUCHI 鞘口 Mouth of the scabbard
7. SEPPA 切羽 Washers on each side of the tsuba
8. KOGAI 笄 Metal implement that fits in a pocket in the scabbard
9. KAERITSUNO 返り角 or ORIGANE 折金 Hook that prevents the
 scabbard from slipping out from under the obi or sash
10. KOJIRI 鐺 Cap at the bottom of the scabbard (often metal or horn)
11. KURIKATA 栗形 Horn or metal loop to hold the sageo or cord securing the
 scabbard to the obi or sash
12. SHITODOME 鵐目 Metal liners inside of the kurikata
13. KOZUKA 小柄 Knife and handle kept in a pocket
 on the side of the scabbard

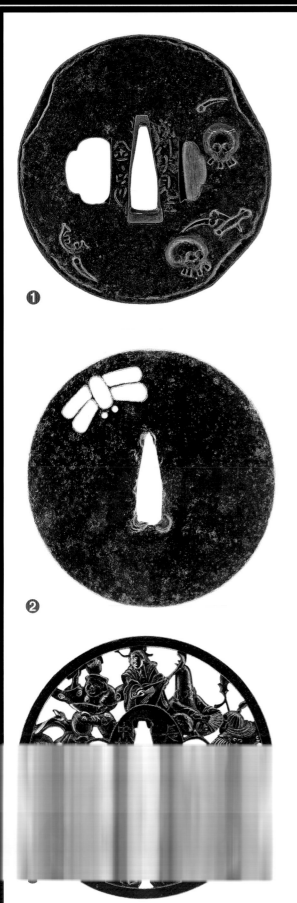

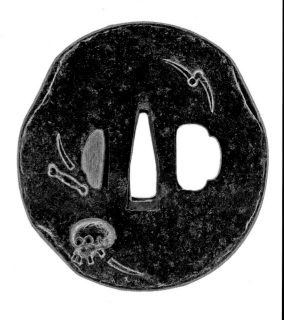

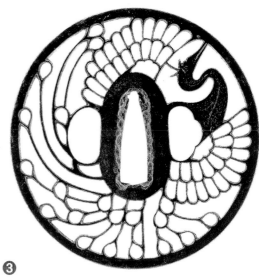

1. A simple iron tsuba from the Muromachi period with carved and inlaid skull and bone images. This is signed by Kaneie, one of the earliest smiths to use decoration on his tsuba.
2. An iron tsuba made by a smith in the Muromachi period. The simple iron plate is decorated with

during the Edo period.

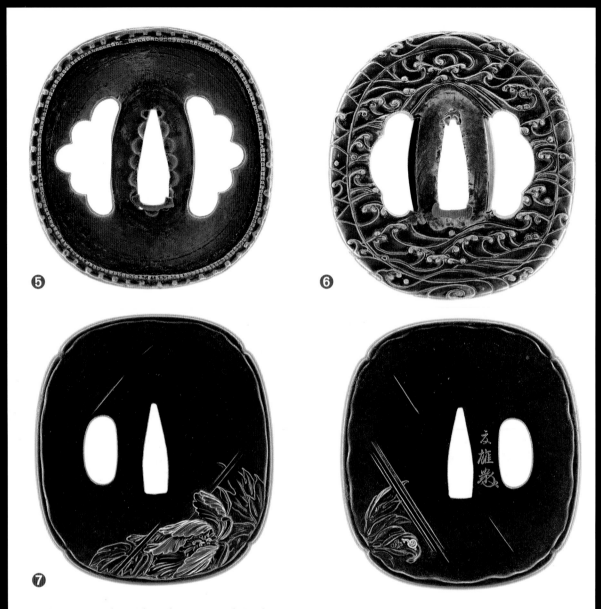

⑤ ⑥ ⑦ ⑧

5. A copper tsuba with a silver rim made in the Momoyama period. This tsuba has colored metal in its body and rim, and is decorated with punch work and filing. There are simple circular filed lines in the body of the tsuba.

6. This tsuba, also from the Momoyama period, uses brass and extensive, well-delineated engraved lines for decoration.

7. These two images show both sides of an iron tsuba made by Natsuo at the end of the Edo period. The engravings show a peony and rain.

8. This tsuba is made from shakudo (a copper and gold alloy) with a beautiful black patina. The decorative motif, a regular series of black dots, is called "nanako" (fish eggs). Each dot is made with a single chisel punch. The two inlaid shi-shi (lions) are made of gold and shakudo. This was made during the Bakumatsu era (1800–1850) that occurred toward the end of the Edo period.

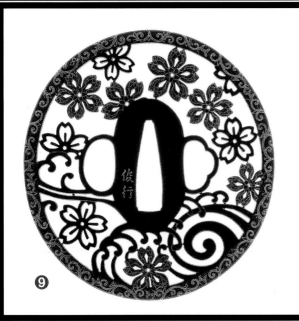

9. This is a gendai (modern) tsuba made by Toshiyuki Tamaoka. It is signed "Toshiyuki" and dated 2009, and is described as a "Yoshindo sukashi zogan tsuba." It has cherry blossoms carved out of the iron body of the tsuba in the sukashi style. The rim and some of the cherry blossoms are highlighted with gold wire inlay (zogan). Yoshindo refers to an area in Kyoto that is famous for cherry blossoms in the early spring.

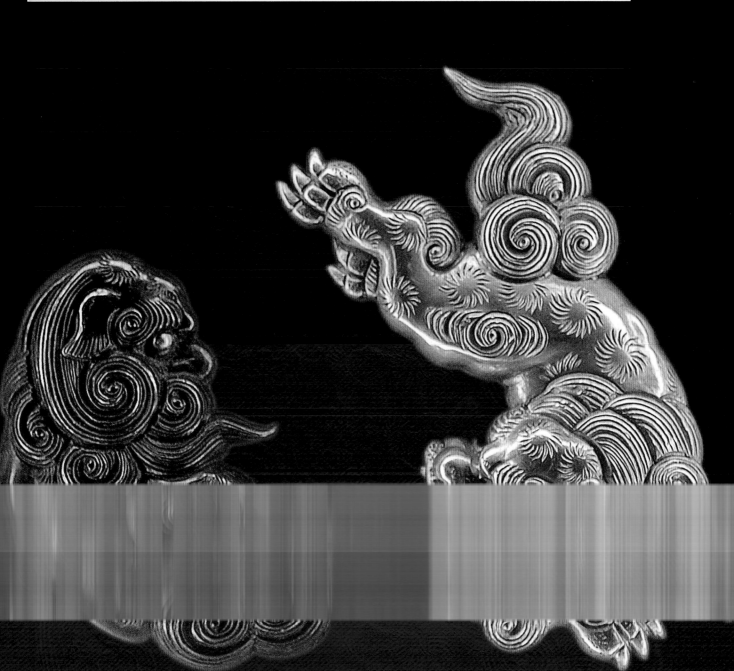

1. This is a pair of fuchi and kashira made for a daisho (large and small swords worn by samurai as a set). A fuchi is a metal cap that fits around the base of the wooden sword hilt; the kashira fits at top of the hilt. This pair is made from shakudo. Their surfaces are decorated with a punched nanako pattern. The detailed inlaid hawks on each piece are made from gold.

 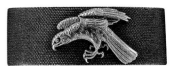

2. These three pieces comprise a set that includes a tsuba, along with a fuchi and kashira. They are decorated with grains of rice made from gold drops and leaves made from shakudo. The rice plants were inlaid on the iron tsuba, and the clouds and moon were carved out at the top. The moon on the tsuba is gold leaf, and there are gold raindrops around the clouds. The fuchi and kashira are made of shakudo; their surfaces are decorated with a nanako pattern.

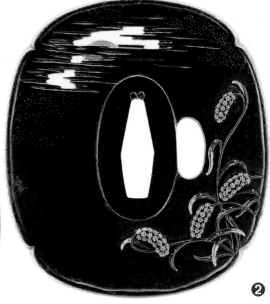

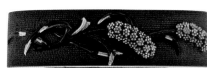

 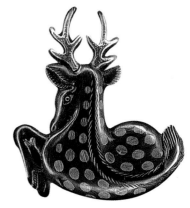

3. This is a pair of menuki, ornaments to fit on either side of the sword hilt. One is a deer, and the other is a mythical figure holding a turtle. Both are carved from shakudo and have inset gold details.

❹

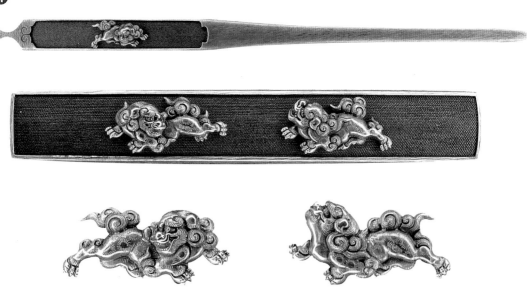

4. A mitokoromono set comprising three items used for sword mountings. This type of set includes a pair of menuki, a kozuka (the hilt for a small utility knife), and a kogai (an implement used for arranging the samurai's hair). In this set, the menuki are gold shi-shi (lions); the kogai and kozuka also display shi-shi on a shakudo surface.

❺

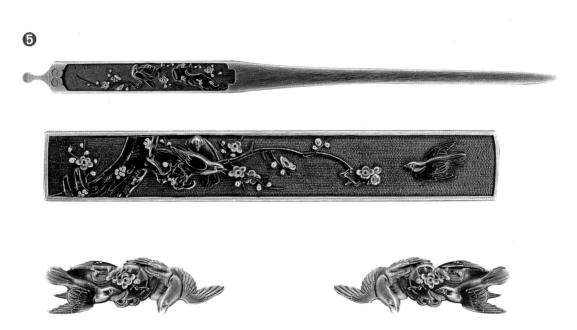

5. A mitokoromono set. The menuki in this set are carved birds made of gold and shakudo. The gold-edged kogai and kozuka are made of shakudo decorated with a punched nanako pattern; they are decorated with carved shakudo birds and plum trees with blossoms of inlaid gold.

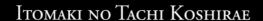

Itomaki no Tachi Koshirae

This type of tachi koshirae, which was first seen from the late Kamakura period to the Muromachi period, was used for formal attire in the Edo period. As it is the mounting for a tachi, which was worn edge-down, it has an attached belt to suspend the sword from the waist. The two hangers, or ashi, on the scabbard were used to attach the scabbard to the belt. The braiding around the hilt extends into the upper part of the scabbard. The detail photos show the hilt and the bottom of the scabbard.

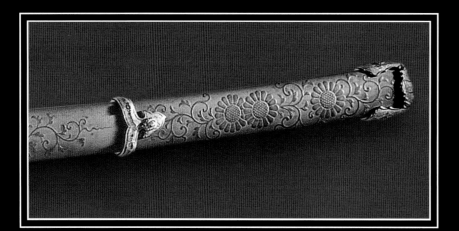

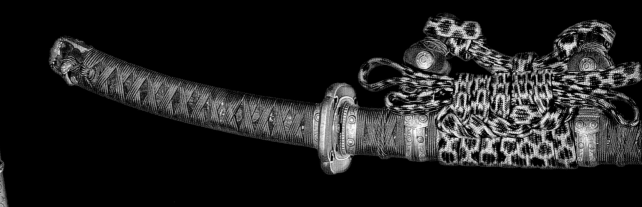

Daisho Koshirae

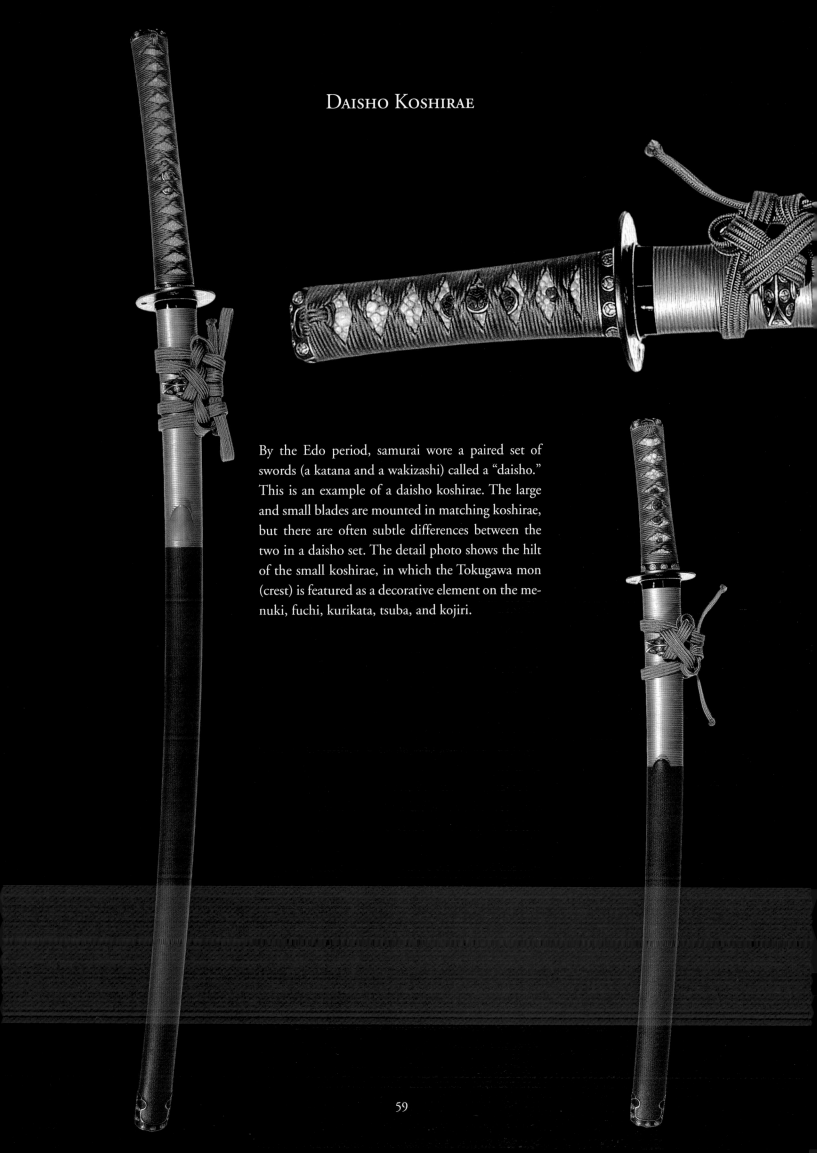

By the Edo period, samurai wore a paired set of swords (a katana and a wakizashi) called a "daisho." This is an example of a daisho koshirae. The large and small blades are mounted in matching koshirae, but there are often subtle differences between the two in a daisho set. The detail photo shows the hilt of the small koshirae, in which the Tokugawa mon (crest) is featured as a decorative element on the menuki, fuchi, kurikata, tsuba, and kojiri.

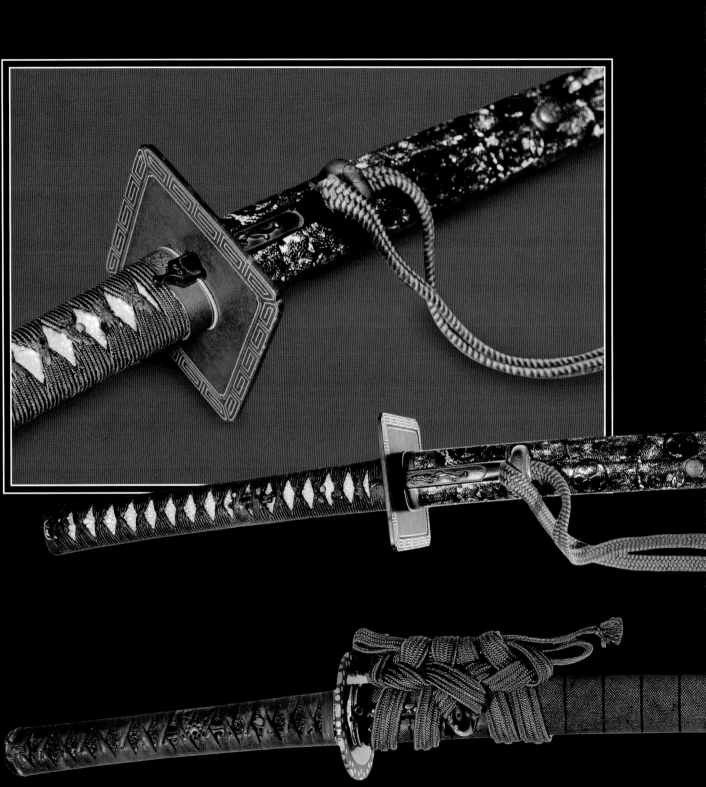

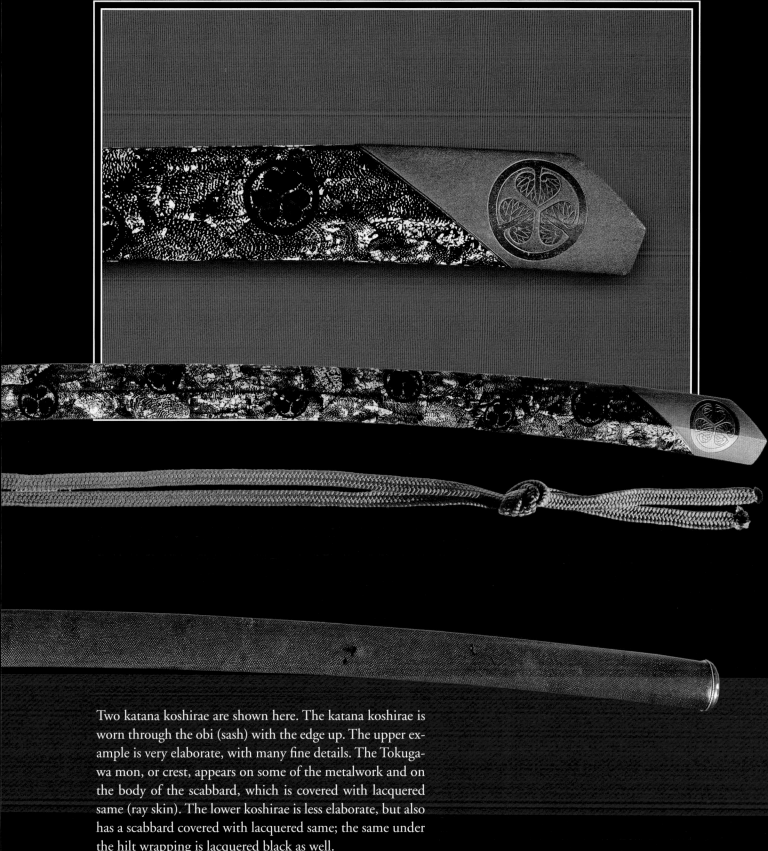

Two katana koshirae are shown here. The katana koshirae is worn through the obi (sash) with the edge up. The upper example is very elaborate, with many fine details. The Tokugawa mon, or crest, appears on some of the metalwork and on the body of the scabbard, which is covered with lacquered same (ray skin). The lower koshirae is less elaborate, but also has a scabbard covered with lacquered same; the same under the hilt wrapping is lacquered black as well.

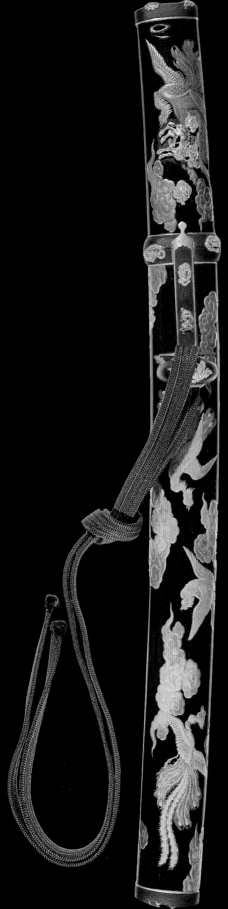
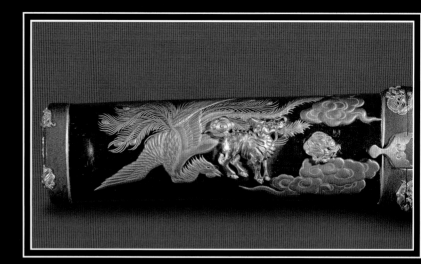
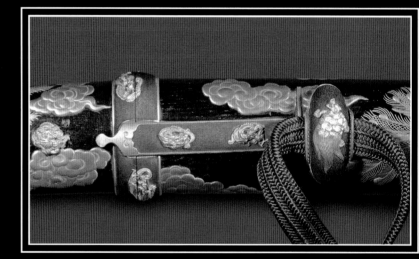
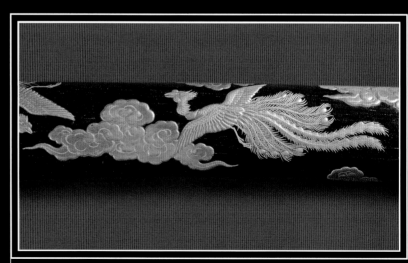

Aikuchi tanto koshirae do not have a tsuba. The koshirae above, which dates from the latter part of the Edo period, features very elaborate metal- and lacquerwork on the scabbard. The decorative theme consists of ho-o (phoenix) birds and clouds in gold over a black lacquered scabbard and hilt. The inset photos show details of this koshirae.

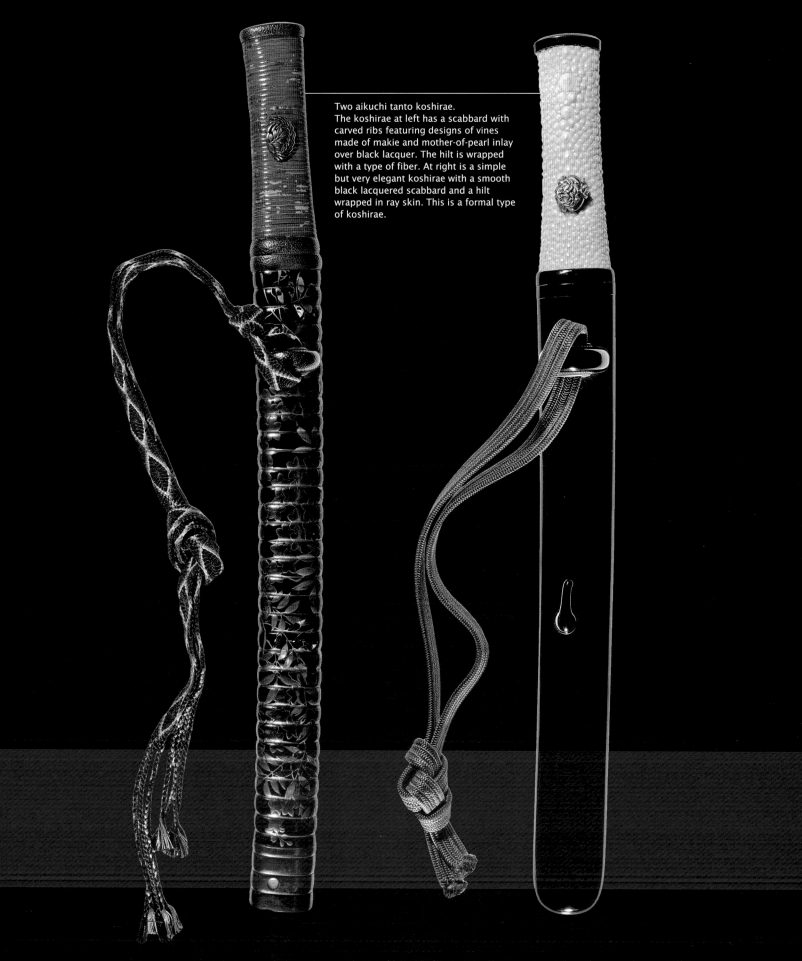

Two aikuchi tanto koshirae.
The koshirae at left has a scabbard with carved ribs featuring designs of vines made of makie and mother-of-pearl inlay over black lacquer. The hilt is wrapped with a type of fiber. At right is a simple but very elegant koshirae with a smooth black lacquered scabbard and a hilt wrapped in ray skin. This is a formal type of koshirae.

Thoughts on the Japanese Sword

JIM SANDLER

Jim Sandler is a sword enthusiast living in San Francisco, California. He works as an administrator for a nonprofit foundation focusing on environmental issues and new green technologies. Jim's participation in Japanese martial arts as a young man led him to cultivate an interest in Japanese swords. Having inherited a passion for art collection from his parents, whose avocation is modern art, Jim focused his interest on Japanese swords. He collects both old and modern blades, along with their accompanying koshirae.

I find that there is something quite strange about holding a piece of steel in my hands. Here is something that is created from nature, yet is totally unnatural, an object that gives a sense of artificial permanence in a world that is constantly in flux. Steel, in most of its functional forms, can be cold and unfeeling. Yet, when shaped by an artist's hand, it can give an impression of spirituality and vitality, becoming something that is both inanimate and alive at the same time. A knife or sword blade has many of these contradictory aspects flowing through its form. However, a sword is very different from a bronze sculpture, as it is a tool whose main function is to kill another human being. For me, this is both scary and thrilling. As I pass an unsheathed sword to a fellow sword enthusiast, I am always aware that I am relinquishing my power over their life and giving them power over mine.

All knives and swords have some of these characteristics. A sword wielded by a knight in the Middle Ages has a particular shape and majesty all its own, and definitely possesses the ability to kill. A good hunting knife can have aggressive contours, yet feel wonderfully balanced in the hand. The European rapier has elegance and subtlety combined with a lethal thrusting range. Such distinct characteristics come from the practical usefulness of these blades, combined with the personal touches imbued in them by their creator. For me, however, the Japanese sword takes everything to a higher level. There is a commitment by these smiths to create something that is so lethal that it becomes beautiful—not to mention the intriguing use of heat and steel alloys to produce a sword that is light, sturdy, and supple.

When I first started to learn about the Japanese sword, I was fascinated by the reverence that enthusiasts showed for the blades and the swordsmiths that produced them. Smiths of ages past are revered for their sword-making skills, yet each subsequent generation seems to have produced smiths that excelled in crafting noteworthy blades.

For a thousand years the sword seemed to evolve with Japan's politics and fighting styles, yet it remained faithful to certain higher principles. Like fine wines that have to be produced within particular parameters that are recognized by all wine experts, the Japanese sword adheres to its own set of values. One that appeals to me most is that the sword must have practical use as a weapon. Because of this, the range of options in which to manipulate the shape, weight, and balance of the blade is very small. If there is too much tweaking or variation, the sword changes from something useful into something impractical, not only becoming useless as a weapon, but also losing its appeal as a collectible work of art. Many artists who make knives, for example, add flashy and decorative elements to make them appealing to collectors. To me, these elements detract from the essence of the knife, serving only to avoid the exploration of the true nature of the weapon. In contrast, the simplicity found in the shape of the Japanese sword reflects the commitment to continually strive for perfection.

CLIVE SINCLAIRE

Clive Sinclaire lives near London in the UK, where he worked in the advertising business until his retirement. His long-term experience as a serious student and instructor of Kendo and Iaido has influenced his views on Japanese swords. He sees the practice of these arts as the practical and reverse side of the same coin; that is, the artistic appreciation of Nihonto. Clive is chairman of the To-ken Society of Great Britain, one of the first Western study and preservation groups focusing on the Japanese sword, and has written two books on the subject. His special interest is in Hizen-to, swords made in Hizen province (present-day Saga Prefecture) in the Edo period.

Of course, there are many reasons to enjoy and appreciate the Japanese sword. An understanding of jigane and jihada, as well as the intricacies of the hamon's

hataraki and form, is visually perceived. Even if some education and explanations are needed and desirable, provided that you have eyes to see, the sword should hold no secrets. It takes only a sensitive nature and relaxed mind to fully appreciate such things. For some, this may be where it ends, but a fuller study of the culture of the Japanese sword will add a further dimension. To me this is an integral and important part of Japanese sword appreciation.

Ogasawara sensei once said to me, "The trouble with you, Clive, is that you look at swords from a Kendo man's point of view." Whilst I may not agree with this assessment completely, I have no problem with it. Even modern swords, far removed from the life-and-death struggles of bygone times, acknowledge the importance of a sword's practical properties. That is to say, to maintain their integrity as a weapon, they must not bend or break, and must be capable of cutting well. It is such considerations that make today's shinsaku-to so satisfying to view and handle.

How can one not be moved, therefore, when the historical context of a sword's life is considered on top of all this? To own a sword that may have seen the Mongol invaders, or had fifty generations of previous owners who had cared for and preserved it, places weighty obligations on our shoulders. There can also be no doubt that there is a "way" in the Zen sense of the word, and a spiritual aspect, associated with the study and appreciation of fine Japanese swords. Such study as this was the province of the gentleman of rank in old Japan.

Personally, I think an even greater appreciation of swords may be gained from adding an active study of Kendo and Iaido, the martial arts of the sword. This helps give a very practical understanding of what a sword was made to do and is capable of. I consider this to be the other side of the coin to a purely academic study of swords. Of course, it may not be suitable for everyone, but both Kendo and Iaido may be practiced to a fine old age. For a sword collector, this may be a great experience as well as a way to gain a fuller understanding of the sword.

Beyond the aspects described above, I have not touched on the other great benefits of Japanese sword study in today's international market. I owe a debt

of gratitude to the Japanese sword for bringing me to many places and introducing me to friends that I have made all over the world. This is the culture of the Japanese sword as I see it today, and it is this culture that I enjoy so much. If this means that I look at swords from a Kendo practitioner's perspective, then I suppose that Ogasawara sensei was right.

WAYNE SHIJO

Wayne Shijo is a serious enthusiast and collector of Japanese swords. A third-generation Japanese-American, he grew up in Palo Alto, California. He moved to his current home, Sacramento, when he began working as an environmental planner and transportation engineer after college. Wayne's fascination with Nihonto, which began more than twenty-five years ago, grew from his Japanese heritage. He became a very serious student of the Japanese sword, and he remains active in local sword organizations while continuing to collect and study swords. He has also learned to make shirasaya (storage scabbards) using traditional Japanese methods, tools, and materials.

Like many people, I am fascinated by the katana, or Japanese sword. My interest in katana is enduring because it has not been static, but has changed, grown, and progressed, constantly presenting me with new facets. Katana first attracted my attention in an almost human way, interested me in learning more about them, and then motivated me to learn how to protect and care for them. Sometimes it seems that katana have consciously guided my progression from simple fascination to interested study, and thence to active stewardship.

For me, katana are not only a window to the history and culture of Japan, but also a physical connection to my ancestry. They are a manifestation of an ancient craft, something constant and stable I can hold in my hands in today's too-transient modern world. Because of this personal connection, I have developed a feeling of responsibility for them.

Admittedly, I was initially drawn to katana because they are weapons. I was interested because they are from Japan and they are old, and my eyes were attracted to them. This initial interest spurred me to learn about the different types of katana, their many different shapes, what they are made of, and how they are formed. I learned that their shape, structure, and composition have changed over time to meet and overcome the demands of the time in which they were

made. Studying katana reveals changes in the society of Japan and in the way individual Japanese viewed their world. In fact, studying katana without understanding the society and the people of Japan ignores a critical aspect of these works. As they are a reflection of the society and individuals that created them, understanding katana requires an understanding of their context. Over the years, I have collected katana—but I have also collected a shelf full of history books.

When I was in school, I had very little interest in history, but katana have completely changed that. As I write these words, I have in front of me a katana made by a craftsman in Japan before Christopher Columbus was even born. I know the craftsman's name; I know where he lived; I know when he made this katana; and I admire the quality of his work. Such experiences have completely changed what history means to me. History simply stops being an academic exercise when you can hold it in your own hands.

Over time, even as I learned about Japanese history, the katana grew to mean much more. While they are a connection to the past, my fascination with katana comes from the strong presence they have at the current moment in time. The common saying is that the katana is the "soul of the samurai," but that phrase does not really do justice to the way they affect the people around them. They have a strength of presence that is greater than any other inanimate object I know of; it exceeds even that of many living things. I believe this presence results from how they are formed. The craft of the katana is enduring because of its great age, exacting because of its demanding function, and difficult because of its austere simplicity.

Nearly everything about katana reflects a severe, demanding minimalism. The raw materials used are fundamental: earth, fire, water, and air. The way the raw materials are processed is severe: the iron sand passes through a hellish process to become steel. The way the materials are formed is demanding, requiring an exacting art. And the forms that katana take are austere, requiring functionality, simplicity, and purity. The creation of a katana reflects a simple birth, a demanding formation, and a severe life. The same elements that create a strong personality in a human result in a strong presence in a katana.

The demanding creation of a katana is not unlike the formation of the warrior who would wield such a weapon. The training and development a human must undergo to become a warrior is a destructive process, and the transformation occurs because the process is so hard. The creation of a katana is similar—the heat, the pounding, and the stresses on the metal—all threaten to destroy the blade before it ever becomes a katana. Not all humans survive the process of becoming a warrior, and not all pieces of steel survive to become katana. It takes more than strength: the survivors, both human and steel, are those with a strong, simple core. The result of the process is a warrior—or a katana—that has an inner strength, a quiet confidence, and a form defined by a straightforward function.

My relationship with katana has been shaped by the presence that they possess. Whereas I was initially just fascinated by them, I now feel a sense of responsibility toward them. Technically, I own the swords in my collection, but I often do not feel like an owner; rather more like a protector or steward. Though it may be an inanimate object, a good sword feels like a living thing—and I cannot own something that has its own separate living spirit. For example, two of the swords in my collection are six hundred years old. Probably more than twenty generations of people before me have taken good care of these swords, and, because of that care, I now have the honor and responsibility of their stewardship. I do not feel like I own them; I take care of them.

Thanks to the generosity and teaching of Yoshindo Yoshihara and Lonnie Kapp, I have had the opportunity to begin to learn sword polishing and shirasaya-making. Polishing restores katana, and shirasaya protect them. This is of great value to me, as I feel a strong sense of responsibility toward katana. If I can learn enough about sword polishing and shirasaya-making, I will actually be able to contribute to their restoration and protection.

Through katana I have progressed from the fascination of a child, to the learning of a student, to the restoration and protection of a steward. I hope I can continue this progression. With hard work, and the good teachers I am fortunate to have, I will fulfill my responsibility, restoring something that has come from the past, and protecting it in the future.

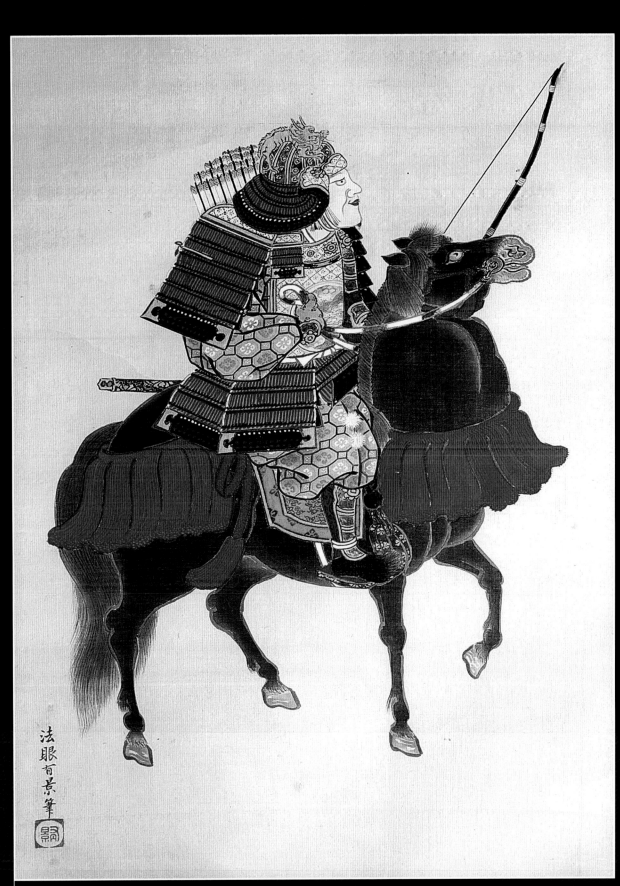

Painting of a mounted samurai from the Edo period. He is armed
with a tachi as well as bow and arrows. Private collection.

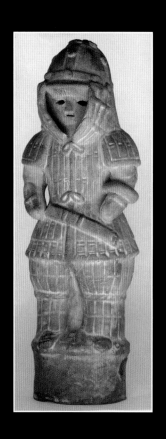

A Brief History of the Japanese Sword

CHAPTER II

REKISHI

A Brief History of the Japanese Sword

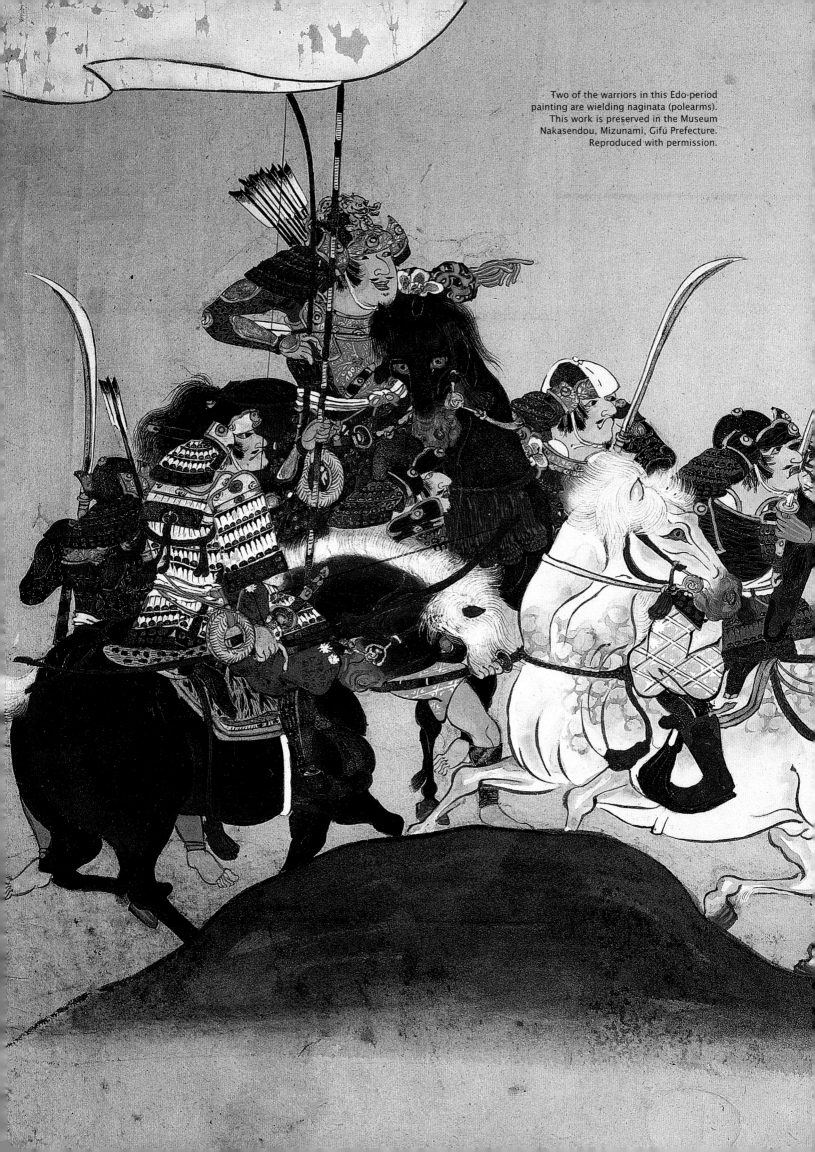

Two of the warriors in this Edo-period painting are wielding naginata (polearms). This work is preserved in the Museum Nakasendou, Mizunami, Gifu Prefecture. Reproduced with permission.

Sword Eras and Historical Periods

Sword Era	Date	Historical Period
上古刀 Jokoto (Very Old Swords) Pre-1000		奈良時代 Nara
	794	
		平安時代 Heian
	1185	
古刀 Koto (Old Swords) 1000–1600		鎌倉時代 Kamakura
	1333 1336	南北朝時代 Nanbokucho
	1392	
		室町時代 Muromachi
	1568 1573	安土桃山時代 Azuchi-Momoyama
新刀 Shinto (New Swords) 1600–1790	1600 1603	
		江戸時代 Edo
新々刀 Shin-shinto (New-new Swords) 1790–1876		
	1867	明治時代 Meiji
	1912	大正時代 Taisho
現代刀 Gendaito (Modern Swords) 1876–Present	1926	昭和時代 Showa
	1989	平成時代 Heisei

Note: Dates on sword inscriptions are given in nengo, or traditional Japanese historical eras. For more information about nengo and a reference table showing nengo eras and their corresponding dates in the common era, please see page 250.

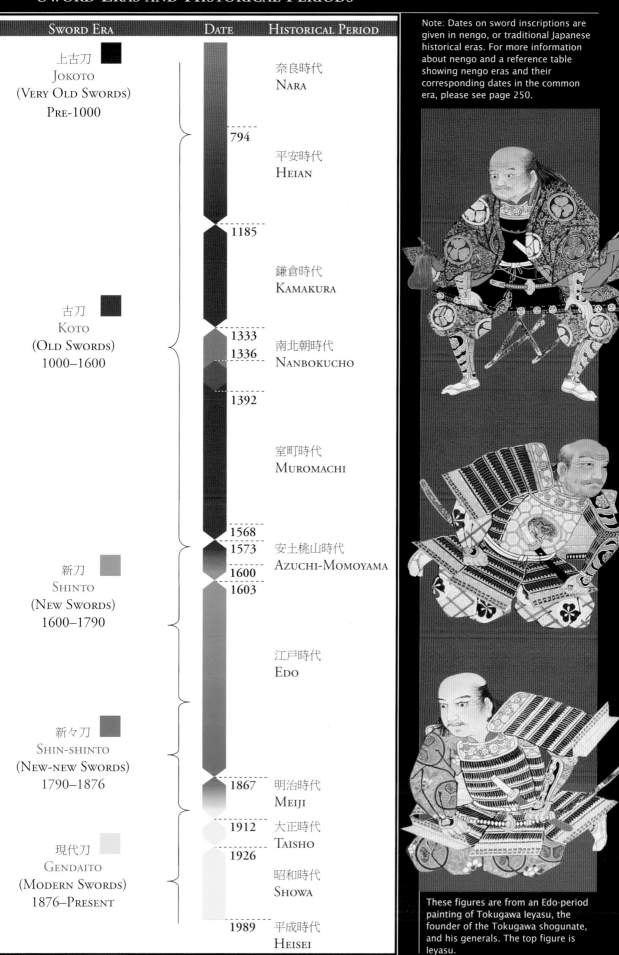

These figures are from an Edo-period painting of Tokugawa Ieyasu, the founder of the Tokugawa shogunate, and his generals. The top figure is Ieyasu.

Early Periods

The earliest swords found in Japan are stone and bronze swords. These may not have been functional weapons, as they appear to have been used primarily for ceremonial functions.

Steel swords first appeared in Japan during the Kofun period (250–538 AD), which was marked by the construction of large earthen tombs. Presumably, these early steel swords, along with the technology to work with steel and make them, were imported from China through Korea. Many such blades have been excavated from tombs, but they are not in the best condition. However, a number of early swords from the eighth century, believed to have been imported from China, have been preserved in perfect condition in the Shoso-in storehouse in Nara. As these swords have been maintained, polished, and restored, it is possible to see what some of the earliest steel blades in Japan looked like. These swords, called "jokoto" (or "chokuto"), were made from at least the fourth or fifth century to the tenth or eleventh century.

These early jokoto swords are straight, with flat sides. Later blades of this type, also found at Shoso-in, are called "kiriha-zukuri." They have flat, parallel sides, with a large bevel or ridge line (shinogi) very close to the cutting edge. The sides of the blade taper down to the cutting edge from the shinogi, making the angle of the cutting edge rather obtuse.

The Shoso-in storehouse holds another type of sword as well. These thicker and wider blades have a more functional appearance; some of them have a double edge extending back from the point a short distance toward the hilt. This type of sword, called "kissaki-moroha-zukuri," may exemplify the swords that were being made in Japan by the eighth century along with the Chinese-style straight sword.

The sword shown at the bottom of the facing page is a near-exact copy (utsushimono) made by Yoshindo Yoshihara. It is adorned with gold dot inlays connected by gold lines in the shape of the Big Dipper star constellation. The original was a sword owned by Prince Shotoku Taishi in the seventh century during the Asuka period (593–710). This sword shape, called "katakiriha-zukuri," has a very narrow, almost straight hamon along the edge of the blade. Such swords are very thin, and do not seem to have been practical weapons intended for combat. They are forged from steel, however, and the presence of a hamon indicates that the steel contains a high level of carbon.

Heian Period (794–1185)

Jokoto swords have a narrow, straight hamon that generally lacks strength and clarity. From about the Asuka period, however, it appears that Japanese swordsmiths began using clay to form their hamon; from this point the jihada and hamon become distinct, with a clearly visible suguha (straight) hamon.

Jokoto kiriha-zukuri swords were made up to at least the beginning, and possibly the middle, of the Heian period. The Japanese sword evolved during this time, and by the mid-Heian period blades that resembled modern Japanese swords had begun to emerge. Larger and longer than those from the Asuka period and the Nara period (710–94), these swords are curved, with a single cutting edge and a shinogi running lengthwise along the upper por-

Note: Oshigata of well-known and important swords from various historical periods are included in this chapter. Unless otherwise noted, the oshigata in these pages were made by Michihiro Tanobe, and are reproduced here with permission.

tion of the blade. The blades themselves are wider and thicker than those of earlier periods. By the end of the Heian period, a shape that was very close to the modern shinogi-zukuri style could be seen. The shinogi was moved higher above the cutting edge, closer to the back surface of the sword, which gave the cutting edge a much more acute angle than the earlier jokoto had. Wider and more complex hamon appeared, featuring patterns like choji; the modern type of point, with a boshi (hamon on the point), emerged as well. The most prominent smiths working at this time were Munechika in Yamashiro; Yasutsuna in Hoki; and Kanehira, Tomonari, and others in Bizen.

KAMAKURA PERIOD (1185–1333)

By the end of the Heian period in the twelfth century, the samurai (warrior) class had accumulated much more power and influence, and had also generated a strong demand for effective and functional swords. This trend continued into the Kamakura period, when the samurai class controlled Japan. Swords acquired more curvature, and were more robust and practical for fighting; the smiths who made them began to sign their work. At the same time, the koshirae (mountings) for ceremonial swords and practical weapons began to differ, as did their shape. Most ceremonial swords had straight ken-style blades, and were clearly derived from the earlier jokoto swords.

The design of swords made at this time appears very close to modern Japanese blades. However, swords continued to evolve and improve from the beginning of the Kamakura period. The new shogunate promoted the production of better, more functional swords, and the Mongol invasion of Japan also led to changes in the design and manufacture of swords. Advances in

sword design included a wider, more complex hamon and the addition of a soft steel or iron core forged into the center of the sword. There were probably improvements in steel-making as well.

The first shogunate, which came into power at the beginning of the Kamakura period, summoned swordsmiths from all over Japan to the town of Kamakura, in Soshu province, to collaborate and produce better swords. This resulted in the foundation of the Soshu school or style of sword-making. Sagami, the region where Kamakura is located, was a major sword-making area throughout the existence of the Kamakura shogunate, a period of about 130 years.

At the same time, however, other sword-making schools were developing all over Japan. Many tanto (daggers) and naginata (polearms) from this period, as well as tachi (longswords), are still extant. Smiths often signed their swords with their name, the date, and the area where they worked.

There were a number of important groups of sword-makers in the Bizen area in central Japan (near the present-day city of Okayama), in places like Fukuoka, Yoshii, and Osafune. Osafune and Fukuoka were the most prolific areas, turning out a large number of Bizen swords over hundreds of years. The productivity in Bizen was due in part to the availability of good satetsu (iron ore), along with abundant wood charcoal, dependable sources of water, and reliable transportation.

Bizen, which may have been where the modern Japanese sword was developed, was also the most productive area for sword-making from around 1250 in the mid-Kamakura period to the beginning of the Edo period in 1603, a span of about four hundred years.

This utsushimono (near-exact copy of an existing or historical sword) of the Seven Star sword was made by Yoshindo. The original sword, which was owned by Prince Shotoku Taishi in the seventh century, is preserved today at the Shoso-in in Nara. The gold dot inlays, connected by gold lines, depict the Big Dipper constellation.

Heian-period Swords

1. TACHI: Yasutsuna (Meibutsu dojigiri Yasutsuna)

太刀　銘：安綱（名物童子切安綱）

National Treasure 国宝

Owned by the Tokyo National Museum

Heian period 平安時代

Length: 80.2 cm　　Sori: 2.7 cm

This is a long tachi-style sword made by Yasutsuna of Hoki in the twelfth century. Its modern-looking design indicates that the Japanese sword was almost fully developed by this time. The blade, which has not been altered, has a length of about 31.5 inches and a strong curvature. The original tang and signature are present. Although the hamon is very complex, it is narrow along its entire length. The boshi is very wide, suggesting that the blade has retained almost all of its original shape.

2. TACHI: Sanjo (Meibutsu Mikazuki Munechika)

太刀　銘：三条（名物三日月宗近）

National Treasure 国宝

Owned by the Tokyo National Museum

Heian period 平安時代

Length: 80 cm　　Sori: 2.8 cm

This long tachi-style sword was made by Munechika in the late Heian period. Munechika lived in Kyoto, which was Japan's capital at that time. The blade is about 31.5 inches long, with a complex hamon that is narrow along nearly the entire length, becoming wider as it approaches the point. The boshi indicates that the sword is in good condition and has retained its original shape in spite of its age. Part of the tip has been cut back, and the tang has been shortened slightly. The tang is very narrow near the tip, widening suddenly just below the beginning of the polished cutting edge—a shape called "kiji-momo" (pheasant's thigh).

3. TACHI: Bizen no kuni Tomonari

太刀　銘：備前国友成

Important Cultural Property 重要文化財

Early Kamakura period 鎌倉時代初期

Length: 79.2 cm　Sori: 2.6 cm

Like the two blades shown on the facing page, this 31-inch Tomonari tachi is a long blade with strong curvature, and appears to possess its original shape. Tomonari lived at the end of the Heian period and worked in the Ko-Bizen (old Bizen) school of sword-making, from which the Bizen school emerged. The hamon of this sword is narrow and complex along the entire length of the blade, with well-defined gunome or choji waves. The blade and the tang appear unaltered.

4. TACHI: Masatsune

太刀　銘：正恒

National Treasure 国宝

Late Heian or early Kamakura period

平安時代末期・鎌倉時代初期

Length: 77.6 cm　Sori: 2.5 cm

This tachi was made by Masatsune, who worked in the late Heian period. It has a similar shape and hamon to the three described above, and is 30.55 inches long. The sword is in very good condition, and the long narrow hamon and large boshi indicate that the hamon has retained its original shape. The hamon is very well formed, with frequent continuous gunome waves and ashi. The straight cut at the bottom of the tang, the rivet hole at the bottom of the tang, and the location of the signature (at the center of the tang) are all indications that the tang has been shortened.

MAJOR SWORDSMITHS AND SCHOOLS

There are at least 33,000 smiths listed in various records up to the beginning of the modern era. Smiths and schools considered among the most important are listed here by era and province.

Koto 古刀 era (1000–1600)

SAGAMI 相模 438 swordsmiths listed
Shintogo Kunimitsu 新籐五国光
Yukimitsu 行光
Masamune 正宗
Sadamune 貞宗

YAMATO 大和 1025 swordsmiths listed
Amakuni 天国
Senjuin Nobuyoshi 千手院延吉
Nagayoshi 長吉
Tegai Kanenaga 手掻包永
Taima 当麻 **school smiths**

YAMASHIRO 山城 847 swordsmiths listed
Sanjo Munechika 三条宗近
Awataguchi Kunitomo 粟田口国友
Norikuni 則国
Hisakuni 久国, **Kunitsuna** 国綱
Yoshimitsu 吉光
Rai Kuniyuki 来国行, **Kunitoshi** 国俊,
Kunimitsu 国光, **Kunitsugu** 国次,
Tomokuni 倫国
Ayanokoji Sadatoshi 綾小路定利
Hasebe Kunishige 長谷部国重, **Kuninobu** 国信

BIZEN 備前 4005 swordsmiths listed
Ko-bizen Tomonari 古備前友成, **Kanehira** 包平
Fukuoka Ichimonji Norimune 福岡一文字則宗,
Sukemune 助宗, **Moritoshi** 守利, **Yoshifusa** 吉房
Osafune Mitsutada 長船光忠, **Nagamitsu** 長光,
Kagemitsu 景光, **Kanemitsu** 兼光, **Sukesada** 佑定

BITCHU 備中 933 swordsmiths listed
Aoe 青江 **school smiths**

BINGO 備後 565 swordsmiths listed
Mihara 三原 **school smiths**

MINO 美濃 1269 swordsmiths listed
Shizu Kaneuji 志津兼氏, **Kanemoto** 兼元,
Kanesada 兼定

ETCHU 越中 256 swordsmiths listed
Go Yoshihiro 郷義弘, **Norishige** 則重

ISE 伊勢 57 swordsmiths listed
Muramasa 村正

CHIKUZEN 筑前 277 swordsmiths listed
Samonji 左文字

HIGO 肥後 247 swordsmiths listed

SATSUMA 薩摩 587 swordsmiths listed
Naminohira Yukiyasu 波平行安

IWAMI 石見 270 swordsmiths listed
Naotsuna 直綱

HOKI 伯耆 269 swordsmiths listed
Yasutsuna 安綱

Shinto 新刀 era (1600–1790)

MUSASHI 武蔵 463 swordsmiths listed
Kotetsu 虎徹, **Ishido Korekazu** 石堂是一

YAMASHIRO 山城 295 swordsmiths listed
Kunihiro 国広

SETTSU 摂津 380 swordsmiths listed
Sukehiro 助広, **Tadatsuna** 忠綱, **Kunisada** 国定,
Shinkai 眞改, **Kinmichi** 金道

SATSUMA 薩摩 185 swordsmiths listed
Masakiyo 正清

HIZEN 肥前 245 swordsmiths listed
Tadayoshi 忠吉, **Tadahiro** 忠広

MUTSU 陸奥 299 swordsmiths listed
Kunikane 国包

Shin-shinto 新々刀 era (1790–1876)

MUSASHI 武蔵 373 swordsmiths listed
Masahide 正秀, **Munetsugu** 宗次,
Kiyomaro 清麿

SETTSU 摂津 84 swordsmiths listed
Gassan 月山

MUTSU 陸奥 295 swordsmiths listed
Kanesada 兼定

TOSA 土佐 113 swordsmiths listed
Hideyuki 行秀

BIZEN 備前 46 swordsmiths listed
Sukenaga 佑永

SATSUMA 薩摩 116 swordsmiths listed
Motohira 元平

HISTORICAL JAPANESE PROVINCES

1. 蝦夷　EZO
2. 陸奥　MUTSU
3. 陸中　RIKUCHU
4. 陸前　RIKUZEN
5. 羽後　UGO
6. 羽前　UZEN
7. 佐渡　SADO
8. 越後　ECHIGO
9. 岩代　IWASHIRO
10. 磐城　IWAKI
11. 下野　SHIMOTSUKE
12. 常陸　HITACHI
13. 上野　KOZUKE
14. 武蔵　MUSASHI
15. 下総　SHIMOUSA
16. 上総　KAZUSA
17. 安房　AWA
18. 信濃　SHINANO
19. 甲斐　KAI
20. 相模　SAGAMI
21. 駿河　SURUGA
22. 伊豆　IZU
23. 越中　ETCHU
24. 飛騨　HIDA
25. 美濃　MINO
26. 尾張　OWARI
27. 三河　MIKAWA
28. 遠江　TOTOMI

29. 能登　NOTO
30. 加賀　KAGA
31. 越前　ECHIZEN
32. 近江　OMI
33. 伊賀　IGA
34. 伊勢　ISE
35. 志摩　SHIMA
36. 若狭　WAKASA
37. 丹後　TANGO
38. 丹波　TANBA
39. 山城　YAMASHIRO
40. 和泉　IZUMI
41. 摂津　SETTSU
42. 河内　KAWACHI
43. 大和　YAMATO
44. 紀伊　KII
45. 但馬　TAJIMA
46. 播磨　HARIMA
47. 淡路　AWAJI
48. 因幡　INABA
49. 美作　MIMASAKA
50. 備前　BIZEN
51. 伯耆　HOKI
52. 備中　BITCHU
53. 出雲　IZUMO
54. 備後　BINGO
55. 石見　IWAMI
56. 安芸　AKI

57. 長門　NAGATO
58. 周防　SUO
59. 讃岐　SANUKI
60. 阿波　AWA
61. 伊予　IYO
62. 土佐　TOSA
63. 対馬　TSUSHIMA
64. 壱岐　IKI
65. 筑前　CHIKUZEN
66. 豊前　BUZEN
67. 肥前　HIZEN
68. 筑後　CHIKUGO
69. 豊後　BUNGO
70. 肥後　HIGO
71. 日向　HYUGA
72. 薩摩　SATSUMA
73. 大隅　OSUMI

The Gokaden 五箇伝
(five traditional schools)

Yamato Den 大和伝
Yamashiro Den 山城伝
Soshu Den 相州伝
Bizen Den 備前伝
Mino Den 美濃伝

Kamakura-period Swords

5. TACHI: Kuniyuki

太刀　銘：国行

National Treasure 国宝

Kamakura period 鎌倉時代

Length: 69.8 cm　　Sori: 1.5 cm

This sword was made by Kuniyuki, who founded the Rai school in Yamashiro during the Kamakura period. It is about 27.5 inches long. The signature is located just below the middle rivet hole, which is the original one. The hamon is formed of a continuous series of gunome waves, with a clear pattern along the entire length. There is a horimono (engraving) of a ken-style straight sword on either side of the blade.

6. TACHI: Yoshifusa

太刀　銘：吉房

National Treasure 国宝

Early Kamakura period 鎌倉時代初期

Length: 73.9 cm　　Sori: 3.4 cm

This is a tachi by Yoshifusa, who worked in the Fukuoka Ichimonji school in Bizen during the mid-Kamakura period. It is about eight hundred years old, but appears to be almost perfectly preserved. The 29-inch sword is strongly curved; its broad tang, wide blade, and spectacular hamon show it to be a fully developed Japanese sword. The hamon has a clear nioi boundary, and shows well-defined choji and gunome waves along the entire length of the blade.

7. TACHI: Bizen no kuni Osafune ju Nagamitsu saku Shoan ni nen ni gatsu kichijitsu

太刀　銘：備前国長船住長光作

正安二年二月吉日

Important Cultural Property 重要文化財

Kamakura period 鎌倉時代

Length: 77.3 cm　　Sori: 2.6 cm

This tachi by Nagamitsu, the second-generation leader of the Osafune school in Bizen, was made around the middle of the Kamakura period (mid-thirteenth century). It is 30.4 inches long, with a moderate curvature and an imposing shape. The distinctive hamon is composed of small choji waves along the lower half of the blade, shifting to a suguha (straight) pattern with ashi along the upper half of the blade. The hamon is very subdued compared to many earlier examples from this period.

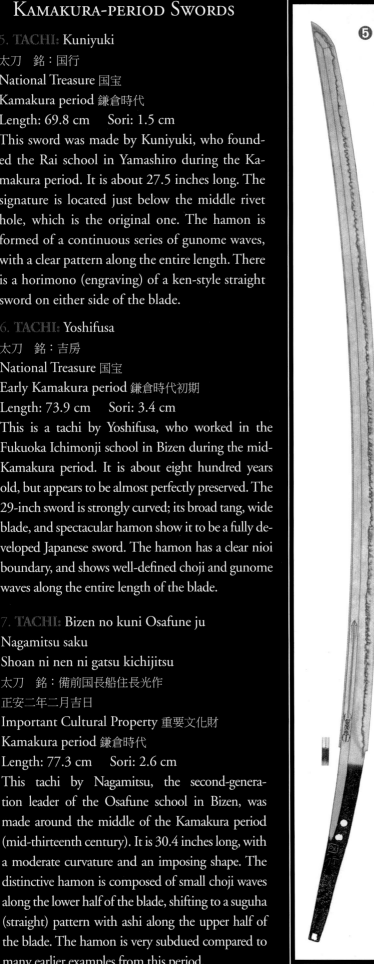
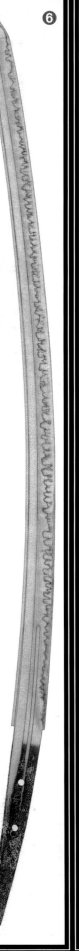
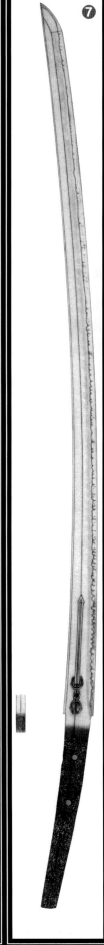

THE ROLE OF THE GOKADEN SCHOOLS

Five major sword-making traditions or schools developed in Japan from the end of the Kamakura period in 1333 through the Nanbokucho period (1331–92). These include the Bizen school (centered near modern-day Okayama); the Soshu school (Kamakura); the Yamashiro tradition (Kyoto); the Yamato tradition (Nara); and the Mino school (around modern-day Seki, near Nagoya). These five sword-making traditions were called the Gokaden, or five schools. They were the major centers of sword-making at the end of the Kamakura period and during the Nanbokucho period that followed. Each school of the Gokaden developed effective and functional swords with their own features. For example, each school gave its swords their own characteristic hamon, shape, steel, and other details. The Gokaden traditions were very strong through the early Muromachi period (1336–1573).

The Gokaden schools solidified the technology and design of Japanese swords; sword enthusiasts still make efforts to acquire Gokaden swords today. However, only a small fraction of the Japanese swords now extant were made by Gokaden smiths, or are good examples of Gokaden work.

These swords were made during a period of constant warfare, when swords were in regular use, so many of them have not survived into modern times. In the early Muromachi period, there may have been over a hundred daimyo (provincial lords with their own domains), each of whom supported sword-making. Smiths from the original Gokaden schools therefore dispersed all over Japan and established their own schools of sword-making in the various provinces. Although there are clear similarities between many of these off-shoot schools and the original Gokaden, the later smiths developed their own styles and techniques, giving their work their own characteristics.

Modern collectors often try to see whether Koto blades (those made between the thirteenth and sixteenth centuries) can be placed into one of the Gokaden traditions. While there are extant swords made by the Gokaden, most of the blades one is likely to see now were made in other areas of Japan. Today, in a random group of Koto swords, only perhaps one out of ten would be clearly identifiable as work from a Gokaden school. Nonetheless, Gokaden swords provide standards for appraisal, appreciation, and comparison of swords today.

The beginning of the Nanbokucho period saw a significant increase in the size of some swords. Very large tachi called "no-dachi" and "o-dachi," some with a cutting edge 3 feet (90 cm) in length or more, were being made. Samurai fought on foot during this period rather than from horseback, which affected the size and design of these big swords. The unwieldy-looking blades are characteristic of the Nanbokucho period.

MUROMACHI PERIOD (1336–1573)

A new shogunate government was formed by Ashikaga Takauji in 1336. The Ashikaga shogunate was located in close proximity to the emperor in the Muromachi part of Kyoto.

The Sengoku (Warring States) period, which lasted from approximately 1467 to 1600, was a time of almost constant civil war, as the various daimyo (regional lords) sought to unify and rule the country. The fighting involved large groups of foot soldiers, or ashigaru. These part-time soldiers worked as farmers when they were not fighting, so they were not trained for sword combat. As a result, yari—simple straight blades about 6 to 10 inches (15–25 cm) in length, mounted on poles—became their preferred weapon. Some of the poles used to hold yari were up to 12 feet (4 meters) long. However, samurai also developed many fighting techniques using yari, along with different shapes and sizes of the weapon, such as straight yari (su-yari), cross-shaped yari (jumonji yari), and many others (see page 30 for examples).

Note: Historians disagree as to the exact dates of the Nanbokucho and Muromachi periods. For the purposes of this text, the Nanbokucho period will be considered as falling largely within the Muromachi period.

These yari were forged from tamahagane steel and had hamon, but were often finished very roughly. They were most often made by specialized craftsmen (though occasionally swordsmiths did make them) and were not made to the same high standards as a sword. This stands in contrast to the naginata, another type of large polearm that was first used by soldiers during the Heian period and was further developed during the Kamakura period. A naginata blade can be as massive and well made as a good sword; they were made by swordsmiths using the same techniques used for swords.

During the beginning of the Sengoku period, many soldiers began using swords called "uchigatana," which could be wielded with one hand and were more suitable for use in enclosed spaces such as buildings and forts. They were much lighter and more easily handled than the longer and heavier tachi. Uchigatana were around 22 to 26 inches (60–70 cm) long, whereas traditional tachi could be as long as 39 inches (1 meter). They were also worn differently: tachi were worn cutting-edge-down, with the scabbard suspended from the waist by a belt. In contrast, an uchigatana was worn under an obi or sash with the edge up. It could be drawn with only one hand because the scabbard was secured in the obi, whereas a tachi required two hands to draw. An uchigatana had to have a shorter blade than a tachi, however, or it would have been impossible to draw from the secured scabbard.

After uchigatana became widespread, swordsmiths began to make smaller swords in general. The simple black lacquered scabbards in which uchigatana were usually mounted evolved into the traditional mounting used for Japanese swords from this period on.

This is an Edo-period painting of the conflict between Uesugi Kenshin (1530-78) and Takeda Shingen (1521-73) at the fourth battle of Kawanakajima in 1561. Notice that many of the foot soldiers and mounted soldiers are carrying yari (long polearms with straight steel blades).
Reprinted with permission of the Museum Nakasendou, Mizunami, Gifu Prefecture.

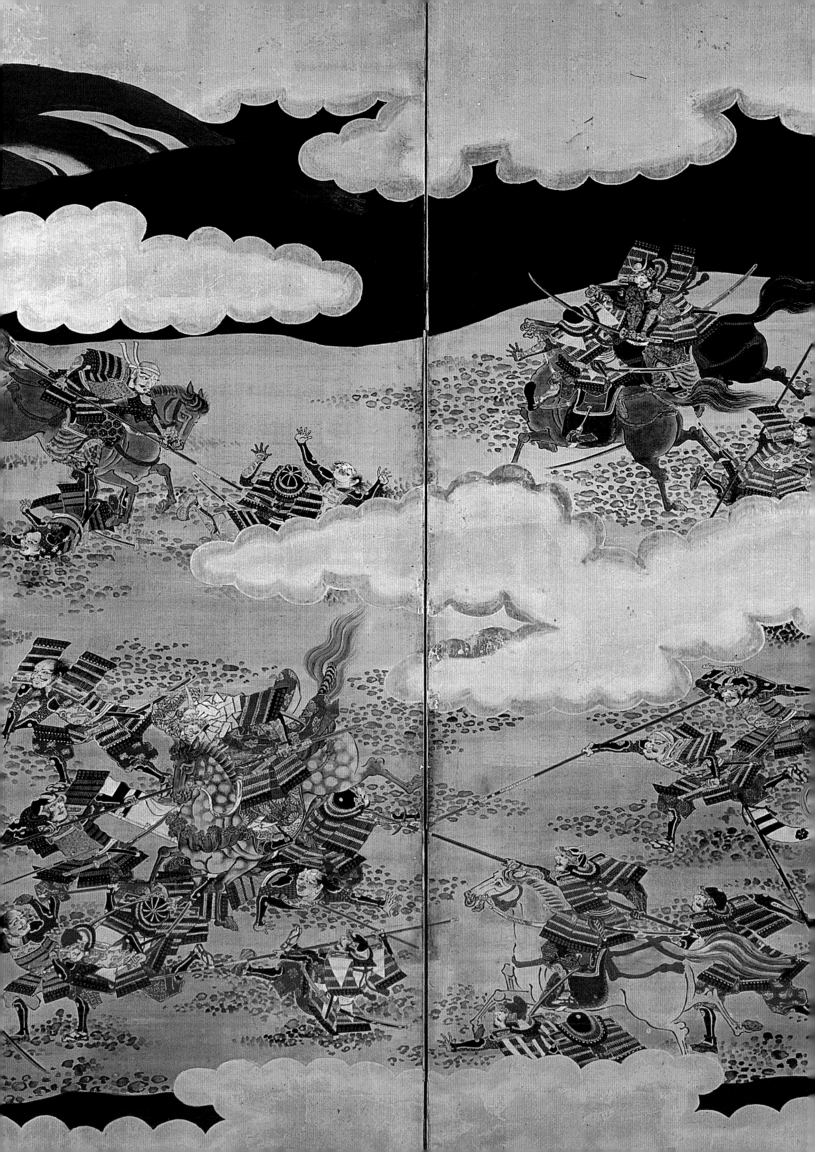

Nanbokucho-period Swords

8. TACHI: Bishu Osafune Hidemitsu

Oan yo nen ju gatsu bi

太刀　銘：備州長船秀光

応安四年十月日

Important Cultural Property 重要文化財

Nanbokucho period 南北朝時代

Length: 81.6 cm　　Sori: 3 cm

This tachi by Hidemitsu, like other swords from the Nanbokucho period (1331–92), is large and wide, with a sizable point. The blade is 32.1 inches long, with a hamon composed of a clear, continuous nioi line which shows gunome and ashi. One side of the blade has a horimono of a ken (straight sword). There are large grooves cut in the shinogi-ji along both sides. The tip of the tang is straight, suggesting that it has been shortened slightly.

9. TACHI: Hasebe Kuninobu (go Karakashiwa)

太刀　銘：長谷部国信

Important Art Object 重要美術品

Nanbokucho period 南北朝時代

Length: 79.4 cm　　Sori: 3.3 cm

This Nanbokucho-period sword made by Kuninobu is 31.25 inches long, with a large point. The blade has a very unusual tang, but its most spectacular feature is the active and irregular hamon. In this style of hamon, called "hitatsura," the surface of the upper part of the blade is hardened along with the edge. On this sword, the continuous hamon-like appearance of the surface running along the mune and extending down toward the normal hamon along the edge indicates that these blade surfaces were hardened as well. This school originated in Yamato (around the Nara area), and later moved to Kyoto.

10. TACHI: Bizen no kuni ju Osafune Morikage

太刀　銘：備前国住長船盛景

Important Cultural Property 重要文化財

Nanbokucho period 南北朝時代

Length: 74.2 cm　　Sori: 2 cm

This is a sword made by Morikage of Bizen during the Nanbokucho period. It is 29.2 inches long, with a large point. The sword tapers very little from the top of the tang to the point, which is another characteristic of this period. The hamon, which features ashi, gunome, and choji, is well defined by a continuous nioi boundary.

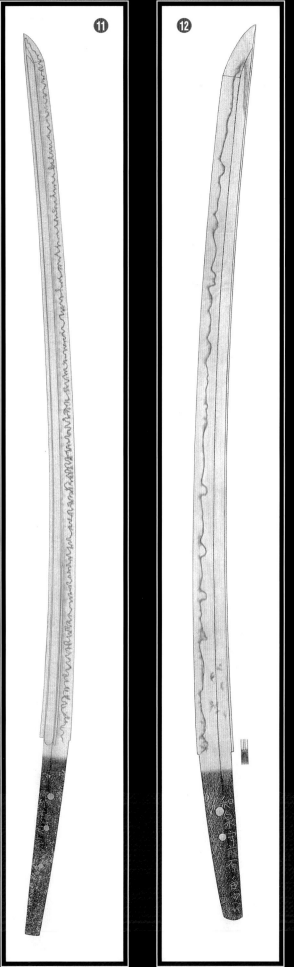

11. TACHI: Bishu Osafune Yasumitsu

Oei sanju-ni nen san gatsu bi

太刀　銘：備州長船康光

応永三十二年三月日

Important Art Object 重要美術品

Early Muromachi period 室町時代初期

Length: 80.6 cm　　Sori: 2.1 cm

This tachi was made by Yasumitsu, who worked in Bizen during the Muromachi period. The blade is 31.7 inches long with a moderate curvature. The hamon is an active Bizen-style hamon with choji, gunome, ashi, and sharp-tipped togari gunome. The three holes in the tang suggest that the sword has been shortened twice since it was made. The blade was shortened from the tang end, so the lowest hole was the original one.

12. KATANA:

Izuminokami Fujiwara Kanesada saku

刀　銘：和泉守藤原兼定作

Exceptionally Important Sword 特別重要刀剣

Late Muromachi period 室町時代後期

Length: 64.84 cm　　Sori: 1.8 cm

This sword was made by Kanesada, who worked in Seki toward the end of the Muromachi period. It was made toward the end of the Koto era, and resembles the newly developing styles of swords in the Shinto era. The blade is 25.5 inches long, with a relatively small curvature. With its solid and functional appearance, it is not quite as graceful as earlier Koto-period works.

Shinto and Shin-shinto Eras

Azuchi-Momoyama Period
(1568–1600)

The Azuchi-Momoyama period was one of renaissance in Japan, in which substantial foreign trade resulted in a newly wealthy merchant class. During this period, it became customary for the shogun, emperor, and daimyo to present valued retainers with swords as gifts or rewards. As a result, sword mountings became very expensive and elaborate. Smiths began incorporating gold, lacquer, and other costly materials into sword fittings, making tsuba, fuchi and kashira, menuki, kogatana, kozuka, and other embellishments. Time-consuming and expensive techniques such as carving, engraving, and inlays also became more common. In addition, from the end of the Muromachi period and into the Azuchi-Momoyama period, artists often signed their more elaborate and elegant work.

Uchigatana of this period were generally of two types. The first, for use in combat, was mounted very simply and in a very functional manner.

Ornately mounted uchigatana with costly decorations and metal fittings, on the other hand, were used as gifts and were for higher-ranking warriors.

The use and style of wearing swords evolved during the Muromachi and Azuchi-Momoyama periods, and by the beginning of the Edo period (1603–1867), wearing a daisho paired set of swords had become customary among samurai. The matched set included a long (dai) blade of at least 26 inches (60 cm), and a shorter (sho) wakizashi that was usually around 16 or 18 inches (40–45 cm) long. Daisho could be very elaborately fitted for ceremonial or formal use, or mounted more simply for practical use. The wearing of daisho was restricted to members of the samurai class, but non-samurai could wear a single wakizashi, provided it was less than 26 inches long. Merchants often commissioned beautiful and elaborate sword mountings for their short swords, thereby supporting many highly skilled craftsmen.

This is a painting of Suishinshi Masahide (1750–1825) by Takeda Kounsai (1803-65). Masahide, the father of the Shin-shinto era, brought new attention and enthusiasm to the traditions of sword-making. Masahide and the smiths he trained used famous swords from the Kamakura and Nanbokucho periods as models for their work. The revival of interest that Masahide inspired did not wane until the Meiji Restoration in 1868.

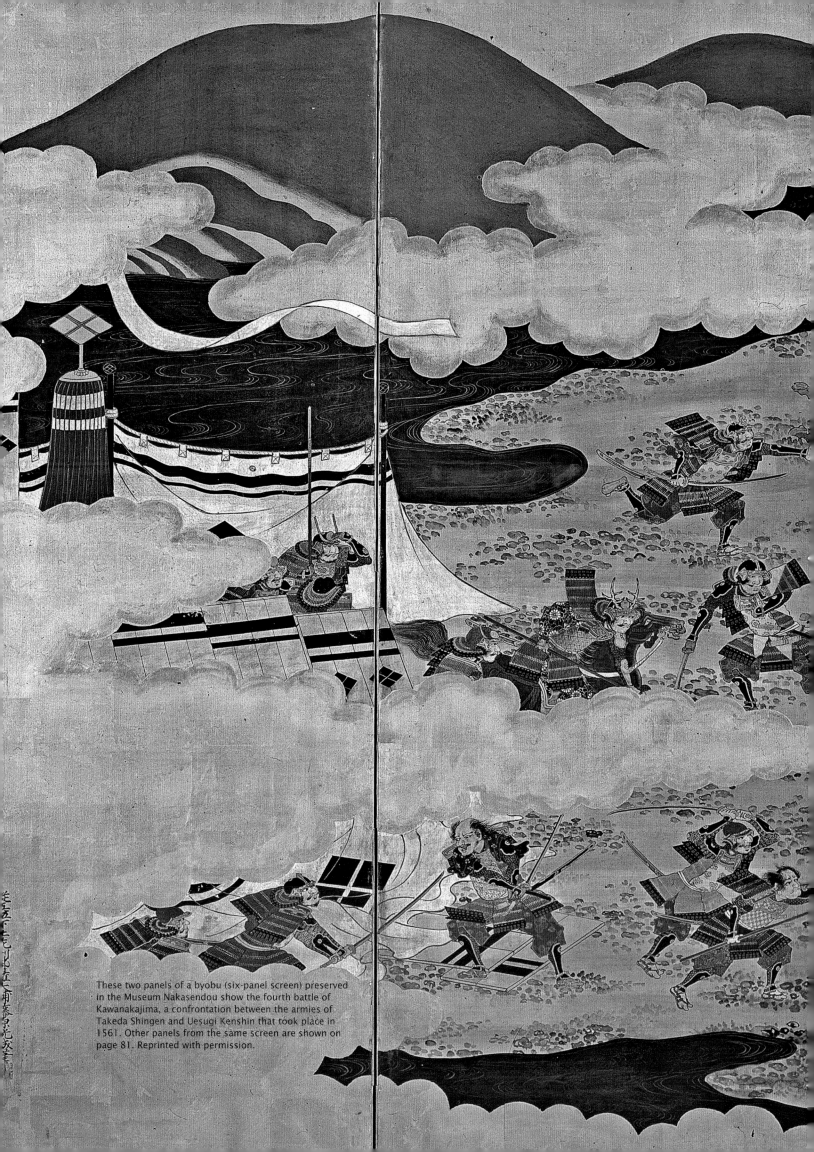

These two panels of a byobu (six-panel screen) preserved in the Museum Nakasendou show the fourth battle of Kawanakajima, a confrontation between the armies of Takeda Shingen and Uesugi Kenshin that took place in 1561. Other panels from the same screen are shown on page 81. Reprinted with permission.

EDO PERIOD
(1603–1867)

During the early part of the Edo period, the daimyo (feudal lords) of the Japanese provinces became patrons of swordsmiths, as they needed a source of swords to equip the samurai they employed. Groups of highly skilled smiths were drawn to the areas around the major cities such as Edo, Osaka, and Kyoto. This was the beginning of the Shinto (new sword) era, during which a number of important swordsmiths emerged. Books about swords being written at that time used the term Koto (old sword) to refer to blades made from the early to mid-Heian period through the end of the Azuchi-Momoyama period. Swords made after around 1600 were called "Shinto" blades.

The Edo period was a peaceful one, with Japan unified under a strong government, the Tokugawa shogunate, for nearly three hundred years. As there was little combat or fighting after the early years of the period, swordsmiths found that their work was no longer in demand. As a result, over a period of almost one hundred years—from the end of the 1600s until the end of the 1700s—the quality and design of the average sword declined. Many smiths were probably barely able to make a living during this time.

Beginning in the very late 1700s, swordsmith Suishinshi Masahide spurred a revival of interest in traditional Japanese swords. He traveled all over Japan to study old swords, sword-making, and steel-making, focusing particularly on famous Koto blades from the Kamakura and Nanbokucho periods. Masahide also trained numerous smiths—perhaps hundreds—during his career, bringing new attention to famous classical blades. The efforts of these smiths to make new blades as grand and functional as the Koto swords of yore marked the beginning of the Shin-shinto (new-new sword) era.

Shin-shinto blades were intended to be functional and effective for combat. Their shapes, steel, and hamon were clearly different from earlier swords (even though they were modeled on Kamakura-period examples), lending them a clear style and character of their own. These blades are often long and fairly straight with a narrow hamon, reflecting the influence of the older swords used as models.

The Shin-shinto era extended from Suishinshi Masahide's time (about 1780 or 1790) until the Meiji Restoration in 1868, when the Tokugawa shogunate was abolished and the authority of the emperor was restored. The social upheaval of the Bakamatsu era that marked the end of the Edo period (approximately 1800 to 1868) reinforced the demand for practical blades, stimulating sword production.

During the Edo period, the main branch of the Hon'ami school was the sole distributor of origami. These certificates, issued after an appraisal, stated the name of the smith, the length of the sword, its value, the appraisal date, and the name of the appraiser. The origami shown here is for a sword made by Yukimitsu, a Soshu school smith who was the father of Masamune. The appraiser was twelfth-generation Hon'ami Kojo.

EARLY EDO-PERIOD SWORDS

13. KATANA: Dewa-daijo Fujiwara Kunimichi

刀　銘：出羽大掾藤原国路

Important Cultural Property　重要文化財

Early Edo period　江戸時代初期

Length: 70.3 cm　　Sori: just over 1.5 cm

Kunimichi worked during the end of the Koto era and at the beginnning of the Shinto era. His teacher was Horikawa Kunihiro, one of the great early Shinto swordsmiths. This blade was made around the Keicho era (1596–1614) which is considered the beginning of the Shinto era. It is 27.6 inches long, with a very shallow curvature and a fairly large point. With its well-defined and finished tang, the blade appears robust and functional. The wide, irregular hamon is composed of gunome and choji that vary in size. This is a good example of the style of Shinto-era blades.

14. KATANA: Tsuda Echizen-no-kami Sukehiro
Enpo nana nen ni gatsu bi

刀　銘：津田越前守助広 延宝七年二月日

Important Cultural Property　重要文化財

Early Edo period　江戸時代初期

Length: 71.2 cm　　Sori: 1.5 cm

This is a dynamic and healthy blade from the Kanbun era (1661–72) with a spectacular toran hamon. Kanbun-era blades are characterized by their relatively straight shape. This one was made by Tsuda Sukehiro, who worked in the area around Osaka during the Shinto era. Sukehiro invented this hamon pattern, called "toranba," which was inspired by breaking ocean waves; it is characteristic of Shinto-era swords from the Osaka area, but also appears on blades from other areas.

LATE EDO-PERIOD SWORDS

15. KATANA: Zou Taikei Naotane (Kao) (stamp)
Tenpo go nen chushun

刀　銘：造大慶直胤（花押）天保五年仲春

Important Art Object　重要美術品

Late Edo period　江戸時代後期

Length: 72.4 cm　　Sori: 2.3 cm

This is a tachi made by Naotane, who is considered to be one of the five most important Shin-shinto smiths. The blade is dated 1834; like other swords made around this time, it was closely modeled on older Koto swords. It is a fairly straight blade, 28.3 inches long, and is in its original condition. The narrow hamon has a sawtooth appearance.

A Brief History of Tanto

Tanto Shapes and History

The Ju-to-ho (gun and sword law) enacted in Japan after World War II defines a tanto as any blade having a length of under 30 centimeters (approximately 12 inches). Before the law was in place, many blades longer than 12 inches were categorized as tanto. Sunnobi tanto, for example, were 13 to 14 inches (33–36 cm) long.

Generally speaking, josun no tanto (meaning roughly "normal-sized tanto") are representative of typical tanto. These blades are about 9.5 to 10 inches (24–25 cm) in length. There are some differences among josun no tanto, depending on the era in which they were made and the smiths who made them, but they are fairly similar in shape and dimensions. The mihaba (width) is usually about a tenth of the length, and the blades are mostly muzori (without curvature). A few josun no tanto have a very slight sori.

It is worth noting that tanto were never forged in an uchizori shape; that is, with the back surface curving down towards the edge. (Uchizori tanto are sometimes referred to as having takenoko-zori, or "bamboo-shoot curvature." There are written accounts as early as the Kamakura period describing tanto as uchizori, even if they were muzori (straight). In the late Muromachi period, for example, a short and thick tanto style became very popular. These were always described as uchizori or takenoko-zori, but they are actually muzori blades.

The curvature of a tanto is evaluated by looking at the line where the edge of the mune surface meets the side of the blade. Years of polishing and wear on a straight tanto will wear down this line, creating the appearance of an uchizori blade. That is, the height of the mune ridge will wear down faster toward the point, giving it an uchizori shape. Although the body of the tanto is straight, it appears to have reverse curvature.

There are not many tanto left today from the Heian period, but it is possible to discuss and compare tanto from the mid-Kamakura period. Some smaller tanto (approximately 8 inches, or 20 cm, long), as well as some sunnobi tanto (around 12 inches or 30 cm in length), still survive from this time. For the most part, these are muzori; a few of them exhibit slight curvature.

From the Nanbokucho period there are some josun no tanto of typical size, but there are also many Enbun-joji-gata tanto, which are large, very wide sunnobi tanto with noticeable curvature. These were quite popular at that time. During the early and middle Muromachi period, there are copies of Nanbokucho-style tanto and sunnobi tanto that are somewhat thin and have a shallow sori. From the late Muromachi period, the short, thick tanto mentioned above became popular, as did double-edged moroha tanto. From the beginning of the Shinto era, smiths made tanto in their own styles, and distinctive tanto were no longer associated with any particular era.

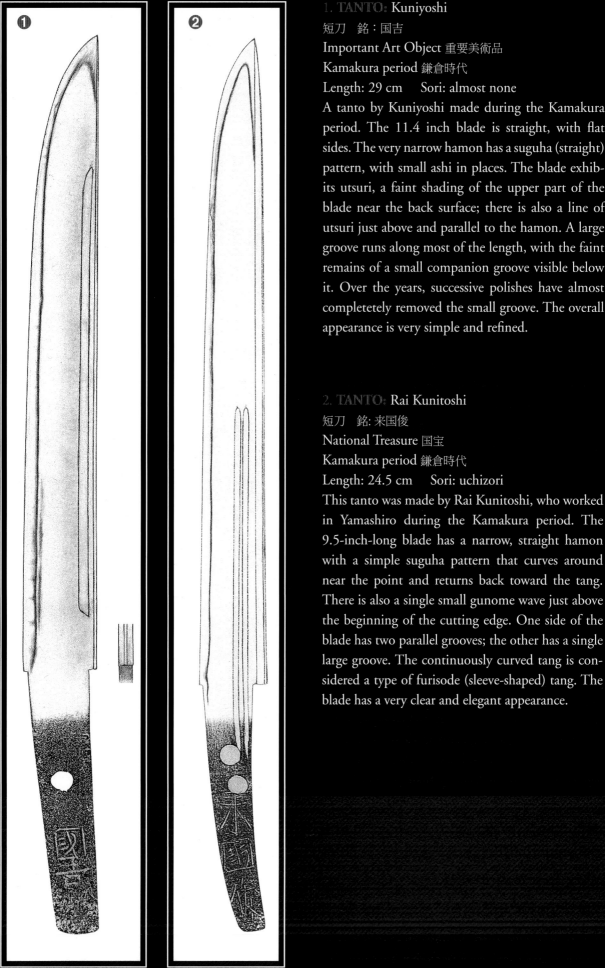

1. TANTO: Kuniyoshi

短刀　銘：国吉

Important Art Object 重要美術品

Kamakura period 鎌倉時代

Length: 29 cm　　Sori: almost none

A tanto by Kuniyoshi made during the Kamakura period. The 11.4 inch blade is straight, with flat sides. The very narrow hamon has a suguha (straight) pattern, with small ashi in places. The blade exhibits utsuri, a faint shading of the upper part of the blade near the back surface; there is also a line of utsuri just above and parallel to the hamon. A large groove runs along most of the length, with the faint remains of a small companion groove visible below it. Over the years, successive polishes have almost completetely removed the small groove. The overall appearance is very simple and refined.

2. TANTO: Rai Kunitoshi

短刀　銘: 来国俊

National Treasure 国宝

Kamakura period 鎌倉時代

Length: 24.5 cm　　Sori: uchizori

This tanto was made by Rai Kunitoshi, who worked in Yamashiro during the Kamakura period. The 9.5-inch-long blade has a narrow, straight hamon with a simple suguha pattern that curves around near the point and returns back toward the tang. There is also a single small gunome wave just above the beginning of the cutting edge. One side of the blade has two parallel grooves; the other has a single large groove. The continuously curved tang is considered a type of furisode (sleeve-shaped) tang. The blade has a very clear and elegant appearance.

3. TANTO: Masamune

短刀　銘：正宗（名物不動正宗）

Important Cultural Property 重要文化財

Owned by the Tokugawa Museum

Kamakura period 鎌倉時代

Length: 24.9 cm　　Sori: slight

This is a tanto by Masamune, one of the most fa-
mous swordsmiths in the history of Japanese swords.
He worked in the Soshu school in Kamakura during
the Kamakura period. This is a wide, heavy tanto just
under ten inches in length. The blade is straight, and
there are horimono (carvings) on both sides. One
side has two parallel grooves, and the other side has
a detailed horimono of a Buddhist deity. The hamon
features a very active series of variable gunome waves
with numerous other details within. There are also
many tobiyaki (hardened areas) above and along the
hamon. The tang appears to be its original size and
shape, and tapers toward the bottom.

4. WAKIZASHI: Sadamune with Hon'a kao

脇差　銘：貞宗（名物朱判貞宗）本阿花押

Important Cultural Property 重要文化財

Nanbokucho period 南北朝時代

Length: 33.78 cm　　Sori: 0.6 cm

This tanto was made by Sadamune, a Soshu school
smith who worked in Kamakura during the Nan-
bokucho period. Sadamune is thought to have been
a student of Masamune. This large, wide sunnobi
tanto could also be called a wakizashi, as it is over
13 inches long. The hamon, an irregular series of
rounded and pointed waves, has many details within
it. The are two large grooves on either side of the
blade, with the lower groove curving beyond and in
front of the upper groove. The mune has three sur-
faces, instead of the more common two surfaces that
meet in a sharp peak.

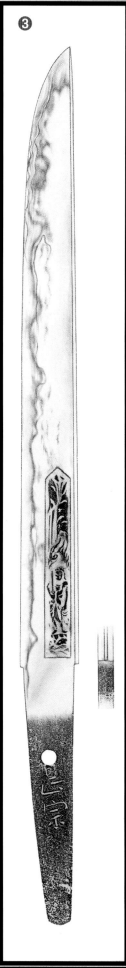

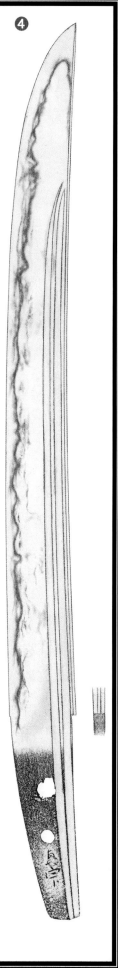

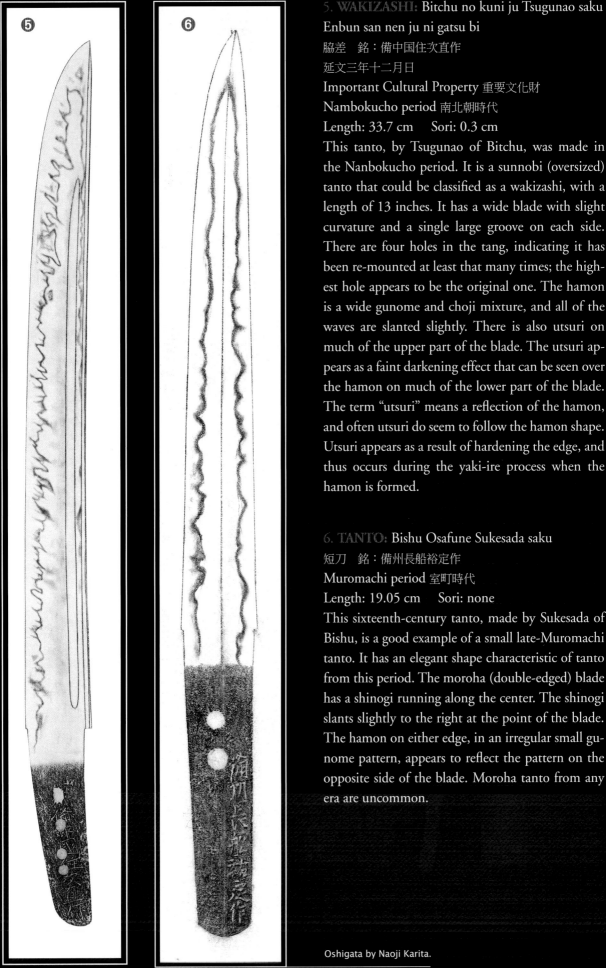

5. WAKIZASHI: Bitchu no kuni ju Tsugunao saku Enbun san nen ju ni gatsu bi

脇差　銘：備中国住次直作

延文三年十二月日

Important Cultural Property 重要文化財

Nambokucho period 南北朝時代

Length: 33.7 cm　　Sori: 0.3 cm

This tanto, by Tsugunao of Bitchu, was made in the Nanbokucho period. It is a sunnobi (oversized) tanto that could be classified as a wakizashi, with a length of 13 inches. It has a wide blade with slight curvature and a single large groove on each side. There are four holes in the tang, indicating it has been re-mounted at least that many times; the highest hole appears to be the original one. The hamon is a wide gunome and choji mixture, and all of the waves are slanted slightly. There is also utsuri on much of the upper part of the blade. The utsuri appears as a faint darkening effect that can be seen over the hamon on much of the lower part of the blade. The term "utsuri" means a reflection of the hamon, and often utsuri do seem to follow the hamon shape. Utsuri appears as a result of hardening the edge, and thus occurs during the yaki-ire process when the hamon is formed.

6. TANTO: Bishu Osafune Sukesada saku

短刀　銘：備州長船裕定作

Muromachi period 室町時代

Length: 19.05 cm　　Sori: none

This sixteenth-century tanto, made by Sukesada of Bishu, is a good example of a small late-Muromachi tanto. It has an elegant shape characteristic of tanto from this period. The moroha (double-edged) blade has a shinogi running along the center. The shinogi slants slightly to the right at the point of the blade. The hamon on either edge, in an irregular small gunome pattern, appears to reflect the pattern on the opposite side of the blade. Moroha tanto from any era are uncommon.

Oshigata by Naoji Karita.

Gendaito

Meiji Era (1868–1912)

Generally, swords made from the Meiji Restoration (1868) up until the present are considered to be modern or contemporary swords, and are referred to as "gendaito."

In 1876, the new Meiji government passed an edict called the "Haitorei," which prohibited the wearing of swords in public. This made it very difficult for a swordsmith to make a living, and consequently only a small number of smiths were able to continue to work. From this time, a large part of the value of traditional swords lay strictly in their value as art objects rather than as functional weapons.

During the Meiji era, the new government began to modernize the Japanese army and navy, and traditional swords were no longer a practical weapon for modern combat. Swords were still carried by military officers, but the Japanese tried to adapt their swords to modern combat conditions. In 1886, they introduced the gunto or military sword. The mounting was similar to that of European military swords, but with a long hilt and a D-shaped guard. However, the blade itself was a traditionally forged Japanese sword. It was usually a shorter blade about 24 to 25 inches (60–65 cm) long.

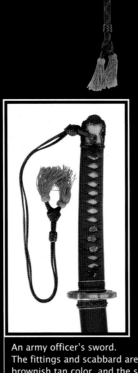

A World War II–period sword in a kai gunto mounting, the style made for naval officers. The scabbard is usually covered with sharkskin or ray skin, and there are two suspension rings to secure the sword to a belt or hanger.

An army officer's sword. The fittings and scabbard are a brownish tan color, and the scabbard is covered with a layer of sheet metal. This mounting is unusual because it has two rings and bands to suspend it from a belt. These swords usually have only a single band and ring.

Mounting for a Japanese sword from the Russo-Japanese War period (1904). These mountings often hold Koto or Shinto swords as well as contemporary swords made from modern steel. The wide D-shaped ring along the hilt is characteristic of swords from this period.

The staff, supporters, and administrators of the Nihonto Tanren Kai (Japanese sword forging association). This photo was taken on the grounds of Yasukuni Shrine on the first day of the group's operation in 1933.

In 1899, the Japanese began to mass-produce swords for the military. To control costs and time, however, the swords were made out of modern foundry steel and were forged using modern machines. The hamon were made by quenching the blades in oil rather than water. These swords were sometimes called "Murata-to" (Murata swords) in honor of one of the founders of the modern Japanese military forces.

In 1906, in an effort to support traditional sword craftsmen, the Meiji emperor named swordsmiths Gassan Sadakazu and Miyamoto Kanenori as "Teishitsu Gigei-in" (official craftsmen for the impe- rial household). Another measure taken to maintain interest and knowledge of Japanese swords was the nomination and recognition of important swords as national treasures. Begun in 1897, this was initially intended only to recognize swords owned by shrines and temples, but in 1929, the system was expanded to recognize any important sword, regardless of who its owner was.

MODERN ERAS (1912–PRESENT)

By the early 1920s, it would have been impossible for a swordsmith to make a living, and only a small number of smiths were keeping the craft alive. At this point, however, it was still possible to make a com- pletely traditional Japanese sword because the tech- niques and knowledge were still available, and the few swordsmiths still working had been trained by tradi- tional smiths.

The large expansion of the Japanese military forces in the middle of the Meiji era created a demand for swords, because the Japanese felt that military offi- cers should carry a fully traditional handmade sword. In order to revive the craft of sword-making, several organizations were created. These groups, which included the Nihonto Denshujo and the Nihonto Tanren Kai, were set up to train new swordsmiths and expand the pool of smiths who could make tra- ditional swords. Another aim was to provide a large number of traditional swords to meet the demand of the Japanese army and navy. The swordsmiths in the town of Seki were also very active in sword pro- duction.

THE NIHONTO TANREN KAI
AT YASUKUNI SHRINE

In 1933, a group of swordsmiths on the grounds of Yasukuni Shrine in Tokyo were organized into a sword-forging organization called the Nihonto Tanren Kai (Japanese sword forging association). Their purpose was to produce swords using tradi- tional materials in a completely traditional manner without the use of power tools or other modern tools.

The Nihonto Denshujo swordsmiths with the organization's founder, Hikosaburo Kurihara, in the early 1930s. Yoshindo and Shoji's father, Masahiro, their grandfather Kuniie, and Kuniie's brother Kuninobu are among the smiths standing in the background.

This group was shown works by Nagamitsu from the Kamakura period (1185–1333) and asked to use these examples as models for their swords. The specifications for these blades were extensive, and as a result, the Nihonto Tanren Kai developed a very specific style of sword that can be recognized by its shape and details. The Yasukuni smiths may represent the last example of a traditional school of sword-making. They developed their own style and a very high level of quality and workmanship. According to their records, 8,100 swords were made by these smiths from 1933 to 1945, and approximately thirty smiths and related people were trained during this period.

Qualified smiths trained by this group were given names beginning with the character "yasu" from Yasukuni. These included Yasutoku, Yasunori, Yasuoki, and so on.

A group of swordsmiths in Seki after the end of WW II.

THE NIHONTO DENSHUJO

The other major organization founded in 1933 to preserve the Japanese sword was the Nihonto Denshujo. This group, also located in Tokyo, was organized by Hikosaburo Kurihara. Kurihara, a member of the Japanese Diet (house of representatives), was asked by the Diet to do something to help preserve the Japanese sword. He organized and opened the Nihonto Denshujo on the grounds of his house in Tokyo, and apparently helped to finance it as well. He welcomed anyone who wanted to learn how to make Japanese swords, and hoped to use the organization to train about a thousand smiths. Kurihara's efforts made him a key figure in the movement to preserve the craft of the Japanese sword. He trained about 150 smiths at the Denshujo, and later opened a sister organization called the Nihonto Gakuin, which also trained swordsmiths. The importance of Kurihara's organization is demonstrated by the fact

that most of the swordsmiths who were named Living National Treasures after the war were trained by the Denshujo or by someone who learned their craft at the Denshujo.

As there were no students at the Denshujo when it opened, Kurihara advertised in newspapers to recruit students. The first student to respond to the advertisements and enter the Denshujo was Kuniie Yoshihara, grandfather of Yoshindo and Shoji Yoshihara. Kuniie was not only the first student, but he also later became the head of the Denshujo's sister organization, the Nihonto Gakuin, when it was founded. The students lived and worked at the Denshujo. When one was considered competent as a swordsmith he was given a name containing a character from Kurihara's name. Most of the Denshujo's students signed their work with a name beginning with the character for "aki": Akihiro, Akitomo, Akifusa, and the like.

An exhibition of new swords was planned in Tokyo shortly after the founding of the Denshujo; however, not enough swords could be found for the exhibit. At this time (1934), there were fewer than fifty traditional swordsmiths known to be active in Japan, but by 1942 this number had grown. On the annually published table showing the most popular swordsmiths working in Japan, Sadamitsu Gassan was listed as the foremost smith in western Japan in 1942. In eastern Japan, the most influential smith was Kuniie Yoshihara.

THE TOWN OF SEKI

The town of Seki has been a center for Japanese sword production for approximately seven hundred years, and was active as part of the Mino tradition of the Gokaden (five schools). It is sometimes said that a majority of the swords made in

RANKING AND TITLES OF SWORDSMITHS IN 1942

西　　　　　　　　　　　　東

現代刀匠人氣大番附

This 1942 table showing the ranking of all swordsmiths gives an idea of how many smiths were active before the end of the war. Smiths from western Japan are listed on the left half of the table; those from eastern Japan are on the right half of the table. The number-one ranking smith from the east (essentially the Tokyo area) is Kuniie Yoshihara, Yoshindo and Shoji's grandfather. The table shows his title as "Yokozuna," the equivalent of "Grand Champion." The yokozuna for western Japan is Sadamitsu Gassan, who became a "Ningen Kokuho," or Living National Treasure, in the 1960s.

Japan during the Edo period (1603–1867) were made in Seki. It was not a large town, and by the end of the Meiji period it was estimated that about half of the population of thirty thousand were involved in some aspect of sword production. Seki had an organization called the Seki Tanren Jo, founded in 1907, which consisted of swordsmiths and others who tried to promote and protect the craft of traditional sword-making. The group secured financial support for its swordsmiths from the Gifu prefectural government and other sources. In 1933, in an effort similar to those of the Denshujo and Yasukuni's Nihonto Tanren Kai in Tokyo, the Nihon Token Tanren Jo was organized to train new swordsmiths in Seki.

SHOWA-TO

One important result of the large demand for Japanese swords by the Japanese military was the production of Showa-to, or Showa-era swords. This name refers to many of the swords made in the Showa era (1926–89), especially beginning in the early 1930s. These blades look like traditional Japanese swords, but were made from modern foundry steel instead of the traditionally smelted tamahagane. Although they have the shape of traditional swords, and may also have a hamon or hardened edge, it is clear to anyone familiar with Japanese swords that they do not have the characteristic steel surface and surface pattern (jihada). In addition, the quality of the hamon, if present, is different from that seen in traditional swords made out of tamahagane.

It was far less expensive (in terms of labor and material) to make swords from modern steel recovered from worn railroad tracks and from structural steel recovered from buidings being demolished than from new tamahagane. Because soldiers had to buy their swords themselves, many of them needed a cheaper alternative to traditionally made modern blades, which were very expensive. Showa-to mass-produced wartime blades were often very well made, and someone who was not knowledgeable about Japanese swords often could not tell the difference between mass-produced Showa-to and traditionally made blades.

The difference in price between these swords, however, was very large. A high-quality sword from Yasukuni's Nihonto Tanren Kai could sell for as much as the work of some of the best smiths from the early Edo period (about 100 to 125 yen at the time). The best Showa-to, on the other hand, might sell for about 60 yen, and lower quality Showa-to would sell for even

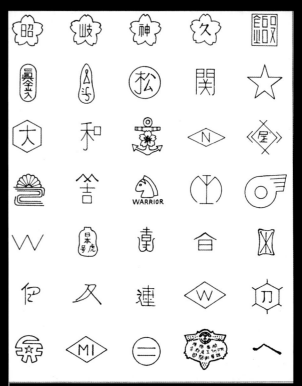

This table shows many of the stamps that may be seen on World War II–era swords. Any sword made from salvaged or other steel that was not traditional tamahagane was required by law to have some kind of stamp on the tang. The stamps shown in this table, which was compiled by Richard Fuller, are commonly seen on swords made for Japanese military personnel before 1945.

less—about 25 yen. To make it easier for buyers to identify Showa-to, in 1937 the government decided that every non-tamahagane blade must have a stamp on the tang to indicate that it was not traditionally forged. Showa-to were required to have a stamp on their tangs by 1940.

Sword production in the town of Seki serves as an example of the scale of wartime production of Showa-to. The town shipped about eighteen thousand swords per month to the Japanese army and navy during the late 1930s and mid-1940s. Of these, about seventeen thousand were mass-produced Showa-to; the rest were traditionally forged swords made from tamahagane.

Because of the large-scale production of Showa-to, a general perception arose that wartime swords in Japan were of poor quality when compared to older swords made in historical times. In fact, blades made from tamahagane at this time were excellent, being equivalent in quality to older blades made before the Meiji Restoration.

SWORDS AFTER WORLD WAR II

After the end of the war in 1945, the production of all weapons was prohibited in Japan. In addition, the occupation forces began to confiscate all weapons, including swords. The confiscation of traditional Japanese swords continued for almost a year, until the American authorities finally decided that traditional swords were not modern weapons but had cultural and artistic value, and that they would no longer be confiscated. During this period, however, the occupation authorities had a very large number of swords stored in armories in Japan, and any serviceman could ask for swords to take home as souvenirs. Many servicemen did so, and brought the swords home to the United States and Europe. As a result, there may have been more Japanese swords in the United States in the 1950s than in Japan.

Since weapons production was completely prohibited, no Japanese swords were made from the end of the war in 1945 until 1951. Hikosaburo Kurihara, the founder of the Nihonto Denshujo, began to organize a project to have three hundred new swords made to commemorate the end of the war and the founding of the United Nations. These swords were to be presented to national leaders around the world. In 1952, the Japanese government gave Kurihara permission to begin the project, and within a month he had traveled all over Japan to meet with swordsmiths and ask them to participate. The project began and some of the swords were made, but Kurihara fell ill and passed away in 1954.

Even though it ended with Kurihara's death, this project was very important because it pushed swordsmiths into once again making Japanese swords in a fully traditional manner. Many of the swordsmiths who resumed working at that time,

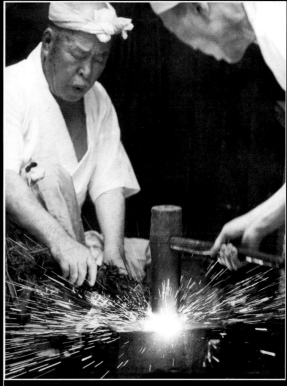

Yoshindo's grandfather, Kuniie Yoshihara.

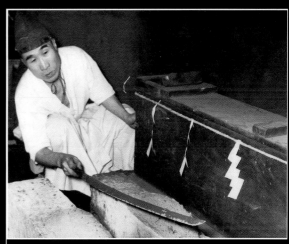

Yoshindo's father, Masahiro Yoshihara.

including Kuniie Yoshihara, Yoshindo's grandfather, said they might never have gone back to making swords if Hikosaburo Kurihara had not organized this effort. Yoshindo himself began working with his grandfather then, and assisted him in making a sword for Kurihara's project. From this point on, swords were once again made in Japan, although the economics and politics involved were very different from the past. Still, it was possible to make Japanese swords in 1952 because all of the traditional techniques, as well as the knowledge and skills to make tamahagane, had been preserved intact from the feudal past.

MAKING SWORDS IN TODAY'S WORLD

Although the Japanese government allowed swordsmiths to resume making new swords in 1953, some restrictions were put in place that still apply today. The primary concern was that swordsmiths make only high-quality traditional swords. To insure this, a limit was put on the number of swords a smith could make. After carefully watching Yukihira Miyairi, one of the preeminent smiths working at that time, the authorities determined that he could produce approximately two swords a month. They therefore decided to restrict smiths to making two long swords or three shorter blades (such as waki-zashi or tanto) per month. This would allow smiths to make a reasonable living in postwar Japan while assuring the quality of their production.

The reason that such restrictions could be enforced was because of the Ju-to-ho (gun and sword law), which was passed after the end of the war. This law requires that all Japanese swords be reported to the local police and be registered. If an unregistered sword is found, the owner could be subject to legal penalties. In addition, polishers or other craftsmen may not work on unregistered swords, and dealers may not buy or sell them. If a smith makes a new sword, it must be registered. Only licensed smiths can register new swords, and they must receive permission to do so from the government. To receive a license as a swordsmith, a new smith must undertake a five-year apprenticeship with a currently licensed swordsmith, and then make a sword from scratch in front of a committee of licensed swordsmiths.

These are demanding requirements, so it is not easy for young people to become licensed swordsmiths in Japan today. There are several hundred licensed smiths, some of whom make a full-time living from sword-making. Others may make a few swords a year, and do other types of forging and cutlery work for their main income.

THE NIHON BIJUTSU TOKEN HOZON KYOKAI (NBTHK)

The title of this organization can be translated as the "Society for the Preservation of Japanese Art Swords." This organization (usually referred to by

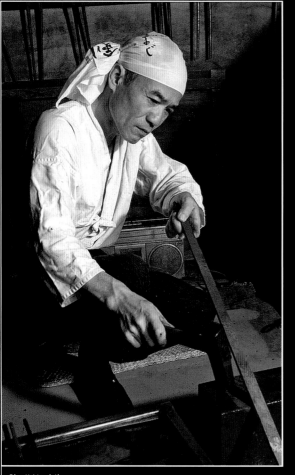

Shoji Yoshihara.

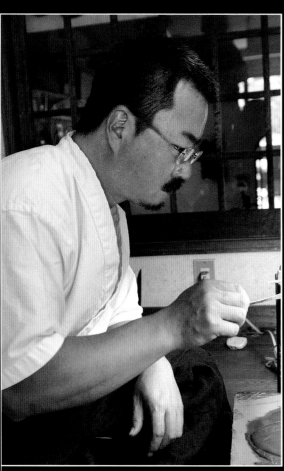

Yoshikazu Yoshihara.

its initials) was founded shortly after the end of the war to support all matters related to traditional Japanese swords. The NBTHK is a quasi-governmental organization that supports activities related to the appreciation and preservation of Japanese swords. These include the publication of a monthly sword journal, regular meetings to examine and study swords, formal appraisal meetings at which swords are examined and given appropriate papers to indicate their quality and provenance, and other activities to promote the study of Japanese swords and support Japanese sword craftsmen. The NBTHK building in Yoyogi, Tokyo, contains a sword museum.

The NBTHK also organizes an annual competition and display called the "Shinsaku To Mei To Ten" (competition of newly made swords). Swordsmiths enter one of their newly made swords in the contest, and all entries are scored and ranked. The top-scoring swords receive prizes, and all of the swords are displayed in Tokyo after the competition. When a smith has won a number of the top prizes, he receives the title or rank of mukansa, which means "no judgment." From this point on, his work is no longer subject to judging; it is only put on display. A smith who is selected to receive the title of Juyo Mukei Bunkazai (colloquially, "Living National Treasure") will be selected from among the mukansa-level smiths. The annual competition is important to young smiths for another reason, as well: as they place higher in the competition and win more honors over time, they can command higher prices for their work. For a young smith to eventually make a living as a swordsmith, he must do well in these annual competitions.

THE TATARA

Japanese swords are made from a very specific type of high-carbon steel called "tamahagane," which is made in a traditional Japanese smelter called a "tatara." Tamahagane is essential for making traditional Japanese swords, as the qualities and properties of the sword are associated with the characteristics of the steel it is made from. Tamagahane has been made in tatara for as long as swords have been made in Japan; Edo-period tatara were based on designs that originated in the fifteenth century during the Muromachi period. These tatara smelters were common in Japan until the twentieth century.

Before the end of the war in 1945, tatara smelters had ceased operation, having been displaced by modern steelmaking technology. In the 1970s, however, the NBTHK decided that it was necessary to support the operation of a tatara to produce tamahagane for making new swords in the twentieth century. They were able to obtain and activate a tatara in the city of Yokota, in Shimane Prefecture, that had been in operation until the end of the war. This tatara, which had been constructed to provide tamahagane for the swordsmiths working at the Nihonto Tanren Kai in Yasukuni Shrine, had produced tamahagane from 1933 to 1945, but had been closed at the end of the war and had remained idle since then. Two of the people responsible for operating the tatara before the war, Yoshizo Abe and Kenji Kumura, were located and given the title of Living National Treasure, and the tatara began operations once again in 1977. It currently provides most of the tamahagane used in Japan for making traditional swords.

SWORDSMITHS TODAY

The Japanese sword has a very long history, and has evolved continuously in response to changing demands made on the weapon. Today, these swords are primarily objects of art, although many people still use them to practice traditional Japanese martial arts. Despite its long history, the essential technology, shape, character, and features of the Japanese sword that we recognize today were perfected during the middle to the end of the Kamakura period in the twelfth and thirteenth centuries. Although the sword did continue to change from the thirteenth century to the end of the feudal period in 1868, these later changes were made within the framework and technology developed in the Kamakura period. Even today, swordsmiths still strive to make better swords, and have a wealth of modern technology, metallurgy, and advanced scientific understanding of steel to draw on. However, any changes must occur inside of the framework that defines a classical or traditional Japanese sword.

The remaining sections of this book describe the operation of the tatara and the making of tamahagane, and the making of a Japanese sword by Yoshindo Yoshihara. Yoshindo prefers to work in the Bizen style of sword-making, and his work clearly reflects this. Some recent examples of his swords are shown on the following pages, along with works by his son Yoshikazu and his brother Shoji.

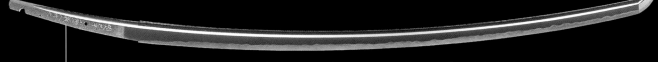

This is an utsushimono (a new sword made in the same style as an extant older sword) made by Yoshindo. It is modeled after a sword called "O-Kanehira," which was made at the end of the Heian period in the twelfth century. The O-Kanehira sword, a national treasure, has been preserved in almost perfect condition. It is a very long blade with a length of about 36 inches (90 cm), and is very wide with a strong curvature. The shape and form are very good, and it is very well balanced and comfortable to handle despite its imposing size. The hamon is somewhat narrow for the width of the blade; it is composed of gunome and choji waves with many ashi. The irregular notch and extra mekugiana on the nakago are exact copies of the details of the nakago on the actual O-Kanehira. That sword is a remarkable example of the blades that were being made in the twelfth century even before the beginning of the Kamakura period.

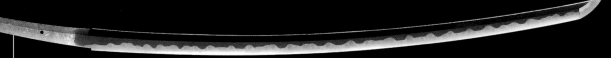

This is a large tachi-style sword made by Yoshikazu. It has a wide blade, a strong curvature, and a variable choji hamon. It is made in the style of a Bizen sword from the thirteenth century.

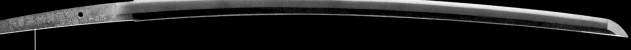

A short katana made by Yoshindo's grandfather Kuniie. This is a graceful and somewhat light blade made in the early 1940s. It is a bit unusual for Kuniie's work because it has a suguha (straight) hamon.

This utsushimono by Yoshindo is a copy of an important sword from the eighth century that has been preserved in the Shoso-in storehouse at Nara. It is a straight sword with a very low shinogi just above the cutting edge. It has silver inlay work depicting a series of clouds along the blade. This sword was made in 2009.

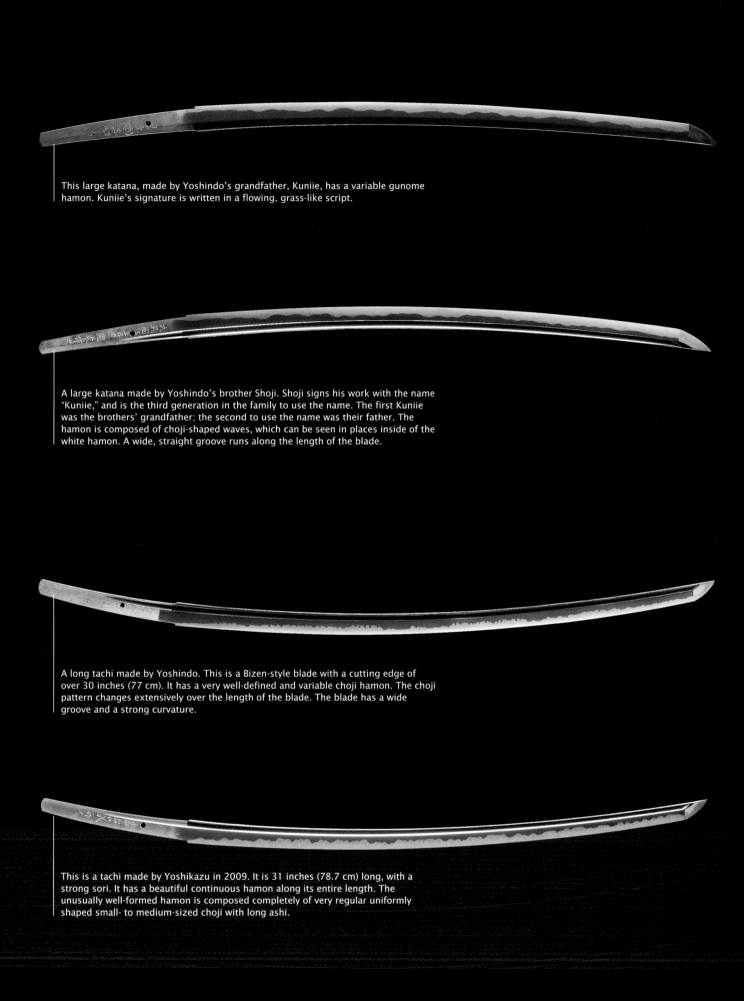

This large katana, made by Yoshindo's grandfather, Kuniie, has a variable gunome hamon. Kuniie's signature is written in a flowing, grass-like script.

A large katana made by Yoshindo's brother Shoji. Shoji signs his work with the name "Kuniie," and is the third generation in the family to use the name. The first Kuniie was the brothers' grandfather; the second to use the name was their father. The hamon is composed of choji-shaped waves, which can be seen in places inside of the white hamon. A wide, straight groove runs along the length of the blade.

A long tachi made by Yoshindo. This is a Bizen-style blade with a cutting edge of over 30 inches (77 cm). It has a very well-defined and variable choji hamon. The choji pattern changes extensively over the length of the blade. The blade has a wide groove and a strong curvature.

This is a tachi made by Yoshikazu in 2009. It is 31 inches (78.7 cm) long, with a strong sori. It has a beautiful continuous hamon along its entire length. The unusually well-formed hamon is composed completely of very regular uniformly shaped small- to medium-sized choji with long ashi.

TANTO BY YOSHINDO

This is a sunnobi (large) tanto. It is about 13 inches (33 cm) long, with flat sides and some curvature. It features a large straight groove with a smaller soe-bi (companion groove) just below and parallel to it. The hamon is composed of slanted large choji loops. With its wide flat shape, curvature, and slanted hamon, the blade resembles Aoe-school work from the Muromachi period.

This is a hira-zukuri-style flat tanto with no curvature. It has a simple straight hamon and presents a very elegant and simple appearance. The horimono (carvings) are Sanskrit characters, or bonji. Both the horimono and the blade were made by Yoshindo.

A katakiriha tanto about 12 inches (30 cm) long. The blade has a flat hira-zukuri shape on one side (not shown) and a shinogi very close to the edge on the side shown here. It is straight, with no curvature. The hamon, formed of simple, regular gunome-style semicircles, is restricted to the area under the shinogi on the side shown. The blade is signed on the other side. This type of tanto is relatively heavy because of its thick body.

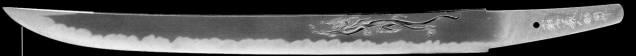

This is a large tanto with a length of about 18 inches (46 cm). Its size, weight, and well-formed hamon give it an imposing appearance. It has wide, flat sides and some curvature. The hamon is formed of small, slanted choji waves. There is a horimono of a tiger near the base of the blade. Both the blade and the horimono were made by Yoshindo.

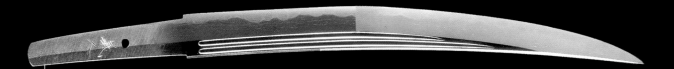

This style of tanto, called "osoraku," first appeared during the Muromachi period. An osoraku tanto has a well-defined point extending over 50 to 60 percent of the length of the blade (depending on the exact style in which it is made). This tanto makes a strong impression on the viewer. The hamon is formed of small, uniformly shaped gunome waves, and there are two parallel grooves above the shinogi.

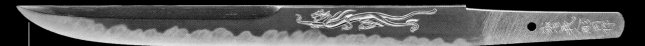

A kanmuriotoshi-style tanto. This blade is about 12 inches (30 cm) long, with flat sides and a horimono of a tiger. A wide bevel begins just above the tiger horimono and extends almost all the way to the tip of the point. The hamon is composed of small, well-formed, slanted choji and gunome waves.

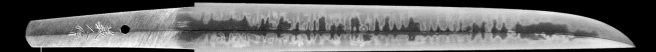

A moroha tanto. This shape, which is uncommon for tanto, is double-edged, with a hamon along each edge. The blade has a shinogi line along the center that curves as it reaches the tip of the blade. The hamon is composed of a complex and variable series of small, well-defined, high choji. The hamon on the two edges come close to each other near the shinogi line, and are mirror images in places. The overall impression of this style of tanto is very striking, especially with the spectacular appearance of the double hamon.

This is a small tanto with a length of about 9 inches (20 cm). It has a hira-zukuri shape and no curvature. The simple narrow hamon is composed of small regular gunome waves. There are two parallel straight grooves along the bottom portion of the blade, ending in carved round ends toward the tip. This elegant style of tanto, sometimes called a "kaiken" (concealed) tanto, was often used by women.

Traditional Japanese Steel-making

TAMAHAGANE AND THE TATARA
Traditional Japanese Steel-making

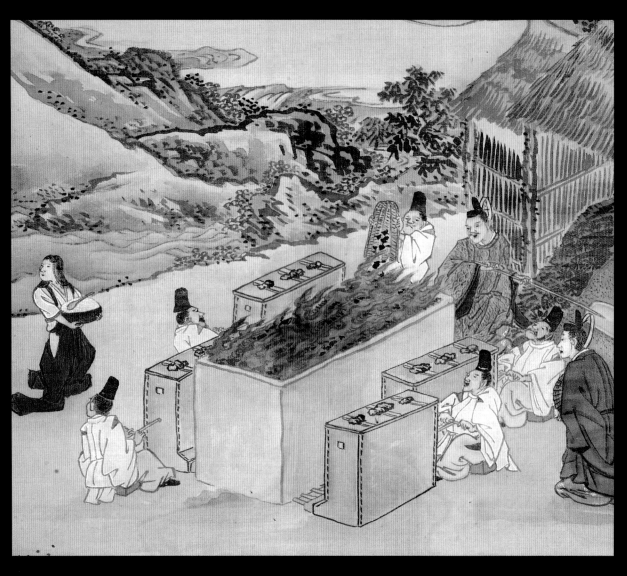

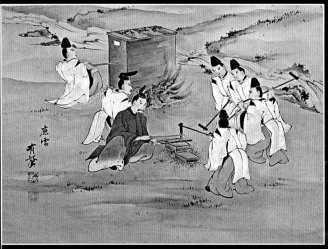

These paintings from an Edo-period screen show the operation of an outdoor tatara. The top painting shows four fuigo (bellows) being operated to supply air to a single tatara furnace. The lower painting shows sakite (assistants) hammering a piece of steel for a swordsmith. The fuigo in the background of the lower painting is being used to heat the steel for hammering. These paintings were preserved by Akira Kihara, and are reproduced with permission.

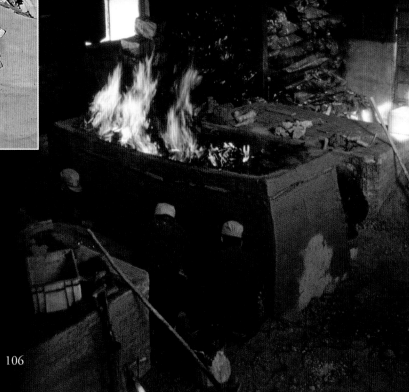

A unique component of traditional Japanese swords is the steel they are made from. This steel, called "tamahagane," is made in a Japanese-style furnace or smelter called a "tatara." Steel made from tamahagane has characteristic properties that contribute to the nature and qualities of the Japanese sword. It has a high carbon content, and it is very tough, allowing it to bend or deform without cracking or fracturing; it is also easy to weld.

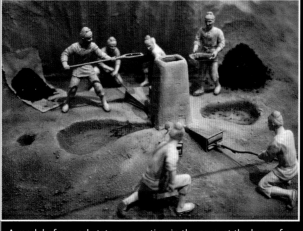

A model of an early tatara operating in the open at the base of a slope. The size is small compared to Edo-period tatara.

The tatara process has exerted a great influence on Japanese culture and history. It is still used today in the Chugoku region (in western Honshu, near the Japan Sea). The wako it produces is a very interesting and valuable material: Japanese swords made from wako are superior to those made even from modern steels. This chapter describes the history and characteristics of the tatara process and wako steel. The details of the tatara and its operation as described here date back to the Edo period.

Due to its composition, the steel can be hardened through heat-treating, making it possible to create the distinctive hamon on the sword's cutting edge. Steel made from tamahagane can be polished so that all of the details in the hardened edge and the features in the steel composing the body of the sword are revealed.

In prehistoric times, iron was imported into Japan from China and the Korean peninsula. Based on indigenous iron-making technology and influences from China and Korea, the Japanese developed their own smelting method, the tatara process, to produce pure iron and steel in the fifth or sixth century, when steel swords first appeared in Japan. This process uses satetsu, high-quality Japanese iron ore in a fine sand form, along with a large amount of charcoal, and produces a high-quality steel called "wako." The tatara method was developed and improved over the centuries. Starting in the Muromachi period, steel production became possible on a large scale, allowing smiths to produce large quantities of high-quality steel for making swords, carpenter's chisels, kitchen knives, and other edged tools. The tatara smelters operating around Japan provided most of the tamahagane used for swords from this time until the Meiji era, in the late nineteenth century.

THE WAKO MUSEUM AND THE NITTOHO TATARA

The Wako Museum, in the city of Yasugi, Shimane Prefecture, is the only museum in Japan to feature exhibits detailing the complete history and characteristics of the tatara process. Yasugi is located near the Chugoku mountain range, where numerous tatara operating sites existed for a long period. As the area also contains an excellent harbor, Yasugi had a history of prosperity as a port for shipping iron. In 1899, when the introduction of modern iron manufacturing processes using a blast furnace had displaced the tatara, some tatara operators established a new steel-making company in Yasugi. Since then, Yasugi has been widely known as "Steel Town." The Wako Memorial Museum, the predecessor of today's Wako Museum, was established by the Hitachi Metals Company in 1946. When the city of Yasugi opened the Wako Museum in 1993, it inherited historically important cultural assets from the Wako Memorial Museum.

As previously described, tatara operations in Japan ceased in 1945; however, people who valued traditional Japanese swords and culture made a determined effort

to revive this technology. The Society for the Preservation of Japanese Art Swords (NBTHK) restored the Nittoho Tatara in Yokota, Shimane Prefecture, in 1977, and started supplying tamahagane to Japanese swordsmiths every year. Because of this, an invaluable aspect of traditional Japanese culture has been preserved.

Iron Production and Steel-making with the Tatara

According to archaeologists, iron ware and raw iron were introduced into Japan from China and the Korean peninsula. The tatara process for iron and steel production dates back to the sixth century in Japan. A model of an ancient tatara operation at the foot of a slope is shown in the illustration on page 107.

During the Heian and Kamakura periods, there was a huge demand for weapons and tools, and accordingly, the technology for iron smelting with the tatara improved continuously. An advanced technology for iron production using the tatara process was developed in the seventeenth century during the Edo period, and since then the modern tatara process for smelting has remained largely unchanged.

Records show that 70 to 80 percent of the Japanese steel production that used this method was located in the Chugoku region of Japan, which is the westernmost area of the main island of Honshu. As this area

An Edo-period painting of Kanayago, the goddess of iron.
Reproduced with permission of Akira Kihara.

had both large quantities of good quality charcoal and abundant satetsu (iron sand ore), it was ideally suited for tatara operations.

Although the tatara process for producing iron and steel reached its most advanced stage during the latter part of the Edo period and the beginning of the Meiji era, the demand for iron gradually increased to the point that the tatara process was unable to meet it, and by 1925, tatara production had almost disappeared. Only the Yasukuni tatara, which was temporarily revived in the late 1930s to provide traditional steel for Japanese swords, was partially active. At the end of the Second World War, use of the tatara production method ceased completely.

In the postwar years, however, traditional Japanese steel again began to be sought. This eventually led to the resurrection and preservation of tatara technology, which is now considered to be an important Japanese cultural asset. To this end, in 1977 a facility was set up in the city of Yokota, in the Chugoku region, to produce steel in a tatara using charcoal. The facility was located on the grounds of the Hitachi Metals Company. Today, iron and steel production takes place during two or three runs of the tatara in the winter, when humidity and temperatures are low. The steel that is produced from these efforts is distributed to swordsmiths to use in making traditional Japanese swords.

According to historical documents, during the Nara period in the eighth century the annual production of steel in Japan was approximately 110 tons, or 100 metric tons. In the Azuchi-Momoyama period at the end of the sixteenth century this was estimated at 1100 tons (1000 metric tons) per year; in the Edo period (1603–1867), 11,000 tons (10,000 metric tons) per year; and in the Meiji era around the turn of the nineteenth century, approximately 16,500 tons (15,000 metric tons) per year.

Tatara Features

Either iron or steel can be smelted in a tatara; the process of producing high-carbon steel directly is called "keraoshi," while zuku (pig iron) is produced with the zukuoshi process. The historical tatara has several key features. First, the technology uses large quantities of iron sand and charcoal. The furnace, which consists of a rectangular box constructed from clay, incorporates an elaborate underground structure to

prevent heat radiation and moisture absorption. A further key point is that the slag produced in the smelting of iron sand is generated by the deterioration and oxidation of the clay furnace walls.

Raw Materials Used for Iron Production

IRON SAND

In general, iron sand serves as the raw material for iron production in Chugoku. This material, which consists of weathered granite, contains about 58 percent iron along with very small amounts of titanium and other impurities. The quality of iron sand from the Chugoku region is better than that in other regions in Japan. In ancient times, iron sand was extracted by digging a hole and excavating the soil in the mountains. Later, to improve productivity, the technique was altered to involve digging away an entire mountain slope manually to extract iron sand. The extracted mixture of earth and sand was then washed by transporting it through a water channel or canal. This method used gravity to separate the iron sand from the other materials in the soil, with the heavier iron sand settling to the bottom of the water channels faster than the other material. Most of the iron sand mined in this way was used in tatara smelters operating in the Chugoku mountains; some was sent to Yasugi, a central location from which steel was shipped all over Japan.

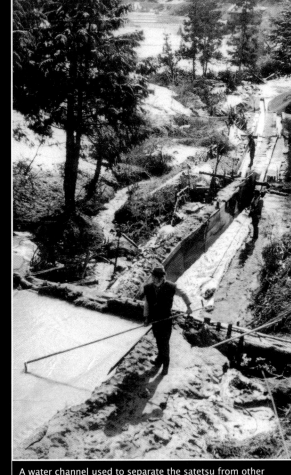
A water channel used to separate the satetsu from other materials in the soil by washing.

There are two types of iron sand: masa and akome. Masa iron sand has a larger particle size and is easy to separate from the other associated material. It is used when making high-carbon steel by the keraoshi method described in this chapter. Akome sand is finer, and is difficult to separate from other associated material. Akome sand is used to produce pig iron with the zuku-oshi smelting method. The chemical compositions of masa iron sand, akome iron sand, river iron sand, and beach iron sand are shown in Table 1. Note that the levels of impurities such as titanium and other elements in masa iron sand are very low.

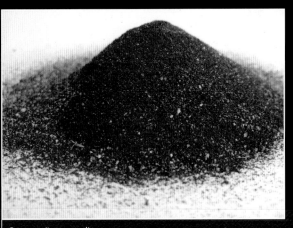
Satetsu (iron sand).

	Total Fe	Fe_2O_3	FeO	SiO_2	Al_2O_3	TiO_2	P	S
Masa iron sand	59.00	64.45	24.72	8.40	2.34	1.27	0.064	0.009
Akome iron sand	52.07	52.71	19.55	14.50	4.98	5.32	0.095	0.026
River iron sand	62.55	64.84	22.13	2.24	4.51	5.23	0.061	0.014
Beach iron sand	59.00	56.87	24.72	4.90	1.79	6.98	0.121	0.032

Table 1. Chemical elements (shown as a percentage of mass) in different types of iron sand.

CHARCOAL

Traditional charcoal is prepared so that the form and shape of the wood are preserved; it is brittle, and will break if struck. Charcoal cut into large pieces is used in the tatara process for iron smelting, while charcoal cut into smaller pieces is usually used in the forge by blacksmiths or swordsmiths. For small-sized charcoal, which is only used to generate heat, the type of tree the charcoal comes from generally does not matter. However, it is very important in the tatara process.

Tatara charcoal is made by professional craftsmen using selected trees at a designated facility to insure the proper quality and quantity of iron production. The trees used for producing tatara charcoal are usually 6 to 9 inches (15–20 cm) in diameter, and are thirty to forty years old on average. It is estimated that 14.3 to 16.5 tons (13–15 metric tons) of charcoal are required to produce a kera, or slab of steel, in one run of the tatara. To make this much charcoal requires at least 2.5 acres (1 hectare) of forest. If the tatara operation takes place sixty times a

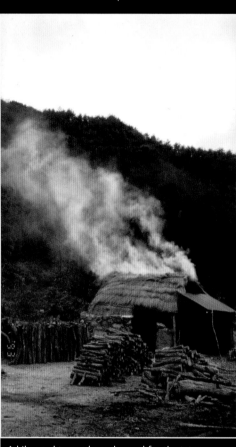

A kiln used to produce charcoal for the tatara.

year, therefore, 150 acres (60 hectares) of trees are required annually to support tatara operations. Clearly, a large forest area is required for continuous tatara operations: over a thirty- or forty-year period, the total forest area needed would be 4500 to 5250 acres (1800–2400 hectares). The abundant forest in Shimane Prefecture, along with the area's monsoon weather pattern, which is favorable for the rapid growth of trees, make it an ideal place for tatara operations.

Different techniques are used for tatara charcoal production in different places. However, the primary objective of each technique is to obtain a reducing flame during the smelting operation. Studies have shown that pine, chestnut, and oak are the best raw materials to make charcoal for the tatara operation. Japanese cedar can be used, but it is not as effective as pine and oak. Cherry and hornbeam are not effective for smelting. Under the tatara's operating conditions, pine and chestnut burn very rapidly, and therefore raise the tatara temperature rapidly, but these woods can only burn for a short time. These types of charcoal are used only when a high temperature is required for a very short time.

If the cross-section of charcoal is observed with a scanning electron microscope (SEM), a honeycomb structure can be seen, as in the photos at left. The pores of pine charcoal have a larger diameter than oak charcoal, while oak charcoal has thicker cell walls than pine charcoal. As it is easier for oxygen to penetrate through the larger pores, combustion takes place faster when pine charcoal is used, rapidly generating a high temperature inside the tatara furnace. In contrast, the structure of oak charcoal results in a slower burning rate and a longer combustion period at a constant temperature, giving it a longer useful life. It is used once tatara operations are underway.

Scanning electron microscope (SEM) photos of red pine charcoal (left) and oak charcoal (right) in cross-section.

Tatara Construction and Operation

Iron Smelting in the Tatara

CONSTRUCTION OF THE TATARA FURNACE

Early versions of the tatara, called "no-tatara," were small vertical furnaces constructed at the base of a mountain slope. As they were operated in the open air, rain would delay or halt the smelting process. In times of civil wars, when there was a huge demand for arms, tatara operations in open fields gave way to new type of tatara called "eidai tatara." These furnaces, developed during the Muromachi period, protected smelting operations from rain and weather so that iron could be continuously produced on a larger scale. Eidai tatara were operated inside a square building roughly 60 feet (18 meters) on each side. This simple building, which was roofed with chestnut wood, had storage areas where raw materials such as iron sand, clay, and charcoal could be stored.

The success of the tatara operation has to do with how the furnace is constructed. Successful operations depend on the type of kiln used, the type of clay used, and the skill of the murage (the person responsible for overseeing the construction and operation of the tatara). The selection of clay for the kiln, and the ratio of masa iron sand to charcoal used during the tatara process, were important secrets that the tatara operators would not re-veal. To date, this information has not been found in any historical sources.

The complex underground structure of the tatara is approximately 10 to 13 feet (3–4 m) deep; 15 to 20 feet (5–6 m) wide; and 13 to 16 feet (4–5 m) long. A drain is constructed in the lowest sections. The upper zone of the drain is composed of a mixture of round stones, shingles, and dry clay that have all been pressed together to compact the materials. In addition, there are two open channels where firewood is burned to thoroughly dry the surrounding clay and soil before the smelting process begins. When all of the wood in these channels is burned, the floor of the tatara area is cleared of ashes. Firewood is then piled in the tatara, burned, and converted to charcoal, which is crushed. This process is then repeated, thereby forming a bed of carbon.

At this point, the rectangular tatara furnace is built over the carbon bed. This structure is approximately 10 feet (3 m) long; 4 feet (1.3 m) wide; and 3.9 feet (1.2 m) high. The bottom section of the furnace is sloped so that molten material can flow out. Firewood is stacked inside of the furnace and burned for one day to ensure that the furnace is completely dry. It takes approximately one hundred days and three hundred man-hours to build the underground tatara structure. About 11 tons (10 metric tons) of firewood are burned to dry the tatara completely during this process. A drawing of the underground structure of the tatara and its appearance during operations is shown on page 114.

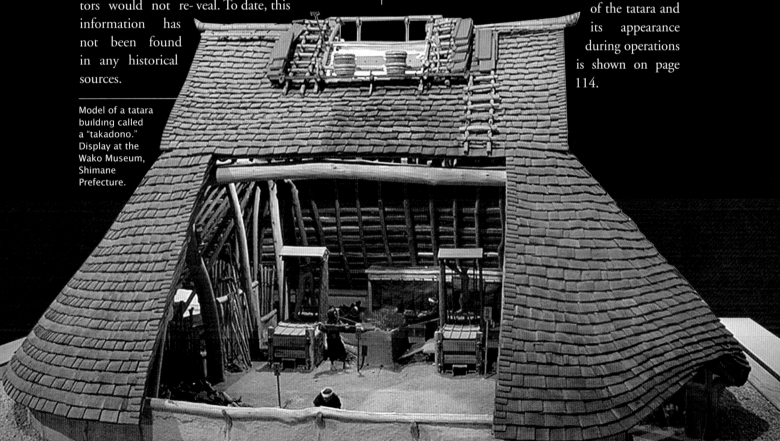

Model of a tatara building called a "takadono." Display at the Wako Museum, Shimane Prefecture.

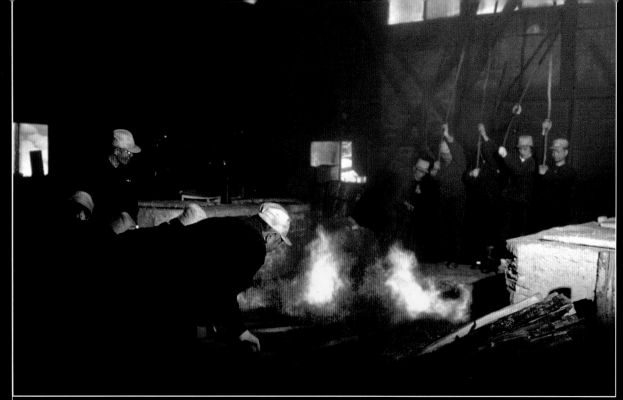

Constructing the furnace is a very important process. The success of the tatara's operation depends on the structure and design of the furnace and the clay used to make it, as well as on the murage (supervisor). Building the tatara and choosing the appropriate clay depend on the murage's knowledge and experience.

After firewood is burned, the ground and burned wood are pounded with wooden poles for about 40 minutes to produce a dry, flat surface that becomes the foundation of the furnace. When the tatara is running, the floor reaches very high temperatures, and steam will be visible.

Making the motogama (base wall), including the three holes through which slag (waste) can run out during the operation of the tatara.

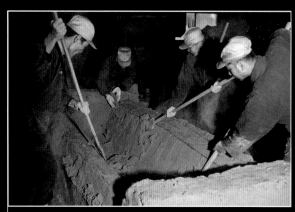

An 8-inch (20 cm) high clay wall is erected, and excess clay is shaved away.

OPERATION OF THE TATARA FURNACE

The smelting process is overseen by the murage (supervisor). He observes the operation and controls the flames in the furnace, which reaches temperatures of about 2700°F (1500°C), throughout the day and night. He also controls the air flowing into the combustion chamber. The murage monitors the activity inside the furnace by means of a row of small holes along the length of the tatara. If the murage spends too much time watching the flames and the processes inside of the tatara through the observation holes, his eyesight will deteriorate; in the past, murage often lost their sight. Historically, if the murage failed to achieve success after several operations, he was dismissed by the tesshi, or owner of the tatara.

The processing of iron in the tatara starts at around five in the morning. Charcoal is heaped in the furnace and ignited. After one hour, iron sand is spread over the charcoal by the murage and his assistants. The tatara process is divided into four stages, which correspond to the smelting conditions. Over the 70 continuous hours of smelting, approximately 155 pounds (70 kg) of iron sand and 190 pounds (85 kg) of charcoal are added to the furnace every 30 minutes. As the operation progresses, the amount of iron sand and charcoal added at each step is increased, and gradually, the interval between the successive additions is reduced from 30 minutes to 10 minutes, because the efficiency of the process increases with time. These additions are made 140 times over the three days and nights that comprise the operation.

As the smelting operation progresses, the chemical reactions listed in Table 2 below take place, with the char-coal acting as a reducing agent. The processing times required for the tatara operation are shown in Table 3, and the chemical reactions are shown in Table 2 at the bottom of the page. When the air volume inside of the furnace is small, the volume of carbon monoxide (CO) increases. When there is a large volume of carbon dioxide or CO_2, reduction of the iron oxide to iron is inhibited. As a result of the third reaction shown in Table 2 below, the iron is carburized until the carbon content reaches about 1.0 to 1.5 percent of the material, and the iron and carbon form a solid solution; that is, steel.

It was very difficult for the tatara workers to generate a continuous flow of air into the tatara with a traditional tread- or step-type bellows. A revolutionary instrument was invented during the Genroku era in the Edo period (1688–1703). This device, called a "tenbin fuigo" (balanced bellows), led to a substantial reduction of labor and greatly improved the efficiency of the tatara operation.

When the tatara furnace is broken down by the workers, just after the end of the 70-hour operating period, the hot kera (steel mass) is pulled out of the furnace and cooled in air or water. The raw iron and steel block formed at the bottom of the furnace is about 10 inches (25 cm) thick and weighs approximately 5500 pounds (2500 kg). Since approximately 29,000 pounds (13,000 kg) of iron sand were fed into the furnace, the kera therefore contains about 19 percent of the raw iron sand fed into the tatara. It also contains steel, pig iron, and slag (refer to the compositional diagram of kera shown at the bottom of page 114). As noted earlier, the steel made with the tatara process is called "wako"; the "wa" means Japanese, and "ko" means steel. Thus "wako" means Japanese steel.

Indirect reaction	Direct reaction
$Fe_3O_4 + CO \rightarrow 3FeO + CO_2$ reduction	$Fe_3O_4 + C \rightarrow 3FeO + CO$ reduction
$FeO + CO \rightarrow Fe + CO_2$ reduction	$FeO + CO \rightarrow Fe + CO$ reduction
$Fe + 2CO \rightarrow Fe\text{-}C + CO$ carburizing	$Fe + C \rightarrow Fe\text{-}C$ carburizing

Table 2. Chemical reactions in the tatara furnace.

Step	Process	Time required (hr)	Details
1st	Komori ki	7.5	Increase of temperature, production of slag
2nd	Komoritsugi ki	7.5	Greater increase in temperature, acceleration of reduction from iron sand
3rd	Nobori ki	18	Nucleation and growth of kera steel
4th	Kudari ki	36	Further growth of kera
Total	_____	69	_____

Table 3. Processes during the tatara operation.

TATARA DESIGN

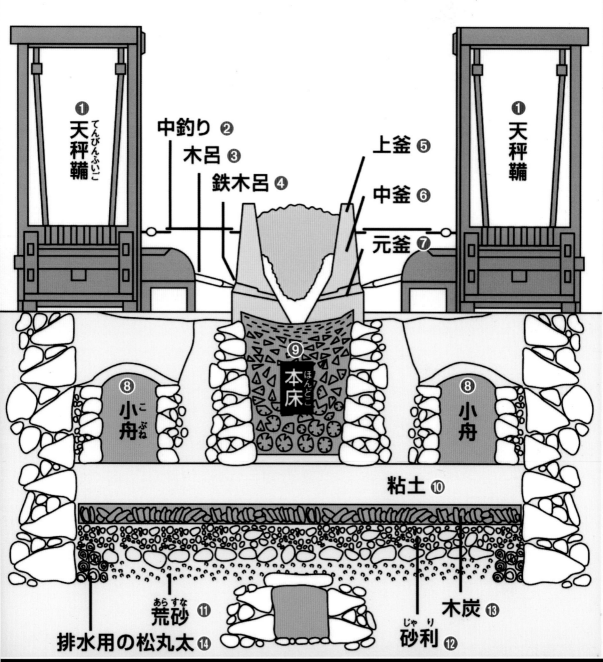

Tatara furnace structure.

1. TENBIN FUIGO foot-operated bellows
2. NAKATSURI middle balance
3. KIRO air ducts (tuyeres)
4. TETSUKIRO furnace
5. UWAGAMA upper wall
6. CHUGAMA middle wall
7. MOTOGAMA base wall
8. KOBUNE air ducts
9. HONDOKO charcoal ash bed
10. NENDO clay base
11. ARASUNA rough sand
12. JARI gravel
13. MOKUTAN charcoal
14. HAISUI-YO MATSUMARUTA
 pine-log channel for drainage

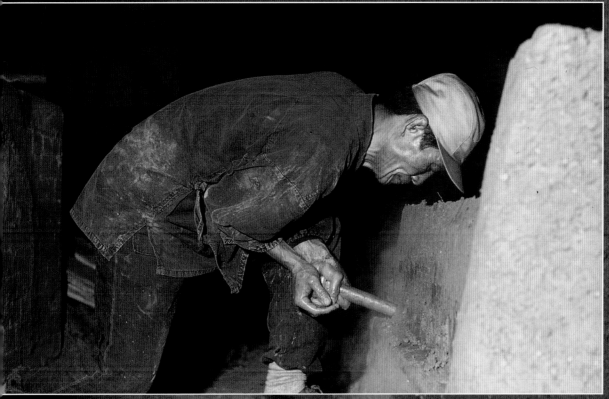

The murage pushes a long pole through the wall to make observation ports.

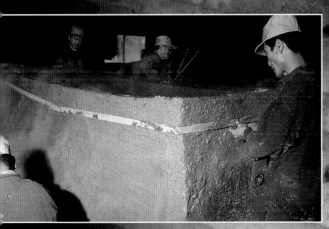

The completed furnace is reinforced with steel bands to help it maintain its shape during the smelting operation.

Placing bamboo pipes from the fuigo (bellows) through the wall. These pipes will serve as ducts to inject air from the fuigo into the furnace.

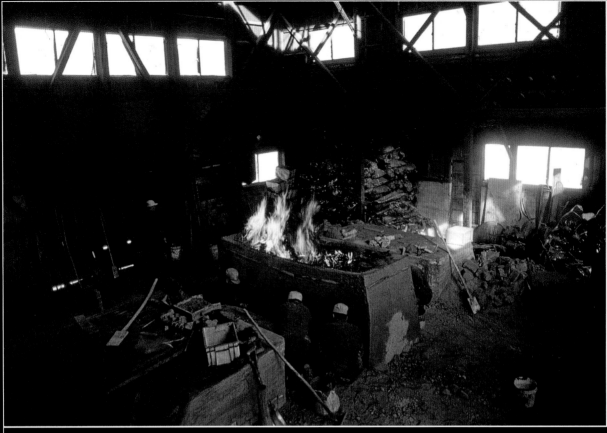

The operation of the tatara begins. The workers at the bottom
of the tatara are checking the air ducts to insure that they are
working properly and are unobstructed.

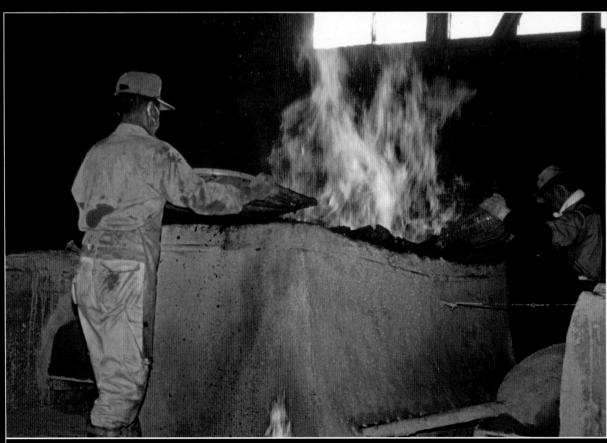

When the tatara is in operation, it is periodically filled to the
top with fresh charcoal, and new iron sand is spread over the
top. The workers here are adding iron sand.

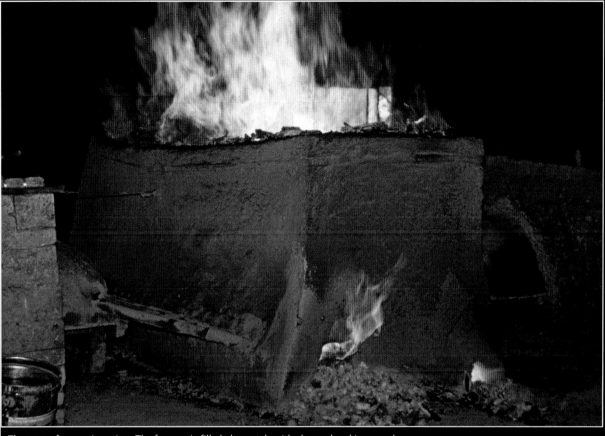

The tatara furnace in action. The furnace is filled alternately with charcoal and iron sand; the operation continues until a set amount of charcoal and iron sand is processed. The slag—impure material that melts at lower temperatures than iron and steel—will run out from the slag holes at the bottom of the tatara, where flames are emerging in this photo.

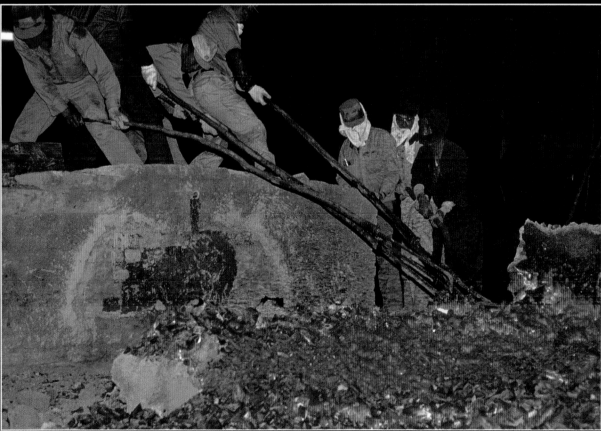

After the tatara operation is finished, the workers tear down the walls of the tatara and rake out the remaining charcoal to

TAMAHAGANE

GRADES OF TAMAHAGANE

In Edo times, the kera was broken into several pieces by dropping weights onto it; in modern times, a power hammer is used. These pieces are subsequently broken again into smaller pieces at another forging site. Finally, after manual hammering, fist-sized pieces of tamahagane are picked and graded by brightness, color, and porosity by looking at the fracture surfaces. Pieces of tamahagane are shown in the photo on page 119.

Good-quality steel is defined as steel with a moderate carbon content of about 1.0–1.5 percent and very low levels of impurities such as titanium, phosphorus, sulfur, silicon, manganese, nickel, and copper.

If the carbon content is greater than 1.7 percent, the material is called "pig iron." The carbon content of the tamahagane is crucial in making a Japanese sword. A good sword cannot be produced from steel with a carbon level of less than 1 percent, as it will lack the proper hardness after forging and heat treatment. In addition, the toughness and strength of a sword will be compromised by the presence of any of the above-mentioned contaminating elements.

The chemical makeup of each of the three grades of tamahagane is shown in Table 4. Impurities, if measurable, are present at very low levels. The carbon content of grade one tamahagane is suitable for use as a raw material for making a Japanese sword. Grade two tamahagane is not as good, and grade three is the lowest quality.

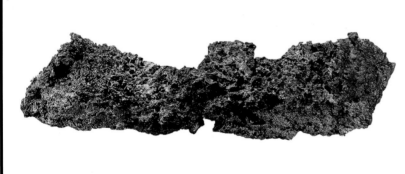

Tamahagane is inhomogeneous; that is, the carbon distribution is not uniform. Different parts of the tamahagane mass will have different properties, depending on their carbon concentration. The tamahagane is broken up and the pieces are sorted according to their nature. Swordsmiths and other craftsmen who use them can compensate for the variations in carbon content.

The top photo shows the kera, while the compositional diagram below it shows the various sections identified by color. The different types of steel are used for different purposes, as follows:

1. YELLOW AREAS: These sections, the tamahagane, contain 0.5 to 1.2 percent carbon. They can be used directly by a swordsmith.

2. PINK AREAS: Owarishita. This contains 0.2 to 1.0 percent carbon.

3. BLUE AREAS: These sections, called "hobo," are used by blacksmiths. They consist of a mixture of tamahagane and iron.

4. GRAY AREAS: These sections, called "noro," contain slag, or iron and steel mixed with other elements, and pieces of charcoal; this is not a useful material.

5. GREEN AREAS: These sections are sen or pig iron, which contains more than 1.7 percent carbon.

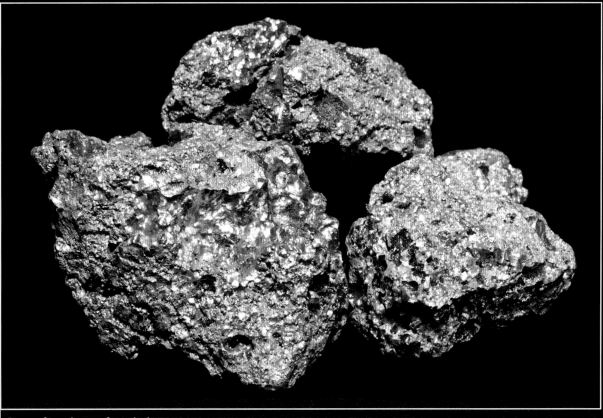

Pieces of tamahagane from the kera.

	C	Si	Mn	P	S	Ti	Ni	Cu
Grade one	1.31	0.02	0.01	0.017	0.003	0.002	0.001	0.01
Grade two	0.77	0.01	0.01	0.022	0.004	0.004	Nil	<0.01
Grade three	0.31	0.02	0.004	0.021	0.007	0.003	0.001	0.01

Table 4. Chemical elements in tamahagane shown as percentage of total mass.

Making the Sword

CHAPTER IV

SAKUTO
MAKING THE SWORD

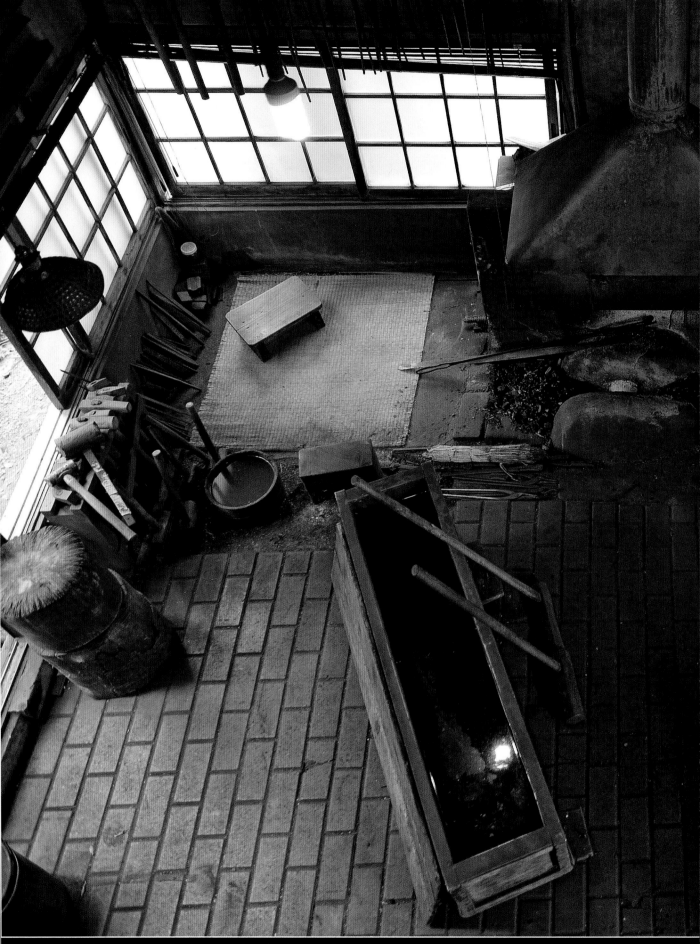

A view of Yoshindo's shop. Every surface is covered with ash and characoal dust. The shop is kept dark so that the color of the steel can be accurately observed during forging.

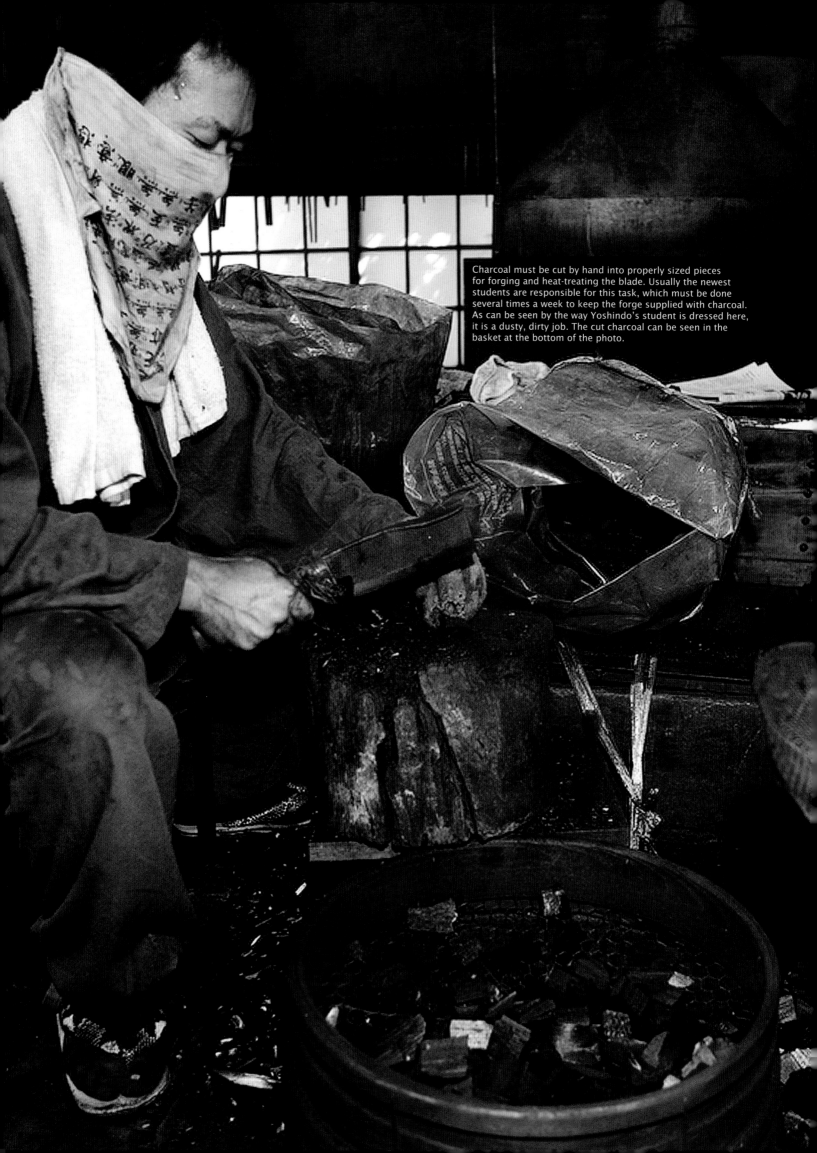

Charcoal must be cut by hand into properly sized pieces for forging and heat-treating the blade. Usually the newest students are responsible for this task, which must be done several times a week to keep the forge supplied with charcoal. As can be seen by the way Yoshindo's student is dressed here, it is a dusty, dirty job. The cut charcoal can be seen in the basket at the bottom of the photo.

TOOLS AND PREPARATION

The tools and working methods used by the modern swordsmith are not much different from those in the historical past. The sword is made using a charcoal-fueled fire, a traditional fuigo (bellows), and traditional Japanese-style hammers, drawknives, and other tools. The simple setup shown on pages 122–23 is typical. Gray and black colors predominate, as almost every surface in an active shop is covered with ash and charcoal dust.

Cut charcoal for forging is heaped on a shovel to be added to the forge as needed.

CHARCOAL

The size and type of charcoal used during forging varies according to task. Larger pieces are used for forging, while very small pieces are used for the yaki-ire. The pieces must be uniform in size to produce a hot fire with even temperatures, so the charcoal is cut into appropriate sizes with a knife or cleaver before use. This is usually the task of the younger students. After cutting, the charcoal is filtered to remove dust and very small pieces.

For several reasons, charcoal made from pine wood is used in forging. First, pine charcoal contains very little phosphorus and sulfur. These elements, if worked into the steel from any source, could make the steel brittle and keep it from welding together properly during the folding process. Pine charcoal is also soft and light. This is important during yaki-ire, when the blade is covered with a thin clay coating that will define the hamon. If the charcoal is too hard, it will damage the clay coating when the blade is moved through the charcoal during heating. Any scratches or holes in the clay coating will affect the final hamon, and could even ruin it.

The charcoal is cut with a tool resembling a bamboo knife. Here, Yoshindo's student is preparing to cut new lengths of charcoal into smaller pieces of uniform size.

The Fuigo

The fuigo (bellows) is a crucial tool for a smith. The fuigo can generate enough heat to melt the steel if the smith is not careful. The fuigo used in the forge is the same design as the larger one used in the tatara to produce tamahagane. This bellows design, which existed in China over two thousand years ago according to archaeological evidence, was probably imported into Japan along with sword-making techniques at some point in the fourth to sixth centuries.

The double-acting bellows is relatively simple, but very effective. It is basically a long box with a rectangular cross-section and a fitted rectangular piston inside; the piston moves back and forth along the full length of the bellows. Fur is used to make a seal between the edges of the piston and the walls of the bellows. The piston pumps air into the forge both when it is pushed and when it is pulled. This allows the flame to be controlled very efficiently. If a larger volume of air is required, a fuigo with a larger cross-section is used.

Tools

The primary tools used by a traditional swordsmith consist of a variety of hammers, drawknives, and files. Their design, developed over the past thousand years, has changed little in modern times; they work very well and efficiently in properly trained hands. The smith also uses different types of tongs to grip the tamahagane or steel while hammering and heating the metal.

The interior of the fuigo. The single piston is pushed and pulled to pump air. The fur around the piston makes a seal between the piston and the interior surfaces of the fuigo.

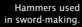

Hammers used in sword-making.

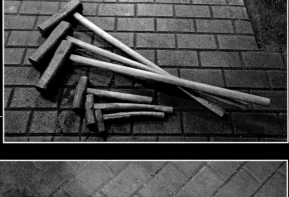

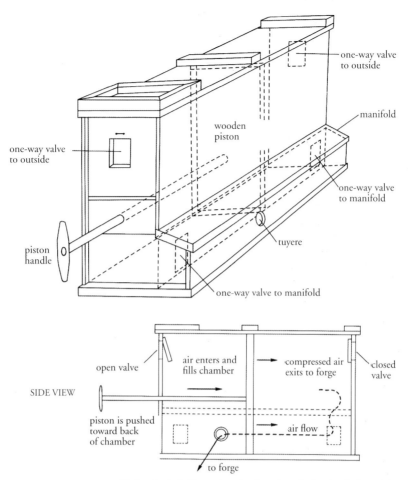

one-way valve
to outside

one-way valve
to outside

wooden
piston

manifold

one-way valve
to manifold

piston
handle

tuyere

one-way valve to manifold

SIDE VIEW

open valve

air enters and
fills chamber

compressed air
exits to forge

closed
valve

piston is pushed
toward back
of chamber

air flow

to forge

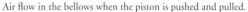

Air flow in the bellows when the piston is pushed and pulled.

piston is pushed:
manifold valve is closed

piston is pulled:
compressed air enters
front manifold

FRONT VIEW

A diagram of the fuigo
(bellows).

Tongs for
handling
tamahagane.

Tongs for
gripping the
steel.

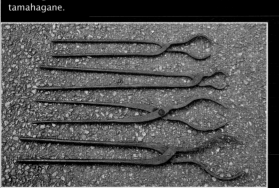

❶ TAMAHAGANE 玉鋼
The initial tamahagane pieces.

❷ HESHITETSU へし鋼
The tamahagane is hammered out into flat pieces.

❸ KOWARI 小割り
The flattened tamahagane is broken into small pieces.

❹ TSUMIWAKASHI-DAI ZUKURI
積沸し台造り
A rectangular plate of tamahagane is forged.

❺ TEKO-DAI ZUKURI テコ台造り
The plate is welded on to a handle (teko).

❻ TSUMIWAKASHI 積沸かし
Tamahagane pieces are carefully stacked onto the plate.

❼ ORIKAESHI-TANREN 折返し鍛錬
The plate and stacked pieces of tamahagane are forged into a billet that is repeatedly drawn out and folded over onto itself.

❽ FINISHING THE ORIKAESHI-TANREN STAGE
折返し鍛錬終了
Early and late folds. Notice that during the early stages of the folding process, the surface of the expanding section is granular and irregular. During the later stages of folding, the surface of the steel remains smooth and continuous as it is drawn out, with no gaps or irregularities.

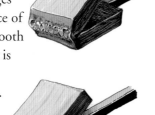

❾ KAWAGANE ZUKURI 皮鉄造り
The outer kawagane steel is forged into a U-shaped bar.

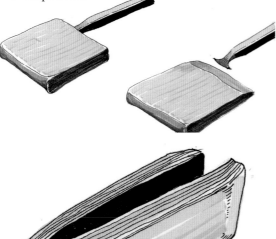

❿ SHINGANE ZUKURI 心鉄造り
The shingane (softer core steel) is forged into a narrow bar that will fit into the U-shaped kawagane.

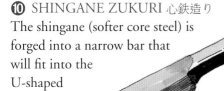

⓫ TSUKURIKOMI 造り込み
The inner shingane steel is welded into the outer kawagane steel.

⓬ WAKASHI-NOBE 沸かし延べ
The resulting composite steel bar is forged into a long bar for a sword. Steel is cut from the end to form the point.

⓭ SUNOBE 素延べ (early stage)
In some swords made using certain forging styles, the shingane core steel extends all the way through the tip of the steel bar. Because the tip should be made of hard kawagane steel only, the end of the bar is cut off at an angle to remove the soft core steel. The hard steel left at the end is then forged up to make a point composed completely of kawagane.

⓮ SUNOBE 素延べ (last stage)
The sunobe is finished by forming the point.

⓯ HIZUKURI 火造り
At this stage, the entire shape of the sword is forged from the sunobe. The edge, sides, point, shinogi, and tang are delineated by hammering the steel.

MAKING TAMAHAGANE IN THE FORGE

Most of the tamahagane used today comes from the traditional tatara in Shimane Prefecture, as described in the previous chapter. A swordsmith can also make his own tamahagane on a small scale in his forge, however, both to reuse old iron and steel and to make small amounts of tamahagane to experiment with. It appears likely that the earliest swordsmiths in Japan made most of their own steel on a small scale. Large-scale production of tamahagane by specialists did not take place until the fourteenth or fifteenth centuries and afterward in Japan.

Using his forge, Yoshindo can make enough tamahagane for one sword in a half day or full day of work in the shop. He begins either with pure iron (extracted by an electrolytic process); or he can use old iron made from tamahagane some time in the past four hundred years. Such iron is usually salvaged from buildings such as shrines, temples, and old houses.

Modern electrolytic iron contains virtually no other contaminating elements. It comes in large bars or rods, and must be forged out into thin sheets and broken up into small pieces before use. The old salvaged iron generally consists of small nails, brackets, and other small structural pieces of steel used in construction. Large pieces of salvaged iron must be broken up before they are used to make tamahagane.

Once the starting material for making steel is ready to use, the forge is prepared so it can function as a small tatara. A bank of charcoal dust is built up on both sides of the tuyeres or pipes that bring the air into the forge from the fuigo. The forge is cleaned up, and the area around and below the tuyeres is kept clear to maintain an unobstructed path for air to enter the forge. The charcoal dust will act as insulation, conserving heat inside the center of the forge where uniform high temperatures must be generated to smelt the iron into tamahagane.

Next, the center of the forge is filled to the top of the charcoal embankments with larger pieces of charcoal. The charcoal is ignited and, bolstered by air from the fuigo, begins to heat up the forge. More charcoal pieces are added to the forge until they reach over

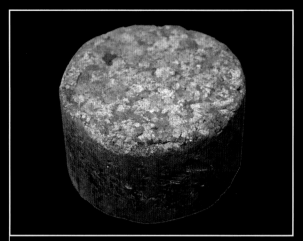
Pure modern iron made by an electrolytic process.

Electrolytic iron is hammered into a sheet and broken into small pieces for use in steel-making.

Old iron nails, brackets, and structural components salvaged from Edo-period buildings. The iron pieces to be used in this process must be small.

The center of the forge. The charcoal banks and the tuyeres are visible.

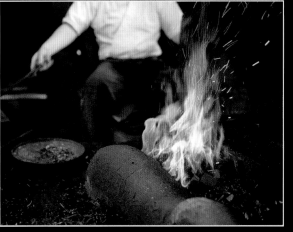
Charcoal is burned to heat the forge.

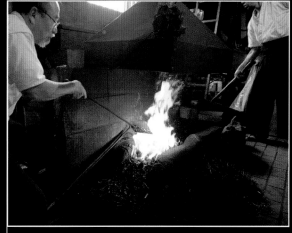
Yoshindo spreads salvaged iron over the charcoal.

The salvaged iron pieces are ready to be placed in the forge.

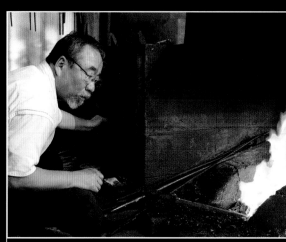
Yoshindo listens to the sound of the forge. This helps him determine when to end the smelting process.

the charcoal dust embankments. Once the forge is hot enough, the smith takes a handful of iron pieces and places them on a shovel, and then spreads them over the charcoal in the center of the forge. The forge is then operated until the top of the charcoal burns down to 1.5 to 2 inches (3–4 cm) below the charcoal dust embankments. More charcoal is then added to the forge to raise the top of the charcoal over the dust embankments again, additional iron is spread over top, and the forge is operated until the charcoal level drops again.

This process is repeated, with iron and then charcoal being added, until about 6.6 pounds (3 kg) of iron have gone into the forge. Because of the scale of the forge, this is the maximum amount of iron that can be added to the forge to produce a good yield of tamahagane. Once the proper amount of material has been added to the forge, the smith continues to operate the bellows until most of the charcoal has been consumed and he judges that it is time to stop. He does this by monitoring the noises the charcoal and steel make in the forge; when the

sound is correct, he ends the process. Once the forge is stopped, it is allowed to cool down. The tamahagane mass is at the bottom of the forge, below the tuyere openings.

During smelting, the iron and iron oxide are reduced to pure iron and combine with the carbon in the charcoal to produce steel, the best fraction of which will be used for making swords. It is an efficient process: 6.6 pounds (3 kg) of iron starting material will yield around 4.4 to 5.5 pounds (2–2.5 kg) of tamahagane.

Smelting steel in the forge offers the swordsmith an opportunity to experiment with his steel, or to produce custom steel on a small scale for a sword. In the process shown in the accompanying photos, Yoshindo mixed old Japanese steel and iron salvaged from Edo-period buildings with an equal amount of pure electrolytic iron. He will make a new sword from this steel and see how the hamon and the jigane turn out. The results will guide his efforts in the future for making steel and swords.

TANREN: FORGING

TSUMIWAKASHI: BEGINNING WITH THE NEW STEEL

The smith can begin to make a new sword once the tamahagane is ready. The first step is to heat a piece of tamahagane in the forge until it is yellow in color. The steel is hammered out into a flat plate about ¼ inch (0.75 cm) thick, which is then broken up into small pieces that can be easily examined in cross-section. The smith uses the color and appearance of the tamahagane cross-section to determine which pieces have the desired properties for the type of steel he needs. The best pieces will be used for the kawagane (the hard steel that composes the outer layer of the sword, including the hamon), as a high carbon content is necessary. For the shingane (inner steel core of the sword), the smith selects pieces of tamahagane with a lower carbon content in order to make a softer steel.

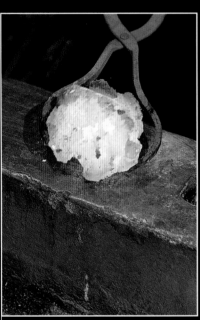
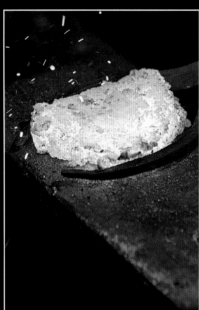
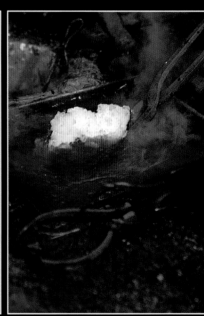

Quenching the tamahagane. A piece of tamahagane is heated and forged into a thin plate. When the plate is still a red or yellow color it is quenched in water to cool it rapidly. It is then broken up into small pieces.

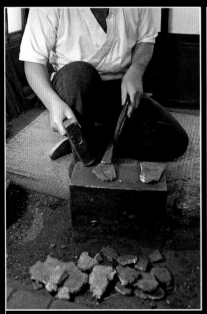
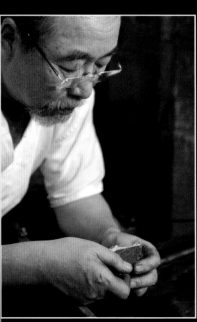
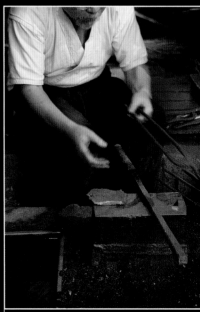

Breaking a plate of tamahagane into small pieces with a hammer.

Yoshindo inspects and evaluates a piece of tamahagane.

Preparing the teko (steel handle) and the tamahagane plate that it will be welded to.

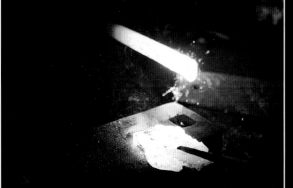

The teko and the steel plate on which the tamahagane will be stacked are heated separately.

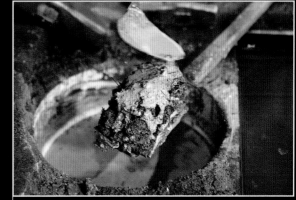

The tamahagane is covered with ashes and clay.

Hammering the teko and steel plate while they are heated.

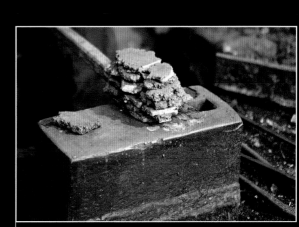

The tamahagane is stacked and ready for forging.

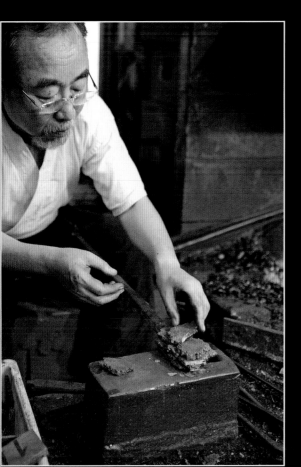

Stacking the tamahagane pieces on the plate.

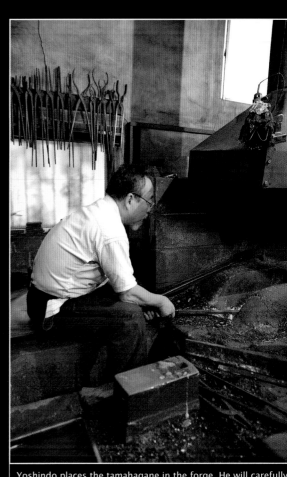

Yoshindo places the tamahagane in the forge. He will carefully pile up charcoal around the steel and heat the forge.

The tamahagane is covered with charcoal and the forge is heated.

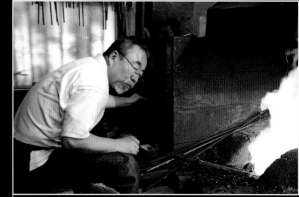

Yoshindo can judge when the tamahagane is hot enough to be welded into a single mass by listening to the sounds from the forge.

The tamahagane billet is periodically rolled in straw ashes during the heating process. The ashes help protect the steel from oxidation and decarburization.

Next, a teko, or handle, is made so that the smith can easily work the steel while it is being heated and folded. He first forges a long steel handle, and then welds a steel plate to the end of the handle. This provides a surface on which to stack the selected pieces of tamahagane. These are arranged together as tightly as possible. The plate and tamahagane pieces are then entirely covered with a clay slurry and straw ashes before being carefully placed into the forge. This step, like much of the smith's work at this stage, is designed to protect the tamahagane and preserve the carbon content in the steel, as the clay and ashes will keep the steel from decarburizing into soft iron in the flames.

The smith judges the temperature of the metal by the color and from the sound coming from the forge. When it is hot enough, he carefully removes it from the forge and gently hammers it to make all of the pieces into a single billet of tamahagane. This is then heated to a very high temperature to fuse all of the tamahagane pieces into a single mass of steel. At this temperature the tamahagane is bright yellowish white, and sparks fly from the hot steel. As the smith holds the steel on the anvil, an apprentice carefully hammers it into a single fused bar. Once the billet is hammered, it is rolled in straw ashes to coat the metal before it is placed into the forge again.

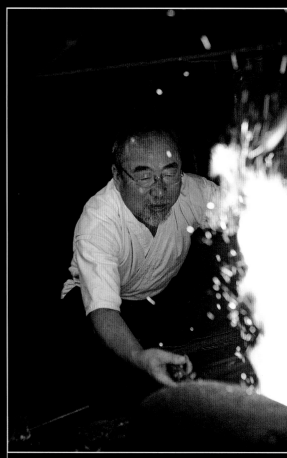

The billet of tamahagane is heated until it is ready to be forged.

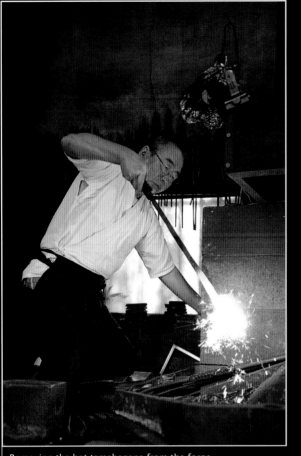
Removing the hot tamahagane from the forge.

When the tamahagane has been heated again, the smith and two or three assistants, or sakite, begin to work the steel. The smith, who holds the teko, keeps a bundle of wet rice straw between himself and the steel to protect him from sparks and flying bits of metal shooting out of the hot steel as his assistants hammer the tamahagane. Smiths these days often use a power hammer to work the steel, but apprentices or students may also serve as traditional sakite instead. Up to three sakite can work with a smith, hammering continuously in sequence to work the steel. A smith and three experienced sakite can forge the steel in about the same amount of time as a smith using a modern power hammer can.

Yoshindo uses a small hand-held hammer to set the pace for his assistants as they hammer. The sakite direct their strikes to the center of the anvil. Meanwhile, Yoshindo moves the steel billet so that the sakite strike the steel exactly where he wants them to.

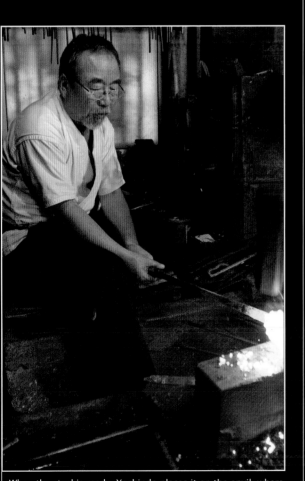
When the steel is ready, Yoshindo places it on the anvil, where his sakite (assistants) can hammer it.

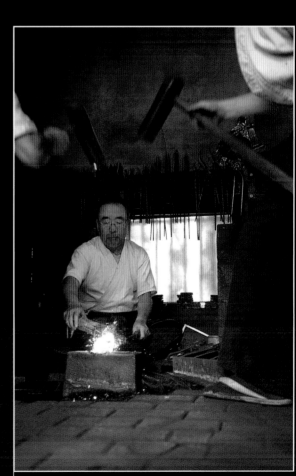
Hammering the tamahagane into a single mass.

KITAE: HEATING AND FOLDING THE STEEL

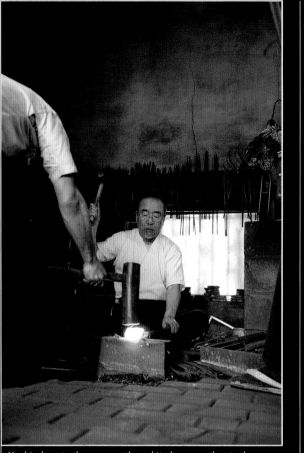

Yoshindo sets the pace as the sakite hammer the steel.

Once the tamahagane pieces have been fused together, the resulting billet of metal is continuously hammered to draw it out to about twice its original length. The billet is then scored with a chisel and folded over onto itself. Then the process is repeated: the steel is heated, drawn out, cut partly through, and folded over again. The steel is usually folded six times to complete the shita-kitae (foundation forging) stage. After the first lengthening and folding, Yoshindo usually draws the steel out sideways and folds it over on itself. He then continues to alternate drawing the steel out lengthwise and sideways at each stage, holding the steel himself while the sakite strike it with sledgehammers.

After the shita-kitae stage is complete, the billet is scored with a chisel to divide it into two or three sections while the steel is still hot. It is then quenched in water. When the billet is completely cool, it is struck with a hammer to break it into sections along the score marks.

The photographs at the bottom of page 140 show two different billets: the one at left is made of tamahagane, and the one on the right is made of modern high-carbon steel. The tamahagane billet has a rough grain structure, and the grains are large. The visible horizontal lines running across the billet are formed when the steel is folded over onto itself and welded together. In contrast, the billet made of high-carbon tool steel has a very fine uniform grain structure and appearance. The tamahagane billet is much tougher and far more difficult to break with a hammer. Along with the chemical composition of the steel, the layers and grain structure visible in the photo are what make tamahagane steel most suitable for making a sword.

Blocks of steel from the shita-kitae stage are combined, and the heating, folding, and hammering continues in the age-kitae, or finish forging, stage. The smith must work the steel while it is very hot (usually yellow or white), as it may be damaged by the hammering if it hardens; it usually requires about 15 minutes of heating in the forge before it is ready to be worked. It can generally be hammered for several minutes before it becomes too cool to work with and must be returned to the forge and heated again. The steel is alternately heated and worked until all of the forging is finished.

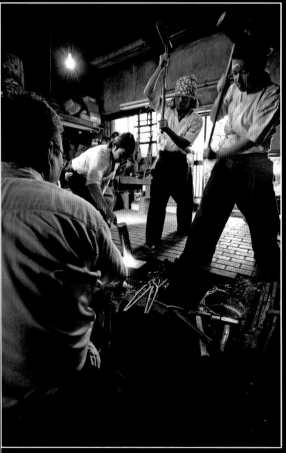

Yoshindo holds the steel as his three assistants hammer it.

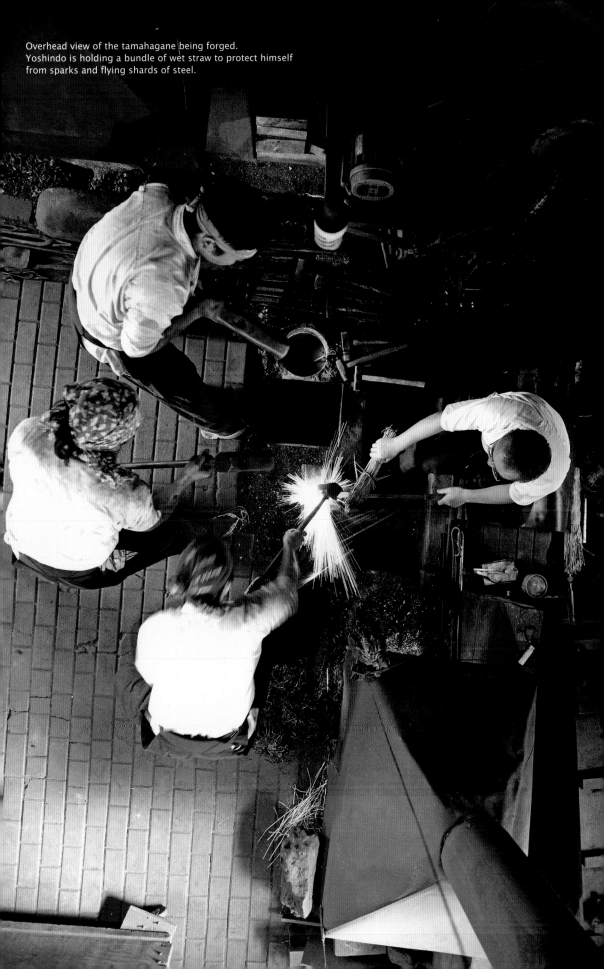

Overhead view of the tamahagane being forged.
Yoshindo is holding a bundle of wet straw to protect himself
from sparks and flying shards of steel.

The anvil and hammer are kept wet.

almost explodes, blowing any dust, metal scale, or rust from the surface of the steel and the anvil. This protects the steel and keeps it clean, so no contaminants are hammered into the newly forming sword steel.

This part of the process is especially challenging because the steel loses a bit of its carbon each time it is heated in the forge. A good smith works efficiently and rapidly to minimize the amount of time the steel spends at a high temperature, as well as the number of times the steel must be heated. If the steel is heated too frequently, or spends too long in the forge, the final carbon levels in the steel will be lower than optimal, making it too soft. In addition, if the carbon level falls too low, it will not be possible to make a proper hamon.

While the steel is heating, the swordsmith periodically dips his hammer into a bucket of water and touches it to the anvil so that a thin layer of water covers the surface. When the hot steel is taken out of the forge and placed on the anvil, the heat from the steel instantly evaporates the water on the anvil. The boiling water

As a further measure to keep the carbon from oxidizing, the steel billet is periodically rolled in straw ashes and covered with a clay slurry before being heated. The clay material protects the steel in the forge at temperatures of up to 1800°F (1000°C), while the straw ashes stay on the surface of the steel at even higher temperatures. These measures are essential for minimizing the loss of carbon.

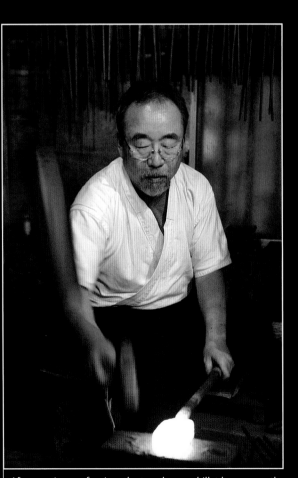
After continuous forging, the tamahagane billet has a smooth and regular shape.

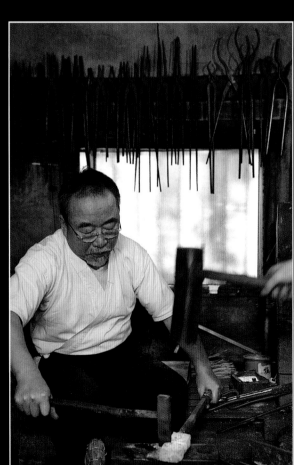
The drawn-out billet will be scored with a chisel while hot, and then folded over onto itself.

If the carbon content of the steel is too high, the steel will be very hard and brittle, and is liable to crack or fracture when the sword is used. However, if the carbon level is too low, the steel will be too soft, and may bend or deform when the sword is used. A final carbon level between 0.6 and 0.7 percent is generally sufficient for the outer steel of the sword to be quite hard, and to make a well-formed hamon to define the cutting edge.

In order to forge the steel to have the optimal carbon level for a sword, the swordsmith must watch the billet closely when it has been partially chiseled through and is being folded. At this time, the smith

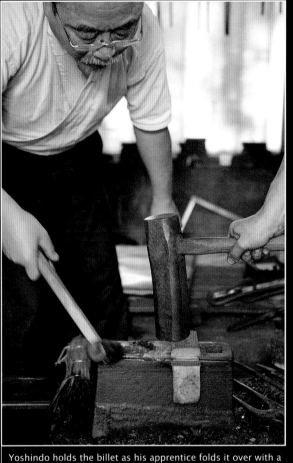

Yoshindo holds the billet as his apprentice folds it over with a sledgehammer.

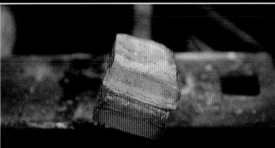

The folded billet.

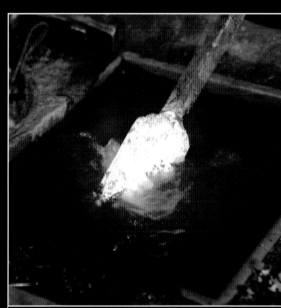

The billet is quenched in water.

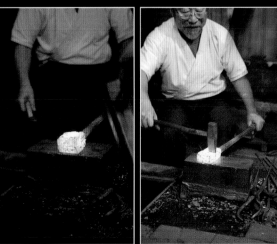

The folded billet is heated again.

Using a chisel to cut partway through the steel.

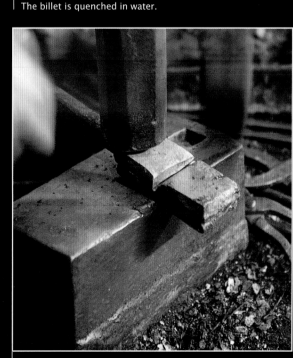

The cooled billet is broken into sections.

can observe the section of steel that is being stretched and expanded. If the carbon levels are high, the steel is brittle, and gaps or pockets may be visible in the metal as it is folded. As the carbon level is reduced, the steel becomes more ductile. When the steel can be folded over onto itself completely, and stretches uniformly and smoothly without gaps or pockets forming, the carbon content is at the desired level. The smith works the steel by forging and folding it until the proper carbon level is obtained. In general, the steel is folded twelve times in all to obtain the desired carbon level and properties required for kawagane, and five to seven times for shingane, but this will depend on the original tamahagane and its starting carbon levels, as well as on the purity of the steel. The smith must observe each batch of steel very carefully as he works so he can decide when it has the quality and properties he desires.

This process of folding and forging the steel also has another purpose. As the steel is heated and hammered, slag—steel combined with contaminating elements or other minerals—is removed. Slag particles or other impurities in the steel would create weak points in a sword where a crack or fracture may occur when the blade is used. Therefore the hammering and folding purifies the steel while at the same time producing a high-strength steel with an ideal carbon content.

The forging process also results in the jihada, the pattern in the surface of the steel. Since the intensity of the hammering on the steel varies, the hammered surface develops a visible pattern. This may appear similar to wood grain (itame-hada) or a burl

grain variant (mokume-hada). The sides of the billet, meanwhile, will show a straight grain pattern (masame-hada). If the smith uses the top and bottom surfaces of the billet to form the jihada, the surface of the final polished sword will have a mokume- or itame-hada pattern. If the sides of the billet are used, the surface will have a masame-hada pattern. There are many subtle variations of these patterns, and even combinations of the patterns on single swords. The final result depends on the smith's forging technique and what he wants to do.

As noted above, the forging process comprises two stages: shita-kitae (foundation forging) and age-kitae (finish forging). The tamahagane billet is drawn out and folded over six times in the shita-kitae stage, after which it is drawn out once more and cut into three equal sections. The blocks of steel from the shita-kitae stage are combined and drawn out and folded six more times in the age-kitae to make kawagane.

The amount of tamahagane used at the beginning of the forging process is far greater than the amount of steel in the finished sword. About half of the original steel is lost during the shita-kitae stage. Hammering and folding the steel during the age-kitae stage will result in losing about one-half of the material again, so the final steel billet to be used for the sword only contains about a fourth of the original tamahagane the smith started with. At the end of the entire forging process, the smith will have a bar of kawagane steel to form the outer layer of a large sword, and a second billet of lower-carbon shingane that will be used for the core of the sword.

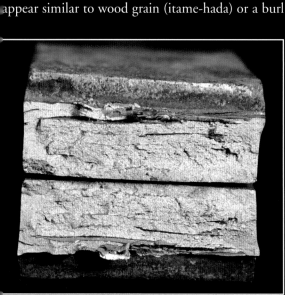

Cross-section of the tamahagane billet after the shita-kitae stage.

Cross-section of a billet of modern tool steel.

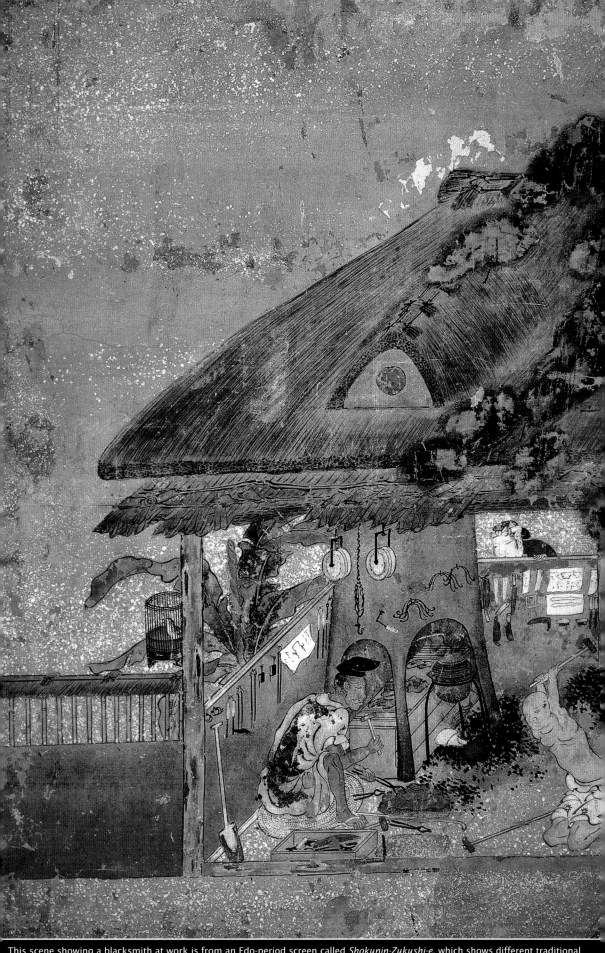

This scene showing a blacksmith at work is from an Edo-period screen called *Shokunin-Zukushi-e*, which shows different traditional craftsmen at work. The screen is preserved at the Kita-in temple, Saitama Prefecture. Reproduced with permission.

ITAME 板目 AND MASAME 柾目 SURFACE PATTERNS
IN THE STEEL

ITAME-HADA 板目肌

MASAME-HADA 柾目肌

During forging, the steel bar is repeatedly folded over on itself and hammered out again until it acquires the desired properties. This repeated forging and hammering produces the jihada, a visible surface pattern in the steel. Japanese swords usually show one of two basic types of jihada. The surface of the bar exposed to direct hammering acquires a wood-grain–like pattern called "itame-hada." This occurs because the hammering penetrates through the top surface layers, allowing several adjacent layers of steel to become visible on the surface of the bar. In contrast, the sides of the bar will display a straight grain, or a series of parallel straight layers, called "masame-hada." After the forging process is finished, if the swordsmith uses the hammered surface of the billet to form the sides of the sword, the jihada will have an itame-hada or wood-grain appearance (a burl-grain variant called "mokume-hada" is also common). Alternatively, if the swordsmith uses the layered sides of the billet to form the sides of the sword, the new sword will have a straight-grained masame-hada pattern in the steel. The exact pattern will depend on what the smith does and what forging method he uses. Variations of itame-hada and masame-hada can be seen in different swords due to individual variations in forging techniques.

Tsukurikomi and Sunobe:
Forming the Stock and the Blank

Tsukurikomi:
Forming the Steel Stock

As noted above, forging a Japanese sword involves two types of steel: the high-carbon outer steel kawagane, and the softer, lower-carbon shingane core. Both of these steels are forged in a similar manner, by repeatedly drawing the steel out and folding it over on itself. However, the starting tamahagane used for each is different, as the functions the two steels perform in the final sword are not the same. The shingane steel is softer and more ductile than the hard kawagane; it functions as a shock absorber to keep the sword from breaking under hard blows. The harder kawagane provides the outer surface of the sword, with its visible surface pattern or jihada; its high carbon content is also necessary to make a hamon.

To make a sword, the smith forges the kawagane and the shingane together into a composite bar. Most Japanese swords, including those Yoshindo makes, are forged in the simple "kobuse" style shown in the illustration at right. However, there are other ways to form a composite bar, and different methods are used by different groups of swordsmiths. For example, the more complex honsanmai structure requires four blocks of steel—a hard steel edge, a soft steel core, and hard steel sides—to be welded together. In the Shin-shinto era (approximately 1790 to 1876), smiths used many different methods to make swords that they hoped would rival the best swords from the past.

For the kobuse-style construction, the hard kawagane steel bar is first forged into a wide, almost square plate. After the attached handle is cut off, the smith hammers the kawagane plate into a narrow U shape by forging it into the center of a mold made from a thick iron bar, hammering it along the center to force it into the mold. The smith holds the plate with tongs, and uses a special hammer with a

rounded face to shape the steel. When the kawagane plate is the right shape, one end is hammered shut; this will form the point of the sword.

The next step is to prepare the softer shingane steel to fit into the core of the sword. The shingane is folded and forged into a narrow bar with a tapered end that will fit into the U-shaped kawagane plate. Because the point of the sword must be very hard, the tapered end of the shingane bar does not extend into the sealed front of the kawagane that will form the point. After it is shaped, the shingane is welded onto a handle.

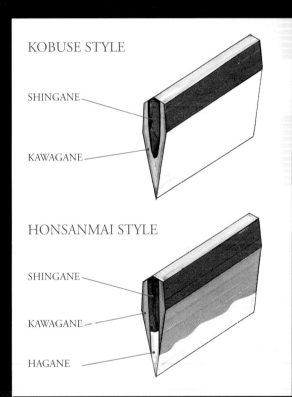

KOBUSE STYLE

SHINGANE

KAWAGANE

HONSANMAI STYLE

SHINGANE

KAWAGANE

HAGANE

The drawings here illustrate two common methods of combining different types of steel to make a sword. The honsanmai tsukurikomi style uses three types of steel— soft central shingane, hard kawagane, and hard hagane forming the edge—to make a composite sword. The shingane is placed between two pieces of kawagane, and the hagane is placed below that to form the hardened edge.
At the junction where the hagane and kawagane steels come together, features such as kinsuji ("golden lines") and sunagashi ("flowing sand") may emerge on the surface of the finished sword. The kobuse style of construction used by Yoshindo is simpler. The shingane is placed into a U-shaped piece of kawagane, and the two pieces are welded together. The kawagane will be hardened along the bottom edge to form the hamon.

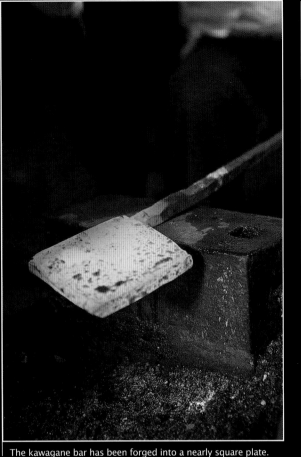

The kawagane bar has been forged into a nearly square plate.

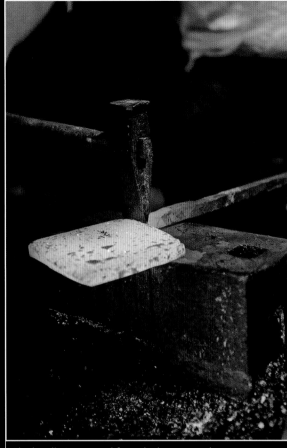

The handle is removed from the kawagane plate.

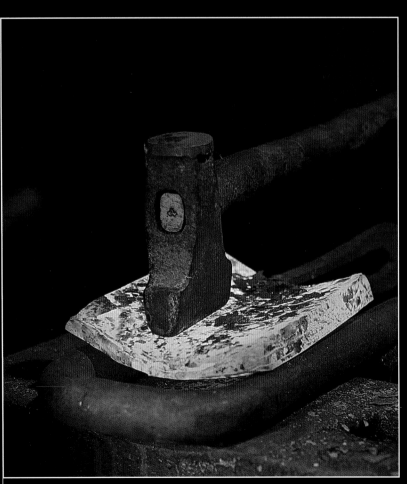

Beginning to bend the kawagane plate into a U shape.

The shingane and kawagane must be forged together into a single bar of steel that will form the sword. The two pieces have to fit perfectly along all of their surfaces, with absolutely no gaps between them. To accomplish this, the shingane and kawagane are heated and borax is spread over the surfaces that are to be welded together. Borax acts as a flux, keeping oxygen away from the hot steel surfaces in order to prevent oxidation and the formation of rust, which would keep them from being strongly welded together. The swordsmith must work very rapidly and carefully at this stage to weld the two pieces of steel together properly so that they form a strong composite bar for the sword.

The kawagane plate has been bent slightly.

The kawagane plate is continually forged until it has a narrow U shape.

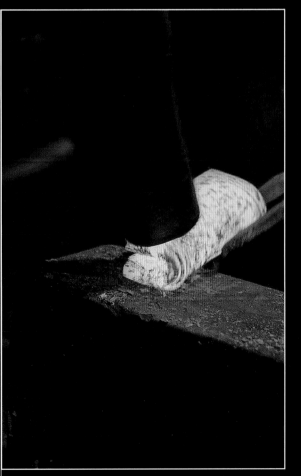

The U-shaped plate is hammered shut at one end.

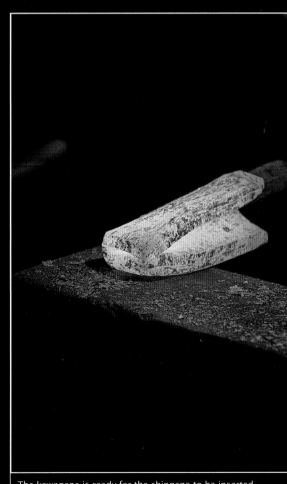

The kawagane is ready for the shingane to be inserted.

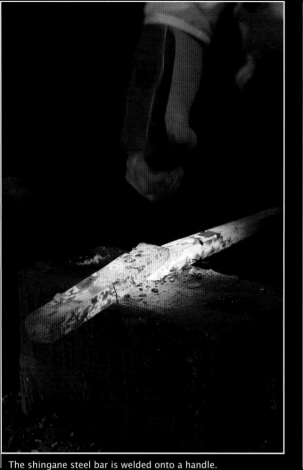

The shingane steel bar is welded onto a handle.

The shingane is forged so that it is tapered at one end.

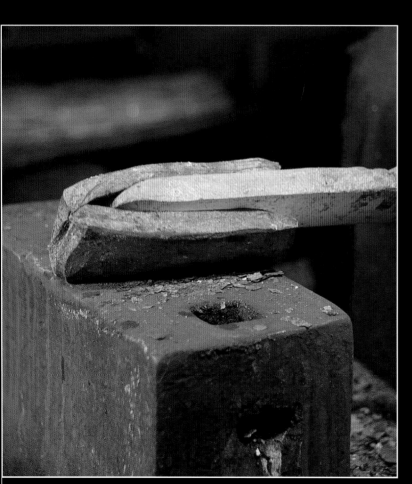

The shingane is fitted into the kawagane.

Once the borax flux is added to the hot steel surfaces, the shingane bar is fitted inside of the U-shaped kawagane plate. The smith and his assistants will hammer the bar to weld the two pieces into a single composite bar of steel that will form the sword. The kawagane will be closed over the shingane to form what will be the mune (unsharpened back edge) of the sword. The solid kawagane along the bottom of the U-shaped bar will form the edge of the sword. The soft inner steel will make the sword very tough, and the outer surface will provide a very hard cutting edge and allow for the creation of the hamon.

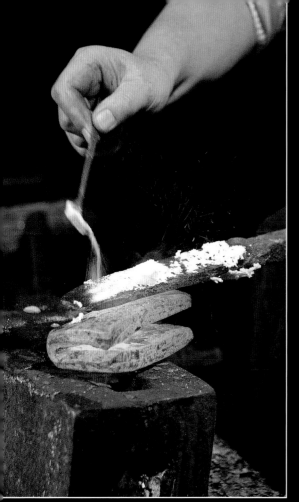

Borax, which serves as a flux, is spread over the surfaces to be welded together.

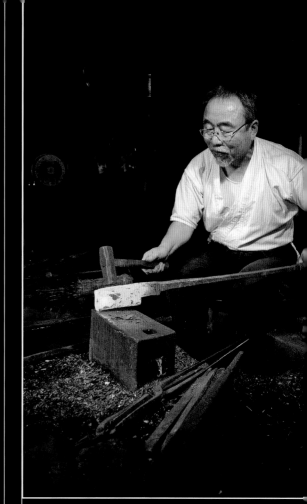

Yoshindo forges the kawagane and the shingane so that the two pieces of steel fit together seamlessly.

THE SUNOBE: FORMING A BLANK FOR THE SWORD

The composite bar of steel formed by the kawagane and shingane must now be forged to weld the two pieces together over their entire internal surfaces. As before, to prevent the oxidization of carbon in the steel, a clay slurry is poured over the bar and it is rolled in straw ashes before it is placed into the forge to be heated. When it is hot, the smith and his assistants begin ham-

mering the bar over its entire surface to weld the two pieces together completely. Because of the size and thickness of the steel, this type of forging must be done with the help of an assistant or a power hammer; the smith cannot hammer it himself with enough force. As in the previous forging, the assistants use heavy sledgehammers to work the steel, while the smith uses a small hammer to set the pace of the hammering. The smith keeps a bundle of wet rice straw between himself and the anvil to protect himself from flying sparks and particles of steel.

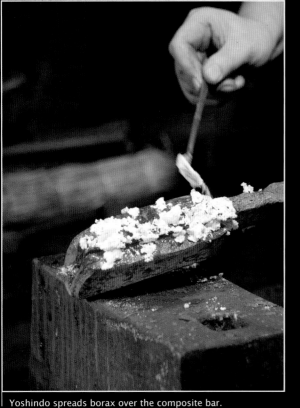
Yoshindo spreads borax over the composite bar.

This sequence of protecting the steel with clay and ashes, heating, and hammering is repeated until the core and outer steel are forged together. During this process, the steel is also being drawn out into a longer, thinner shape until it becomes long enough to make a sword. (For a katana, the steel will be forged until it is 24 to 28 inches (60–70 cm) long.) Once formed, this sunobe, or blank, will define the thickness and width of the new sword, so the smith must maintain the correct proportions as the steel is forged. Although the sunobe has the rough shape of the sword, it bears no close resemblance to what the finished sword will look like.

The smith must check the dimensions of the steel bar frequently to be sure there will be enough steel stock to form a well-shaped sword later. If the steel is too thin at any point, it will be impossible to make a sword with proper dimensions. As the steel lengthens, the handle welded onto the shingane

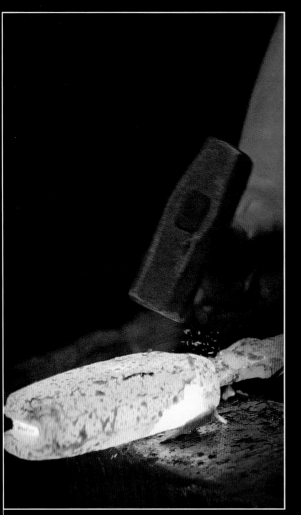
The bar is welded into a single composite structure.

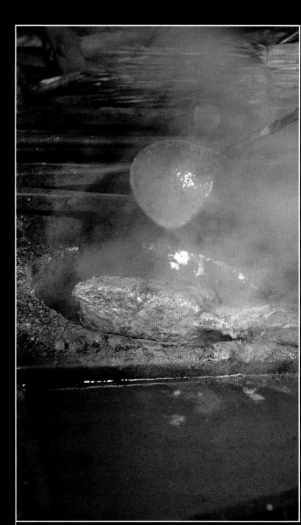
The steel is removed from the forge and covered with a clay slurry, and is then returned to the forge.

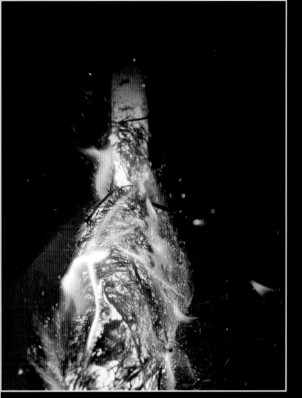

The steel is periodically rolled in straw ashes and returned to the forge.

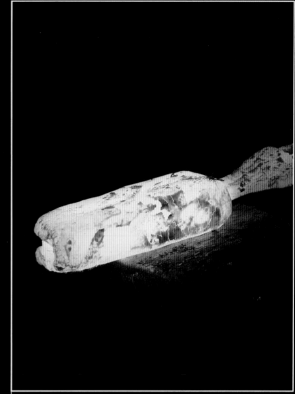

After the composite bar has been forged into a single piece, it is noticeably thinner and flatter.

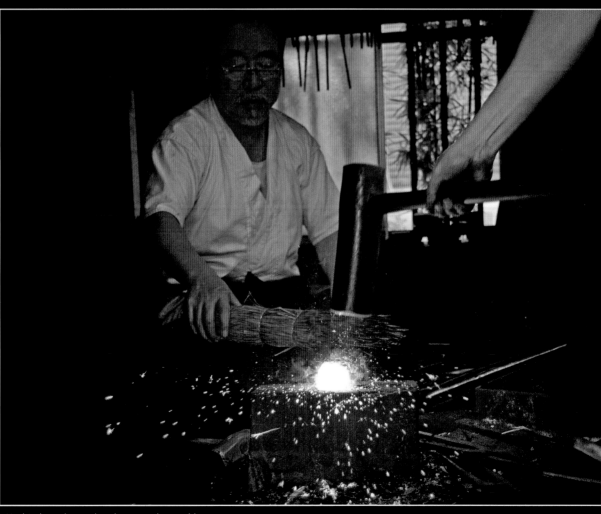

Yoshindo and a student hammer the steel bar.

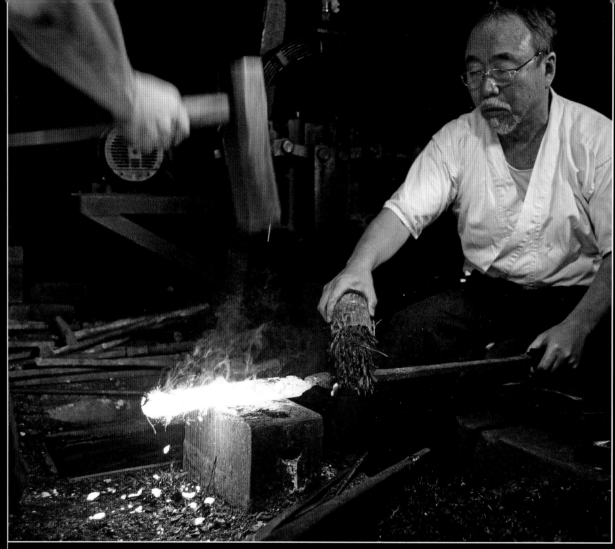

The bar is forged to draw out the steel and to unify the inner and outer components. Here it is becoming noticeably longer.

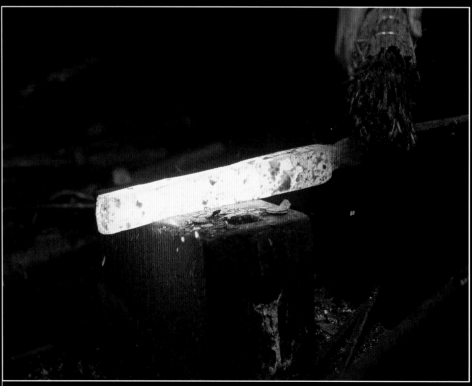

The steel bar is partially drawn out here. The end where the handle is attached will become the tang.

core becomes inconveniently long. The smith uses a chisel to cut partway through the steel, and then breaks off the original handle to make the steel a more comfortable length to work with.

The tang of the sword, which is formed at the end of the steel bar where the original handle was cut off, is hammered and shaped to be narrower than the rest of the bar, with a smooth surface. Once the tang has taken shape, the smith continues to heat and draw out the steel to make a long bar, gripping the steel by the tang as an assistant hammers with a sledgehammer.

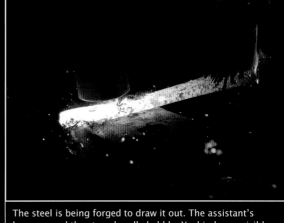

The steel is being forged to draw it out. The assistant's hammer and the straw bundle held by Yoshindo are visible.

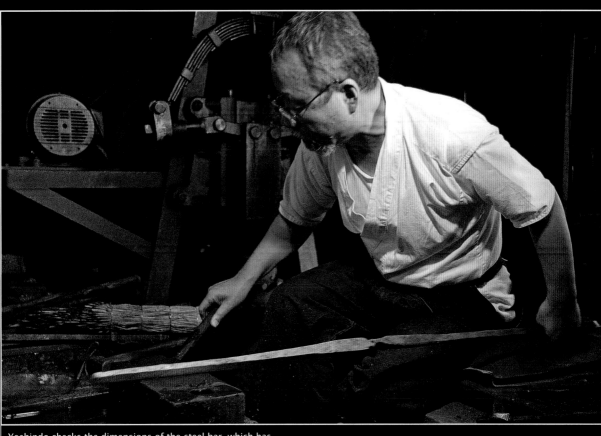

Yoshindo checks the dimensions of the steel bar, which has become much longer.

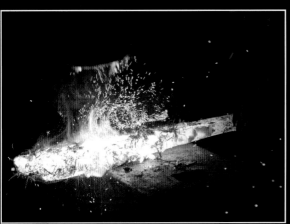

Forging the steel bar. The sparks swirling around the steel are from the straw ashes.

Once the steel bar has been forged out to approximately the planned length, excess steel is cut from the point area to make the blank exactly the length desired. The smith places a chisel on the hot steel where he wants to cut it, and his assistant strikes the chisel with a sledgehammer to cut partway through the steel bar. The end of the bar can now be bent with a small hammer until it breaks off. Forging then resumes, with the steel being worked on the sides and the top and bottom surfaces to define the point.

Cutting off the handle that was welded to the shingane core steel. This end of the bar will form the tang.

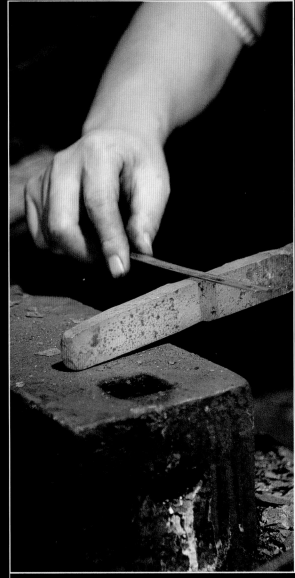

Checking the dimensions of the steel where the tang is being formed.

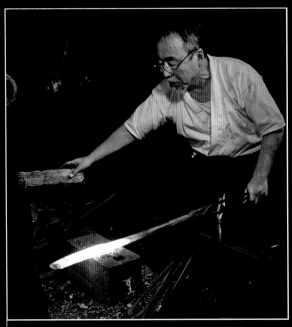

Drawing out the steel into a longer bar. The handle has already been cut off here.

The end of the steel bar has been shaped to form the tang.

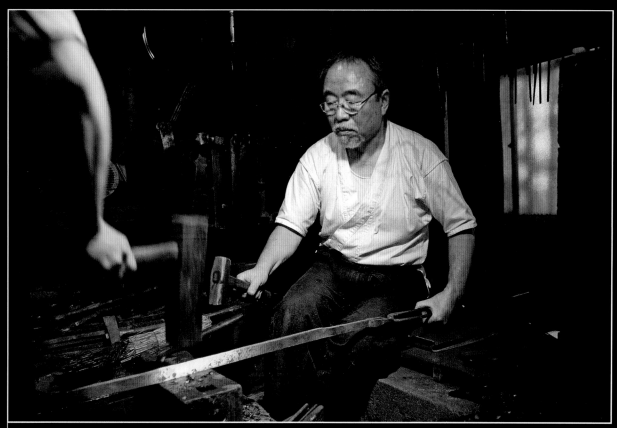

Yoshindo uses a pair of tongs to grip the tang while his assistant hammers the steel. They are working to draw out the steel to the desired length.

The smith continuously checks the steel bar to be sure it has the proper dimensions and thickness, simultaneously inspecting the shape and condition of the steel along its full length. If there are any irregularities, he will repair or correct them by forging. This conserves steel; correcting problems later by filing or grinding could result in the loss of a large amount of steel.

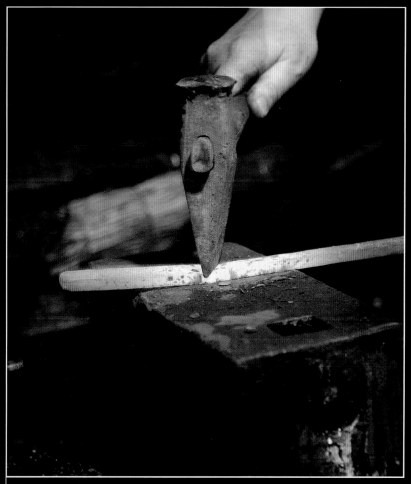

A chisel is used to cut partway through excess steel at the end of the bar.

The smith has now forged the sunobe, the blank from which a sword will be forged. This composite steel bar is of the correct shape and length to make the sword. It has a soft shingane steel core and a hard high-carbon kawagane covering, as well as a defined tang and point area. It is of uniform thickness from the back of the steel to what will be the cutting edge, and has a surprisingly smooth and flat surface considering that it has been formed only by hammering.

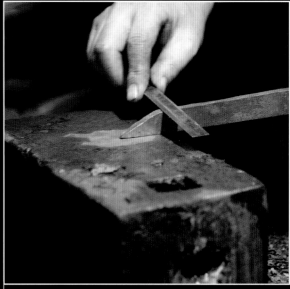

Yoshindo checks the dimensions of the point area.

The point area is being defined through forging.

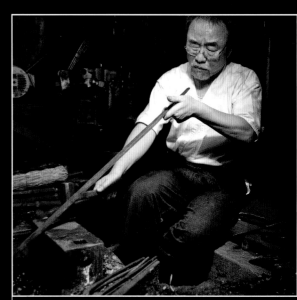

Yoshindo checks the shape of the composite steel bar.

The point area is well defined and the shape of the point is clear.

The composite steel bar has been forged into the sunobe, the blank from which the sword will be made.

Hizukuri: Fully Shaping the Blade

At this point, the overall shape and length of the new sword have been defined. When the sunobe is forged out into the final sword, the blade will be about 10 percent longer and about 20 to 30 percent wider than its current dimensions, and the cutting edge will be formed. The swordsmith must therefore plan for these changes as he works. Forging the sunobe into the final shape of the sword is called "hizukuri." The smith works on the sunobe one section at a time, gradually moving from the tang to the point area. In general, he heats the blade until it is yellow in color (about 2000°F or 1100°C) and works it until it cools down to a dull cherry-red color (about 1300°F or 700°C). It is risky to forge the blade if it becomes any cooler, because hammering it at too low a temperature may damage the blade. Conversely, hammering the steel when it is too hot runs the risk of ruining or deforming the position of the core and jacket components.

The smith must now delineate all of the parts of the sword: the point, the tang, the back surfaces, and the cutting edge. If the sword is made in the traditional shinogi-zukuri style, he will also define the shinogi ridge line running along the complete length of the sword and the flat surface above it. If the sword has a shinogi, the cross-section of the blade will be thickest where the shinogi is located. The blade is thinned out along the edge to create the cutting edge, and the sides near the upper part of the blade are thinned out a bit. The point and tang are also shaped at this stage to define the complete shape.

Most of the forging at this stage is done by the smith with a small hammer, though his assistants must sometimes help by using a sledgehammer. When an experienced smith does this work, it looks effortless; the blade appears to simply take its shape directly under the hammer. This type of forging, however, is much more difficult than it appears, and it takes an apprentice swordsmith three to five years to master. One aspect, perhaps not obvious to an observer, that makes this stage very difficult is the fact that steel does not compress. Every time the smith strikes the blade in one location to shape it, the steel displaced by the hammer must go somewhere. As a result, the blade

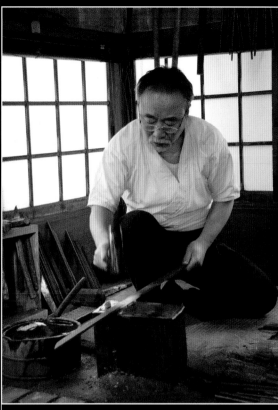

Finishing and adjusting the lines and surfaces of the sunobe.

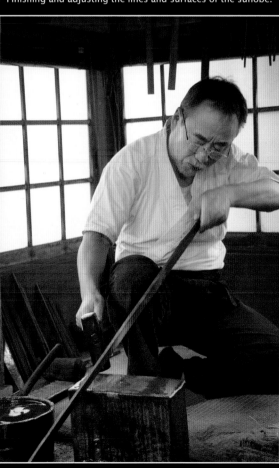

Yoshindo checks the lines of the sunobe.

155

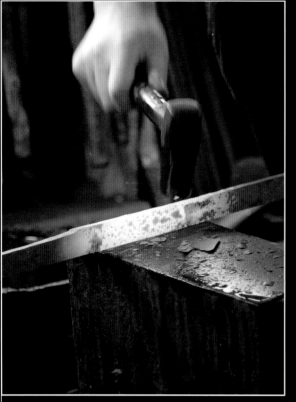

Yoshindo works on the end nearest to the tang. He is forming the iori mune, the roof-like shape along the back surface of the sword.

The mune (unsharpened back edge of the sword) has two surfaces topped by a ridge.

tends to warp and twist during forging, as the steel being displaced moves up or down along the blade.

As in the earlier forging work, the hammer and anvil surface are kept wet, which helps to keep the anvil clean. The hot steel boils the water on contacting the anvil surface, and the resulting steam helps to blow particles and slag off of the anvil and away from the sword. If this is not done, slag or other particles may be hammered into the steel.

The curvature of the sword must be corrected frequently. This is accomplished by hammering on the top ridge surface to straighten the blade. In addition, the sword will develop waves or warping along its surface that must be continually straightened during this forging process.

The smith continues to forge the blade and shape the sunobe section by section until the entire blade and the point are properly shaped. When he finishes shaping the point area, he works progressively back toward the tang to refine the shape, straightening the blade and making it as flat and smooth as possible. Correcting the shape now will conserve steel that would be lost by grinding or filing to finish the shape later.

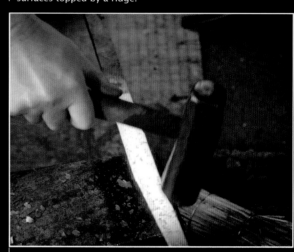

Yoshindo hammers on the edge of the anvil to begin forming the cutting edge.

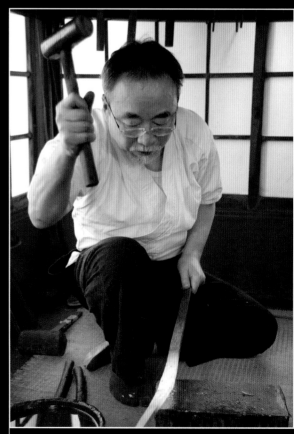

The sunobe expands where Yoshindo is forming the cutting edge. The bulge in the sunobe just above the tang is the beginning of the new edge.

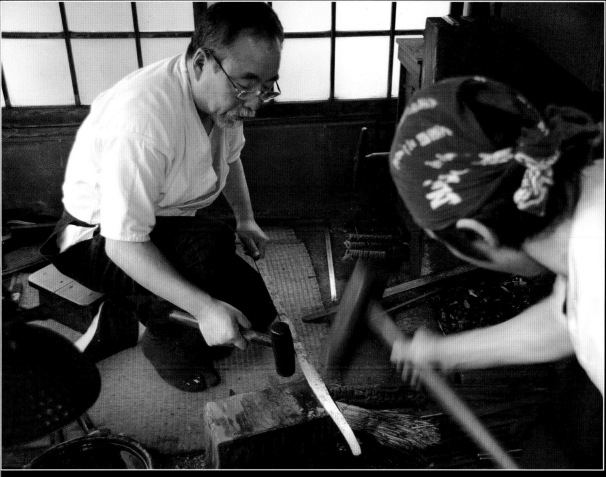

Sometimes Yoshindo's assistant uses a sledgehammer to help with the shaping.

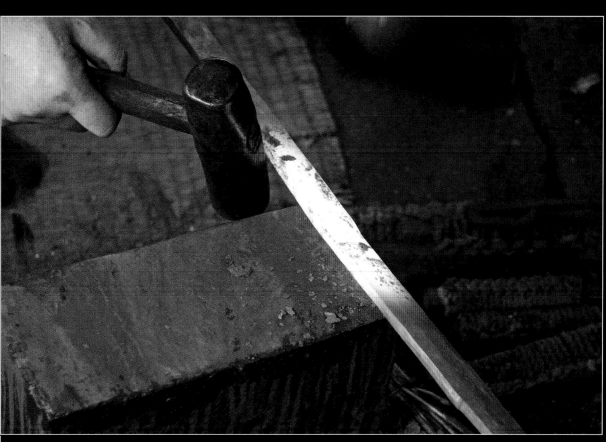

Yoshindo has shaped the first 4 to 6 inches (10-15 cm) of the sword, including the shinogi ridge line and the tang. The original sunobe shape is visible above the forged area.

The hammer and anvil are constantly wetted during the forging process.

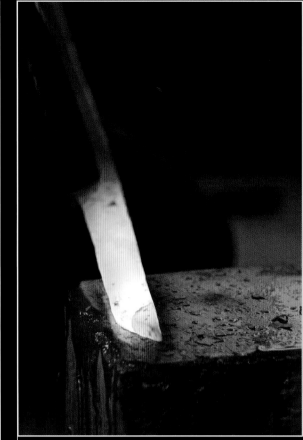

Forging has progressed to the point area, which is now being delineated.

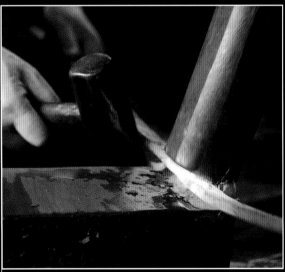

Forging close to the point area. Yoshindo positions the sword while his assistant hits it with a sledgehammer.

At the end of the hizukuri stage, the blade will have its proper and complete shape, the mune or back surface will be formed, the shinogi or ridge line will be in place, and the point and tang will have their proper shape. Although the blade is well formed at this stage, with a defined cutting edge, the edge will be left at least 1/16 inch (2 mm) thick to protect it during the next stages of making the sword.

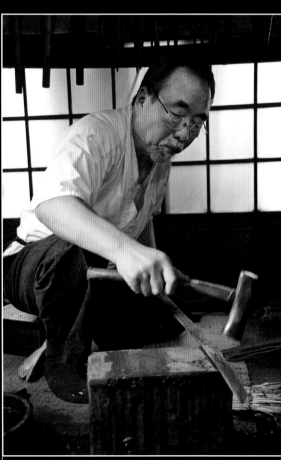

Yoshindo continues to refine the shape of the sword by additional forging. Here he is working his way back from the point to the tang.

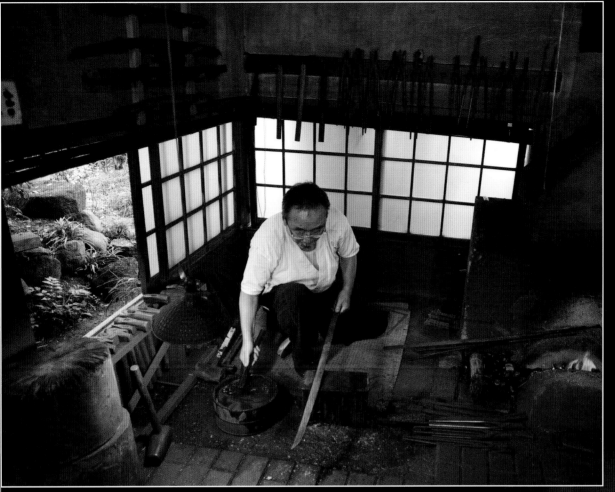

Yoshindo pauses to dip his hammer in water as he works his way back along the sword to the tang.

Yoshindo finishes shaping the tang.

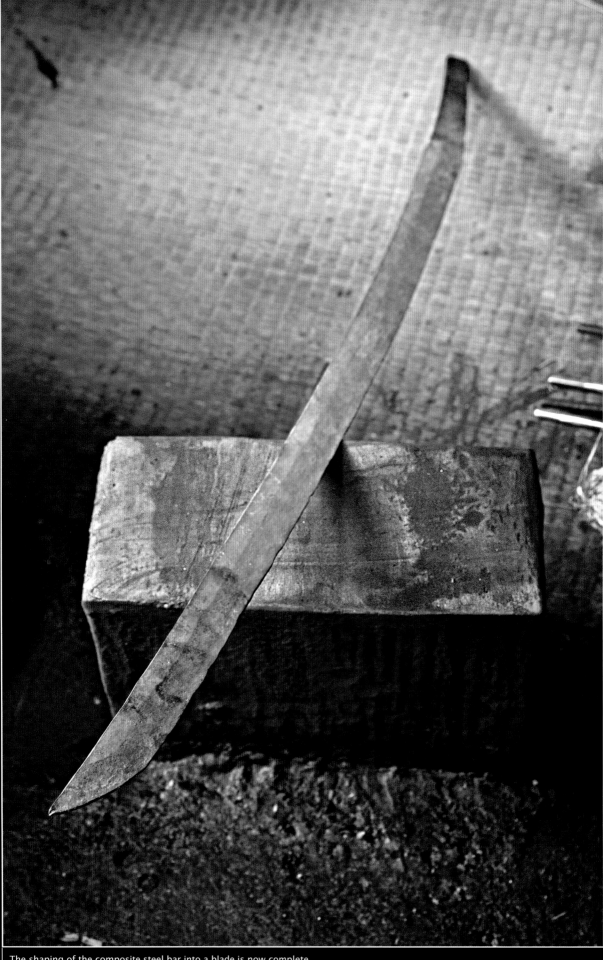

The shaping of the composite steel bar into a blade is now complete.

ARA-SHIAGE:

ROUGH FINISHING

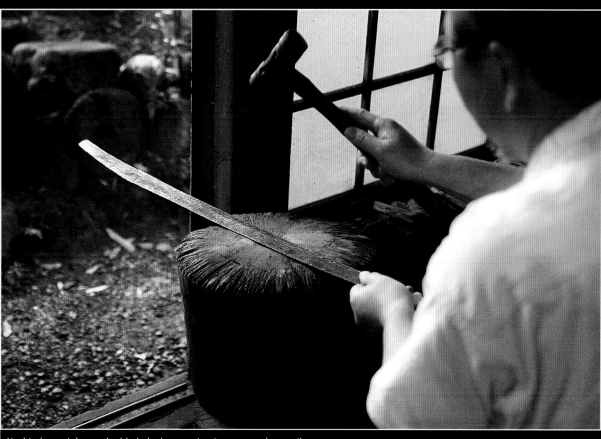

Yoshindo straightens the blade by hammering it on a wooden anvil.

Once the forging work is done, the sword must be straight, with a smooth and continuous curvature; it cannot be warped or twisted. As careful as the forging work is, it is rough work done with a heavy hammer, and many details of the sword's shape must be corrected afterward. Although the blade appears straight during the forging process, it can change shape as it cools down to ambient temperatures.

After examining the blade for waves or warping along its length, the smith places the sword on a wood block (usually a section of a tree trunk), and hammers it carefully in appropriate places to straighten and flatten the blade, working his way along its entire length to be sure it is completely straight. He then checks again to be sure that the blade is perfectly flat along its entire length. Any remaining twisted areas are straightened by bending the blade slightly with a strong U-shaped iron bar. Once again, the smith works his way along the entire blade to correct any deformations. If the forging work was done well, the blade will be very close to its

planned dimensions and shape at this point. This will limit extra filing and shaving work, and hence wasted steel, later on.

Next, a two-handled drawknife called a "sen" and a file are used to further smooth out and refine the edge, back, and sides of the blade, and to correct any remaining irregularities in the surface or in the contours of the blade. The sen is used in a manner similar to a plane to shave and smooth out the sides of the sword. It has a blade made of hardened steel that can easily remove a large amount of metal from the sides of the new sword, leaving a clean, smooth surface. The sword, clamped between two pieces of wood, rests on a long wooden board. The smith pushes the two-handled sen away from himself to shave down the length of the sword. In the photo on page 163, the white parts have been shaved with the sen, while all of the black scale and oxide on the surface of the sword have yet to be removed. Note the large quantity of metal shavings around the sen and the sword.

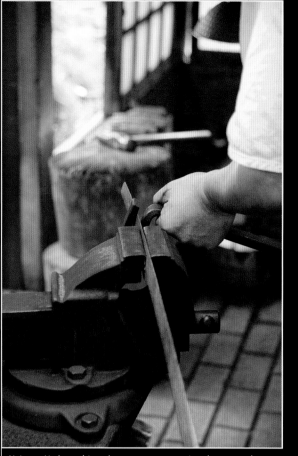
Using a U-shaped iron bar to correct a twisted area on the blade.

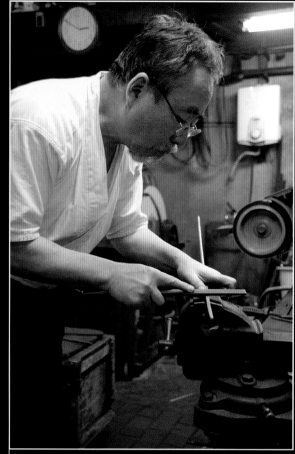
The mune and the cutting edge are finished with a file.

Inspecting the shape of the blade. The blade is constantly inspected to monitor the straightening process.

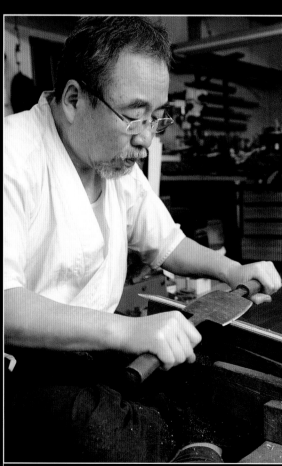
The sides of the blade are finished by shaving it with a sen, a drawknife made from hardened steel.

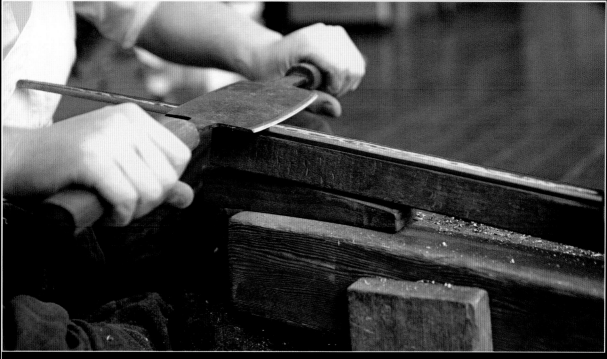

Using a sen to shape the new sword. The steel above the shinogi is white where it has been shaved with this tool.

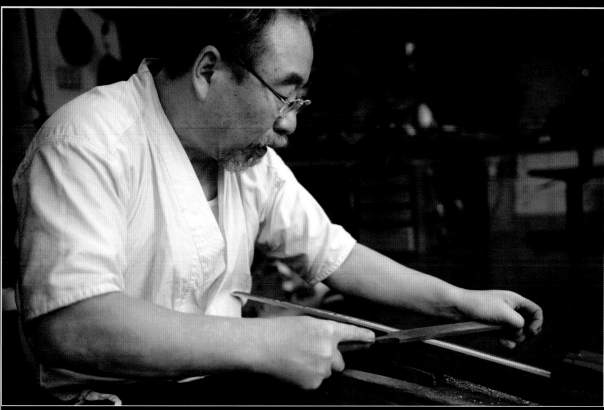

After using the sen, Yoshindo files the surface to make it smoother.

The sen is used to make the edges of the blade smooth and straight, and to eliminate any depressions left on the surface during forging. When the work with the sen is complete, the surfaces are finished with a large, coarse file. The smith then goes over the surface again with a very rough carborundum polishing stone, using it to smooth out the surfaces, the edge, and the back. The lines and surfaces defining the shinogi, the point, the tang, and the machi (notches at the top of the tang just below the cutting edge) will be made very clear and sharp. The regular scratches left by the rough stone will give the surface of the sword a smooth, uniform appearance. The blade is kept very clean, and is not touched with the hands. All of this is preparation for the next stage: creating the hamon.

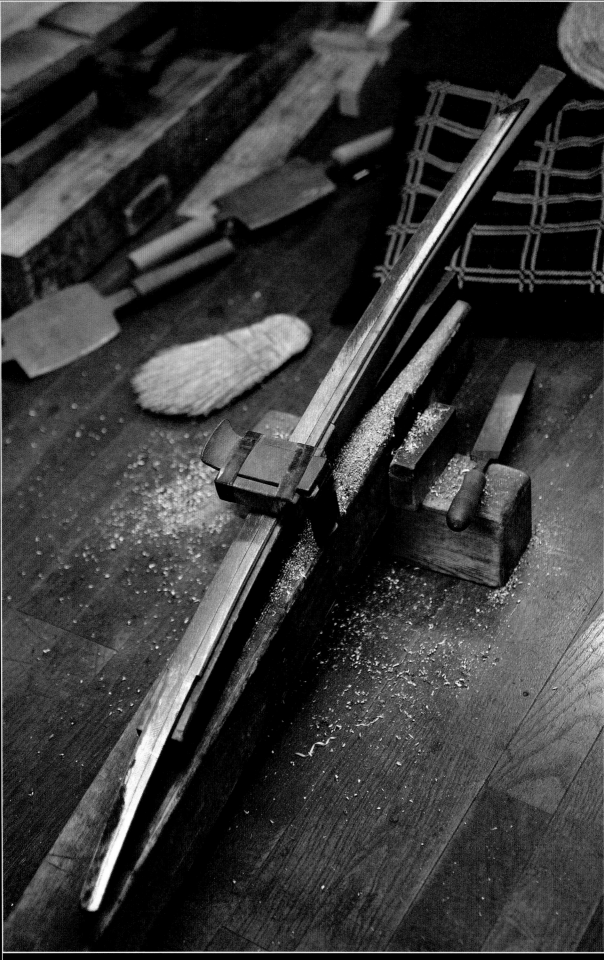

The sword is clamped between two pieces of wood to hold it in position while it is shaped with the sen and file.

TSUCHIOKI:

APPLYING CLAY TO THE BLADE

After forging and rough shaping, the smith has a well-shaped blade with a clean, rough, uniform surface. The next step is to make the hamon, a clearly defined pattern of hardened steel along the cutting edge of the blade. This involves coating the sword with clay before it is heated and quenched. In this process, called "tsuchioki," an insulating layer of clay is applied to the body of the sword except where the edge is to be hardened. The steel is heated to the point at which it is no longer magnetic (this critical temperature, between 1380 and 1560°F or 750–850°C, varies with the particular type of steel), and then cooled very rapidly, usually by quenching it in a tank of cold water. The body of the sword cools more slowly than the edge due to the insulating clay coating. The difference in cooling rates between the edge and body of the sword is relatively small, probably on the order of just a few thousandths of a second. Nonetheless, the faster-cooling steel is far harder. In metallurgical terms, the edge steel is converted to martensite while the body of the sword will remain as ferrite and pearlite. A blade that is successfully heat-treated to form a clear, distinct hamon along the cutting edge usually has a visible line— the nioi-guchi—marking the boundary between the hardened edge and the softer body of the sword.

Creating a hamon that is both functional and aesthetic is a skill that requires years to learn. First, the steel must be properly made from tamahagane. Moreover, the clay coating must be of the proper composition, and it must be placed on the blade in a very careful manner; the blade must be heated to a very precise temperature range, which must be judged only by eye from the color of the steel. Finally, the sword must have a very uniform temperature over its entire length before being quenched if the hamon is to be consistent in appearance and structure along the whole blade.

The composition and carbon content of the steel are critical for making a good hamon, as they affect the formation of martensitic steel during cooling. The smith takes measures to ensure that these are correct from the very beginning, when he begins to make the steel from the tamahagane. If the carbon levels are lower than approximately 0.6 to 0.7 percent, the steel will not form a proper hamon, or the resulting hamon will be very narrow. Further, if the steel contains elements other than iron and carbon, this can affect how it will cool, and may even inhibit martensitic steel from forming.

The shape of the hamon itself is also significant. The oldest Japanese swords had very narrow, straight hamon, so that the softer ferrite and pearlite of the sword body and the martensite edge were joined only by a thin straight line. In combat, under the stress of striking another sword or other object, the bond between these two types of steel could break or weaken, causing the cutting edge to separate from the body of the sword. To solve this problem, swordsmiths during the Heian period (794–1185) began making the hamon outline much more complex. Instead of the earlier simple straight hamon boundary, the new ones featured a series of semicircles, loops, waves, or other shapes projecting down from the top of the hamon toward the cutting edge of the sword. Hamon in this style are far more visually interesting, as well as much more effective. There are names for the many variations of shapes that make up the hamon boundary; the pattern may also change along the length of the blade. A good hamon must have a very clear, unbroken, and defined pattern, however, and it should be possible to describe the pattern with the standard Japanese terms used to discuss hamon.

What is common to all such variations is their ashi, lines of pearlite and ferrite steel extending into the hamon from the body of the blade toward the cutting edge. The ashi effectively form a much longer boundary between the body of the sword and the martensitic hamon. The bond between the hardened cutting edge and the body of the blade is strengthened with a zipper-like structure to maintain the integrity of the sword. Furthermore, if the hardened edge sustains any chips or damage, the tooth-like structure of this hamon ensures that the damage will be restricted to the small space between two adjacent ashi in the hamon.

With these considerations in mind, the smith can begin to prepare the hamon, which is a three-stage process. In the first step, the smith prepares a black coating composed of ceramic clay, ground charcoal, and ground stone (from a rough sandstone called "omura-to"). He then applies a layer of this clay along the cutting edge, scraping it to produce a very thin, uniform coating. The area covered with the black clay coating determines approximately where the hamon will be. This clay covering actually speeds up the cooling rate of the sword when it is quenched in water. Because the ground stone component greatly increases the surface area of the clay over the steel at a microscopic level, the edge steel cools even faster than it would if it were bare, allowing it to convert almost completely into martensitic steel, which helps to produce a better hamon.

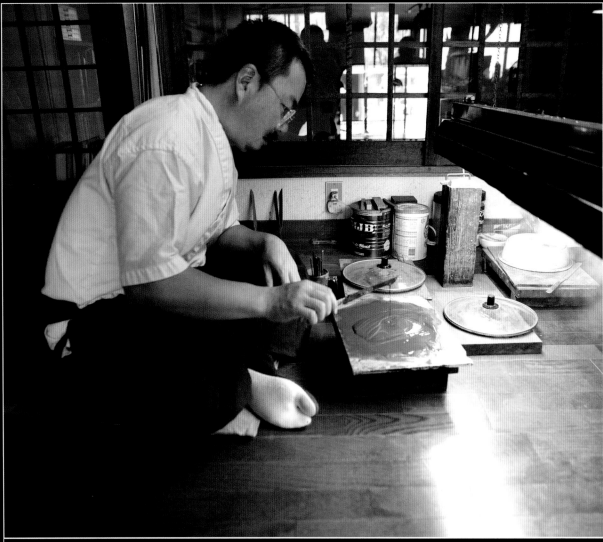

Yoshikazu prepares the black clay mixture that will define the hamon area. When it is at the proper consistency, all of the clay will have dissolved and the mixture will be wet enough to spread over the steel easily. Once it is on the sword, the clay dries rapidly, becoming unworkable.

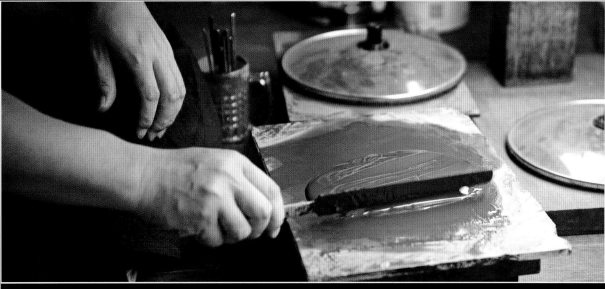

The black clay is mixed with water until it reaches the proper consistency and all the clay particles are completely dissolved.

Yoshikazu begins to spread the black clay mixture over the area where he plans to form the hamon. He uses a small spatula to apply the clay exactly where he wants it.

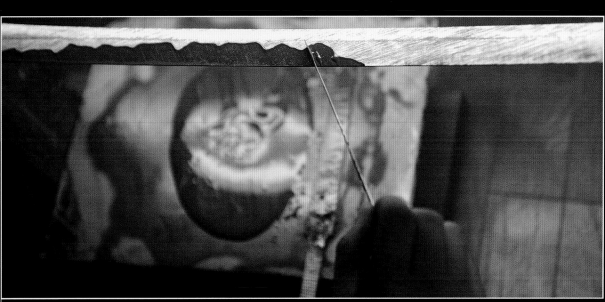

The black clay is spread along the entire sword over the area where the hamon is to form. A narrow raised border of clay demarcates the top of the hamon area.

Next, the smith coats the upper part of the blade with much thicker layer of red clay. This coating extends from the mune (the unsharpened back surface of the sword) down to where the top of the hamon will be, stopping at the raised border of the black clay coating. The red clay mixture contains ceramic clay, ground omura-to, charcoal, and iron oxide (which gives it the red color). The components of the clay coatings described here are those used by Yoshindo and the Yoshihara-school swordsmiths. Other smiths and schools use their own variations of these formulas. The red clay mixture functions as an excellent thermal insulator; furthermore, the color contrast between the red and black clay coatings makes it easier to see the details in the clay pattern that will define the new hamon.

Once the red thermal clay has been applied to the body of the blade, many details must be added. If the blade were heated and quenched at this point, the shape of the hamon would more or less follow the border where the red and black clay coatings meet on the body of the sword. For a complex hamon, the smith uses the red clay to add ashi. To do so, he dips the edge of the spatula into the clay and then rolls it along the blade across the red and black clay-coated areas, from the back of the blade to the edge. This lays a narrow strip of clay across the entire width of the blade down to the edge to make thick ashi. The steel will cool almost as slowly under these ashi as under the thicker layer of red clay that covers the upper part of the sword, creating narrow strips of softer steel wherever the clay is placed along the

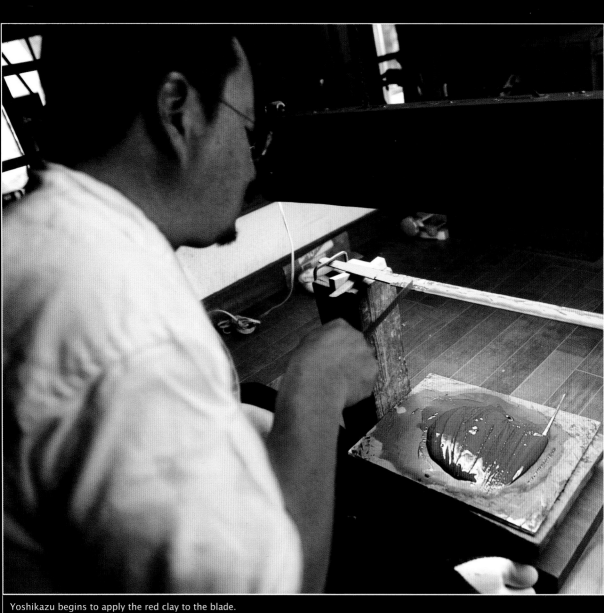

Yoshikazu begins to apply the red clay to the blade.

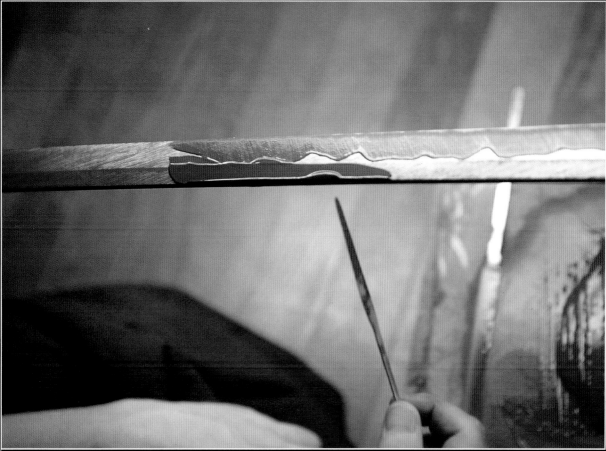

Yoshikazu applies the red clay to the upper part of the blade, which will not be hardened. The clay is applied with a small spatula and then spread down to the boundary of the black clay.

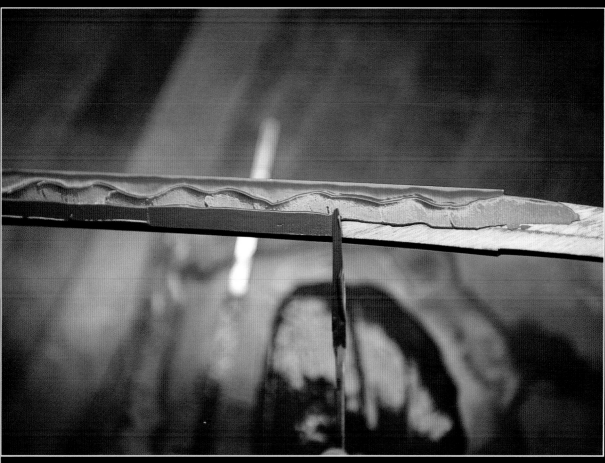

The red clay is spread down to the border of the black clay and on the remaining surface area of the sword. The entire blade must be covered with clay before yaki-ire.

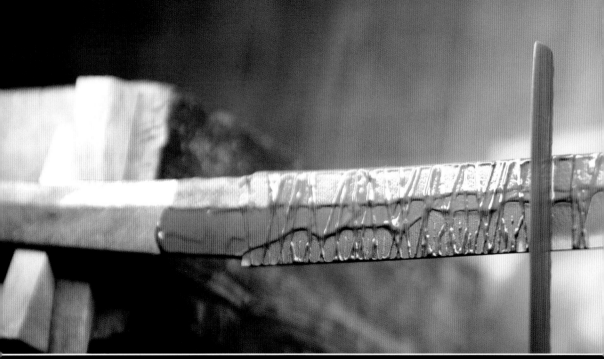

Applying the ashi. A spatula is dipped in red clay and rolled across the blade to leave a thin strip across the black clay coating. The area under the strips will not harden during yaki-ire, resulting in thin lines of soft steel across the hardened edge.

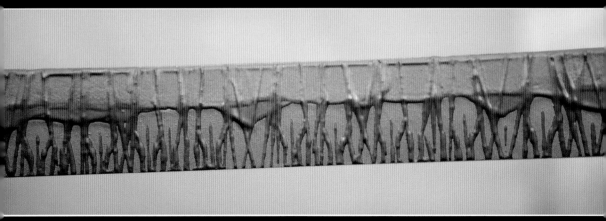

Ashi are placed along the entire hamon. In this photo, the upper red layer is visibly thicker, and the red ashi are visible over the black clay. This pattern will produce a choji-midare hamon.

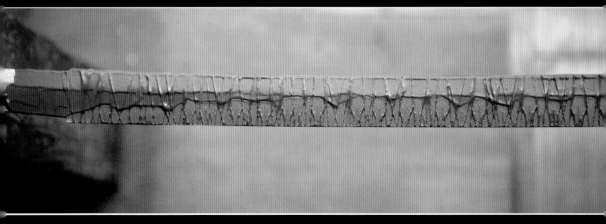

hamon. These soft areas will be very clearly visible in the final hamon. Thus, if the smith heats the blade to precisely the correct temperature, and the clay pattern is well designed, the final hamon area will be defined by two major factors: the heavy red clay layer above the black clay coating, and the ashi inside of the hamon.

When the clay coating is partially dry, it is possible to get an idea of what the final hamon will look like. The light gray areas extending up from the cutting edge in the photo below show approximately how the hamon will appear. The dry gray areas form loops that arch up from the cutting edge toward the back of the blade. This pattern, in which the tops of the individual loops are wider than the bottoms, is called "choji."

Once the clay applied to the sword has dried, the next step, yaki-ire, can be performed. The smith

heats the sword in the forge until it reaches a critical temperature (usually about 1380 to 1560°F or 750–850°C) at which the blade is a dull to bright yellow. When he judges the moment to be correct, the smith plunges the hot blade into a tank of water to cool it rapidly and form the hamon.

This spectacular process is much more difficult than it appears to a casual observer. The sword must be heated to a very precise range of temperatures for a given clay pattern, clay composition, and clay thickness to produce the hamon that the smith expects. If the blade is heated too much, the desired pattern will not be produced. The blade must reach the proper temperature; the steel must be pure carbon steel with a proper carbon content; the blade must be heated very evenly along its entire length; and the clay coating must have a proper design and be applied properly to achieve the desired hamon.

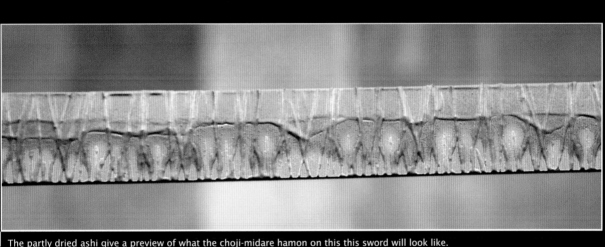

The partly dried ashi give a preview of what the choji-midare hamon on this this sword will look like.

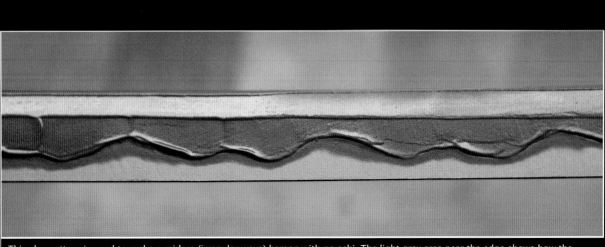

This clay pattern is used to make a midare (irregular wave) hamon with no ashi. The light gray area near the edge shows how the outline of the hamon will look.

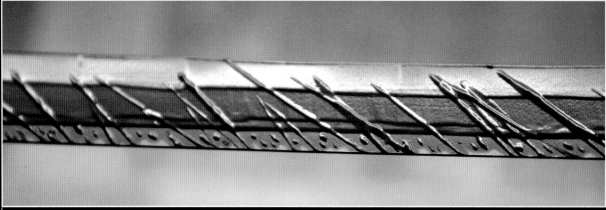

This clay pattern will produce a slanted and variable gunome wave hamon.

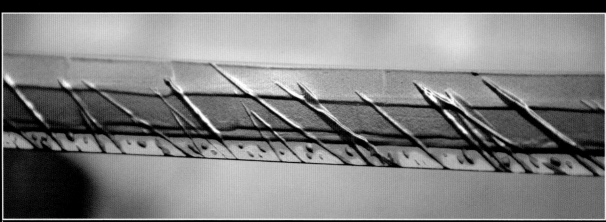

The partly dry gray area gives an idea of the final appearance of the slanted gunome hamon.

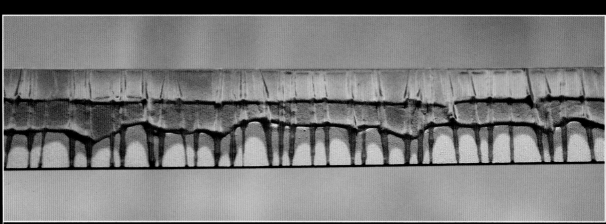

This clay coating will produce a gunome hamon. Gunome waves—regularly shaped waves that are widest at the bottom near the cutting edge—are visible in the gray areas.

This clay coating will produce a suguha (straight) hamon without ashi.

YAKI-IRE:
HEAT-TREATING

Yoshindo begins to heat the sword in the forge at the start of the yaki-ire process. Holding the blade edge-up, he slowly moves it into the forge and then pulls it out again, pumping the fuigo (bellows) all the while. The clay pattern on the blade can be seen clearly here.

The yaki-ire is usually carried out after sundown, so that the shop can be completely dark. This is important because the smith must determine the temperature of the blade by its color, and any additional light in the shop could interfere with his judgment. He begins by heating the blade in the forge, edge-side up. The sword is drawn through the forge slowly, replaced, and then pulled though again slowly. As this process is repeated, the blade begins to change color, initially turning a dull red. The smith continues to heat the blade slowly. When the color is orange, he rotates the blade so that it is drawn through the forge edge-side down. He goes on heating the blade until the edge is bright orange or almost yellow, and the back is a duller orange. This color pattern means that the edge is hotter than the body of the blade. Ideally, if the heating step is performed properly, the edge of the blade will be approximately 1470°F (800°C) and the back will be between 1290 and 1330°F (700–720°C); these temperatures will be consistent along the entire length of the blade. At this point, it is possible to see where the hamon will form, because the thick clay boundary and approximate outline of the hamon can be seen on the heated steel. When the blade is uniformly heated along its entire length, and the color of the edge and back are correct, the smith pulls the blade out of the forge and plunges it into a tank of cold water.

As the sword is slowly drawn through the forge, the temperature of the steel increases and the color progresses from black to red to orange to yellow.

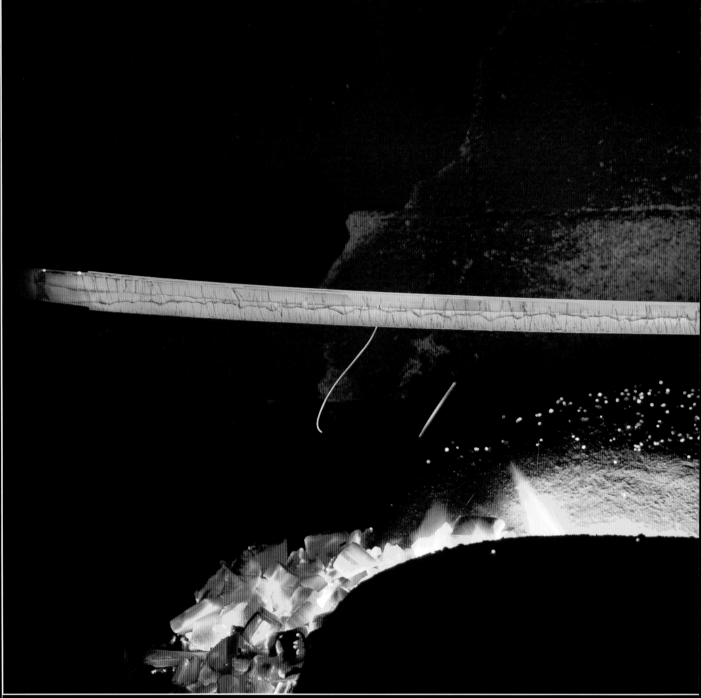

Yoshindo has let the fire in the forge die down so he can see the color of the sword as clearly as possible. The blade should be an even color before quenching, with the edge noticeably brighter than the rest of the sword.

After the blade has cooled, the smith takes it out of the water and inspects it. If the clay coating is intact and the shape is undamaged, the blade must then be annealed (yaki-modoshi). The blade is placed back into the forge and reheated to about 350°F (170–180°C), and then quenched again. The edge of the blade is very hard and brittle after yaki-ire, and would be prone to chipping or cracking if used or even polished in this condition. The annealing step softens the edge and makes it much less brittle.

Although yaki-ire is necessary to make a Japanese sword, it is a very stressful process for the blade. The steel cools at different rates in different areas, which causes twisting. It also flexes strongly when it is quenched in cold water, which can break or damage the blade if the sword has not been properly forged. A poorly forged blade can crack, warp, develop defects in the steel, or have a poor hamon after this process.

If the results from yaki-ire are not acceptable, but the blade is otherwise sound, the smith can remove the hamon by heating it in the forge until it reaches a yellow color and then allowing it to cool slowly in air. The smith can then clean the blade, recoat it with clay, and attempt to perform yaki-ire again to produce a good sword with an acceptable hamon. A well-forged sword can survive yaki-ire several times, so the smith usually will have more than one chance to produce a good hamon on a new sword. Similarly, old swords that have been in a fire, show damage from extensive use and wear, or have been polished too many times can be heat-treated again to create a new hamon.

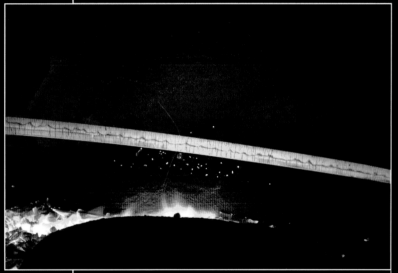

The blade is still being heated with the edge up. The steel has turned a dull yellow color, and the outline of the clay coating is clearly visible.

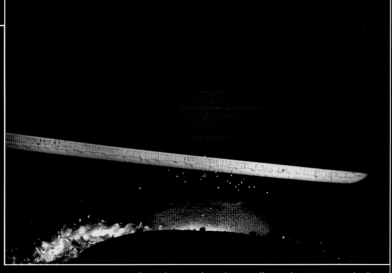

Once the sword reaches a yellow color, it is turned edge-down, and the movement in and out of the forge continues.

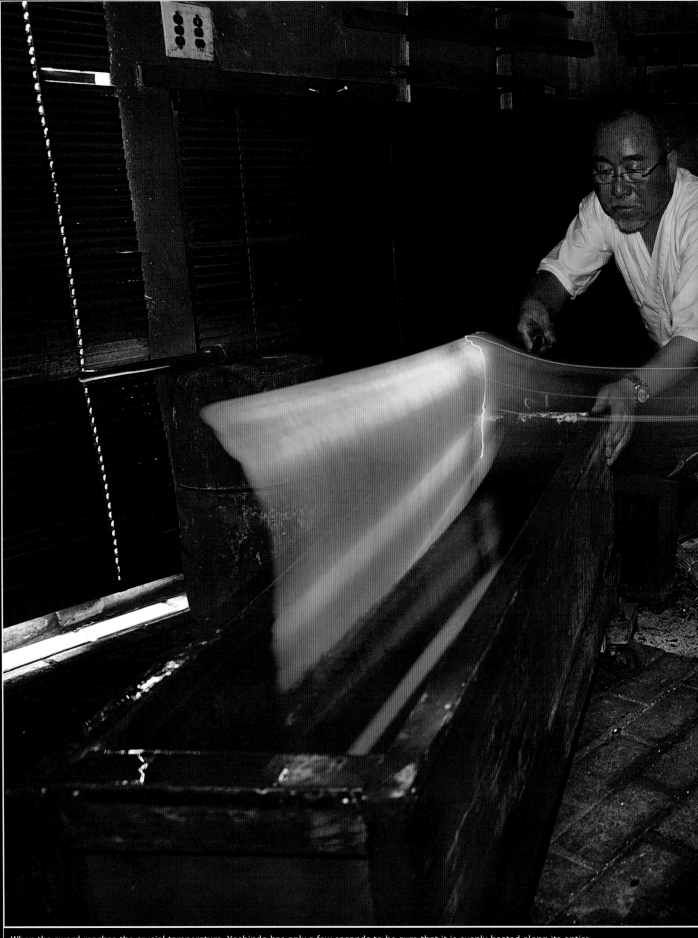

When the sword reaches the crucial temperature, Yoshindo has only a few seconds to be sure that it is evenly heated along its entire length and that it is the proper color. When it is ready, it is rapidly moved parallel to the ground and plunged into a tank of water to cool it. If everything has gone well, the sword will now have a hamon.

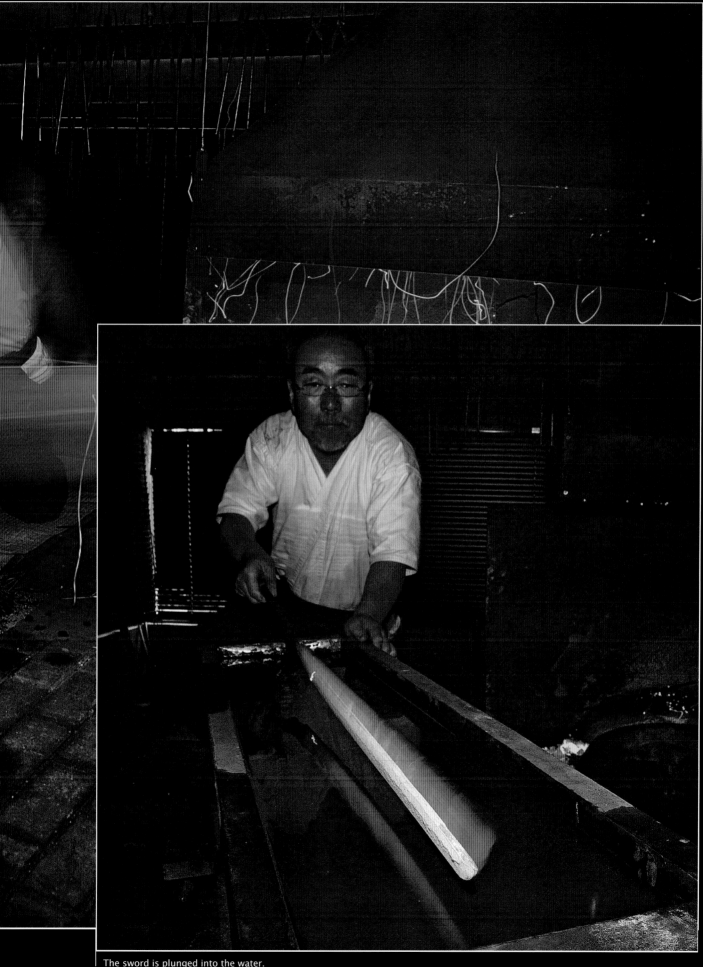

The sword is plunged into the water.

HADAKA-YAKI: CREATING A
HAMON WITHOUT A CLAY COATING

Creating a hamon through the tsuchioki process (applying a clay coating) allows the smith to define its shape and form, and the result reflects his sensibility, skills, and characteristic way of working. It is also possible to make a hamon without applying a clay coating. This process, called "hadaka-yaki," may be the oldest way of making a hamon. With this method, the final hamon depends on the carbon level in the steel, how the surface of the sword is prepared, and the specific temperature to which the sword was heated before quenching. Although hadaka-yaki may produce a distinctive hamon, it does not show the smith's personality and style as clearly as one created using clay would.

When hadaka-yaki is successful, however, it can result in a complex and beautiful hamon with gunome and choji with fine and frequent ashi, as well as yo (ashi that are separate from the main hamon line). Soft islands of steel inside the hamon sometimes appear; these are impossible to make using tsuchioki. Sometimes, if the temperature is just right, a bright utsuri (a misty white formation that runs parallel to the hamon in the body of the sword) will also be present. Many of the Ichimonji school's choji-midare hamon and the Aoe school's saka-choji hamon are thought to have been made using hadaka-yaki.

Using tsuchioki to make a simple, straight suguha hamon on a small blade takes about 20 minutes. For a complicated hamon with gunome

and choji, it can take two to three hours to apply the clay; some smiths require more than half a day. Hadaka-yaki can be done very rapidly. The photos on the following pages show a katana that has undergone the more usual tsuchioki yaki-ire, and a tanto hardened with hadaka-yaki, being quenched in a transparent water tank. As the blade with tsuchioki is plunged in the cold water, few bubbles form along the sides of the sword; most of those that are present originate from the edge of the sword. This is because the edge of the sword cools very rapidly, transferring heat to the water along the edge of the sword and causing it to boil. The body of the sword, covered with a thicker layer of clay, cools more slowly, producing fewer bubbles.

On the hadaka-yaki blade, bubbles can be seen forming over the entire surface of the blade. As soon as the smith puts the blade in the water, it begins to cool rapidly over its entire surface, not just the edge, so the heat is transferred to the water all around the steel. However, many bubbles form first near the hot narrow edge and travel up along the blade's surface. These air bubbles act an an insulator, changing the rate and pattern of cooling along the sword's surface. Their form and movements are random, so the differential cooling effect that they have along the sides of the blade—the action that produces the hamon—is impossible to predict. The resulting hamon may be very successful, but the smith has little control over its appearance.

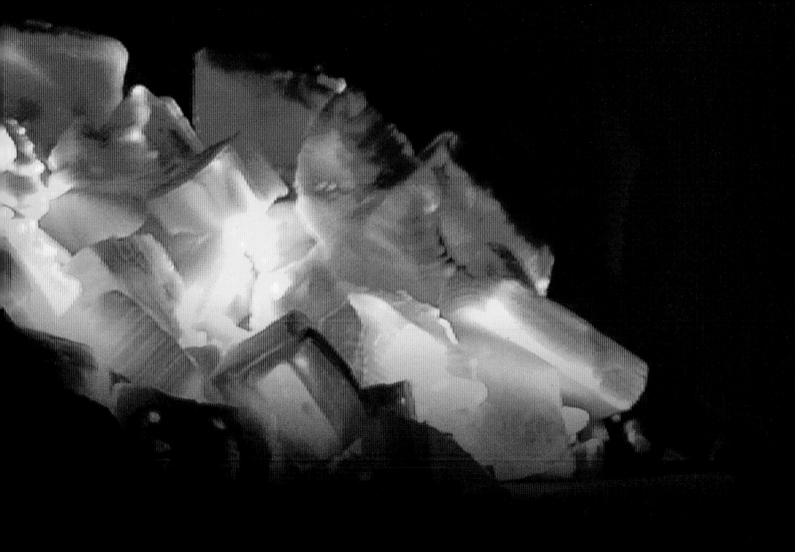

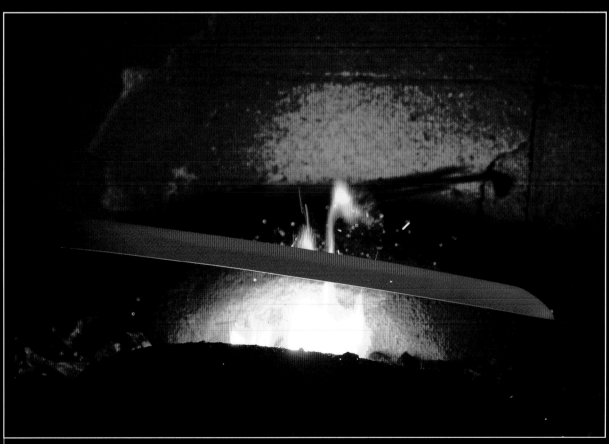

An uncoated blade, held edge-up, is heated in the forge for hadaka-yaki. Careful heating is essential for this process to work. The body of the blade is a dark red, while the edge is much brighter. Before quenching, the edge should be 1380 to 1470˚F (750–800˚C); the body must be 1130˚F (720˚C) or cooler.

Yaki-ire with a Clay-coated Blade

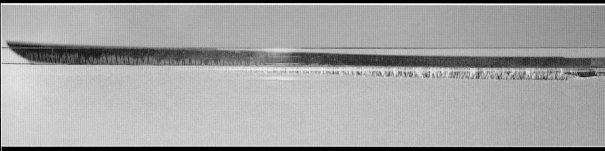

The heated blade is plunged into the water. A few small bubbles can be seen along the edge, and the sword has a slight downward curve.

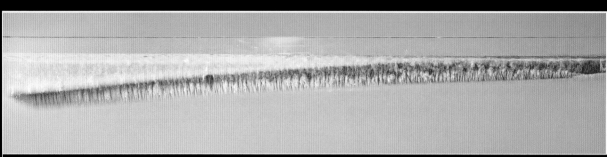

The blade 0.3 seconds after entering the water. Most of the bubbles are along the hamon area, extending up to the boundary between the black and red clay layers. The blade now has a pronounced sickle-shaped curve, and the steel is under great stress.

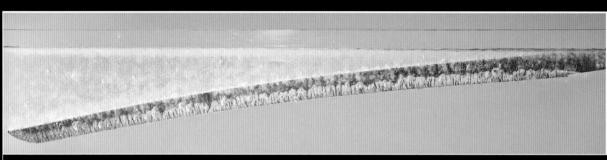

The blade 0.5 seconds after entering the water. It is cooling off, but still has a strong downward curve. Most of the bubbles are still along the edge, indicating that the hamon area cools down far more rapidly than the rest of the blade.

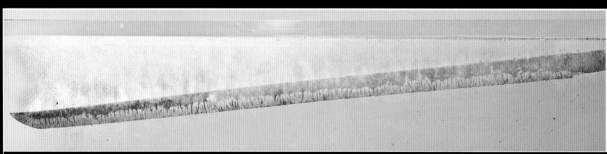

The blade 3 seconds after entering the water. The steel is almost completely cooled, and no more large bubbles can be seen.

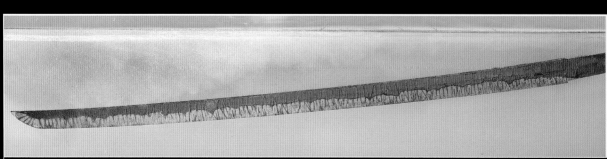

The blade 9 seconds after entering the water. It has cooled off completely and resumed its original shape. Small pieces of clay have come off in a few places along the blade, which may or may not affect the hamon. The process is completely over at this point.

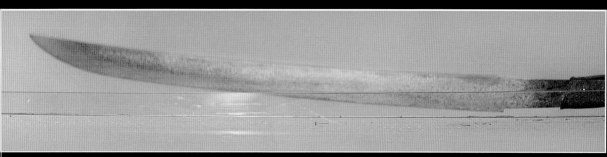

An uncoated hira-zukuri tanto is plunged into the water during the hadaka-yaki process. The edge is hotter than the rest of the blade.

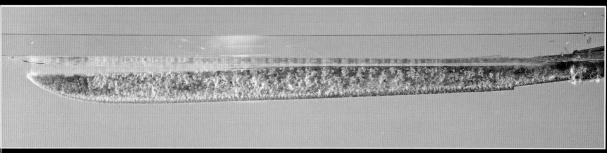

The blade 0.4 seconds after entering the water. A dense layer of bubbles forms along the edge. Numerous bubbles can also be seen along the sides of the blade up to the mune.

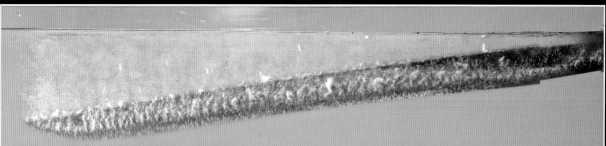

The blade 0.7 seconds after entering the water. It has now curved downward, giving the edge a concave contour. There are bubbles all over the sides of the blade, including many large ones.

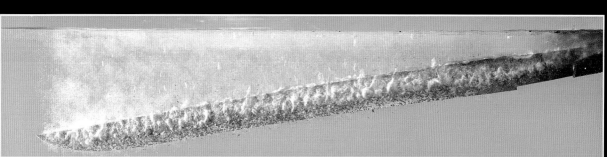

The blade 1.2 seconds after entering the water. It is a bit straighter, and there are fewer bubbles along the edge. The sides are covered with numerous large bubbles.

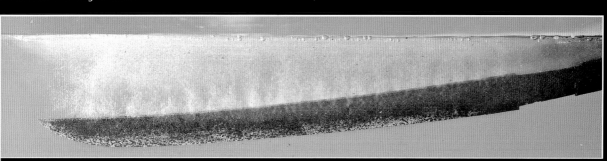

The blade 3 seconds after entering the water. It has straightened out, and bubbles are no longer visible along the blade.

SHIAGE: FINISHING THE BLADE

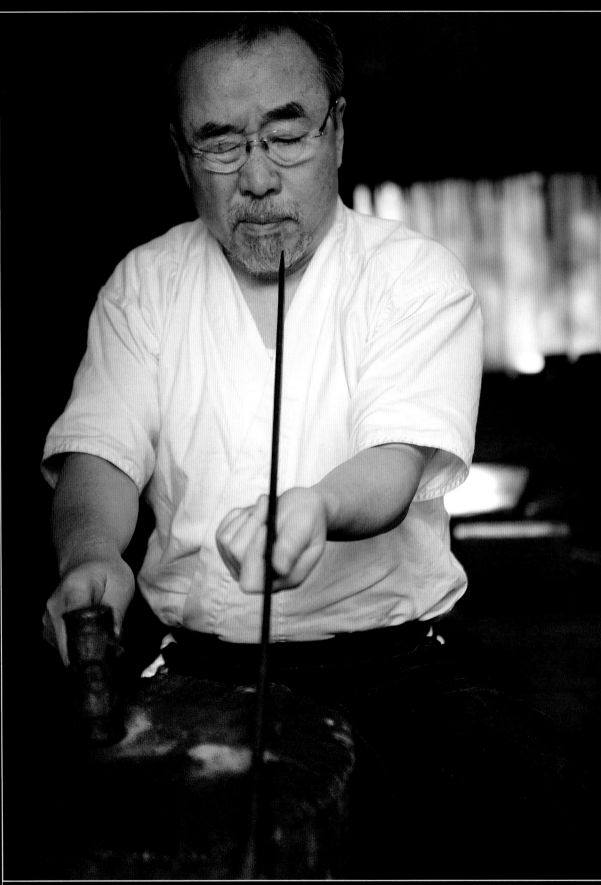

Yoshindo inspects the blade for straightness.

Straightening and Cleaning

After yaki-ire and yaki-modoshi, the smith must inspect the blade and make any corrections needed so that it is absolutely straight. Generally, the heating and quenching process will cause some warping and twisting along the length of the blade. The smith places the sword on a wood block and hammers it wherever necessary to straighten it.

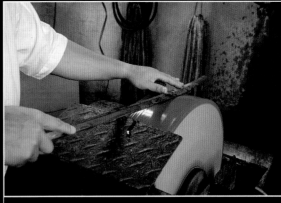
Using a water-cooled grinding wheel to clean and shape the blade after yaki-ire.

Once the blade is straight, a water-cooled grinding wheel or sanding belt is used to remove the clay and scale and leave a clean surface. This will also allow the smith to examine the new hamon and inspect the blade for flaws. Serious flaws can often appear on a blade after yaki-ire. As mentioned above, a blade can bend, the steel surface can open or form a blister, or a blade can now have a large fracture or crack somewhere on its surface. If the blade has survived yaki-ire with no problems, the smith can now proceed with the next steps of finishing the blade.

Sorinaoshi: Adjusting the Curvature

The yaki-ire process usually introduces some curvature in random places along the blade. As a finished blade must have a uniform and regular sori (curvature), this has to be adjusted, taking into consideration such factors as the kind of sori desired, as well as the depth and degree of curvature along the entire blade. The most pronounced part of the curve may be in the center of the blade (toriizori), near the tang (koshizori), or near the point area (sakizori).

The first step is to straighten the blade where there is too much curvature. This is done by hammering on the shinogi-ji surface, which lengthens the mune very slightly and straightens out the blade in a small area. This must be done carefully, being sure that the hammer does not strike near the edge where it may chip the brittle hardened steel.

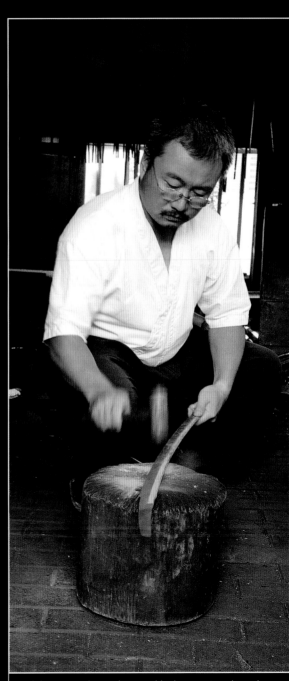
Yoshikazu straightens the sword by hammering along the shinogi-ji.

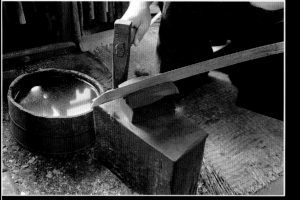

A large copper block with a deep groove is prepared. The groove must be large enough to accommodate the back surface of the sword.

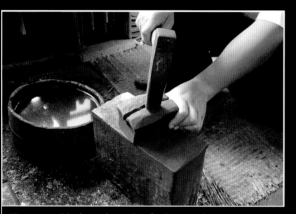

The copper block is adjusted to fit the sword.

Curvature is introduced into a specific area of the blade with heat. One technique uses a block of red-hot copper with a groove running along its center that is wide enough to accommodate the mune. The smith heats the block to around 1290°F (700°C), when it turns a dull red. He touches the mune to the block at the exact point where a small amount of curvature is required. When the mune comes into contact with the hot copper, it shrinks slightly, giving the blade more curvature. To add more curvature to the same area, the mune is touched to the block again in a slightly different place. This process is repeated until the desired curvature has been attained. By using a hammer to straighten areas where the curvature is too great, and applying heat to add curvature, the smith can adjust the curvature in any section of the sword. Thus, the exact curvature of the blade is determined by the smith and is not a random artifact of yaki-ire. Note that the edge, still unsharpened, is about ¹⁄₁₆ inch (2 mm) thick. If this process were done with a sharpened sword, the thin cutting edge could crack.

The back of the sword is placed on the hot copper block. The small area where the steel heats up is turning black.

The sword is touched to the block at a second point.

The sword is placed on the block at a third spot. A bit of curvature will appear wherever the sword has contacted the copper block. The three black areas show where the sword was placed on the block each time.

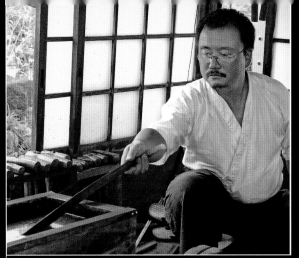

Each time the the sword is heated to adjust the curvature, it is quenched in water. The hamon can be damaged if the steel gets too hot.

An alternative to using a hot copper block is to adjust the curvature with a gas torch. The smith prepares a tank of water and uses the torch to heat a small spot on the mune. A bit of curvature will appear at the spot where the torch heats the blade. He then quenches the blade in the water. The smith continues heating spots along entire mune, putting the blade underwater to cool it, until he is satisfied with the overall curvature.

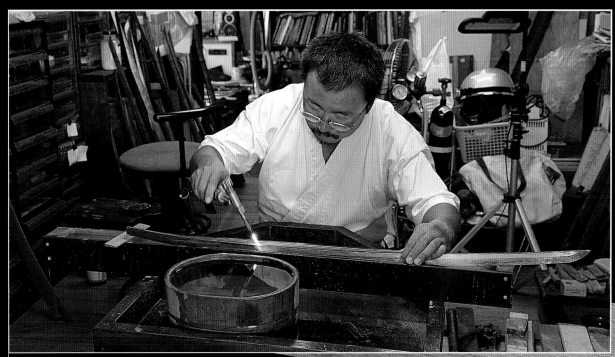

The mune is heated with a gas torch in areas where curvature is required. Water is kept close at hand to cool the blade.

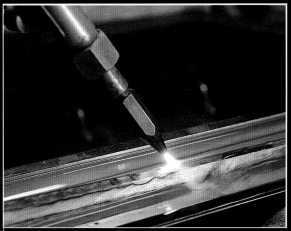

A close-up of the mune being heated with a gas torch. The shinogi-ji and the mune turn black wherever the torch is focused, so it is easy to monitor the process.

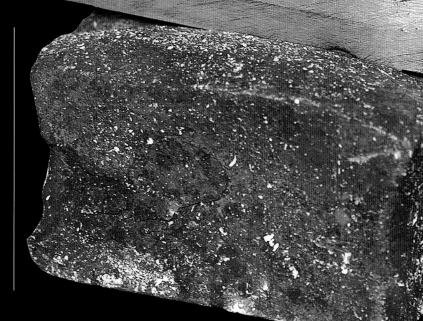

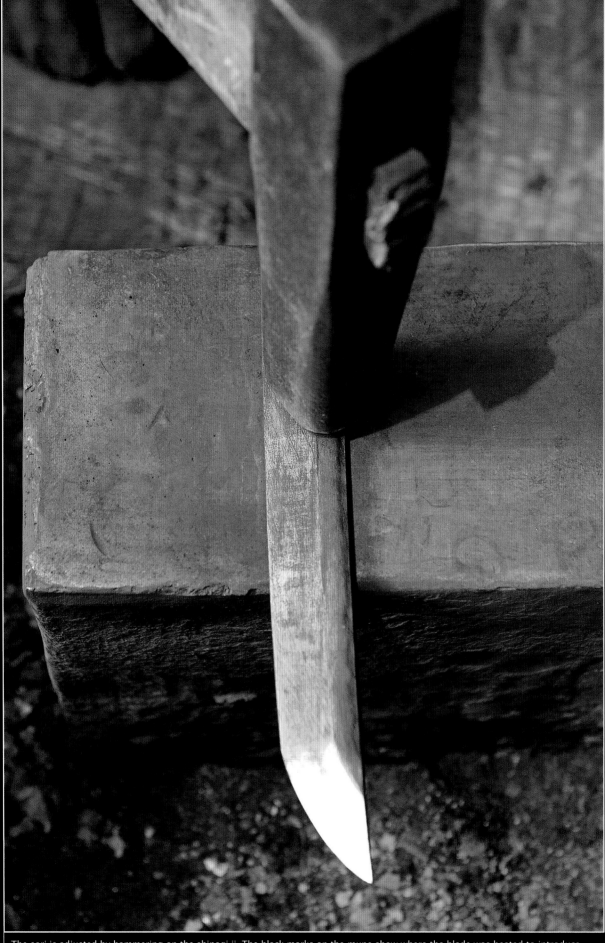
The sori is adjusted by hammering on the shinogi-ji. The black marks on the mune show where the blade was heated to introduce more curvature.

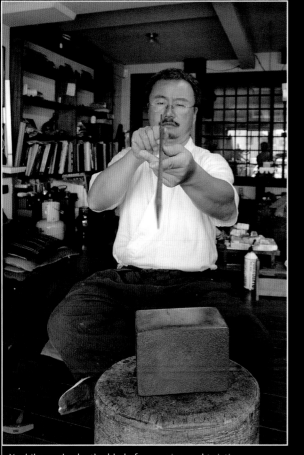

Yoshikazu checks the blade for warping and twisting.

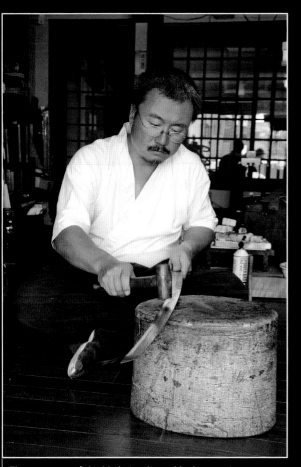

The curvature of the blade is adjusted by hammering.

A hammer with a narrow face is used to expand the shinogi-ji and straighten the blade around the point area. This allows corrections to be made in very small areas. The black areas show where curvature was added to the blade.

Once the forging and heat-treating are complete and the curvature has been adjusted, the smith must clean and shape the surfaces of the blade, define all its lines, and sharpen the edge of the sword. This work begins with a belt grinder or water-cooled grinding wheel and progresses to rough polishing stones lubricated with water. These polishing stones sharpen the edge, contours, and other lines of the blade, and remove all of the coarse marks and scratches left by the grinding wheel. The smith usually uses two or three progressively finer stones (starting around 120 grit). Any scratches or marks left on the sword after this rough polishing stage, called "kajitogi" (swordsmith polishing), are fine enough to be addressed by a professional polisher, who will finish the sword, revealing the hamon and the steel surface and using various techniques to produce an aesthetic and elegant appearance. However, the sword's shape is sufficiently defined at this point that a habaki (blade collar) and a shirasaya (storage scabbard) can be made. After these steps, it will go to a polisher for the last bit of work necessary to finish the blade.

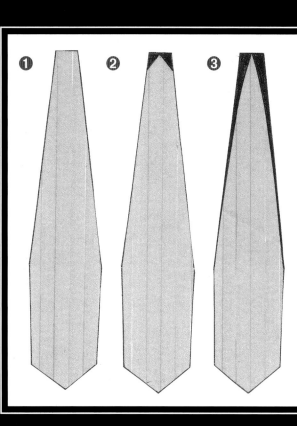

THE KAJITOGI PROCESS

1. This is the final shape of the sword after the forging is finished and yaki-ire has been performed. The edge must be left very thick up to this point to prevent the sword from cracking during yaki-ire.

2. Here the sword has been ground to create the sharp edge (the shaded portion is removed).

3. This is the final shape with the finished edge. The sides of the blade are ground to form a curved cross-section, and the contour of the sides meets the sharpened edge. Notice that the blade is ground smoothly right to the edge, leaving no bevel. The exact shape of the blade cross-section depends on the style of the blade and the shape the swordsmith wants.

In the early stages of kajitogi, a water-cooled belt grinder is usually used to begin shaping the edge and the contours of the blade's surfaces. The steel is very hard after yaki-ire, and this process would be extremely slow if done by hand. Initially, the mune surface is shaped along the entire blade. Next the area around the shinogi line is formed, along with the shinogi-ji (the area above the shinogi). The width of the shinogi-ji from the munemachi at the base of the blade to the koshinogi (start of the point) must be in proportion to the width of the sword. The width of the shinogi-ji on the nakago must also be proportionate.

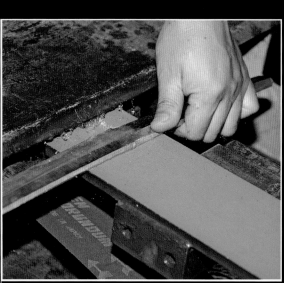

Using a water-cooled belt grinder to begin polishing the blade, starting from the mune-machi and working toward the point. Notice the water dripping down on the belt to keep the sword cool. If the blade becomes too hot, the hamon could be damaged.

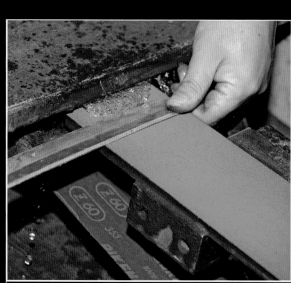

Working on the shinogi-ji surface from the machi to the point. This surface must have a continuous thickness in proportion to the blade's width.

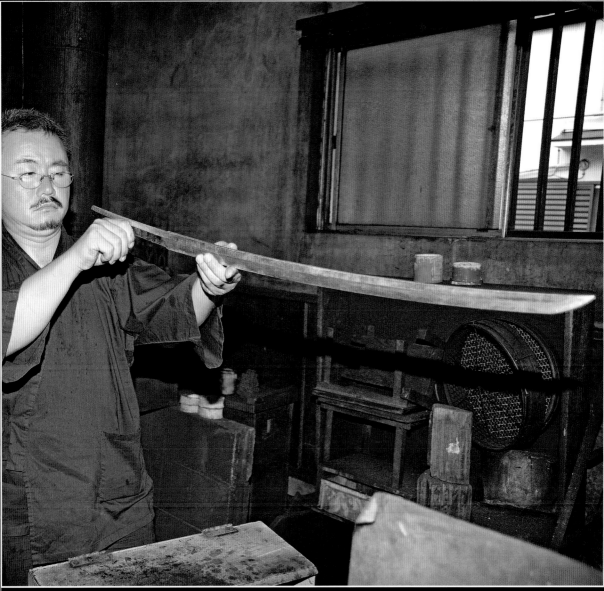

The blade is checked frequently and carefully. There must be no uneven surfaces. Once the shape is formed, taganeha (cutting a beveled sharp edge) begins.

In the taganeha step, both sides of the edge are cut at a 45° angle.

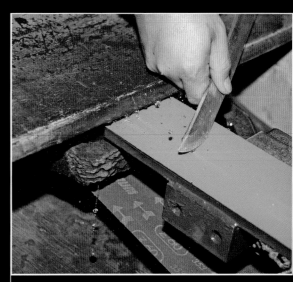

The ha (cutting edge) is formed on the point area.

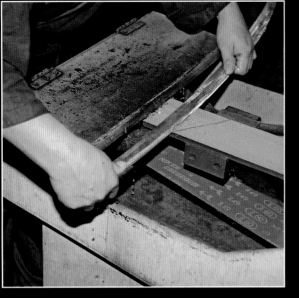

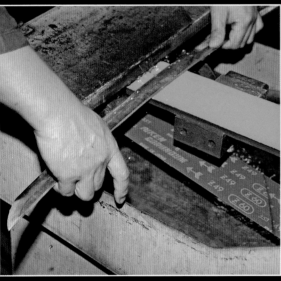

The two photos above show the shinogi-ji being formed on both sides of the sword. This defines the nikuoki (cross-section) of the blade.

Shaping the point area and edge. When using the belt grinder along the curved point, the cutting edge must be correctly positioned relative to the movement of the belt.

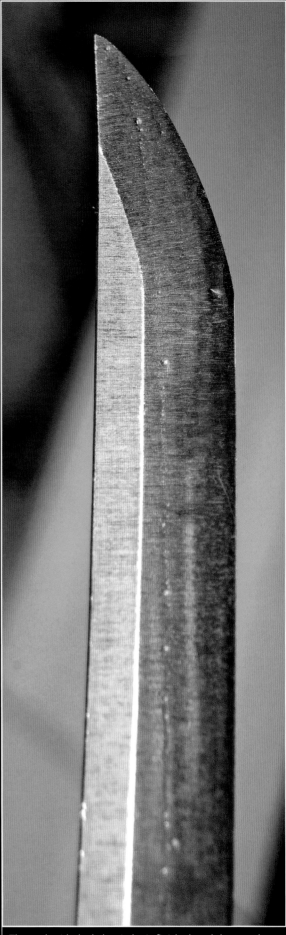

The work with the belt grinder is finished, and the complete detailed shape of the sword is now defined.

Polishing the mune surface with a stone.

Once the initial shaping is complete, the smith creates a beveled sharp edge. This step is called "taganeha."

The abrasive belts used on the grinder have a grit number of about 80 and are very rough. They leave deep scratches on the sword. The next step is to polish out these deep scratches by hand with a series of finer abrasive stones starting with a grit number of 200 and going up to about 1000. All of the surfaces are polished, starting with the mune, the shinogi-ji, and the ji and ha. After this process, the sword is ready to have a habaki and saya made.

Polishing the shinogi-ji.

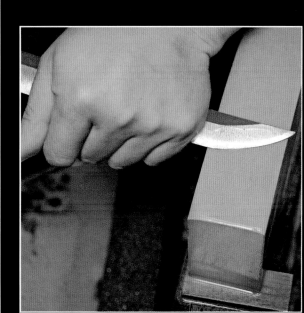
Polishing the kissaki (point area).

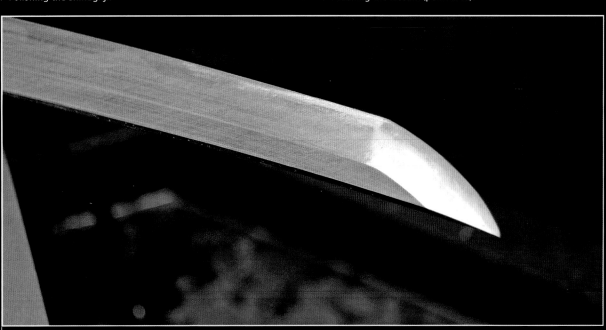
The sword has been polished with a 240-grit polishing stone.

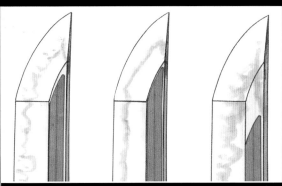

These drawings show how the tops of the grooves can terminate. At left, the groove stops just before the koshinogi in the point area; at center, the groove extends right up to the koshinogi line. The groove in the drawing at right stops below the yokote line and the point area.

The smith must decide where to place the grooves, how wide they will be, and what the ends will look like. Yoshindo's student Ryoichi Mizuki carefully marks where the grooves are to be cut.

Mizuki begins to cut the groove with a sen (drawknife). He starts in the center of the marked area and slowly widens and deepens the groove. Several different types of sen are used during this process. The edge of the blade and the point are covered with electrical tape to protect them.

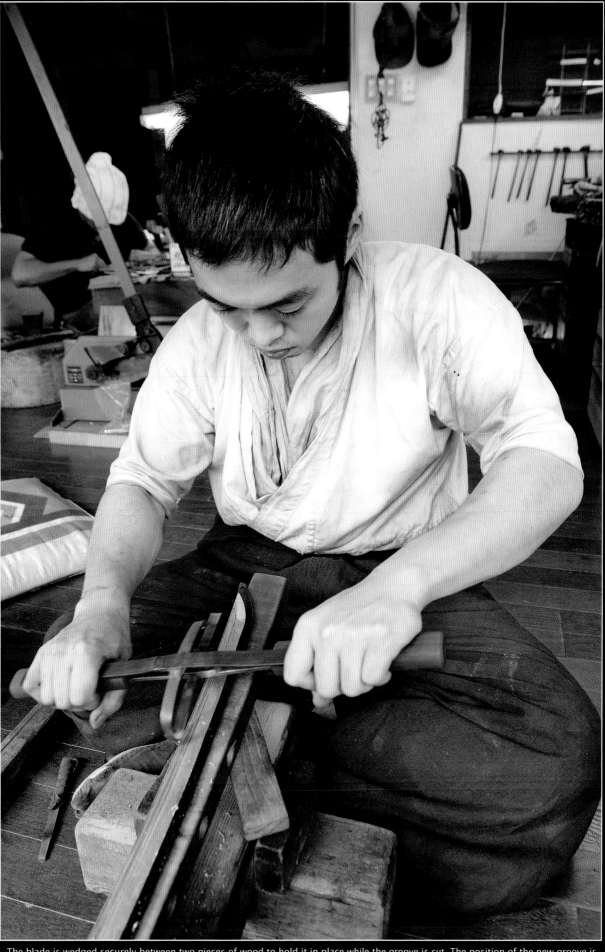

The blade is wedged securely between two pieces of wood to hold it in place while the groove is cut. The position of the new groove is marked in black ink.

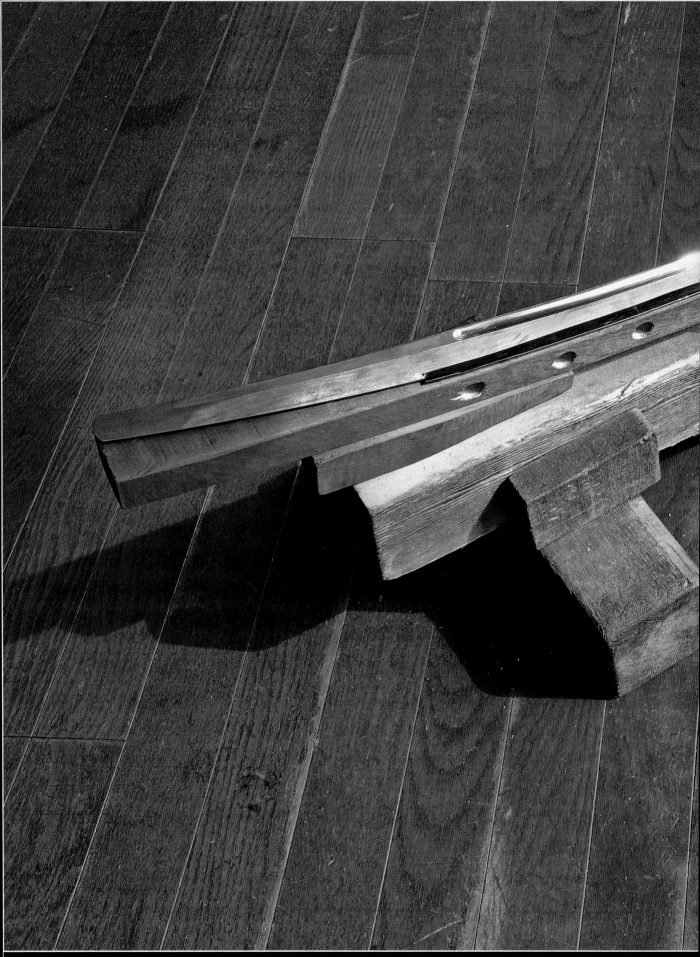

Tools used to make grooves: the wooden support and clamp, sen, small handheld chisels, and round files.

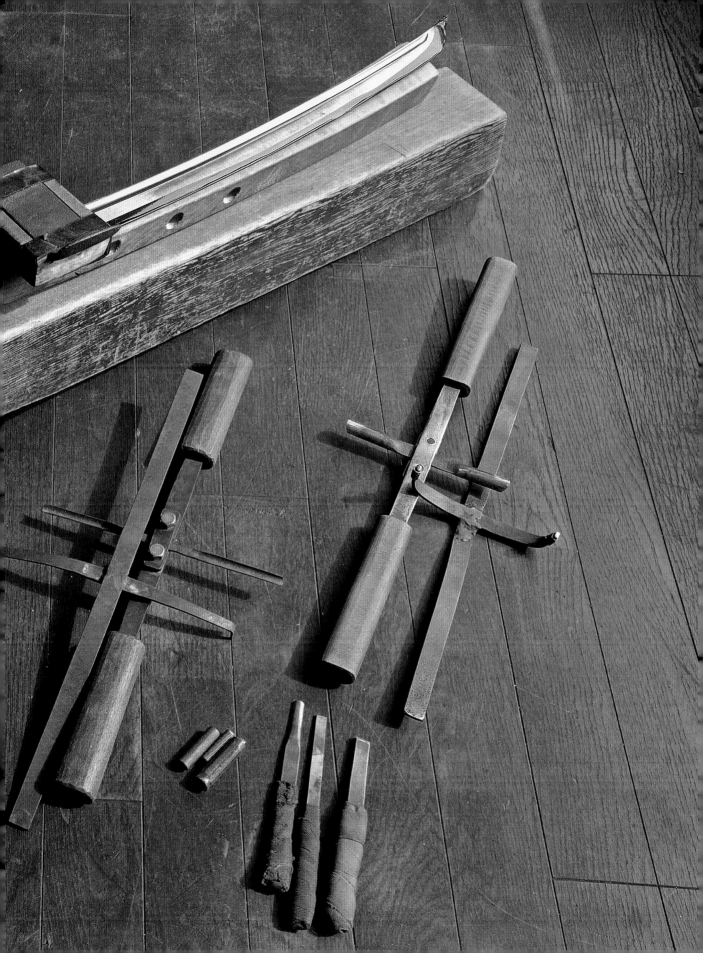

A handheld chisel is used to finish cutting the grooves right up to the original inked lines.

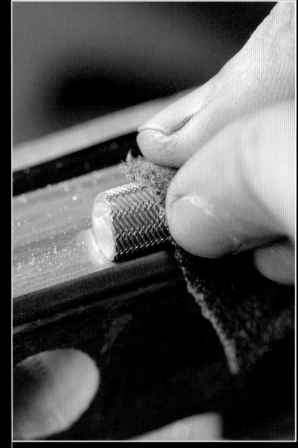

The insides of the groove are smoothed out and finished with a round file.

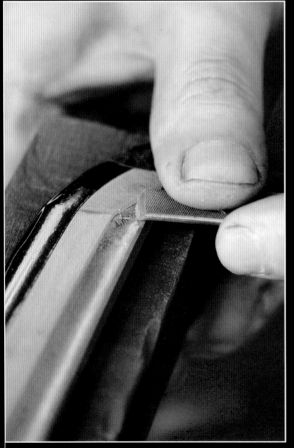

A chisel is also used to finish the groove ends, which must be clear and well shaped.

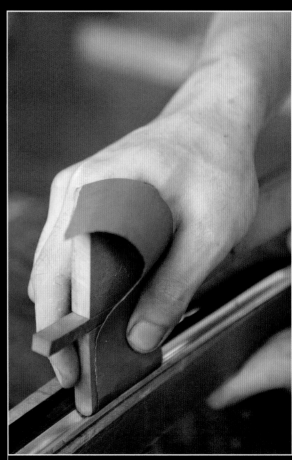

After filing, the insides of the grooves are sanded to a very smooth finish. Mizuki is using a rounded sanding block to control the sandpaper.

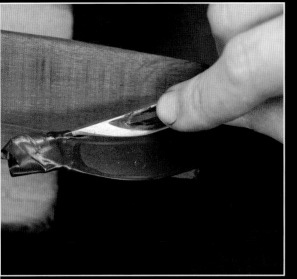

The insides of the groove ends are cleaned again with a fine stone. Kerosene is used to lubricate the grooves while working with the stone.

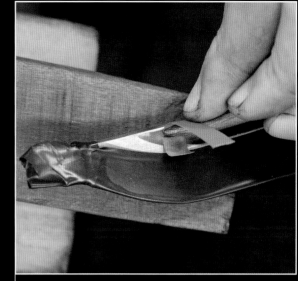

The groove ends are sanded again with finer sandpaper that is held with a piece of bamboo.

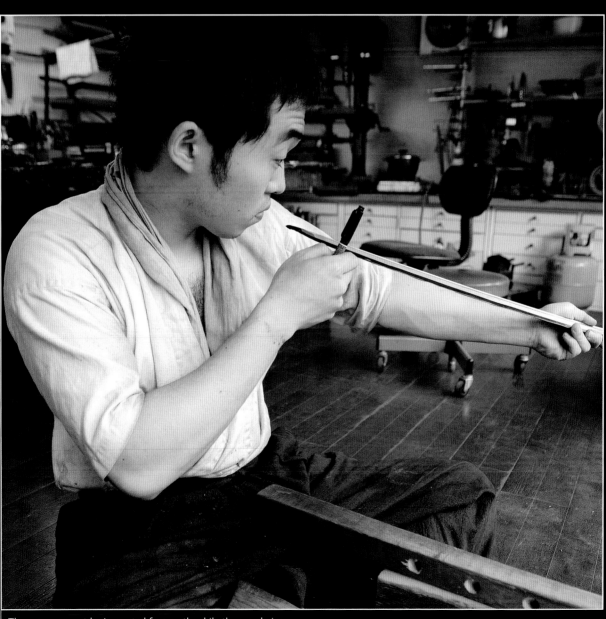

The grooves must be inspected frequently while they are being worked on to ensure that the insides are smooth, straight, and uniform in depth along their entire length.

DECORATIVE HORIMONO

In addition to grooves, which are considered to be a type of horimono (engraving), decorative carvings are often added to blades. Horimono designs are usually traditional images such as ken (straight swords), dragons, deities, Buddhist motifs, bonji (Sanskrit characters), and kanji characters, among others. The figures are engraved with a series of small chisels driven by a hammer. The inside surfaces of the engravings are finished to a smooth, fine surface and are burnished during the polishing process. Making such engravings is exacting and time-consuming; most swordsmiths make their own grooves (hi) and simple bonji, but more elaborate horimono are usually made by craftsmen who specialize in such work.

Yoshindo is unusual because he makes all of his own horimono. Once he decides on the image to be used, he carefully draws the detailed figure on the sword in ink at the spot where it is to be be engraved. He then completes the engraving. A good horimono must be well proportioned, with dimensions appropriate to the sword it will be engraved on, and should be positioned in a suitable location.

Yoshindo carefully draws the image to be engraved—a tiger—onto the blade.

A French curve template is used to give the tiger its shape.

The pattern for the new horimono is finished.

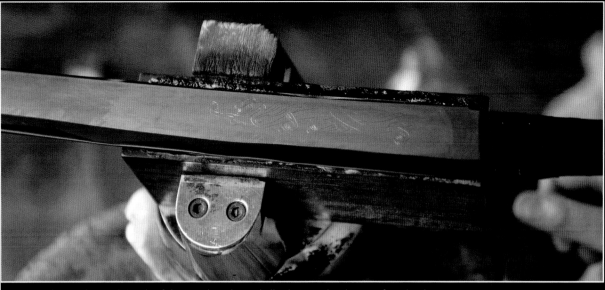

The complete outline and details of the tiger have been shallowly incised with a very fine chisel.

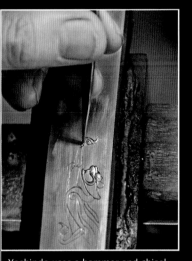

Yoshindo uses a hammer and chisel to deepen the lines and details of the horimono, starting with the paw and claws on the leading edge of the engraving and working his way down.

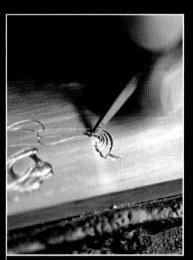

Details of the claws are cut deeply into the surface. The internal lines and surfaces of the horimono must be very clean and even.

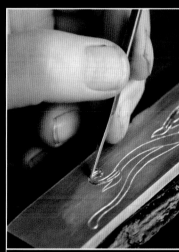

The hind paws being carved in detail.

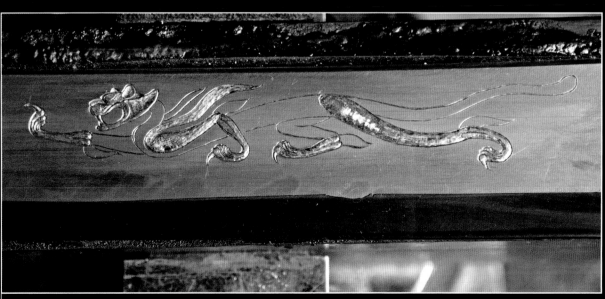

The horimono will not be flat, but is carved out from the surface of the sword. Here, the legs and head have been chiseled out.

201

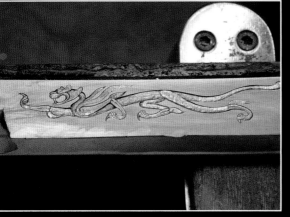

All of the details in the horimono are carved out below the surface of the sword.

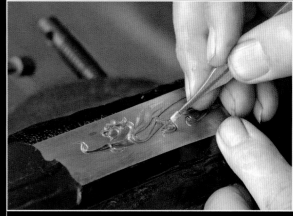

All of the inner surfaces of the horimono are polished with a fine abrasive stone.

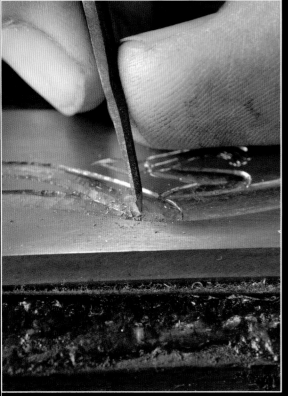

Yoshindo uses very fine small chisels to carve the surfaces of the horimono to a smooth finish. He shapes the points on all of these special chisels himself.

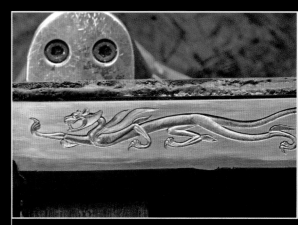

The chiseling has smoothed the surfaces and contours of the horimono.

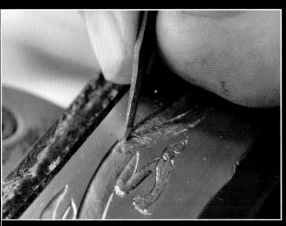

The surfaces of the tiger are smoothed out with a small handheld chisel.

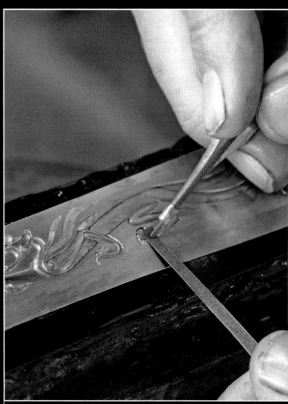

The inner surfaces of the horimono are sanded down with small strips of fine sandpaper. The sandpaper is held and guided with a small piece of a synthetic polishing stone.

The inner surface is sanded to a fine finish. The horimono will have high relief and a very smooth three-dimensional surface.

Some of the chisels used for engraving work. There are a number of different sizes, with differently shaped points; these have very fine points.

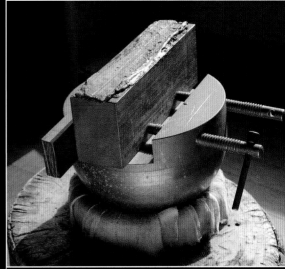

A vise is used to hold the sword in place as it is engraved. The surface is covered with a hard black paste made from pine sap and charcoal. The black surface is heated gently with a torch, and the sword is pressed right onto it. The sword can then be moved into any convenient position for engraving work.

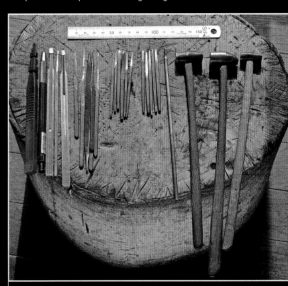

The various hammers, chisels, and other tools used to make horimono.

More chisels used for horimono. These have relatively large tips.

Traditional Horimono
Designs Carved by Yoshindo

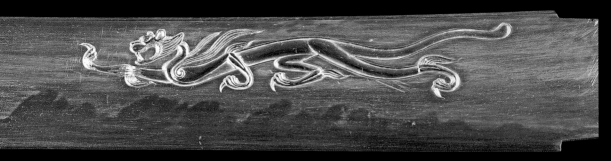

This tiger is engraved on a new sword. Polishing takes place after the horimono is complete.

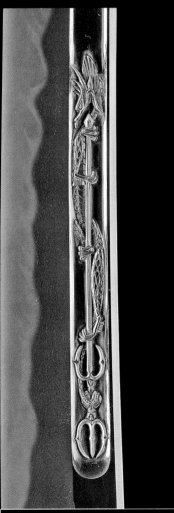

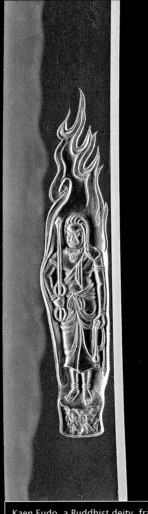

A dragon climbing a sword.

Kaen Fudo, a Buddhist deity, framed in fire.

Amida Nyorai, a Buddhist deity.

Nakago and Meikiri:
Filing and Signing the Tang

FINISHING THE TANG

Once all the other work on the sword has been finished, the last remaining task is to finish and sign the tang. First, a sen is used to clean and shape the contours of the tang surfaces. Then the surface of the tang is finished with files. The file marks, called "yasurime," are left on the tang, serving as a decorative finish. There are many different yasurime patterns used on Japanese sword tangs, but Yoshindo and his students use a simple one of parallel slanted marks. Each surface of the tang must be filed separately: the ji, the shinogi-ji, and the mune. Once the tang is coarsely filed, Yoshindo goes over it again with a finer file, using a copper guide to make sure that the yasurime are regular, uniform, and all made at the same angle.

After the file work is finished, a hole is drilled to hold the mekugi (bamboo rivet) that will secure the tang in the hilt. The inside and edges of this hole, called the "mekugiana," are smoothed with a file.

INSCRIBING THE MEI

The last step in finishing the tang is to inscribe the mei (signature). After deciding what to write, the smith brushes the inscription in ink. The quality

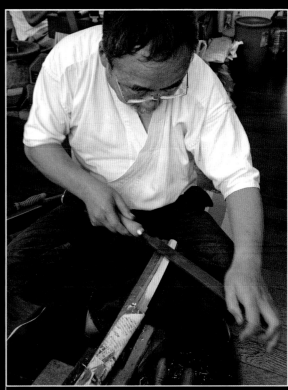

Using a rough file to finish the tang.

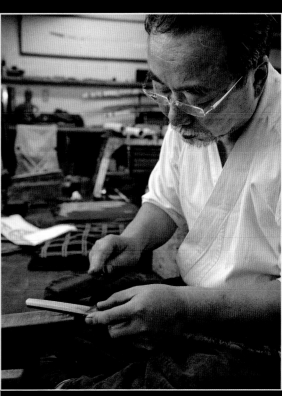

Using a finer file to make the yasurime (decorative file marks) on the tang. Yoshindo uses a copper guide, visible under his left thumb and forefinger, to produce very regular, uniform, parallel file marks.

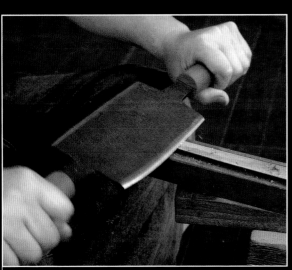

Using a sen to clean and shape the tang.

Drilling the hole for the mekugi (bamboo rivet).

of the calligraphy is important, because the final inscription will be made with a hammer and chisel on the tang, and the smith will follow the inked inscription very closely. A well-written inscription will produce an elegant mei, but a poor-quality inked inscription will result in a coarse or rough mei. Thus two skills are required here: skill at writing the traditional ink inscription, and skill in following the inked inscription with a hammer and chisel to make the final and permanent mei.

Inscribing the mei is done with with a chisel and a hammer. The signature can be very characteristic of a swordsmith, since he can use a thick chisel, a thin fine chisel and a light or heavy hammer. The number of chisel strokes per inch can also vary. These details, along with a smith's individual calligraphy, produce a unique signature for any smith.

Cleaning the inside and edges of the mekugiana (rivet hole).

The mei inscribed on the sword shown in these photos says "Kokaji Yoshindo" (swordsmith Yoshindo). Yoshindo uses a variety of mei, including "Yoshindo" (simply his name in two characters); "Yoshindo saku" (made by Yoshindo); "Takasago ju Yoshindo" (made by Yoshindo living in Takasago), and other variations. Frequently, the owner of a new sword will ask Yoshindo to include an "owner's mei," an inscription containing the owner's name and possibly other information about the owner and his family.

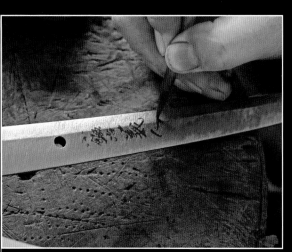

Yoshindo brushes the mei on the tang in red ink. The mei, "Kokaji Yoshindo," is very clear and easily readable.

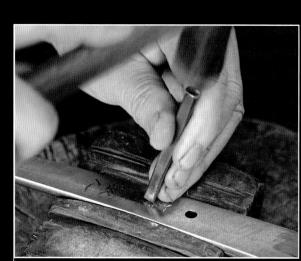

Inscribing the mei onto the tang. This is done using a hammer and chisel, following the inscription brushed in ink on the tang.

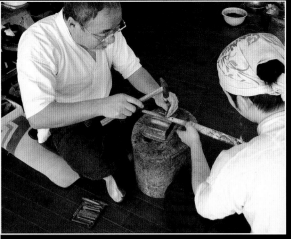

Yoshindo's student Mizuki holds the sword with the tang flat as Yoshindo inscribes the mei. The tang must be flat on the block at the proper angle for optimal results when inscribing the mei.

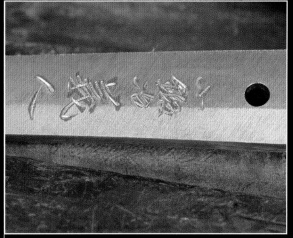

The red ink inscription and the chiseled mei are both visible here. The chisel strokes follow the ink inscription very closely.

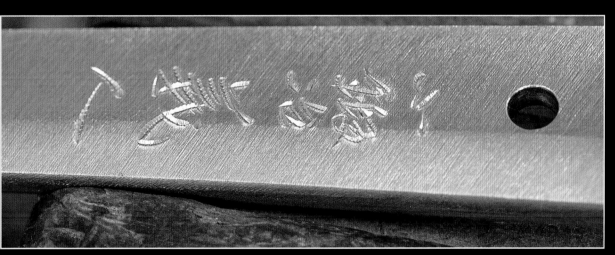

When the ink is removed, the new mei is clearly visible.

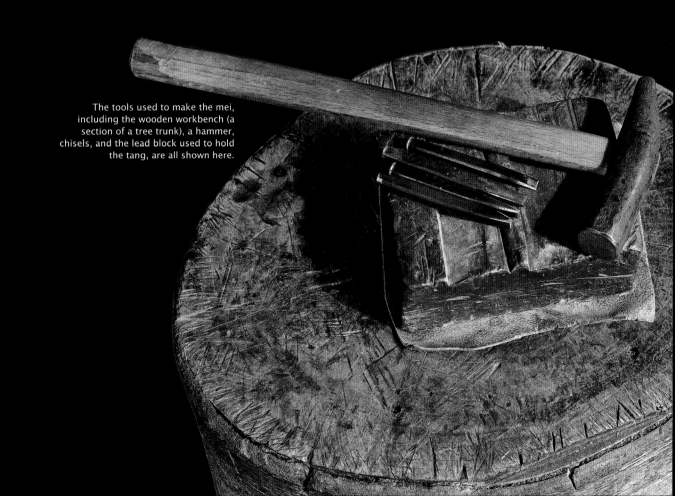

The tools used to make the mei, including the wooden workbench (a section of a tree trunk), a hammer, chisels, and the lead block used to hold the tang, are all shown here.

This painting showing a polisher at work is from an Edo-period series, *Shokunin Zukushi-e*, which shows individual craftsmen working. The book is preserved at Kita-in temple, Saitama Prefecture. Reproduced with permission.

POLISHING, HABAKI, AND SAYA

FINISHING THE SWORD
Polishing, Habaki, and Saya

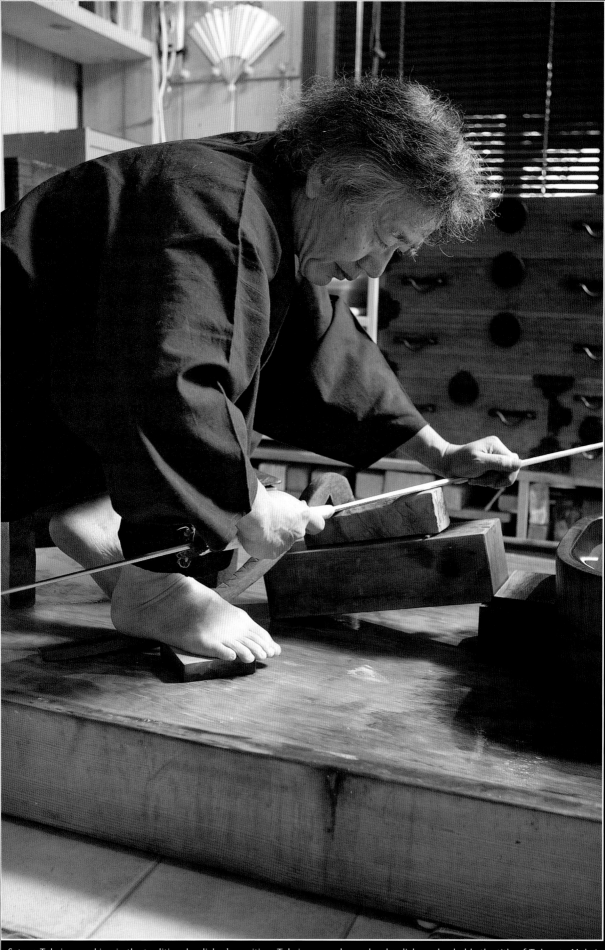

Setsuo Takaiwa working in the traditional polisher's position. Takaiwa, a mukansa-level polisher, also holds the title of Tokyo-to Mukei Bunkazai (Living Cultural Property of Tokyo).

Togi: Sword Polishing

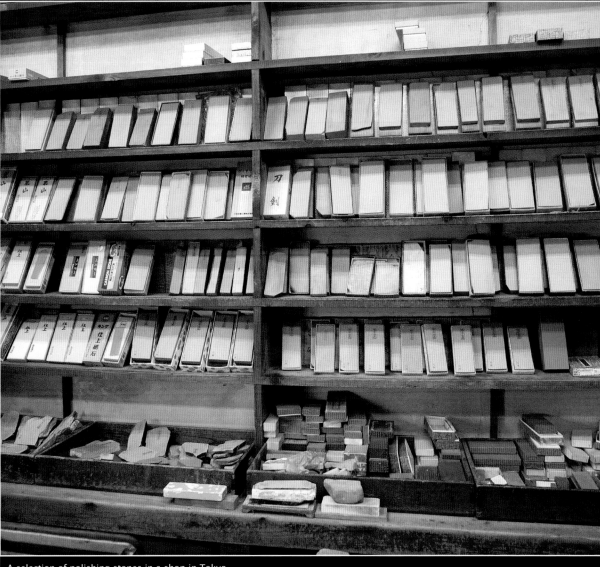

A selection of polishing stones in a shop in Tokyo.

After the smith has finished his work, several tasks remain before the sword is finished: it must be polished; a habaki must be made so the sword can be placed in a saya (scabbard); and a saya must be made to protect the sword. Each of these is completed by an independent craftsman who specializes in that craft.

The polisher will bring out all of the important features of the sword's surface such as the hamon, the jihada, and the jigane. He will also refine the shape, make the sharpened edge, and refine all the lines and surfaces.

There are many details and techniques to master in polishing, so it takes a long time to become a professional polisher. The man shown in these photos, Setsuo Takaiwa, has been polishing swords for more than forty years. The craft is usually learned through a traditional five-year (or longer) apprenticeship with a practicing polisher. After a student completes the training, he can become an independent polisher.

Polishing a Japanese sword is almost as complex as making one; the polisher must bring out all of the fine structural and crystal elements in the surface of

the steel, including the hamon and the jihada (the pattern in the surface), while still making a functional and effective shape. This is a very time-consuming undertaking: probably 60 to 70 percent of the polisher's time is spent bringing out the details that are necessary for aesthetic appreciation and to allow a careful appraisal of the sword and its provenance.

Refining the sword's shape and making the sharp cutting edge is relatively simple, and it seems likely that in times past, there was no need to polish swords intended for combat beyond this point. There is evidence, however, that polishers were able to polish swords well enough in the Kamakura period (1185–1333) to make such details visible. Polishing must have been quite advanced at that time, as the Kamakura-period swordsmiths could not have brought their swords to such a sophisticated level without being able to see their work in detail.

The polisher uses a series of traditional polishing stones, working progressively from the roughest stones needed to shape the sword and remove the file marks and other signs of the smith's work, up to very fine finishing stones that reveal all of the details of the sword's surface and steel crystal structure. Each successive stone should leave the sword with a slightly finer surface than the preceding stone. Not all swords can be polished with exactly the same methods, choice of stones, or number of stones; each sword must be treated as an individual project. A polisher will decide which stones to use depending on the sword he is polishing.

Originally, polishers used only natural stones ranging from rough granite to exceedingly fine limestone. But in recent times, synthetic stones have come into use. Modern synthetic stones are very effective for the first six or seven steps. However, it is necessary to use traditional natural stones in the last half of the process to produce a proper traditional Japanese-style polish. There is some overlap in the quality and fineness of the natural and synthetic stones.

The stones are not all used in the same manner. In the initial steps of foundation polishing, the sword moves perpendicularly to the stone. In the intermediate steps, the sword moves in a diagonal direction. For the rest of foundation polishing and all of finish polishing except for the kissaki, the stones move lengthwise along the sword. In many cases, the particular stone chosen for each step depends on the blade, adding to the complexity of the polisher's task. An appropriately chosen series of stones will leave an increasingly fine surface and bring out the structural elements in the sword's steel, such as the jihada and the hamon, to the greatest extent possible.

All polishing work removes metal from the sword, and extensive polishing will eventually result in a sword that is almost a shadow of its original shape. Too much polishing can remove the kawagane steel from the surface of the sword and expose the core shingane steel. A sword in this condition is referred to as being "tired." For swords in need of extensive polishing work, a polisher will begin with the roughest stones. If the sword's condition is reasonably good, a polisher can begin with a much finer stone.

Polishing of a new blade is carried out in two stages. During the shitage-togi, or foundation polishing, the large, coarser stones listed in Table 5 on the following page are used. In this part of the process, the stone is kept stationary and the sword is moved across the surface of the stone. The second stage, the shiage-togi or finish polishing, involves the tasks listed in Table 6 on the next page. During this stage, the sword is kept stationary and the materials are moved over its surface. These steps remove any roughness left by the foundation polishing stones, enhance the color and appearance of the sword's surface, bring out the jihada and surface details, create a clearly defined point area, leave the hamon very clearly visible and clearly contrasting with the body of the sword, and leave a burnished, mirror-like surface on the shinogi-ji and mune surfaces.

Stone	Type	Application
Arato	Synthetic	Used for new swords or old swords in poor condition
Kongoto	Synthetic	Used for new swords or old swords in poor condition
Binsui	Synthetic	Used for new swords or old swords in poor condition
Kaisei	Synthetic	Used first diagonally, and then in a lengthwise direction
Chu-nagura	Synthetic or natural	Used in a lengthwise direction
Koma-nagura	Synthetic or natural	Used in a lengthwise direction
Suita	Natural	Used in a lengthwise direction
Uchigumori-hato	Natural	Used in a lengthwise direction
Uchigumori-jito	Natural	Used in a lengthwise direction

Table 5. Stones used for foundation polishing.

Modern synthetic stones used in the initial part of the polishing process.

Natural stones used for the latter part of the polishing process. The stones increase in fineness from right to left. The blue-gray stone at the far left is the finest one used.

These steps are carried out after the work with the coarser stones listed in Table 5 is finished.

Step	Material	Purpose
Hazuya	Uchigumori-hato	To remove all of the scratches and harsh finish left from the large stones
Jizuya	Narutaki-do	To bring out the ji and shinogi-ji
Kanahada nugui	Iron oxide in oil	To produce a darker and more uniform finish on the surface of the blade
Sashi-komi nugui	Ground magnetite in oil	May be used in place of kanahada nugui
Hadori	Uchigumori	To polish and lighten the hamon area
Yokotesuji-kiri	Uchigumori (as for hazuya)	To make the yokote line
Narume	Uchigumori (as for hazuya)	To polish the point area
Migaki	Migaki-bera (burnishing spatula) and migaki-bo (burnishing needle)	To produce a mirror-like finish on the shinogi-ji and the mune

Table 6. Steps in finish polishing.

In the photo below, Setsuo Takaiwa stands on a togi-dai, the wooden platform where he does his work. Since water is used to constantly lubricate and clean the surface of the sword and stone, the work area is very wet. For this reason, the floor of the platform slopes away from the work surface, and there is a drain in the front. The polisher sits on a very low stool with the stones positioned in front of him on a sloped wooden block. He uses his feet to brace a fumaegi (clamp) on the top of the polishing stone so it holds the stone in place. Because many of the finest stones are prone to

Takaiwa stands on a togi-dai or sword polisher's work platform.

Takaiwa is seated in his working position. His right foot rests on a wooden block, with his right heel holding the fumaegi in position. His left leg is supported by the stool, with the left toes resting on the fumaegi.

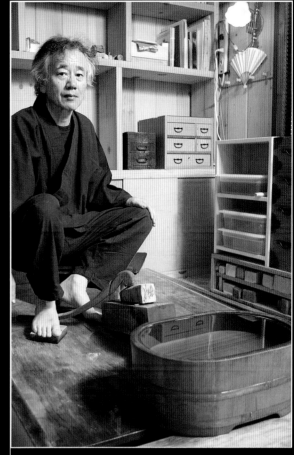

Takaiwa sits on a small stool on the togi-dai. The oke (water bucket), stone, and fumaegi (clamp) are all visible.

cracking or splitting if too much pressure is put on them, using a strong clamp is not advisable. The fumaegi allows the polisher to position the stones exactly where he wants them, and makes it easy to change stones when necessary, all the while avoiding damaging the stones. In this efficient working position, the polisher's head and shoulders are directly over the sword he is working on, giving him a good view of his work, and also allowing him to grip the sword securely as he moves it over the stones.

A proper grip on the sword is essential. The polisher must be able to position the sword in the correct location and at the proper angle over the stones so that he can decide exactly which part of the sword's surface will come into contact with the polishing stones, and which parts of the surface will be protected from too much abrasion against the stones. To accomplish this, he wraps one part of the sword in a rag to protect his right hand, and grips the bare blade in his left hand. Takaiwa uses a very specific grip with his left and right hands.

The sword being polished in the photos on page 216 is a hira-zukuri wakizashi. It has flat surfaces, without a shinogi or a defined point area.

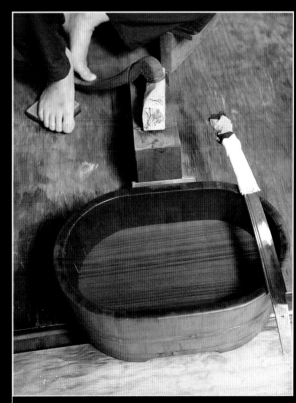

A wakizashi lies on the oke, ready to be worked on. The part of the sword that will be held in the right hand (in this case, the point area) is wrapped in a rag. The left hand will hold the bare blade.

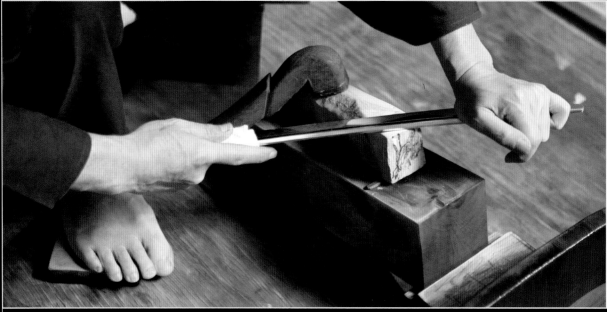

Takaiwa polishes a wakizashi. A rag protects his right hand and provides a grip while the left hand holds the bare blade. The very precise grip allows him to determine the exact part of the sword's surface that makes contact with the polishing stone.

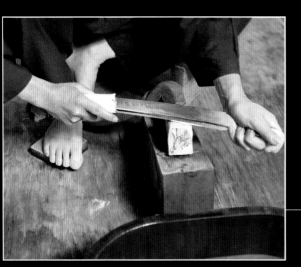

The back surface (mune) is being polished here. Takaiwa will polish one side of the mune along its full length before moving on to the other side.

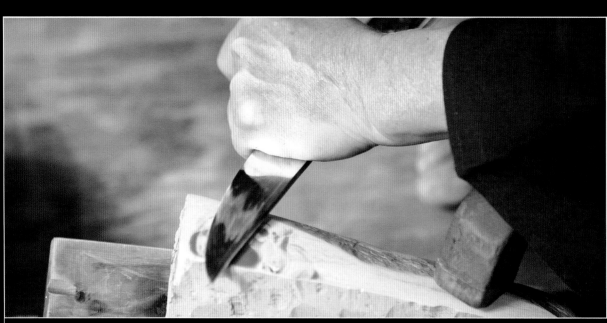

Takaiwa grips the bare blade with his left hand. Although his hand is wrapped around the sharp edge, there is no contact between the edge and his skin.

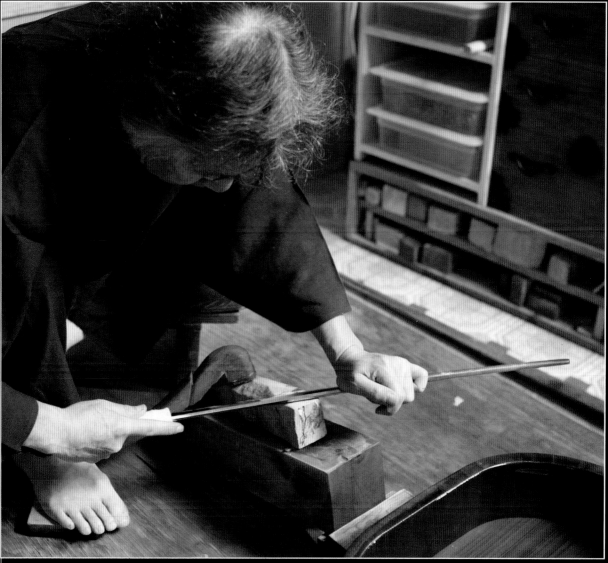

Takaiwa polishes a shinogi-zukuri sword. He uses the same hand position and way of handling the blade here as he did for the wakizashi shown previously.

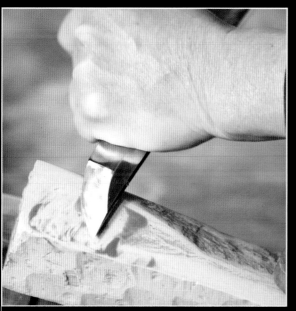

Here Takaiwa polishes the point area on a katana. The surface is whiter, contrasting strongly with the reflective body of the sword, because the point area is polished moving perpendicular to the sword's lengthwise axis.

In the photos on this page, Takaiwa is working on a shinogi-zukuri katana, which has a shinogi and a well-defined point. The shinogi-ji (the upper surface above the shinogi) and the shinogi line itself must be kept very sharp and distinct, and the shinogi-ji surface must be kept flat. The point, which is polished to produce a contrast with the rest of the sword, must be well-defined and properly shaped.

Using the stones in different directions on the point and body of the sword helps create a visible contrast. The point is always polished by moving it in a direction perpendicular to the lengthwise axis of the sword. For the body of the sword, starting with the nagura stone, all the remaining polishing through the last uchigumori stones is done in a lengthwise direction. The

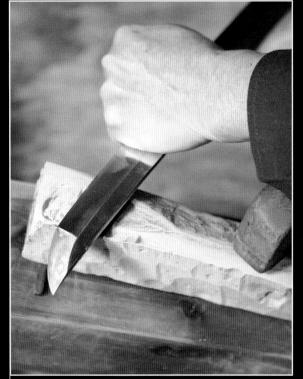

Polishing the body of the sword below the point. The contrast between the point and body of the sword is now much more evident.

series of stones listed in Table 5 are used in shitage-togi foundation polishing, and are held in place while the sword is moved over them. When this stage is complete, the hamon is visible, and the jigane and jihada (steel surface texture and pattern), the point, and the shape must be completely defined.

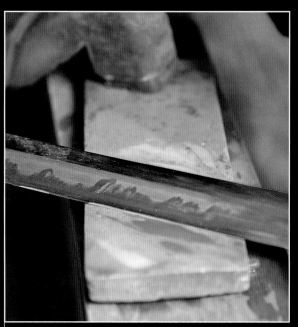

Here the suita stone, the first of the uchigumori stones, is being used. The outline of the hamon is clear, and the hamon is beginning to stand out distinctly from the body of the sword.

Takaiwa polishes the point area of a katana. As the total length of the sword, including the tang, is more than 39 inches (1 meter), working on the very small point area is difficult. It is essential to use the correct grip.

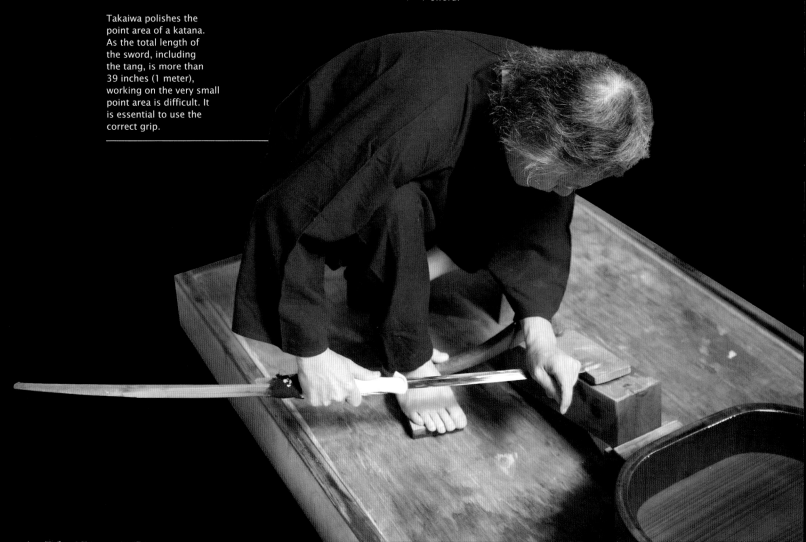

Takaiwa is cutting the hazuya stones into small squares for convenient use. The back side, covered with the lacquer and washi paper, is facing up.

The Finishing Steps

Once the polisher has finished the foundation polishing, he begins the shiage-togi with the materials for finish polishing. During these next steps, the sword is held in a stationary position while the tools or polishing materials move across it. In the first step, hazuya are used to go over the cutting edge and the hamon, excluding the point area. Hazuya must be made by the polisher. He first cuts or chips very thin slices from a large piece of soft uchigumori-hato. He grinds the slices down until they are about the thickness of a piece of paper. He then covers one side of the slice with lacquer (either natural urushi or a modern synthetic), places a sheet of washi paper onto the wet lacquer, and brushes another coat of lacquer over the paper. This creates

a very thin but strong waterproof sheet that is then ground to about ⅟₂₅ of an inch (1 mm) thick and cut into small squares about half an inch (1–1.5 cm) on a side. These will remove all marks left by the foundation polish stones on the cutting edge and hamon. The final surface will appear white, smooth, and uniform.

The polisher starts at the cutting edge and works in 2-inch (5 cm) sections, moving up to the boundary of the hamon and then back down toward the edge. Each section must be properly finished before he moves on to the next. From this stage on, the water used to lubricate the stone when working on the sword contains sodium carbonate (washing soda), which prevents the blade from rusting while it is being polished.

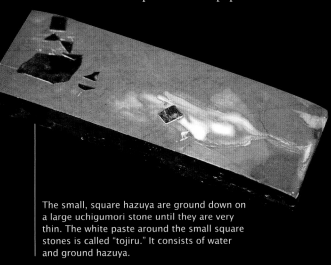

The small, square hazuya are ground down on a large uchigumori stone until they are very thin. The white paste around the small square stones is called "tojiru." It consists of water and ground hazuya.

The hazuya (under Takaiwa's thumb in the photo) is used to polish a small section of the blade. The blade surface is acquiring a uniform whiteness, and the hamon is clearly visible.

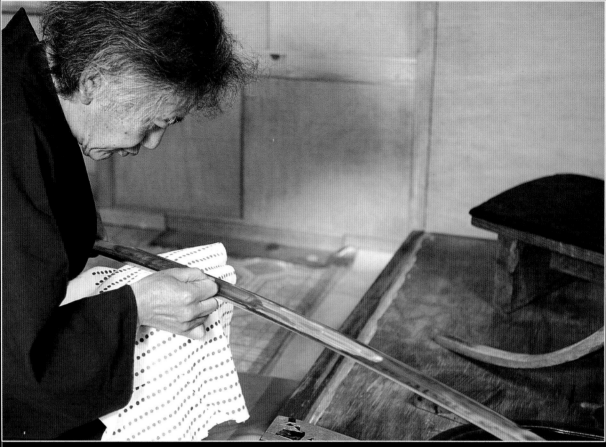

Takaiwa will go over the hamon and edge of the entire blade with the hazuya. The stone wears out and dissolves during this process; the white paste on the sword is residue left from the stone.

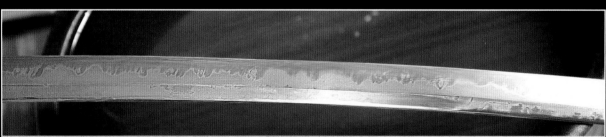

The surface has a uniform milky white appearance after being polished with the hazuya. The hamon and the nioi line are very clear.

Next, jizuya are used on the ji and shinogi-ji. The jizuya are cut from a type of stone called narutaki-do, which is finer and harder than uchigumori-ha-to; they are prepared in the same manner as the hazuya. Proper use of jizuya will bring out and enhance the appearance of the surface of the ji and the shinogi-ji, as well as the jihada (the pattern on the surface of the ji). The polisher begins with a soft jizuya and works his way up to a harder type; because of the stone's hardness, he must be careful to avoid scratching the surface of the sword. He goes over the ji and shinogi-ji with at least two jizuya in the same manner as the hazuya, working on a section of the surface about 2 inches (5 cm) long each time, from the hamon boundary into the shinogi-ji and back down.

Takaiwa folds a washi sheet into eight layers. He will use this to filter the nugui before applying it to the sword.

He will work on the entire ji, including the mune and the koshinogi (the shinogi-ji in the point area) with the jizuya. As the successive jizuya become harder, the jihada on the sword will become clearer and more prominent.

After the last jizuya have been used, kanahada nugui, a mixture of very finely ground iron oxide and other ingredients suspended in clove oil, is applied to the sword. This fine abrasive improves the appearance and color of the sword's surface. Because the iron oxide particles are very hard, and large particles can leave scratches on the sword, the kanahada nugui mixture is filtered through a special type of red-dyed washi paper. The red washi is folded into eight layers and the kanahada nugui is poured on the top of the paper. The bottom surface of the paper is touched to the surface of the sword, leaving a red spot of nugui wherever it makes contact, down the length of the blade. The nugui is then rubbed over the surface in 2-inch (5 cm) sections with a folded piece of cotton, from the edge to the shinogi and then back to the edge again, until the entire blade has been covered. The nugui gives the blade's surface a dark, even non-reflective finish and further emphasizes the jihada.

This container holds the nugui mixture. The red color comes from finely ground iron oxide.

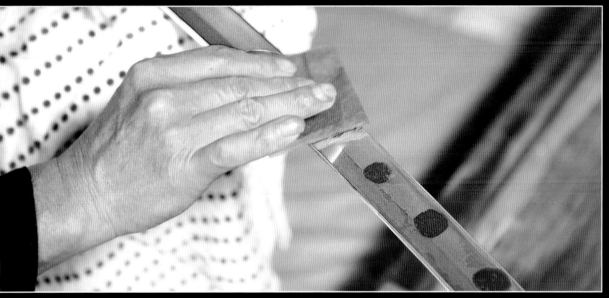

A spot of nugui is left on the sword at each point where it is touched by the folded washi.

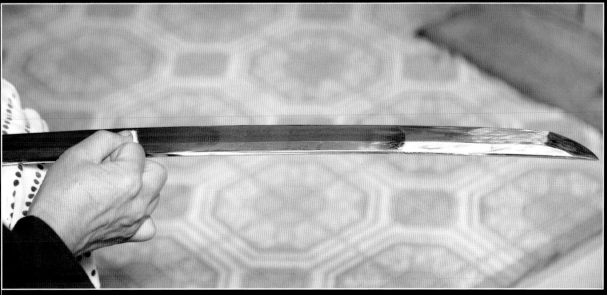

Takaiwa rubs the nugui over the blade's surface using a piece of cotton (visible under his thumb). His forefinger and middle finger are braced against the mune surface as he works.

Once the nugui has been applied, the hamon is polished with a hadori to make it whiter and to give it a strong contrast with the body of the sword. The hadori is made exactly the same way as the hazuya and from the same type of uchigumori-hato stone. However, it is cut into oval shapes to allow the polisher to more easily follow the hamon outline. The polisher uses the hadori to carefully polish the hamon area section by section, as in the previous steps. When one section is finished satisfactorily, he moves on to the next, continuing until the entire hamon is polished.

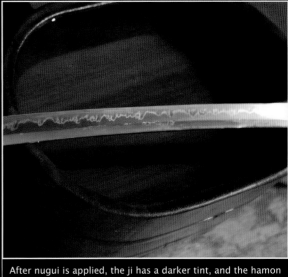

After nugui is applied, the ji has a darker tint, and the hamon outline is very clear.

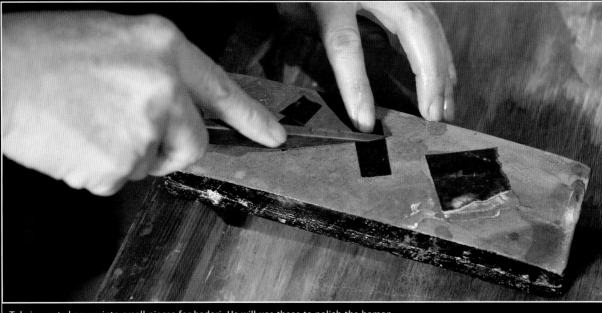

Takaiwa cuts hazuya into small pieces for hadori. He will use these to polish the hamon.

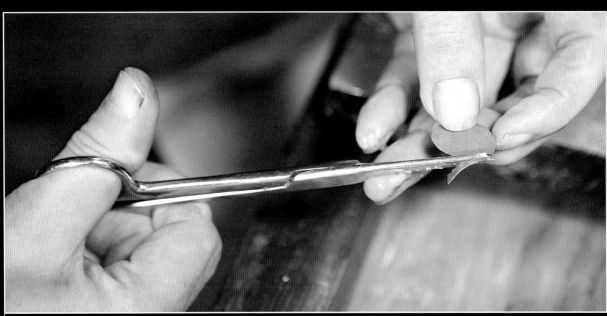

The pieces of hazuya are cut into ovals to make the hadori. The exact size and shape are determined by the size and shape of the hamon to be polished.

Takaiwa rubs a piece of uchigumori over a wet uchigumori stone to make a paste called "tojiru." This will be used as a lubricant between the hadori and the sword's surface while Takaiwa is polishing the hamon.

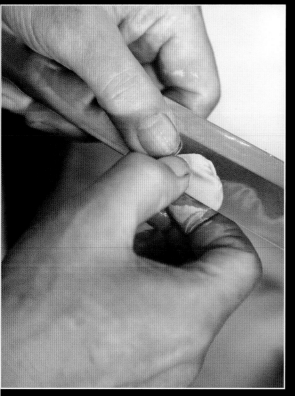

The hamon is polished very carefully from the edge side. The hadori is under Takaiwa's right thumb, surrounded by white tojiru paste. The part of the hamon to the right of Takaiwa's thumb, which has already been polished with the hadori, is much whiter than before.

Next, the polisher will burnish the shinogi-ji and mune surfaces to produce a bright, mirror-like reflective surface. The surfaces are first cleaned with tsunoko paste (a mixture of powdered horn and water) and dried. The polisher then dusts the surfaces with ibota powder, an insect-derived substance that helps the burnishing tools move smoothly across the surface of the steel; this is in turn wiped off. The burnishing is initially done with a burnishing spatula, and is finished with a burnishing needle. Both are made of extremely hard steel. The polisher starts burnishing near the top of the tang and works his way up the blade, burnishing about 1.5 inches (3–4 cm) at a time. After finishing one side of the shinogi-ji, the polisher burnishes the other side in the same way.

The last remaining step is to define the yokote line and put a fine polish on the point area. This task takes immense concentration and focus. Once it is finished, the polishing process is complete.

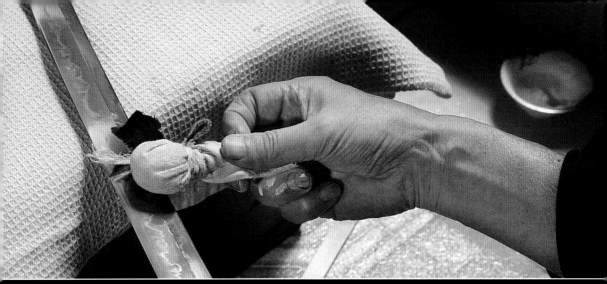

Before burnishing the sword, a fine, waxy powder called "ibota" is applied to the surface and wiped off. This acts as a lubricant during burnishing.

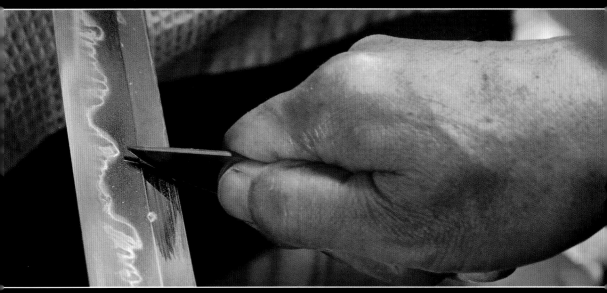

The first burnishing step is done with a migaki-bera, or burnishing spatula. The entire shinogi-ji and mune are burnished in 2-inch (5 cm) sections. The burnished section can be seen just below the burnishing spatula.

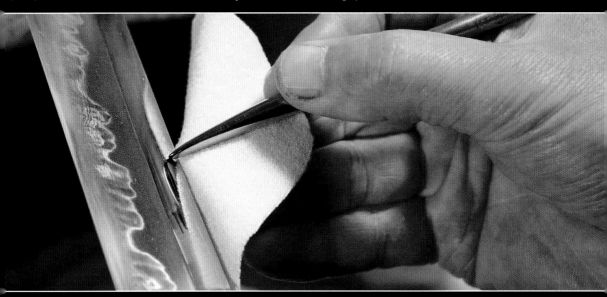

The second step of burnishing uses a migaki-bo (burnishing needle). Takaiwa keeps a piece of cotton cloth between his hand and the steel surface to protect the steel finish and allow the needle to move easily. The newly burnished section is visible around the

Polishing The Kissaki

When the kissaki (point) is polished, it must be distinct from the body of the blade. The boshi (the hamon in the point area) should be very clear, and the kissaki should have a uniform matte white appearance. In addition, the yokote line that defines the border of the kissaki must be at the proper angle relative to the edge and back of the sword.

thin hazuya on the paper over the narumedai, however, can flex sufficiently to cover the entire kissaki surface. The polisher moves the sword over the narumedai perpendicular to the lengthwise axis to polish the kissaki from the tip to the yokote line. When the kissaki is finished, the boshi will be distinct, and the polished surface will have a uniform matte finish that stands in clear contrast with the polished body of the blade.

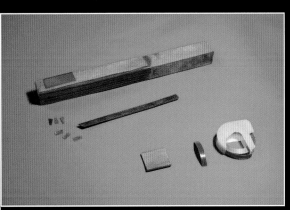

These are the tools used to polish the kissaki. The wooden narumedai has a series of horizontal slits cut into it to make it flexible. Washi paper and a thin slice of hazuya are placed on top of the narumedai. As the sword is moved across the hazuya, the stone follows the contour of the kissaki surface. Other tools used include the bamboo spatula used to move the hazuya when forming the yokote line; small square and polygonal pieces of hazuya used to polish the area just inside of the yokote line; a square piece of bamboo used to mask the blade as the yokote line is created; and the blue tape used to protect the blade and guide the hazuya along the yokote. Many polishers use only a piece of bamboo, or place tape over the bamboo, but Takaiwa uses only tape when he polishes the yokote.

The shape of the kissaki makes it difficult to polish uniformly, so specific tools and techniques are needed. To create the yokote, the polisher uses tape or a piece of bamboo as a guide or a mask. With a bamboo spatula, he moves a small piece of hazuya along the kissaki side of the line until the yokote line forms, marking the boundary of the kissaki. This also creates a white matte finish about ½ inch (1 cm) wide on the kissaki side of the yokote line.

Next, he uses a narrow piece of wood called a "narumedai" to polish the rest of the kissaki. The front half of the narumedai has a series of saw cuts below and parallel to the surface, which makes the wood very flexible. The polisher covers the narumedai with eight layers of Japanese washi paper, and places a thin piece of hazuya over the paper. Thus the tool has a flexible surface that can bend in any direction. Because the surface of the kissaki is rounded from the yokote to the tip, and from the mune toward the edge, if a hard piece of stone were used, it would not make contact with the entire surface area. The

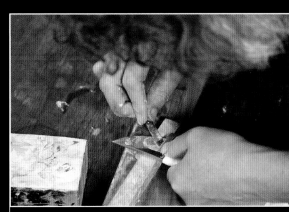

Takaiwa masks the blade with the blue tape to define the yokote line. He then uses the bamboo spatula to move the hazuya perpendicular to the lengthwise axis of the blade, producing a fine matte finish on the inside of the yokote. On the other side of the line, the blade's polished surface is untouched. Takaiwa holds the tape firmly so it will not move during this process.

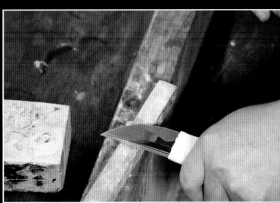

The yokote line is now well defined, and approximately ½ inch (1 cm) of the kissaki along the yokote has been polished. The rest of the kissaki remains to be polished.

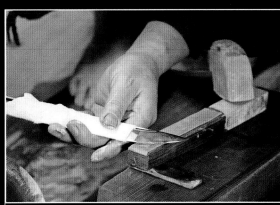

Takaiwa polishes the remainder of the kissaki. Holding the blade carefully, he moves the kissaki over the hazuya on the narumedai. The kissaki is polished from the yokote line to the tip in a direction perpendicular to the lengthwise axis of the blade.

HABAKI: SWORD COLLAR

To be mounted properly, a Japanese sword must be fitted with a special collar called a "habaki." The habaki rests at the top of the tang at the base of the polished surface. It is supported by the hamachi (the notch at the beginning of the sharpened edge) and the munemachi (the notch at the top of the tang where the polished back surface of the sword begins). The habaki, in turn, supports the hilt, which may be either a simple shirasaya hilt or a functional hilt with a sword guard. The shape of the habaki is tapered; it is thinnest in the front, becoming wider as it approaches the hilt. It has another function as well: the Japanese sword is designed to slide in and out of its saya (scabbard) on its unsharpened back surface, without the other polished surfaces coming into contact with the scabbard. When the blade is fully sheathed, the widest part of the habaki fits tightly in the scabbard mouth, holding the blade in the scabbard so that the sharpened edge and polished surfaces of the blade are not touching the wood.

A sword with a habaki is positioned to go into its storage scabbard. Notice that the widest part of the habaki is nearest the hilt (toward the right).

In the past, habaki were usually made by someone in a swordsmith's group. Once the sword was finished and polished to its final shape, a habaki would be made. Since the swordsmiths made the swords and polished them to their final shape, they also made the habaki. The oldest habaki, from the Heian period (794–1185) and the Kamakura period (1185–1333), were forged out of thin sheets of iron, which is a difficult material to work with. During the Muromachi, Azuchi-Momoyama, and Edo periods (1336–1867), most habaki were made from copper, silver, and copper alloys, and were forged by craftsmen who specialized in soft metal work. These specialists also produced beautifully decorated habaki using file work, chisel work, and other techniques, and often covered the copper habaki with gold, silver, or shakudo (a copper-gold alloy) foil.

These days, there are still specialists who make habaki. Some swordsmiths who forge and then polish their swords to their precise final shape also make habaki (the sword must still go to a professional polisher to receive a final polish that will bring out all of the important details and produce the final appearance). Regardless of who makes the habaki and shirasaya, there is always some risk that swords will be scratched during this work. To avoid this, the habaki and shirasaya are made before the sword is fully polished.

Swordsmiths and apprentices from the Yoshihara group make a large number of the habaki for their blades. All of Yoshindo's students learn to make habaki. In the photos in this chapter, Ryoichi Mizuki, one of Yoshindo's students, is shown making a habaki.

The habaki is usually made of copper or a copper alloy. After the size of the new habaki is decided, a piece of metal with the approximate dimensions is cut from a stock sheet of copper.

The thickness of the stock to be used depends on the sword. The habaki must be thick enough to fill in the gap between the tang's mune surface and the top of the polished mune surface (illustrated by the shaded area in the figure above).

Because the edge of the habaki nearest the point will be thinner than the end near the tang, the metal stock is forged so that it has a triangular cross-section.

The metal is forged (hammered) to leave the center of the new habaki far thicker than the sides.

A large rounded punch is used to depress the center of the habaki. This will leave the surface where it contacts the mune slightly concave.

The habaki has a raised ridge and relatively thin sides, and is ready to be shaped around the tang of the sword.

The habaki is bent into a U shape to fit around the tang of the sword.

After the habaki is fitted to the sword, it is filed into a more finished shape. An insert is made and soldered into the open end. The hamachi (notch at the base of the sharpened edge) will rest on the insert (the lower shaded part in the drawing below).

The fit of the habaki on the sword is shown here. The shaded area at the top is the thick center area of the habaki, and the shaded area along the bottom shows how the insert fills the space between the tang and the outside edge of the habaki. The insert and thick center abut the notches at the top of the tang, providing the support the habaki must have to hold the hilt in place. The profile of the habaki widens toward the hilt, allowing it to act as a wedge that holds the sword snugly in the mouth of the scabbard.

The first step in making a habaki is to select the material; they are usually made of copper, shakudo, or shibuichi (an alloy of silver and copper). When the material is selected, a chisel and a hammer are used to cut out a piece to use for the habaki. The individual sizes and proportions of a habaki can vary depending on the sword, its age, condition, and style. In general, however, the height of a habaki is about 70 percent of the width of the sword at the top of the tang. The metal stock is cut as close to the final shape of the habaki as possible in order to save work later in the process.

After the metal stock is cut, one edge is made thinner by forging or hammering it, because the habaki will be much thinner at the edge facing the point of the sword. Forging the metal into shape also conserves the material, whereas later filing will result in wasted material. Soft metals such as copper and copper alloys, however, become

work-hardened : as the smith repeatedly hammers and works the metal to change the shape, it becomes much harder and more difficult to work. To compensate for this, the metal is heated to a red color and then cooled by quenching it in water. The metal reverts to its original condition and is softer again, so the smith can continue with his forging work. He will also shape the tapered metal stock so that it is thick in the center and thin on the sides. The sides of the metal are forged to make them thinner, but no forging is done on the center. After the initial forging, the thick center ridge should be well defined.

In preparation for fitting the habaki on the sword and forging it into shape around the tang, the center ridge of the habaki must be made slightly concave. This is done with a hammer and a round-faced punch. The concave surface will become the inside surface of the habaki, and will match the mune surface of the tang closely.

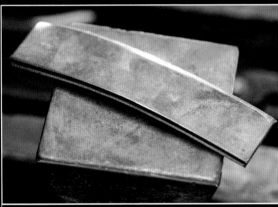
Metal for making the habaki is cut from a stock sheet.

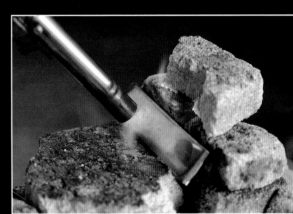
Work-hardened metal is heated to a red color and then cooled. The metal will then be soft enough to continue forging.

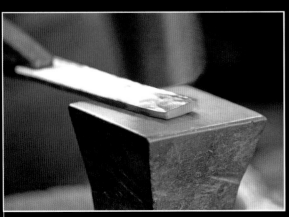
The habaki is forged so that one edge is thinner than the other.

The habaki stock is noticeably thinner on one edge; the cross-section is becoming triangular.

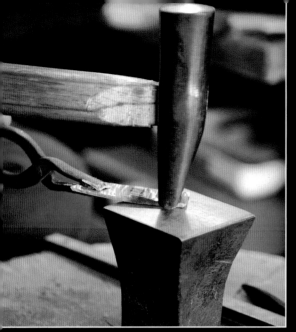

The center of the metal is left thick, while the sides are forged to be much thinner. The thick part in the center will be positioned over the mune surface of the tang.

Once the center ridge is formed and shaped properly, the next step is to begin bending the habaki into a U shape to fit around the tang of the sword. Special pliers are used to grip each side of the habaki and begin bending both sides into a U. The pliers used to bend the habaki are designed specifically to be used on soft metal; they have smooth jaws with no teeth or filed surfaces that might leave marks in the surface of the metal.

Next, the habaki is hammered so that it will fit tightly over the tang. If it does not conform to the shape of the tang closely, it will not function properly in supporting the hilt of the sword and holding the blade securely in the scabbard. As the habaki is shaped, its bottom edges are forged to fit very closely over the thin edge of the tang. It is very important that the hammer not contact or strike the brittle edge of the sword as this is done; it can easily chip the hardened blade. For this reason, the habaki is fitted to the tang slightly below the machi, which helps keep the hammer away from the cutting edge. In the early stages of shaping, some habaki makers use a tang-shaped bar to minimize the amount of hammering required near the actual blade. During the hammering and shaping, the sides of the habaki will expand as they become thinner. The excess material will extend past the thin edge of the tang and must be cut off with a jeweler's saw.

The thick center is well defined here. It is about the same width as the sword's mune surface.

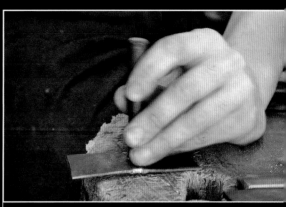

A large, round-faced punch is used to make the inside surface of the center of the habaki slightly concave.

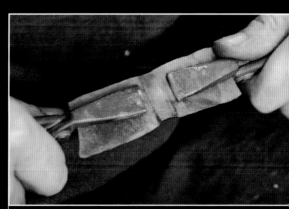

Using smooth-jawed pliers to begin bending the habaki into a U shape.

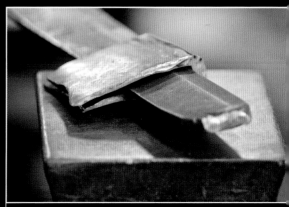

After the habaki has been folded into a U shape, it is forged around the mune surface of the tang. The inside of the habaki must conform very closely to the shape of the tang.

Next, the narrow end of the habaki must be closed. Since the edge of the sword is under the area, a small piece of metal with a triangular cross-section is cut. The narrow edge of this piece will become part of the outer surface of the habaki. This piece is also shorter than the habaki: it will extend from the bottom of the habaki and fill the space inside it, fitting against the hamachi. This will make the habaki strong enough to support the hilt of the sword.

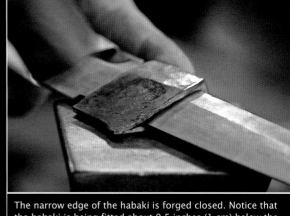

The narrow edge of the habaki is forged closed. Notice that the habaki is being fitted about 0.5 inches (1 cm) below the hamachi and munemachi at the base of the blade.

The habaki and the small metal insert that will be soldered in to close the habaki and hold it in place against the hamachi (the notch at the base of the cutting edge).

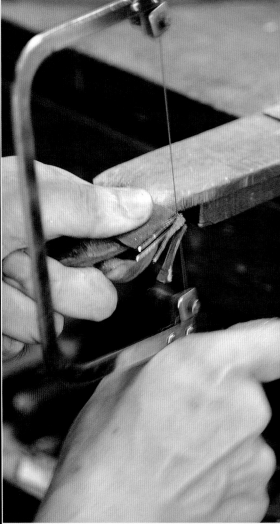

A jeweler's saw is used to cut excess metal from the open end of the habaki.

Once the habaki and the metal insert for the open end have been shaped, the insert is secured with iron thread and fixed into place with silver solder. The habaki is then fitted onto the sword and carefully worked into place by tapping it with a hammer. It is basically stretched to fit very snugly into the proper position just below the hamachi and munemachi notches at the top of the tang.

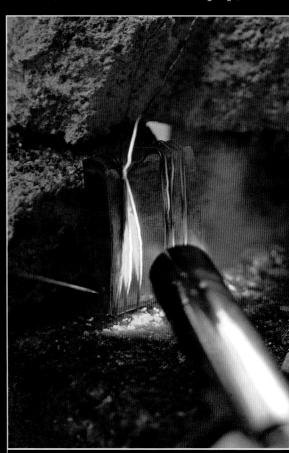

The insert, held in place with iron wire, is soldered into place in the habaki.

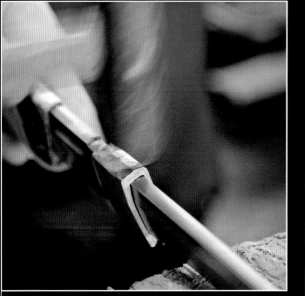

The habaki is being shaped over the tang and stretched into position with careful hammering.

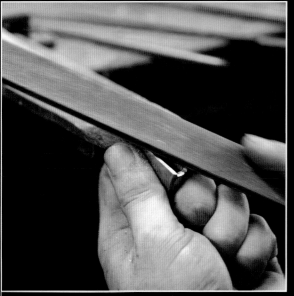

Filing the surface of the habaki that will be closest to the point.

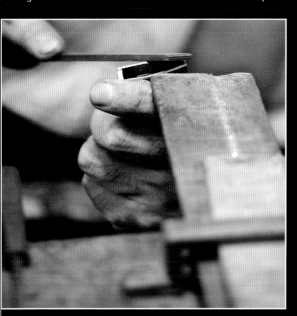

Filing the surface of the habaki that will be closest to the hilt.

FINISHING THE HABAKI

After the habaki has been fitted into its proper location, the outside surfaces are finished by filing. Every surface is shaped, beginning with large coarse files and progressing to increasingly fine ones. All scratches and imperfections must be removed, as the habaki must have a very fine, smooth surface to produce the final desired patina.

When the surface is smooth enough, decorative work can proceed. For the habaki shown in this chapter, the finish work will include black patination and gold foil surfaces on the mune and ha (edge) sides. First the surface is carefully cleaned, and the gold foil is folded to make a perfect match with the mune and ha surfaces. (The gold foil for the mune surface is shown next to the habaki in the photo on page 232.) The folded foil pieces are tied into place with iron wire. Then the habaki is heated, and silver solder is used to affix the foil into place.

Next, the habaki is filed to remove any excess gold and to clean up the surfaces after soldering. Decorative file marks are also made at this point. All of the surfaces are then cleaned with wet charcoal made from ho wood. As this is a soft charcoal, it will clean up the soft metal surfaces without leaving scratches. The habaki is then rubbed with a clean cotton cloth and washed with soap and water. In order to keep the surface free of oil and salt, it is not touched with bare skin after this point.

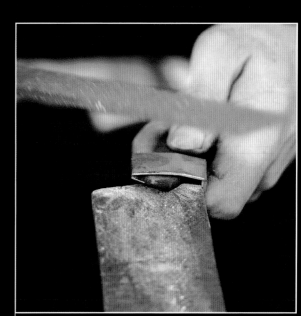

Filing the sides of the habaki until they are smooth.

The final step for the habaki shown in these pages is patination. This is accomplished by immersing the habaki in a very hot solution of cupric sulfate and cupric oxide for 20 to 30 minutes. This solution is kept at a temperature just below boiling to prevent bubbles and foam from forming. At the end of this treatment, the shakudo surface will be completely black, but the gold will be unaffected. The finished habaki has a highly polished jet-black surface, and the mune and ha surfaces are gold, with decorative diagonal file marks.

There are many ways to finish and decorate a habaki. Some examples are shown at the bottom of page 233, as follows:

A. An iron (tetsu) habaki.

B. A two-piece habaki covered in gold foil. The upper piece fits into the lower, wider piece. There is a mon (family crest) carved into the lower piece.

C. A one-piece copper habaki covered with gold foil. The foil has an elaborately filed decorative surface.

D. A polished shakudo habaki with filed gold foil over the mune and ha surfaces. This is similar to the habaki being made in this chapter.

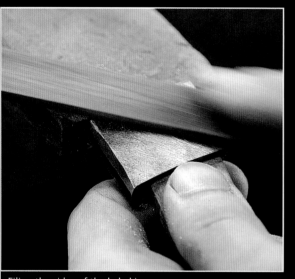

Filing the sides of the habaki.

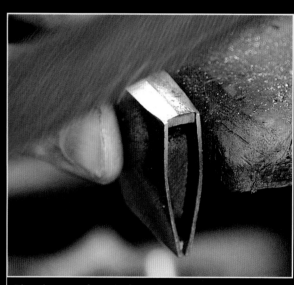

Filing the top surface. The front of the insert, which is visible in the narrow end of the habaki, will rest against the hamachi.

Shaping of the habaki is complete, and all of the surfaces are clean and smooth. Although it looks like copper, this habaki is made out of a gold-copper alloy called shakudo. The gold foil will be soldered onto the mune surface of the habaki.

The gold foil is held securely in place with iron wire.

Charcoal made from ho wood is soaked in water before being used to clean up the habaki surfaces.

Rubbing the habaki with a cotton cloth.

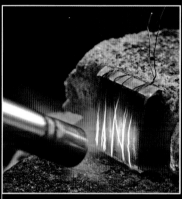

The habaki is heated with the gold foil in place on the mune and ha surfaces.

Soft charcoal is used to clean up all the shakudo and gold surfaces on the habaki. The habaki is held on a wooden blade during the final steps.

The habaki is immersed in a hot solution of cupric sulfate and cupric oxide to give its surface a glossy black patina.

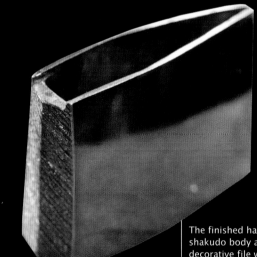

The finished habaki has a glossy black shakudo body and gold surfaces with decorative file work.

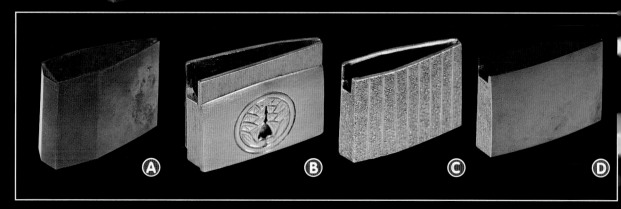

233

SHIRASAYA: STORAGE SCABBARD

Once a sword is finished, a scabbard and hilt are required for storage and protection. In the past, all swords were mounted in functional koshirae for practical use. In modern times, however, simple scabbards made from unstained and unfinished wood have come into use for newly made Japanese swords. These scabbards, which are custom-made to fit the sword, are called "shirasaya" (white scabbards). When a new sword is finished, before it is polished completely a habaki is forged and fitted and a simple shirasaya is made. If the owner wants to use the blade as a sword, or wants it to be mounted in a completely traditional manner, he must commission a group of associated craftsmen to make a koshirae mounting.

A shirasaya, with its graceful, eight-sided shape, is a simple and elegant way to protect a sword, and the craftsmen who make them are highly skilled. The tools used are completely traditional. The craftsman shown making the saya in this chapter is Tadao Okumura, who works in Takasago, Katsushika-ku, Tokyo, very close to the workshops of Yoshindo and Takaiwa.

Traditional saya are made from ho wood, a relatively soft hardwood in the magnolia family. The wood must be well seasoned and completely dried out before the saya is made; if any moisture is left in the wood, it may cause the blade to rust while it is stored inside of the saya.

Each saya is carved out with chisels and fitted very carefully so that the sword can be sheathed and withdrawn by sliding it only along its burnished back surface. The outside of the shirasaya is shaped with planes and polished using a piece of ho wood, and sometimes finished with a waxy insect-derived powder called "ibota." Sandpaper cannot be used at all: if a single bit of grit from the sandpaper found its way to the inside of a saya, it would scratch the blade every time the sword was drawn or sheathed.

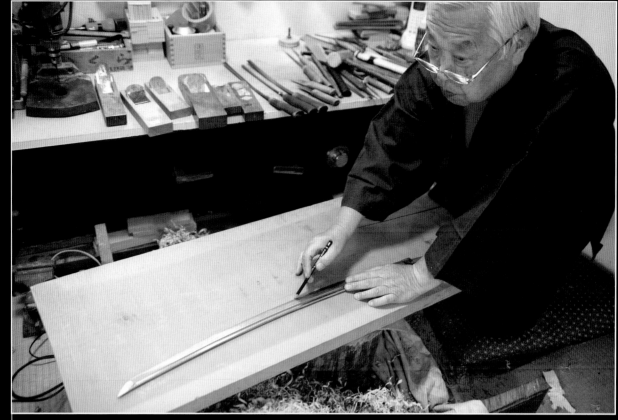

Using a soft pencil to mark the sword's outline on a very thick piece of seasoned wood.

Making a Shirasaya

Work on the shirasaya can begin once the habaki is made. This usually happens once the sword is partially polished, so that it has its final shape, but any scratches or damage that occur while the saya is being made can be removed by the additional polishing. It usually takes about two days to make a shirasaya for a new katana.

The sayashi (scabbard maker) uses tools that are easily recognized by Western woodworkers. These consist mainly of chisels, planes, and knives of many sizes and shapes. Japanese woodworkers sit on the floor, and a section of a tree trunk is often used as a work surface or table for this kind of work.

The first step in making a saya is to select a piece of dry, well-seasoned wood. Notice that the wood shown in the photo above is very thick. A soft pencil is used to mark the outline of the sword on the wood surface; these dimensions are used to judge the rough shape that should be cut initially. This piece of wood is then split along its length; the saya will be made from these two halves, which will eventually be glued together.

Kiridashi knives.

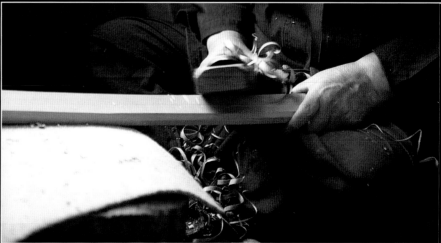

All of the inside and outside surfaces of the wood are smoothed with a plane.

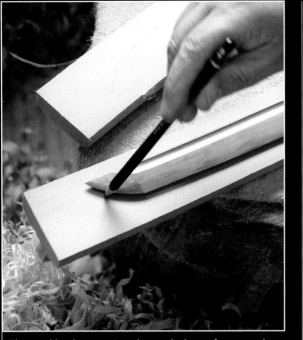

The wood has been cut into the rough shape of a saya and then split into two halves that will be glued back together again after the interior has been carved out. Okumura draws the outline of the sword on the saya blank.

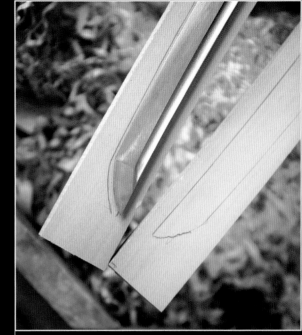

The outline of the sword is carefully marked on both halves of the saya blank.

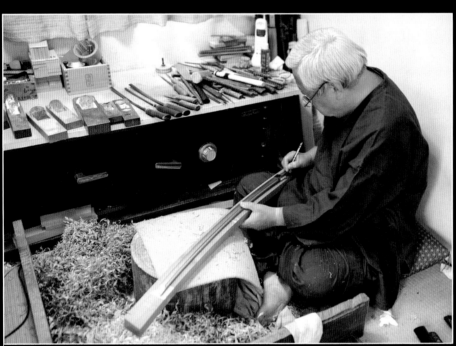

Okumura marks the line at the top of the habaki to determine where the top of the saya will be. He will then make the cut to separate the hilt from the scabbard.

After determining the location of the habaki, the sayashi makes another cut to separate the sections that will form the hilt from those that will form the scabbard. As the wood is already cut in half lengthwise, this leaves two long pieces of wood for the scabbard, and two shorter pieces for the hilt. After a kanna (plane) is used to even out the interior and exterior surfaces, the position of the sword is carefully marked on the inside surfaces of both halves of each section of wood with a soft pencil. The interior of the saya will

be carved out to accommodate the sword, being sure to create sufficient space so that the point of the sword will not be damaged by coming into contact with the wood at the front of the saya.

The penciled lines indicating where the sword will be positioned are scored with a knife called a "kiridashi" in preparation for cutting the space for the sword. Then, a long, curved chisel called a "nomi" is used to begin shaving the area where the mune side of

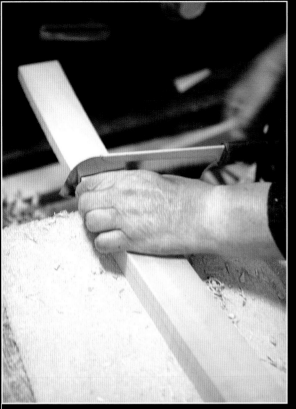
Cutting off the hilt from the saya blank.

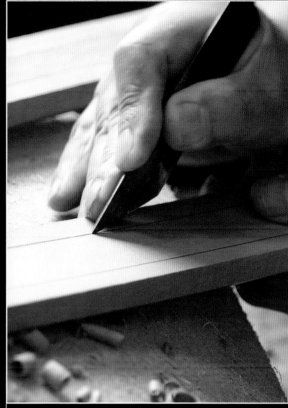
The entire outline of the sword is scored with the kiridashi.

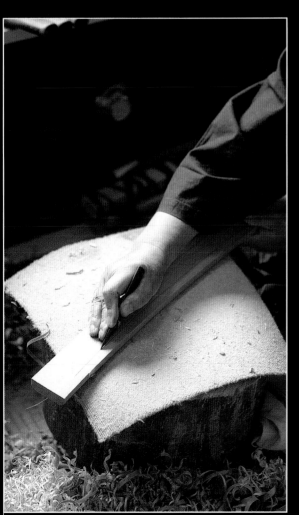
The kiridashi is used to cut all along the sword's outline.

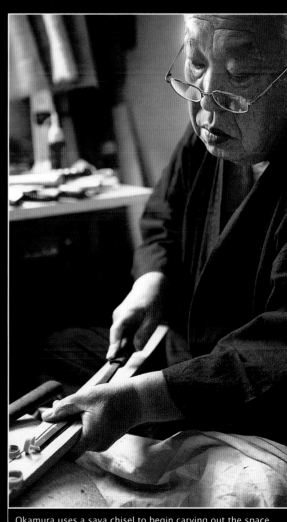
Okamura uses a saya chisel to begin carving out the space where the sword will fit.

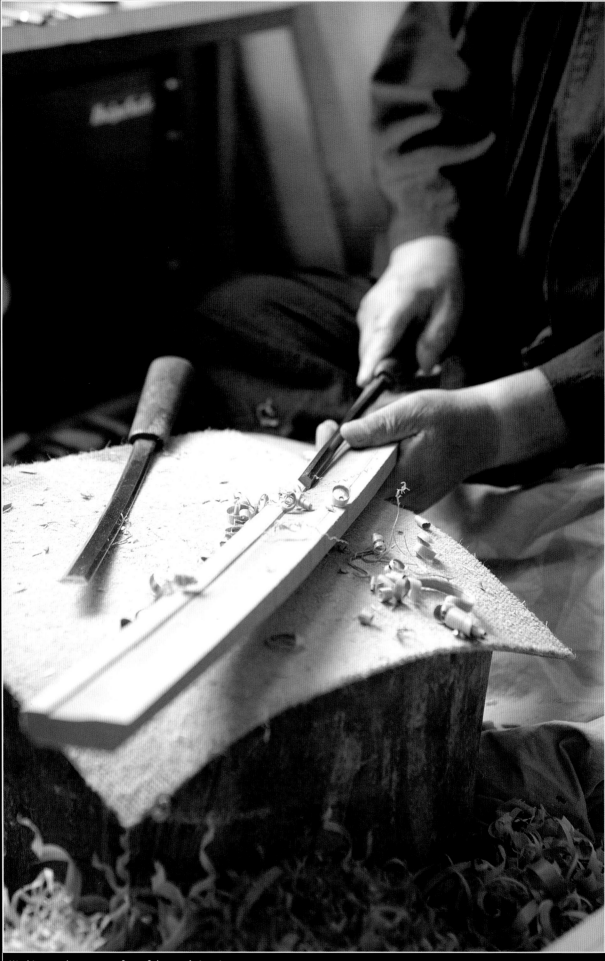

Working on the mune surface of the saya's interior.

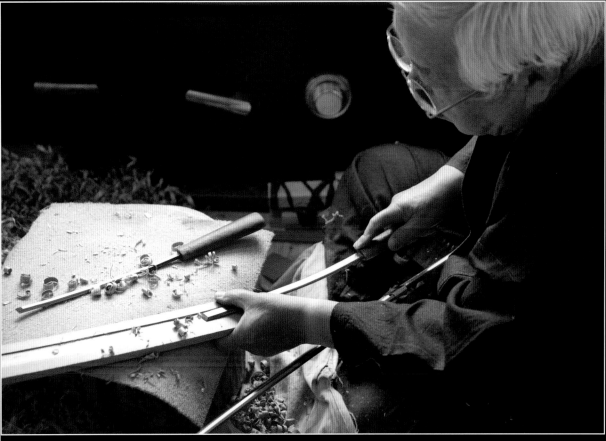

The space inside of the saya becomes deeper.

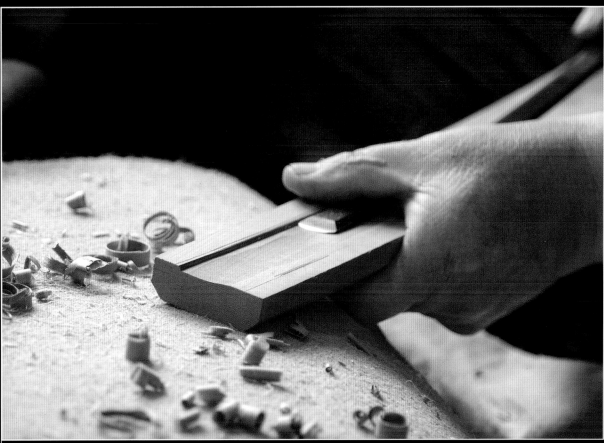

The space inside of the saya is deepest on the mune side, where the sword is thickest, and thinnest at the edge side. Okumura carves out the interior slowly, moving from the mune side. Here, he has not yet begun carving the area of the saya where the edge will rest.

the blade will rest. After the first few gentle passes, a shallow depression begins to form inside of the saya. The sayashi makes repeated passes with the wide nomi to deepen the space for the blade, as well as to smooth out the surfaces. Progress is slow and careful, so that the planed surfaces remain very smooth and uniform. When the inside of the saya conforms to the contours of the sword, the depression will be deep where the mune is to rest, while the space for the cutting edge is fairly shallow.

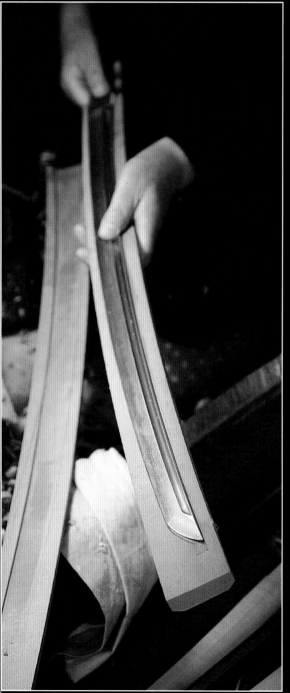

Checking the fit of the sword inside of the saya. Notice the square pocket carved below the point of the blade. This is to create a space inside of the saya where excess oil from the blade can accumulate.

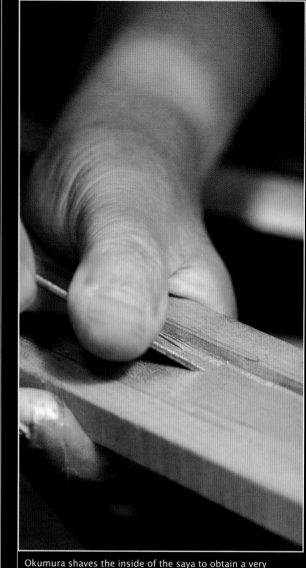

Okumura shaves the inside of the saya to obtain a very smooth surface.

As the sayashi works, he frequently places the sword inside the saya to be sure it fits properly inside of the depression. To check for rubbing or uneven contact at any point inside the saya, he covers the blade with a thin layer of oil and slides it into place inside the scabbard. The oil will leave a clear mark wherever it contacts the wood, showing points that must be shaved down further. After working with the nomi chisel, the sayashi shaves down and smooths out the wood further by using the kiridashi knife crosswise against the grain of the wood. When both halves of the saya have been finished in this way, there will be an ample well-finished space for the sword to be inserted and removed smoothly with no risk of damage.

Once the inside of the saya is carved out, the habaki must be fitted. The upper third of the habaki—the widest part—must fit very tightly in the mouth of the

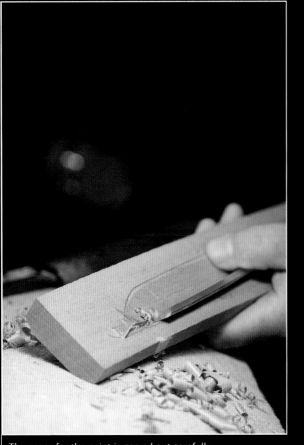

The space for the point is carved out carefully.

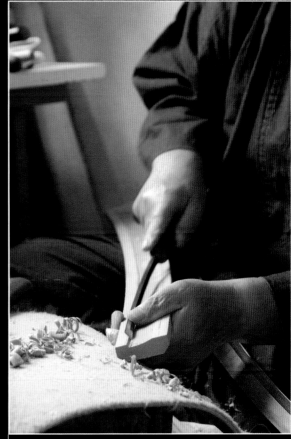

Shaping the mune side of the saya's interior.

The mouth of the saya must be adjusted so that the habaki will fit snugly. The space must be carved out very carefully so that the upper third of the habaki grips the mouth of the saya.

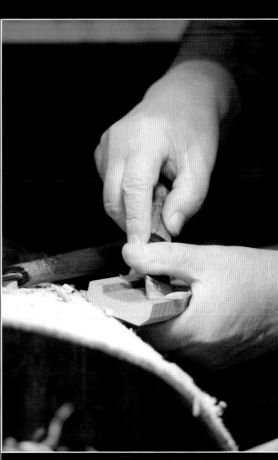

Carving out the mouth of the saya to fit the habaki properly.

Cooked rice is used to make the sokui glue that holds the two halves of the saya together.

Compressing the rice into a paste to make sokui glue.

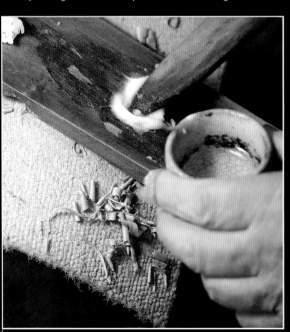

Water is added a drop at a time until the sokui has the proper consistency.

saya, where it will act as a wedge to hold the sword securely. This space must be carved out very carefully to ensure a good fit. The sayashi uses a chisel and kiridashi knives to make a properly flared space that will hold the habaki snugly.

At this point, the two halves of the saya are ready to be glued together. Sokui, or rice glue, is used for this purpose. Sokui is a very old type of glue used in Japan, and it is used today in saya for very practical reasons. Although its strength is more than adequate to hold the shirasaya halves together, it is weak enough to allow the two halves of the shirasaya to be forced apart at some point in the future so that the inside can be cleaned. The two halves will then be glued together again with sokui. This is an important consideration, because the sword must be periodically cleaned and coated with oil to prevent rust during storage. Over time, the oil accumulates inside the saya, and eventually dust may get into the oil and scratch the blade when it is removed and replaced in the saya. When a sword is repolished, a new shirasaya may be made. If not, the existing shirasaya will be opened, cleaned, and glued back together to ensure that it will protect the sword properly.

The process of making sokui glue begins with day-old cooked rice. The rice is compressed with a spatula to make a paste. Water is added a few drops at a time until the mixture is smooth and has reached the proper consistency. A bamboo spatula is then used to apply the sokui to the surfaces to be glued together. The two halves of the saya are matched and tied together with a cord to hold them in place overnight until the sokui is dry. The two halves of the hilt are glued together in the same way.

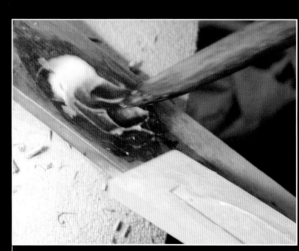

The sokui glue is ready to be applied to each half of the saya.

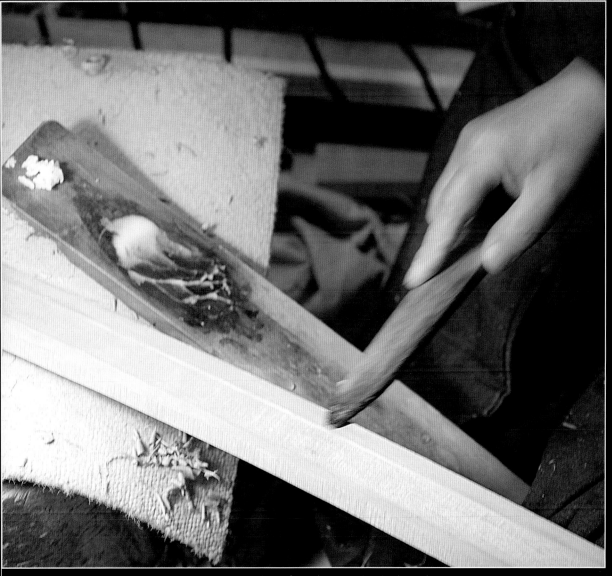

A bamboo spatula is used to spread the sokui glue over the surfaces that are to be glued together.

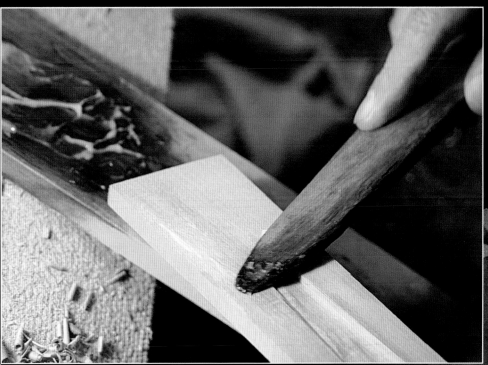

Okumura spreads sokui glue over the hilt surfaces.

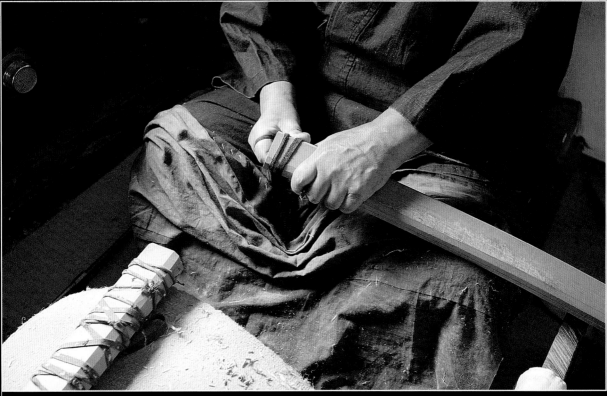

It is essential that the interior surfaces are correctly positioned when the halves are glued together. Okumura is tying the two halves of the saya tightly together with a cord so that they do not slip. The two halves of the hilt, already tied together, are in front of him.

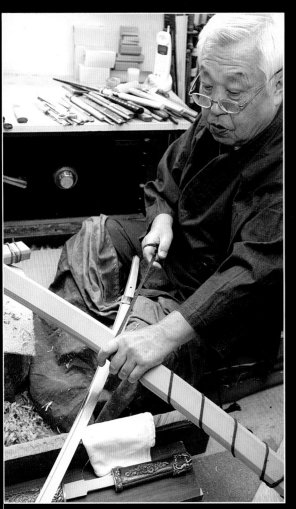

The cord securing the halves of the saya must be tied very tightly, the surfaces fit together seamlessly.

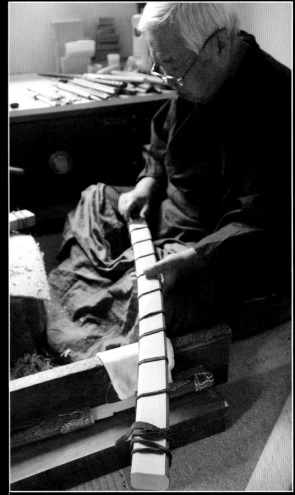

Once the two halves of the saya are tied together, they will be left overnight for the sokui to dry.

Once the two halves of the saya are glued together, the next step is to make the surfaces on the top of the saya and the bottom of the hilt perfectly flat so that they match, forming a dust-proof seal when the sword is in the saya. This work is done with a specially prepared sanding block that uses "tokusa" (horsetail reed) as an abrasive. Sections of tokusa are boiled and cut to form flat sheets, then glued to a piece of wood with sokui. Horsetail reed is ridged and tough, but does not leave grit behind as sandpaper would, so it is a practical choice for saya-making.

The sword is now placed inside of the saya and the hilt is fitted on. With the sword sheathed, the surfaces of the entire shirasaya are finished. A large plane is used at first, followed by progressively smaller ones. In the course of this work, all defects and abrasions on the surface are removed, and the eight distinct surfaces of the saya emerge. The saya maker works on the entire length of the saya from one end to the other, defining and straightening all the lines and surfaces. The edge and mune sides of the saya are given a slightly rounded shape with a tokusa sanding block.

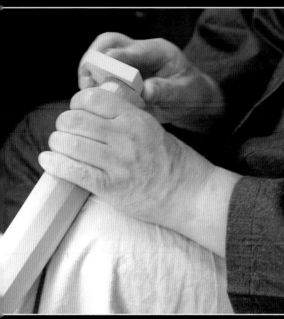

Okumura uses a tokusa sanding block so that the mouth of the saya and the base of the hilt will mate perfectly.

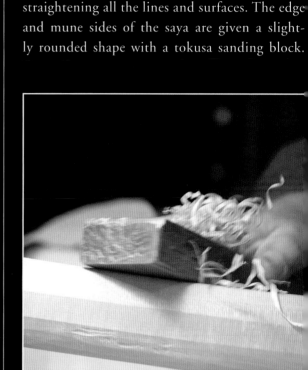

Okumura is using one of the smaller planes here. The shavings are becoming finer and the surface smoother.

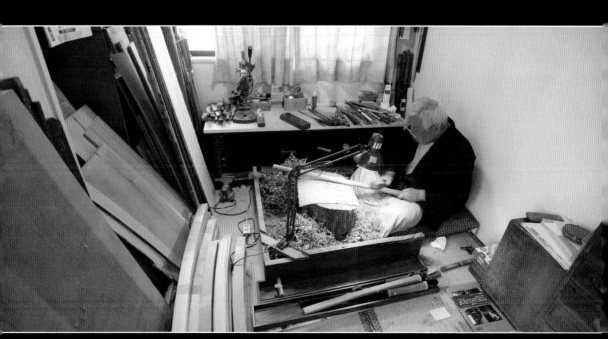

Okumura planes the saya in his workshop. The large piece of wood being seasoned on the left will eventually be used for a

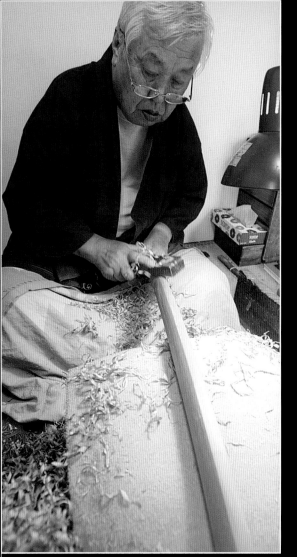

As he does the finishing, Okumura ensures that the lines and surfaces are straight and continuous along the entire length.

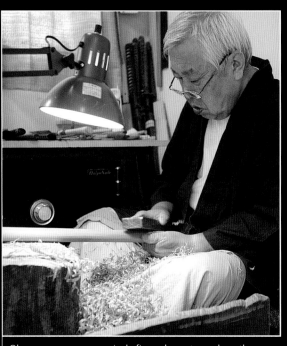

Okumura uses progressively finer planes to work on the surface of the saya.

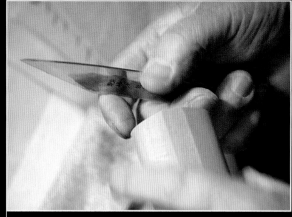

Fine bevels are made around the top and bottom surfaces.

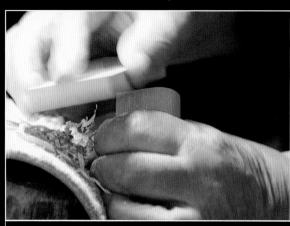

Shaping the hilt with a tokusa sanding block. The top of the hilt now has a rounded surface.

Cleaning the surface with a tokusa sanding block to produce a fine surface finish.

Finally, the entire surface is smoothed with two different tokusa sanding blocks: first a new one, and then one that has previously been used, which gives a finer finish. The entire surface may be burnished by rubbing it with a piece of ho wood. The top and bottom ends of the shirasaya are beveled with a kiridashi knife.

After the shaping and finishing of the saya are complete, the final task is to make the hole for the mekugi (bamboo rivet) that holds the tang in the

hilt. To accomplish this, the hilt is removed from the sword, leaving the blade sheathed so that the top of the habaki is flush with the mouth of the saya. The matching surface of the hilt is placed against the mouth of the saya, so that the position of the mekugiana (the hole in the tang) can be determined and accurately marked on the wood of the hilt. A small hand drill is used to begin making the hole. After the drilling is started, the hilt is replaced on the tang. The saya maker finishes drilling the hole completely through one side of the hilt, the tang, and the other side of the hilt. A tapered hand drill is used to enlarge the hole so that it is wide on one side and narrow on the other. The mekugi itself will also be tapered so that it fits very securely. When the hole is completed, it is filed so that it is smooth. Then the mekugi is whittled from a piece of bamboo, filed smooth, and inserted in the mekugiana to secure the blade.

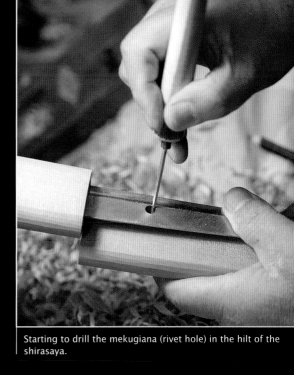

Starting to drill the mekugiana (rivet hole) in the hilt of the shirasaya.

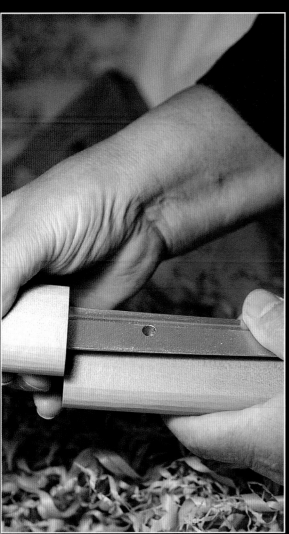

The hilt is held against the top of the saya so the correct spot to drill the mekugiana in the hilt can be determined. The mekugiana in the wood hilt must be in exactly the same place as the one in the tang of the sword.

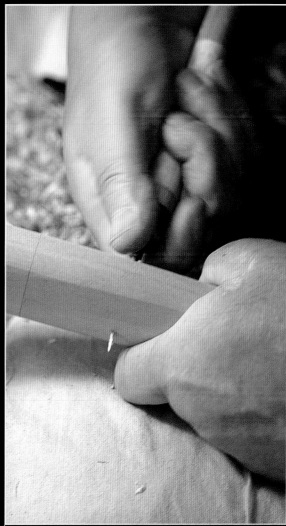

The mekugiana is drilled through the hilt while the blade is in the saya.

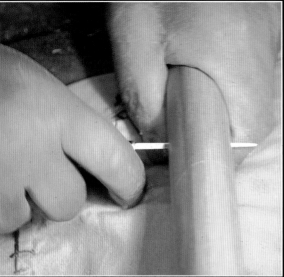

Drilling out the mekugiana to the proper size with a tapered hand drill.

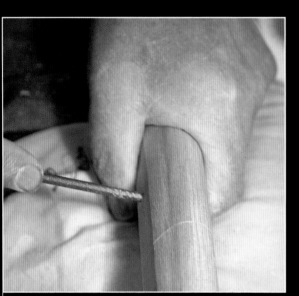

Filing out the mekugiana.

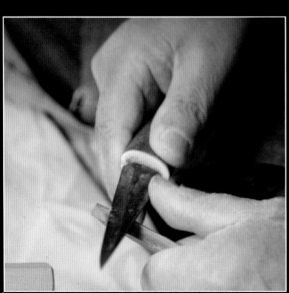

Using a kiridashi knife, Okumura begins to shape a mekugi (bamboo rivet).

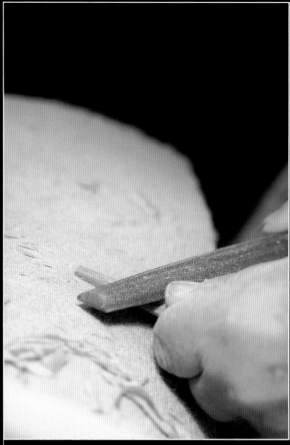

Filing the mekugi to its finished shape. Once the mekugi is inserted, the shirasaya is complete.

Okumura examines the finished shirasaya. Since ho wood is rather soft, he keeps his working surfaces covered with heavy cloth to protect the saya.

A shirasaya made for a
wakizashi or short sword.
The overall length is
approximately 20 inches
(50.5 cm). The graceful
lines of the shirasaya
follow the shape of the
wakizashi.

A shirasaya made for a
tanto. The overall length is
approximately 12 inches
(30 cm). The tanto is quite
wide for its length, and
the shirasaya reflects this
unusual shape.

Japanese Nengo Eras and Dates
A Partial Listing From 1159 to the Present

Japanese history is usually discussed in the context of major periods that are considered significant from a cultural or political viewpoint.* For example, it was during the Heian period that Japanese aristocratic society developed to its fullest extent, while the Kamakura period that followed comprises the centuries during which the basis of feudalism was firmly established.

These are modern classifications, however. Since the seventh century, the Japanese have used a dating system based on "nengo," or eras. Nengo eras often coincide with the reign of an emperor and are named after the ruler. Before the modern period, nengo could also reflect an auspicious event or natural disaster whose occurrence marked the beginning of the era, and were named accordingly.

HEIAN PERIOD

KANJI	NENGO NAME	DATE
平治	Heiji	1159
永暦	Eiryaku	1160-61
應保	Oho	1161-62
長寛	Chokan	1163-64
永萬	Eiman	1165-66
任安	Nin-an	1166-68
嘉應	Kao	1169-70
承安	Shoan	1171-74
安元	Angen	1175-76
治承	Jisho	1177-80
養和	Yowa	1181-82
壽永	Juei	1182-84
元暦	Genryaku	1184-85

KAMAKURA PERIOD

KANJI	NENGO NAME	DATE	KANJI	NENGO NAME	DATE
文治	Bunji	1185-89	建長	Kencho	1249-55
建久	Kenkyu	1190-98	康元	Kogen	1256-57
正治	Shoji	1199-1200	正嘉	Shoka	1257-58
建仁	Kennin	1201-03	正元	Shogen	1259
元久	Genkyu	1204-05	文應	Bun-o	1260
建永	Ken-ei	1206-07	弘長	Kocho	1261-63
承元	Shogen	1207-10	文永	Bun-ei	1264-74
建暦	Kenryaku	1211-12	建治	Kenji	1275-77
建保	Kenpo	1213-18	弘安	Koan	1278-87
承久	Shokyu	1219-21	正應	Sho-o	1288-92
貞應	Joo	1222-23	永仁	Einin	1293-98
元仁	Gennin	1224-25	正安	Shoan	1299-1301
嘉禄	Karoku	1225-26	乾元	Kengen	1302-03
安貞	Antei	1227-28	嘉元	Kagen	1303-05
寛喜	Kanki	1229-31	徳治	Tokuji	1306-07
貞永	Joei	1232-33	延慶	Enkyo	1308-10
天福	Tenpuku	1233-34	應長	Ocho	1311-12
文暦	Bunryaku	1234-35	正和	Showa	1312-16
嘉貞	Katei	1235-37	文保	Bunpo	1317-18
暦仁	Ryakunin	1238-39	元應	Gen-o	1319-20
延應	Enno	1239-40	元亨	Genko	1321-23
仁治	Ninji	1240-42	正中	Shochu	1324-25
寛元	Kangen	1243-46	嘉暦	Karyaku	1326-28
寶治	Hoji	1247-48	元徳	Gentoku	1329-31

NANBOKUCHO PERIOD

Hokucho or North Court

KANJI	NENGO NAME	DATE
元徳	Gentoku (3)	1331
正慶	Shokyo	1332-37
暦應	Ryakuo	1338-41
康永	Koei	1342-44
貞和	Jowa	1345-49
観應	Kan-o	1350-51
文和	Bunwa	1352-55
延文	Enbun	1356-60
康安	Koan	1361-62
貞治	Joji	1362-67
應安	Oan	1368-74
永和	Eiwa	1375-78
康暦	Koryaku	1379-80
永徳	Eitoku	1381-83
至徳	Shitoku	1384-86
嘉慶	Kakei	1387-88
康應	Ko-o	1389-90
明徳	Meitoku	1390-93

Nancho or South Court

KANJI	NENGO NAME	DATE
元弘	Genko	1331-33
建武	Kenmu	1334-35
延元	Engen	1336-39
興国	Kokoku	1340-45
正平	Shohei	1346-69
建徳	Kentoku	1370-71
文中	Bunchu	1372-74
天授	Tenju	1375-80
弘和	Kowa	1381-83
元中	Genchu	1384-92

MUROMACHI PERIOD

KANJI	NENGO NAME	DATE
應永	Oei	1394-1427
正長	Shocho	1428-29
永享	Eikyo	1429-40
嘉吉	Kakitsu	1441-43
文安	Bun-an	1444-48
寶徳	Hotoku	1449-51
享徳	Kyotoku	1452-54
康正	Kousho	1455-56
長禄	Choroku	1457-59
寛正	Kansho	1460-65
文正	Bunsho	1466-67
應仁	Onin	1467-68

KANJI	NENGO NAME	DATE
文明	Bunmei	1469-86
長享	Chokyo	1487-88
延徳	Entoku	1489-91
明應	Meio	1492-1500
文亀	Bunki	1501-03
永正	Eisho	1504-20
大永	Taiei	1521-27
享禄	Kyoroku	1528-31
天文	Tenmon	1532-54
弘治	Koji	1556-57
永禄	Eiroku	1558-67

A given nengo era begins and ends on specific dates that correspond to the events that initiated the era and began the next one. These eras do not correlate directly to years in modern terms; that is, a single year might include the end of one nengo era and the beginning of the next. A table like the one given here is used to convert nengo dates into modern terms.

In the modern period, which began with the Meiji restoration in 1868, Japan adopted the "one reign, one era name" system, wherein era names would change only upon imperial succession. Thus, the nengo eras of the modern period thus far—Meiji, Taisho, Showa and Heisei—coincide directly with each emperor's rule.

On a sword with a mei (inscription), the date of completion is inscribed as the day of the month of a year within a given nengo era. For sword enthusiasts, it is therefore very handy to have a reference table to identify the year in which a sword was made and put it into historical context.

AZUCHI-MOMOYAMA PERIOD

KANJI	NENGO NAME	DATE
永禄	Eiroku (2)	1558-67
元亀	Genki	1570-72
天正	Tensho	1573-91
文禄	Bunroku	1592-95
慶長	Keicho (1-5)	1596-1600

EDO PERIOD

KANJI	NENGO NAME	DATE	KANJI	NENGO NAME	DATE
慶長	Keicho (8-19)	1603-14	延享	Enkyo	1744-47
元和	Genna	1615-23	寛延	Kan-en	1748-50
寛永	Kan-ei	1624-43	寶暦	Horeki	1751-63
正保	Shoho	1644-47	明和	Meiwa	1764-71
慶安	Keian	1648-51	安永	An-ei	1772-80
承應	Sho-o	1652-54	天明	Tenmei	1781-88
明暦	Meireki	1655-57	寛政	Kansei	1789-1800
萬治	Manji	1658-60	享和	Kyowa	1801-03
寛文	Kanbun	1661-72	文化	Bunka	1804-17
延寶	Enpo	1673-80	文政	Bunsei	1818-29
天和	Tenna	1681-83	天保	Tenpo	1830-43
貞享	Jokyo	1684-87	弘和	Koka	1844-47
元禄	Genroku	1688-1703	嘉永	Kaei	1848-53
寶永	Hoei	1704-10	安政	Ansei	1854-59
正徳	Shotoku	1711-15	萬延	Man-en	1860-61
享保	Kyoho	1716-35	文久	Bunkyu	1861-63
元文	Genbun	1736-40	元治	Genji	1864-65
寛保	Kanpo	1741-43	慶應	Keio	1865-67

ACKNOWLEDGMENTS

The three authors of this volume have written previous books on Japanese swords, and had not been thinking of making another book on the subject. However, after several visits to Italy to demonstrate sword-making—both at the Bargello National Museum in Florence and in the area around Florence—Mr. Paolo Saviolo, of the publisher Saviolo Edizioni, approached us with a proposal for another book on Japanese swords. This appeared to be a worthwhile endeavor, especially since the work was to be entirely in color and had no restrictions on length. It was a good opportunity to write a large book that would include extensive sections on the care, examination, and appreciation of Japanese swords; an account of the history and production of traditional Japanese steel; a detailed chapter on making the Japanese sword; and a description of the other craftsmen responsible for finishing and mounting the blade. This effort has been progressing slowly over several years (some credit must go to Paolo Saviolo for the glacial pace, since he never gave the authors any deadlines).

Many people contributed to the making of this book, and the authors would like to acknowledge their help. The chapter on the tatara was written by Muneo Yaso, the director of the Wako Museum in Shimane, Japan. The tatara photos were provided by the Wako Museum and Takeshi Fujimori. All other photographs were taken by Aram Compeau and Yoshikazu Yoshihara. The oshigata of historical and important swords were provided by Michihiro Tanobe, with the exception of the tanto oshigata on page 91, which was made by Naoji Karita. The drawings in black and white and in color were made by Yoshindo's student Ryoichi Mizuki. The photos of gendaito (modern swords) were taken by Aram Compeau and Yoshikazu Yoshihara.

The authors greatly appreciate being given permission to use the following art in this book. The paintings shown on the inside of the front cover and back cover are from the collection of the Museum Nakasendou. The painting of craftsmen on page 1 is from the collection of Kita-in. The painting of the tatara shown on page 2 is from the collection of Akira Kihara. The kodogu shown on pages 53-57 are from the collection of Hirokichi Matsunaga. The koshirae shown on pages 58-63 are from the collection of the NBTHK. Thanks are also due to Tsuneyuki Inuzuka, who provided the portrait of Suishinshi Masahide on page 84, and to Masahiro Mori, the maker of the Yoshindo doll shown on page 120.

It is thanks to the perseverance of Paolo Cammelli and Paolo Saviolo that this book came about. Paolo Cammelli has been extremely helpful in facilitating communications between Italy and the US, and in helping to organize the efforts of the authors and the publishers. The fact that the authors live in California and Japan, while the publisher is located in Italy, added to the difficulty of the task.

The authors are grateful for the opportunity to photograph many swords made by the Yoshihara family, and are indebted to Aram Compeau, Duane Hanson, Thor Heine, Xia Jin, Douglas Louie, Leo Monson, James Nakasuji, Gail Ryujin, James Sandler, Wayne Shijo, Hubert Tsang, and Morgan Yamanaka for their contributions. The editorial efforts of Wayne Shijo and Douglas Louie in reviewing the manuscripts and detecting what seemed like countless errors are particularly appreciated.

We hope that this book will help people who are interested in Japanese swords learn how to examine, view, and maintain them, while offering a basic understanding of how the blades are made and finished. We believe that such knowledge makes Japanese swords far more interesting and enjoyable to view and study.

BIBLIOGRAPHY

Fuller, Richard; and Gregory, Ron. *Military Swords of Japan, 1868-1945*. London: Arms and Armor Press, 1986.

Fuller, Richard; and Gregory, Ron. *Japanese Military and Civil Swords and Dirks*. Charlottesville, VA: Howell Press, Inc., 1997.

Kapp, Leon; Kapp, Hiroko; and Yoshihara, Yoshindo. *The Craft of the Japanese Sword*. Tokyo: Kodansha International, 1987.

Kapp, Leon; Kapp, Hiroko; and Yoshihara, Yoshindo. *Modern Japanese Swords and Swordsmiths: From 1868 to the Present*. Tokyo: Kodansha International, 2002.

Kishida, Tom. *Yasukuni Swordsmiths*. Tokyo: Kodansha International, 1994.

Magotti, Sergio. *Nipponto, the Soul of the Samurai*. Bagnolo San Vito, Italy: Ponchiroli Editore, 2009.

Nagayama Kokan. *The Connoisseur's Book of Japanese Swords*. Tokyo: Kodansha International, 1997.

Nakahara, Nobuo. *Facts and Fundamentals of Japanese Swords*. Tokyo: Kodansha International, 2010.

Sato, Kansan. *The Japanese Sword*. Tokyo: Kodansha International, 1983.

Sinclaire, Clive. *Samurai Swords: A Collector's Guide to Japanese Swords*. New York: New York Book Sales, Inc, 2009.

Takaiwa, Setsuo; Kapp, Leon; Kapp, Hiroko; and Yoshihara, Yoshindo. *The Art of Japanese Sword Polishing*. Tokyo: Kodansha International, 2006.

Yumoto, John. *The Samurai Sword*. Tokyo: Charles E. Tuttle, 1958.

Yoshindo Yoshihara is the third-generation swordsmith in his family. His grandfather Kuniie began making swords in 1933 in Tokyo and was ranked among the top swordsmiths in Japan during his career. Yoshindo lives and works in Tokyo with his son, who represents the fourth generation of sword-smiths in the family. Yoshindo, who is always training young swordsmiths and currently has five apprentices working with him, has been named an Important Cultural Property of the city and prefecture of Tokyo, and is a mukansa (top-ranked swordsmith) in Japan.

Leon Kapp, a molecular biologist, lives with his wife Hiroko in San Rafael, California. He has been seriously interested in Japanese swords for over twenty-five years, and has spent a great deal of time learning about them from Yoshindo.

Hiroko Kapp is a writer for *Senken Shimbun News* of Tokyo and writes about fashion and the fashion industry in the US. She graduated from Musashino Art University in Tokyo. For twenty-five years, she was active in the apparel business and designed scarves for her own line in the US.

The Kapps and Yoshindo have written three previous books on Japanese swords.

PRODUCER

Paolo Saviolo was born in Italy in 1963.

Having spent more than twenty years ascending the corporate ladder, Paolo became president of the Saviolo Publishing House in 1999. His publishing company has received numerous awards and continuous in-ternational recognition for the exceptional quality and innovative page design of its printed works.

Ever attentive to his surroundings and ready to take on new challenges and projects, Paolo will work wherever ideas carry him. His current operations are based in Italy, as well as in the United States and Japan.

CONTACT INFORMATION

YOSHINDO YOSHIHARA

Japan
8-17-11 Takasago
Katsushika-Ku
Tokyo 125-0054, Japan
Fax (81) 3-3607-1405

LEON & HIROKO KAPP

USA
leonkapp@gmail.com

ARAM COMPEAU

USA
aram.compeau@gmail.com

PAOLO SAVIOLO

Italy
Via Col di Lana, 12
13100 Vercelli
Tel. (39) 0161 391000
Fax (39) 0161 271256
paolo@savioloedizioni.it

PAOLO CAMMELLI

Italy
lupocamel@yahoo.it

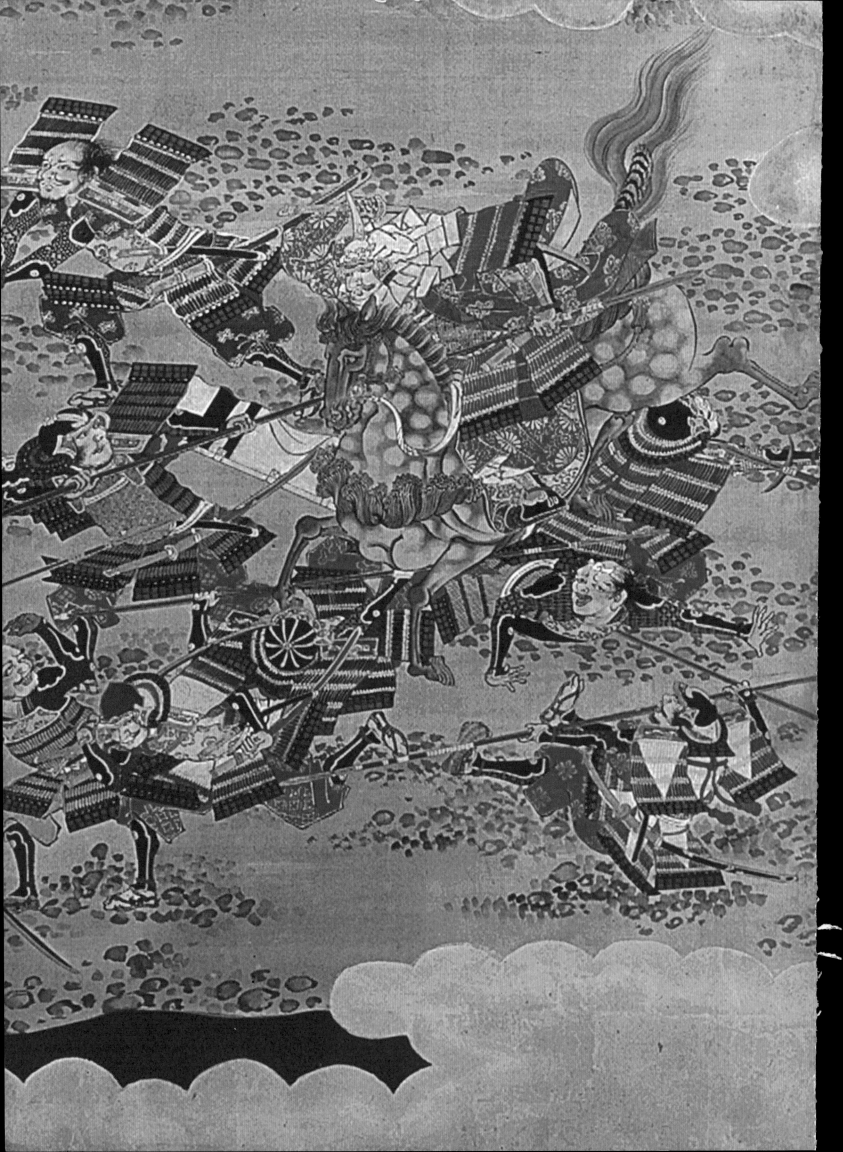